DATE			

45701

The Art
and Peoples
of Black Africa

The Art and Peoples of Black Africa

JACQUELINE DELANGE

PREFACE BY MICHEL LEIRIS

Translated by
Carol F. Jopling
with the assistance of
Hannah Jopling Kaiser and Laura Schultz
and the additional aid of
Vivian Cohen,
Marcel Serraillier,
and Willem Tissot

NEW YORK
E. P. DUTTON & CO., INC. 1974

© Éditions Gallimard, 1967.
English translation copyright © 1974 E. P. Dutton & Co., Inc.

All rights reserved. Printed in the U.S.A.
First Edition
10 9 8 7 6 5 4 3 2 1

Published simultaneously in Canada by Clarke, Irwin & Company Limited, Toronto and Vancouver.

Library of Congress Catalog Card Number: 74-1179

ISBN 0-525-05853-2 (Cloth) ISBN 0-525-47364-5 (DP)

Contents

List of Illustrations

Preface

Rather than being a history of black African plastic art, this book, the fruit of ardent research, comprises the data for such a history. A brief sampling of this book appears in a work signed with both Jacqueline Delange's name and mine: *Black Africa: Plastic Creation,* the eleventh volume in the *Universe of Forms* series.

The data for a history, that is, the elements from which this history could be constructed, are in particular, an inventory of genres and styles of the various kinds of art objects (art here referring to anything that results in a stable product most directly apprehended visually) and of the different forms that each assumes according to the human environment where the concrete realizations come into being. The book is a primordial census, since it is certainly necessary to begin by cataloguing the elements, and then, it will be appropriate to establish a panorama that the dimension of time will animate by introducing perspective and perhaps even the lineaments of a genealogy. Presently, as far as the arts of the black Africans are concerned, it is hardly possible to go beyond a static accumulation. In effect, our knowledge of the past of these arts is too poor for us to envisage them according to the dynamic of history, unless we depend largely on hypothesis. And, one may add, it is even greatly feared that it will never be possible to organize the mass of documents touching on numerous eras and places without which this *history,* in the strict sense of the

term, cannot be established. As far as they could be scientifically collected, the oral traditions certainly furnish invaluable information, but their nature is often mythical or at the very least, legendary, and requires prudent use. In addition, the languages spoken in black Africa were not written, with only a few and recent exceptions (at the end of the eighteenth to the beginning of the nineteenth century in the best-known case, the Vai, a small Guinea Coast group), so ancient documents in a vernacular language are totally lacking. Finally, in this domain, where others seem to have made their work for eternity, the black African people used principally perishable materials (especially wood for most of the sculpture, not to mention their architecture of dried mud) from which it follows that they left only very scarce illustrations of the earlier state of their art.

Should these direct obstacles be overcome, to write a history of the black African plastic arts remains, a priori, more disputable than to draw up a general history of European plastic arts. Indeed, although Europe, seeing only the exoticism common to most of the pieces that have reached it (such statues are too quickly designated "fetishes"), was for a long time inclined to attribute a certain uniformity to them, the arts of black Africa—and singularly the sculpture—revealed little by little an extraordinary diversity, to such a degree that the difference, shall we say, between Sudanese and central Congolese sculpture today appears much greater than what in Europe separates, in one scheme or another, the painting of the commonly called "Latin" and "Germanic" countries. To speak of black African art as a coherent ensemble, which is implied in the notion of writing a history of it, is to forget this fundamental idea: whereas in Europe, Christianity, with a universalist tendency, was a factor in the relative cultural unification, in black Africa, the form of religion, fittingly called "animism," which was basically related to the family group and to a plot of land, favored an artistic particularism, as was mentioned not long ago by William Fagg, one of the great specialists of this sculpture. Further, it must be noted that this religious fragmentation exists within the frame of a more general partitioning: although, from the Middle Ages

to the period of European colonial expansion, the black continent has known hegemonies that temporarily dominated diverse large regions, and, although it is today divided into a restricted number of countries, for the most part independent and politically constituted nations, nevertheless, on a level other than that of national entities, its population is separated into a multitude of societies that differ in their languages as well as in a number of their institutions, of which cults represent only one of many aspects. From the ethnographic point of view, black Africa is similarly atomized, with the exception of several vast unities (for example that which forms the Yoruba of the Guinea area, a block of more than five million people). Unquestionably this results, on the one hand from natural conditions that are not propitious for intense and extensive communications—at least not until recently—and, on the other hand, from the upheavals caused by the very severe blows, which, even before colonialization, were received from the outside by many a black population from technically better-equipped people. Certainly, a great monotheism, Islam, was very widespread south of the Sahara, as it first was in the north, where it was propagated by the Arab conquest. But if it made the blacks who adopted it somewhat culturally uniform, its unifying influence acted negatively with respect to the three-dimensional figurative arts: resulting in plain sterilization because of the mistrust of this religion toward images. The producers of the images, by definition foreign to Islam, have been almost the only ones examined, since precedence is accorded to those "Negro" plastic activities that have received international dissemination. Here, in the discussion of their sculptural arts, the dominant note remains the discontinuity of these styles—the extreme fragmentation that animism with its fundamentally divisory nature can only accentuate.

Under such conditions it is certain that a work in depth on the arts that engages us has every chance of presenting the cloisonné aspect of a mosaic where, more than the interdependence of the elements organized into a whole, their simple coexistence is manifested. In addition, from the outset, it should be stated again that

even if this book were only about the Sudanese area, it could not in any way be organized on the same scheme as, for example, a book on Byzantine or Gothic art, for as complex as the study of those two arts is, this one encompasses material incomparably broader, more disparate, and more riddled with lacunae.

In any case it is vain to look for something in the present work other than an essay that deals essentially with great African art, that is, sculpture, and puts it into its setting. In addition, it is limited to the societies about which there is sufficient ethnographic information, leaving aside, or at least relegating to the background, those that depend only upon archaeology.

Careful not only to reduce to a minimum the role of hypothesis, but also to examine the array of objects under "African" light rather than ours, or, indeed, the cold light of our system of ideas, Jacqueline Delange was induced to put aside those that, for lack of the desired information, she could not merge into their living context. She excluded, with few exceptions, the study of those objects with which only a totally external relationship is possible in view of our unfamiliarity with their origin and consequences. Instead, she fastened upon those with which there can be an authentic relationship, because when looking at these we can understand their use and can begin, more or less, to rediscover the attitude of the creators and users of these works, which are diverted to such an extent from their original purposes when they are found on display in museum cases.

In this way of examining the subject there is nothing that fulfills the intention of setting the ethnological approach on the way to a strictly aesthetic comprehension. If the author herself imposes the rule to which I allude, it is so that this comprehension may be as complete as possible: to treat with art demands (is there any necessity to insist upon it?) primarily that one appreciate the beauty in it, but there is no doubt that to know what it meant to those who created it permits a finer appreciation. Jacqueline Delange's approach remains, then, that of a fervent admirer of "black art." In her manner of proceeding

there is a perfect blend between what is owed to scientific scruple and what could only be dictated by her own sensitivity.

As is natural, sculpture in the round and the art of masks are in the foreground in this picture, which becomes a retrospective when, by chance, although without solving the continuity problem, one can trace back from present-day art to the earlier art (in Nigeria, for example). But, as a general rule, this picture is a reflection of the past in the unique measure that even in the era in which we live, which sees the continuing disintegration of traditions unhalted by the termination of the colonial regime, certain of the arts under consideration exist only in decadent forms, if they have not been completely forsaken. The priority thus granted does not result from a simple personal predilection: the cults that play so important a role in traditional African life and other institutions that are the necessary wheels of the social mechanism involve the use of more or less abundant material objects that comprise statues, masks, or other ceremonial instruments. According to the circumstances, these objects require carving, modeling, casting in iron, or another technique or several techniques in combination, like the masks and disguises, usually made of a certain number of materials of which each must be worked according to an appropriate technology. In addition, the interest that Western art amateurs convey to it depends on the important place that the sculpture occupies in the functioning of most of the agricultural black societies, which are "pagan" in the current and also in the etymological meaning of this word, as if this reaction, purely sentimental or aesthetic, at least originally, was leading where the positive data of ethnographic observation could lead. Certainly these objects were more apt than others to stir the curiosity of travelers and were brought back as souvenirs, so they were among the first that were known in Europe and, in sum, at the beginning of this century, they were almost the only ones with which amateurs could become infatuated. One can think that it is precisely to the fabrication of these objects invested with special functions among most of the blacks that these people have applied the best of their capacities

for plastic creation and that, therefore, finally a preliminary contact, however tenuous, between Europe and the arts of black Africa has led to the recognition of an African reality.

Striving to sift out the specific characteristics of each style of sculpture, Jacqueline Delange has taken care not to attempt a general classification. If the families, each comprising several related styles, can only be distinguished to a limited extent and in most cases on a small scale, the distribution of multiple styles into a very small number of large categories, even more so could not have been accomplished until now except by means of debatable simplifications. Jacqueline Delange's discussion, while going beyond the examination of sculpture alone, does not find an ordering principle for the classification of sculptural styles into large, defined groups, ex cathedra one could say, according to a very schematic, or inversely, a very fluid, conception of differential characteristics. She has proceeded in the following way (like other writers on black art, since those of the period of discovery): basing the division of diverse people on groups recognized as presenting a certain cultural unity, and studying the plastic production of each of these groups while still granting to the sculpture the particular attention it deserves. The empirical method not only leads to a more precise grasp of the sculptural domain but also permits her to take into consideration peoples who, although their sculpture is nearly (in truth, completely) nonexistent, have shown by other techniques that they do not lack the aptitude for the arts. They themselves have proved by their artistic institutions, which rise from a visual sensitivity, that the aesthetic emotion, felt as such, is in no way foreign to them.

This way of making use of a closeness to reality, aside from being more flexible and emanating from the collective life itself rather than being based on stylistic distinctions acquired from more or less arbitrary criteria, gives her the advantage of putting clearly in relief what one might be tempted to call the plastic vocations of different peoples. It seems, indeed, that some excel in sculpture, others in the creation of masks, others in jewelry or in the sculpture of mobile objects, and

some show an equal mastery in several of these arts, and finally, some are oriented in a different direction, for example, the embellishment of dwellings, or personal adornment. Exemplifying this, a chapter is devoted to an extreme case, the Bororo Fulani, a people with very limited resources who use many objects bought from outside and not produced by their own craftsmen, but who manage to express themselves plastically in a convincing, though ephemeral fashion. Certain cultural traits of these Niger Republic shepherds indeed illustrate this fact in a striking way, which at first sight seems paradoxical: a keen taste for beauty of forms can very well exist in a society that produces nothing that could be labeled "an object of art," as if, as opposed to what one is too inclined to believe, there were no common measure between a peoples' aesthetic sensitivity and its practical capacity for fashioning works that form a lasting testimony to it. A divergence separates the ideal and the material realizations, which are directly conditioned by the type of life (nomadic or sedentary, deprived or relatively affluent). This eventual unpretentiousness should not let us infer that their aspirations are mediocre. Although the Bororo Fulani produced nothing that is worthy to appear in our art museums, they still were regarded as the most refined artists, if this were only evidenced in their festival, the *gerewol,* well-known today because of photography, film, and even stage adaptation. This ceremony is a beauty contest among the young men who display beautiful ornaments and delicate facial paintings, and it is also accompanied by poetic jousts.

Actually, it seems that there was no correlation between the aesthetic level of a people (if one takes as a touchstone the admiration, more or less great, that the works of these people aroused) and its technological and political level (if one assigns the highest rank to the societies of traditional Africa that were equipped with a state apparatus, societies where a rather elaborate division of labor was linked to a differentiation of classes bringing about the existence of a state, the instrument of power of the privileged class). Is it possible to say,

for example, that the Benin bronzes, products of a royal art, are aesthetically superior to those masterpieces of carved wood that originate with the Dogon (Mali), whose organization seems always to have been tribal, or with the Tellem, established before them in the cliffs of Bandiagara and certainly endowed with not very different institutions. The Benin bronzes certainly could not have been made anywhere except in a hierarchical society having specialized guilds. They are products of a very skillful use of the lost-wax technique, which had been practiced for a long time in black Africa, as indicated by examples from several areas that appear to be about a thousand years old; so there is no reason to attribute it, as has been done, to the impetus of an external influence. Still, what about the Western amateur or museographer of today who places a beautiful specimen of a statue of Tellem ancestry or a coarser peasant Dogon object next to a male or female head of the great period of the Benin? Unquestionably this bronze head is assessed higher on the international market—nobility of material, certain antiquity, rarity, all converging to add to its price—but this prestige enjoyed by the "historic" piece remains to some degree independent of properly aesthetic judgment. Another, still more remarkable, example is offered by the artistic production of the ancient kingdom of Dahomey, or more exactly by what represented court art as compared with folk art, which also occurred in this country. Even though the iron statue of the deity Gu, which dates from the end of the last century and has been reproduced in so many publications, is one of the most unanimously recognized masterpieces of African statuary, it still is an exceptional specimen in a production that is outstanding for its quantity and the diversity of its repertory rather than its quality. This quality seems, to me, rarely to exceed the picturesque, although to advance this without proof on the faith of only my own appreciation—and only in a discreet manner—is obviously to fall short of the objectivity required when it is a question of the history of art. But can one not join the history of art with art criticism, at least implicitly, and can one have art criticism without the intervention of value judgments?

It must be admitted that if a roster of art masterpieces exists, it is not based on an absolutely fixed judgment. Not only do appreciations differ according to surroundings and people, but they also change with time: what seemed inconsequential at a given period may later be regarded as important. Further, to write the history of an art in whatever may be considered the completely scientific and not the "artistic" way, in principle, it would be necessary to take into account without discrimination the totality of the production in the field to be examined, or, at least, all that is known of it. Indeed, one wonders on what strictly objective bases a valid sampling could be founded, be this only in a provisional manner. No criterion—neither that of the reaction of the largest number (moreover only determinable by means of impracticable tests or referenda) nor that of the opinion of people whom one could call "connoisseurs" (it being assumed that one could not hope to invite *every* sculptor to give his opinion if sculpture is in question, and to depend on the appreciation of a few persons would only shift the problem, for how could it be decreed that these individuals were the most authorized)—allows for a rigorous decision that certain works, because of their aesthetic value or their interest as especially eloquent landmarks in the labyrinth of evolutions and trends, should be kept to the exclusion of others. So as soon as a study of this type goes beyond the framework of the monograph (narrow enough to comprise a complete inventory) and beyond cases where one deals with a few observable specimens (a condition that black African plastic art is far from satisfying), it goes without saying that one must devote oneself to only a part of the production, or, in other words, to the works that one personally considers the best or the most significant or that others have so evaluated. Of course, to the extent that his work is exhaustive, an author does not deviate from objectivity, but every art historian who undertakes a broad subject and aspires to even a minimal synthesis, as careful as he may be to omit nothing, is practically led to take into account only a poetic anthology to supply his evidence. If only on this level, he will act like a critic, sifting in order to discern at once what merits and what does

not merit his attention. If this historian does not wish to be restricted to the discussion of duly recognized works, he can only admit others according to his personal judgment. The impossibility of attaining a completely desirable objectivity is still further affirmed in the present case. Not only are a number of pieces still found on the spot and in such condition that they escape methodical study, but the arts in question are situated in a different context from our own. In spite of the assistance of ethnology in helping us to penetrate this context, our choice is made from the outside and is still more debatable than if it were brought to bear on arts that in some manner make up a part of our culture. Since one is faced with these problems and sees oneself constrained to depend largely on impressions, is there any reason not to clear the ground openly and forgo feigning impartiality on a subject where, by definition, it is taste that reigns supreme? This is the most faithful to actual experience and therefore the least pedantic way of proceeding, and also apparently, the most honest, provided of course, that one does not attempt to conceal its subjective nature and always endeavors to enlarge the de-Westernized views to the greatest extent as much as such a change of axis is possible.

Within the limits, both methodological and corresponding to her own tastes, which she set for herself, Jacqueline Delange proposed essentially to draw up as complete a stylistic inventory as the present state of documentation would permit. No doubt there are holes in this work, but the blame for these should be laid to the lacunae of research rather than to the author. Many societies have been only summarily studied, actually, hardly more than discovered, and there are those whose plastic activities are known only through a very insufficient number of objects. To establish this panorama, a considerable quantity of pieces belonging to private collections as well as those in French and foreign museums have been examined. Yet, this vast amount of information could be utilized only after filtering, or else this book would have been an immense dry repertory, devoid of all animation. Instead, it is a guide helping to enlighten us on the

extraordinarily rich domain of black African plastic art and a stimulus to new investigations of the living cultures.

More than the text itself, a nearly insoluble problem was posed by the illustrations: how to manage it so that an illustration, necessarily reduced to a minimum, was representative enough? In the first place, the temptation to make a sort of gallery of "masterpieces" out of the collection of illustrations was resisted. Naturally it was necessary to show the pinnacles of achievement black artists can attain and, in addition, the extensive range of their work for the degree of application and the particular forms assumed by the objects that stem from a great diversity of types of objects that are fabricated (statues, masks, furniture, and all sorts of instruments within the limits of sculpture alone), and the extreme variety of appearance with which objects of the same category are endowed depending on the group that makes them. Wishing both to bring out this double diversity and to break the framework of prevailing notions, Jacqueline Delange attempted to regenerate as far as possible the iconography that ordinarily is found in books of this type. Especially for the societies whose plastic arts are well known, she chose unpublished illustrations to avoid tedious repetitions and, at the same time, to engage the mind in routes away from the beaten paths. In other respects, she compelled herself to undertake the thankless task of dealing with the arts, still almost unknown or represented by objects, which until now have attracted little attention (East Africa, for example). Finally, to emphasize the marvelous fertility of plastic invention among the blacks, she did not hesitate to reproduce several objects that are "monstrosities" according to the aesthetic norms accepted by most amateurs of African sculpture.

An enterprise conducted on artistic terrain, which is always a shifting one (a terrain that, if more certain, would lose precisely what makes its value, strictly speaking, inestimable), is an enterprise strewn with an excess of pitfalls, since it is carried out in the provinces of universal art, which, on an ideal map, would appear somewhat

marginal to our own (unless one refers to a West so archaic that it is only nominally ours), and which, in any case, belongs to cultures to which, even so far as they engage our sympathy and even with the perspective that persistent study can give us, we remain strangers by definition. This enterprise attempted by the author of *The Art and Peoples of Black Africa* possesses, in my opinion, the rare merit of having been conducted with great modesty.

I mean to say that I am fully conscious of the inevitable boldness of such an intention, since it is a question not only of producing a scientific work where the faithful agents and users could rightly resent scientific involvement but also of disentangling what is essential from what is accessory, where all we have for our Ariadne's thread is a sensitivity formed by traditions and styles of life other than those of which these agents and users were or still are the trustees. Thus strengthened by simplicity itself, the work of Jacqueline Delange provides a lesson that I believe to be important: beyond its scientific interest, it demonstrates that one can never approach these black arts with too much prudence and humility. Several of them have been placed at the top by the greatest artists of our time, and as more profound knowledge of them is acquired more and more subtleties and resistances to definition are revealed.

MICHEL LEIRIS

Upper and Middle Niger

The upper and middle sections of the Niger mark the northern frontier of the Sudanese provinces, where some of the best-known arts of black Africa developed. In this vast region, which links the Saharan oases to the forest, the ethnic groups have jostled each other since the eighth century. The empires of Ghana, Mali, and Gao, the Mossi kingdoms, and Islam have played a notable role in the formation of the peoples who occupy this area.

The arts of the agricultural Dogon and Bambara seem to represent completely the spirit of the sculptural styles of the entire region, at least at the present time and to European art amateurs. Nevertheless, certain other peoples, such as the Bozo, appear bound to hold an important place in the history of traditional Sudanese art in the near future.

Dogon statues and masks do not form a homogeneous assemblage. (The abundant treasury of Dogon myths and rituals is known through the writings of Marcel Griaule, Germaine Dieterlen, and many other investigators.) Representations of mythical persons linked to unchanging periodical ceremonies, the statues are associated with the past. Many of them were found in shelters hollowed out in the sandstone cliffs of the Nigerian central plateau, and the Dogon attributed them to their predecessors, the Tellem. As for the masks, although they are associated with the souls of the dead and are themselves also reposi-

tories of archaic traditions, one could say their function gives them a vivid immediacy. Grouped together as an initiation society, their wearers parade in the public square, particularly on the occasions celebrating the end of mourning for one or several recent deaths. If the deceased is an important person, the carving of new masks is required and the maskers themselves make them. On the other hand, the figures are the work of blacksmiths and are remade much more rarely. Undoubtedly, this is why the art of the Dogon mask-carvers remains so astonishingly alive.

When the masked *corps de ballet* performs, a play is acted which receives different interpretations from the masters, the adult initiated, the actors, and the public. In his last publication, Marcel Griaule points out three masks that he considers fundamental: the *kanaga,* the *sirige,* and the "door of Amma." All three have a characteristic appearance. The face is divided, more or less symmetrically, into two rectangular hollows on either side of the nose (which is most often represented by a simple vertical division). Sometimes, the features of the *kanaga* (nose, mouth, eyes, detached from the geometric protuberances) are more precise. The face represents the creator god from whom evolved the events leading to the building of the foundations of the society. The respective superstructures of these masks (cross of Lorraine; long, vertical pole treated with grilles alternating with full squares; and a small board perforated with double vertical zigzags surmounted with half a calabash) symbolically evoke these events.

The directly representational Dogon masks sometimes portray animals of the savanna, sometimes people. More numerous, the masks in the likeness of the first animals slain recall that the Dogon were hunters before they were farmers. They commemorate the alliance of the animals (twins of men according to some myths) and the first ancestors in the mastery of the human order. The anthropomorphic masks relate to different social categories and tend to fall in the following list: sex, age grades, religious and technological functions, and tribes.

Inseparable from a group of attributes (coiffure, costume, ornament, staff, calabash, and moneybag), the masks were more or less

well carved and painted by their future wearers, whose gesture (dance or mime) achieves a characterization of the person represented. Thus, the mask resembles a theatrical *objet d'art*. In contrast, the Dogon figures can be considered a personal art. (This is not the case in many other societies. Among the Yoruba, for example, statues are carried in public processions.)

The principal characters portrayed in a group of sculptures whose creators the Dogon do not acknowledge (the bisexual spirit, *nommo;* Yasigi, the mythical incestuous woman; the religious chief or *ogon;* the ancestor, Dyongou Serou; the blacksmith, and the twins) are represented in the different moments of their mythical incarnations or in one of the numerous aspects that defines them. In this universe of symbolic constellations, the positions (body upright, kneeling, or sitting; arms raised, or right or left arm raised; hands with fingers spread or interlocking; hands concealing the face or posed on the stomach) and the carefully carved accessories (footstool, calabash, mortar and pestle, musical instruments, clothing and headdress) seem each time amazingly rich in precise meanings. The animals, whether suggested or clearly represented (crocodile, lizard, snake, horse, donkey, dog, or antelope), recall the special links that unite each of them with men. Nonrepresentational elements, either treated in three dimensions (sinuously ringed wood, small boards) or discretely cut out or incised on a flat surface (notches, and broken, crossed, and parallel lines), complete the images of a golden age made vivid by the artist.

We use the term *artist* intentionally. Although aesthetic creation is dominated here by particularly constraining social demands, there is still room for so-called sculptural invention. How else can one explain other than by the margin left to craftsmanship that certain pieces more than others arouse the admiration not only of the European amateurs but also of the Dogon themselves.

In what he calls "an outline of a typology," Jean Laude analyzes the different styles of Dogon sculpture by grouping the works according to how closely they are related to or "embedded in the form of their original material." Thus, one passes through a profusion of varia-

tions from a sculpture whose form is scarcely released from the tree trunk to a clearly defined carving whose three dimensions are strongly affirmed. The famous "hermaphrodite" figure at the Musée de l'Homme is the best example of this "embedding in the form of the original material" of all the known great Dogon sculpture. The undulating body of the tree trunk recalls that of the ancestor in the form of the great serpent. Emerging from the tree trunk, the body elements of one or several mythical characters—head, bust, trunk, legs—are treated more or less freely vis-à-vis the shape of the wood from which, finally, one or two raised arms can detach themselves. The plastic sensitivity of the Dogon sculptors in combination with the complex set of themes enables them to create a great number of incontestable masterpieces.

Today, the Dogon claim that almost all of the sculpture is of Tellem origin. The statuettes in hard wood, covered with a sacrificial coating of millet gruel and dried blood, are, however, the ones ordinarily given this attribution. The thick crust, crackled yellow and gray with trails of ashes, is certainly not strange in relation to the striking appearance of these forms in which it seems desirable only to indicate the essential.

The *nommo* with raised arms is seen again in some monumental statues that belong to the category of the three-dimensional representational works. Here the variety of stylistic formulas is very broad. One encounters in these dark, hard, and polished woods the theme of the ancestors that lent itself to interpretations of harmonious grandeur.

Like the wooden sculptures, the Dogon ritual iron staffs are images of mythical heroes, but when they represent the principal characters of the myth of the organization of the universe, the stem of the iron is linked to the blacksmith. The rigid metal has been bent in the upper part to suggest the sinuous limbs, without joints, of the first craftsman who brought from the heavens instruments (hammer, anvil, and bellows) and seeds (sixteen seeds enclosed in the hollow handle of the hammer, according to one version of the myth). Long, branched rods of iron and small, single or double hooks of iron are associated with the cult offered to the sacrificial *nommo*. The double curve of the iron

terminating on each side in spirals suggests another representation: that of the hands with open palms at the ends of the upstretched arms of the *nommo* who has been brought to life, brought back to life first in the form of the heavenly god, the spirit of water, to which agrarian rites are consecrated, then in the form of the ancestral blacksmith. Hooks are implanted in the gables of the sanctuaries, as anthropomorphic hands of iron apparently "to retain the rain clouds" and "to catch abundance."

The genius of the Dogon is expressed above all in their sculpture. "Great masks" which are not real masks but effigies of an ancestor in the form of a serpent, wood evoking a dog or hyena and destined to protect the fields, and crosses of the *yona* (individuals who are institutionally permitted certain thefts) are among the illustrations of this. But the Dogon have other forms of visual expression, notably painting and weaving, whose social and ritual function is extremely important.

In the southwest, the Bambara, who are part of the Mandé group, live along the two banks of the Niger on the Siguiri-Macina axis. Their wooden sculptures representing the numerous species of antelopes that men encounter in the savanna were the starting point for European interest in Sudanese art. These dance headdresses are used in the villages by young men who belong to the *chi wara* society, in which the teaching and activities are related to agriculture. Almost all these sculptures rest on a rectangular base pierced with holes so that they can be attached with strings to a fiber skullcap. The tangle of the fiber strands forms a base of basketry that gives a harmonious pliancy to the headdress.

The plastic execution always takes place within the schema given by the basic physical form of the animal: whether they are headpieces from the Bamako, Buguni, Koutiala, Segu, or Kenedougou regions; whether these are vertical or horizontal sculptural crests; whether animal or human representations are attached to them; and whether the type of antelope itself varies. From these thematic elements (to which is often added an antelope represented as a quadruped with an angular

jaw, with a long or short tail, and with ears sometimes long and straight), the local or individual talents invent harmonious combinations. In the Koutiala region where a branch of the Senufo, the Minianka, dominate, one finds principally the big male antelopes with long, straight, ringed horns that curve slightly toward the back. The body is carved in openwork, in a large, supple zigzag with a curving dentiled border. There are multiple variations. In this same region, one also finds the fine antelope figures carrying their young on their backs. The compositions range from a sculpture reduced to pure angles to a very refined piece whose decorative effects are the result of carbonized geometric patterns, heads of nails, small metal plates, and rings fixed to certain parts of the body. These crests, which are worn on the head, are attached by their base to a fiber costume blackened with mud that hides the body of the young men acting out the work of the earth. In the Bamako region, the stylized antelope head is supported by a quadrupedal body. The body has disappeared in the Buguni style further to the south, where only traces of it remain in the curvature that delineates the form of the antelope. In front of the horns stands a figurine with female attributes; sometimes two bareheaded and more simplified figures stand back to back. The basket skullcaps, in which two holes are made for the eyes, are decorated with cowrie shells and ram's wool and are often attached to cloaks of European fabric. In this region, though more in the north, headpieces with horizontal antelopes can be found. Here also, modeling variations are made with respect to the horns and their length, curvature, and number.

The same complex group of myths explains the creation of the universe and its organization for the numerous Sudanese peoples who trace their common origin to the Mandé. As with the Dogon, mythical events furnish the Bambara blacksmith with sculptural themes used by the six societies that successively initiate the young boy then the adult man into the knowledge of the different aspects of human reality and its destiny.

Thus the antelope could be one of the forms that the spirit of water

assumes. God of water, he is very naturally the god of the farmers, but he is also a hermaphrodite god from whom future generations will be born and who shares with a pair of unidentical twins the luster of the creator of the world. If the antelope is an incarnation of the god of dispenser of waters, the figure planted between its horns could represent the jealous twin, the sower of disorder of the chthonian god. When not only these myths but also the history of the gods and indeed even the cosmogonic representations bear on the artistic compositions, we recognize the basic feelings of men expressed in these objects, their responses to the problems of life. Also expressed are their pertinent observations of the animal world of which the stylized antelope conveys to us a distilled image, their social and economic needs illustrated by the age-grade society, the periodic wearer of carved headdresses and straw skirts, and equally expressed by the activities of the religious mask-wearing societies. The Bambara masks, with the exception of the *ndomo,* which alone represents a human face, all have horns or ears; they combine human and animal features whose original postures and relationship with the physical world strike the imagination of men.

In his introduction to the study of Bambara initiation societies, Dominique Zahan defines the direction of his works. "It is not one myth," he writes, "but a multiplicity of myths which the Bambara offer us. How are the authentic Bambara themes recognized in these allegorical stories? What materials were imported? Where must one find the firsthand version? How much was apocryphal?" It is the very heart of the relationship between men and things that the author is striving to penetrate, giving us at the same time a more real knowledge of the character of the masks.

According to Dominique Zahan, each of the six Bambara initiation societies plays a well-determined role and maintains with the others a series of analogous relationships based on the different aspects of life. Each one is linked to certain parts of the human body and to one of its joints and at the same time to one of its senses of perception, a

system of correspondences engendering a whole emblematic and symbolic repertory with which the mask is integrated.

The mask of the *ndomo,* "image of man as he leaves the hands of god," is characterized by human traits (in particular, the sense organ of the nose) and by horns, whose number varies between two and eight. "The horns are, for the animal that possesses them, like the vegetable sprouts in the earth." By analogy, they refer then to what is most basic in nature. Grains and cowries, which adorn the face of the mask unevenly, evoke the proliferation of human beings.

In the *kore* society, the displays of lion, hyena, monkey, and horse masks by their wearers, which take place during the rites of the different classes of this society, reflect the character of the animals themselves. Through the virtues, weaknesses, and excesses of the masked men, through their apparent clownings, their acrobatics, their games, and their fights, the progression of man toward knowledge is acted out. The sculptor seems to be endeavoring to rendér each time the particular character of the animal figure, in which also something human always appears. He has played with the significant details: the face is elongated, the ears are thinned, the forehead is rounded or projected abruptly, the mouth, always partially open, is slit differently, and the relations between the primary surfaces are transformed.

The human traits have disappeared on the masks encrusted with sacrificial blood of the *kono* society, like those of the *komo* implanted with antelope horns, little tails, porcupine quills, and bird skulls.

Mandé sculpture consists of a wide spectrum of forms. The statues waver between a very stripped hieraticism, from which is derived the stylized posture of the standing female with arms at the sides of the body, to a slightly more naturalistic sensibility that is expressed especially in the face, whose treatment again recalls that of the half-human, half-animal masks. The breasts, always large, indicate the importance of the female element. The body may be naked or enhanced by multiple engravings dominated by the zigzag or chevron motif, which, as symbol of water, also suggests the image of woman and her beneficent fertility. The hair twisted into a dome shape, the same for all the

figures, suggests again maternity (the multiplicity of the ridges may represent the number of children).

The functions of this statuary are not well known. It is not abundant, in spite of the later appearance on the Western market of large statues originating from the Buguni-Dioila region. They are dignified, imposing figures generally wearing a kind of Phrygian cap. The women are seated holding their breasts or carrying a child. The complementary male figures stand or are on horseback, their silhouettes enhanced by metalwork at the top of the iron staffs. In the most beautiful of these iron pieces, the figure of the horseman seems to be projected into space, suggesting, as with the Dogon, the descent of the celestial god and then that of the blacksmith. The animal ridden, sometimes an antelope whose ties with sun and earth are already known, doubtless refers to the fact that the arrival of the god on earth brings about the appearance of light and rain.

The Bozo fishermen, who, it is said, were born of the first twins of the water spirit, are the oldest occupants of the region. Masters of the Niger, they maintain their advantage in a favored situation. Though their sculpture is less three dimensional than that of the Bambara farmers, let us take note of the geometric water-spirit figures with shining metal symbols and the heads of the circumcision rattles (rings of notched calabashes affixed to handles), wearing pointed combs decorated with fine zigzag lines, which are also found on the girls' dance rattles. This instrument is in the shape of a fish whose form evokes the human fetus.

The stylistic qualities of Mandé sculpture are also manifested in a number of objects of everyday use, particularly the door locks and also the marionettes. The marionettes are worked by a man hidden under a bed of bamboo stalks covered with *pagnes* * sewn together and act out stories that are half way between anecdote and fable.

Polychrome masks, which also emerge from a quadrangular frame covered with *pagnes,* are brought out by the Bambara, the Bozo, and

* Translator's note: a special type of skirtlike loincloth worn by Bozo men.

the Marka at the moment of the *fonio* harvest and the great collective fishing. One of these outings is nocturnal, the other diurnal. These masks are rich in color and in significant decorative forms similar to the paintings periodically executed on the circular white-plastered walls of the sanctuaries. The *pagnes,* which heighten the colored brilliance of the sculptures in daylight or torchlight, remind us of the techniques of weaving that play an important role in the lives of these peoples. For example, the Bambara cotton bands, through the constancy of their decorative designs, oppose the invasion of European fabric. These cotton cloths with black and indigo motifs on a white background are adorned with figures that concern the wearer himself or the history of his tribe.

The Kurumba are said to have played a game of hide-and-seek with the Dogon. Fleeing the Mossi invaders in the company of the Songhai, the Dogon took refuge in the eroded sandstone mass of the Bandiagara and Hombori cliffs. The Kurumba were the first inhabitants of these cliffs and they left traces of their cults when they abandoned them. When they rejoined the southern Yatenga, they, unlike the Dogon, could live with the Mossi. These contacts between the Dogon, the Kurumba, and the Mossi are reflected in their sculpture. Time has paled the delicate polychrome geometric decoration (face-to-face triangles; white, yellow, red, blue, and ocher lozenges) in the absence of periodic renewal, which gave the colors their brilliance. Parallel colored stripes that cover the sculptures entirely, representing hyenas and antelopes, recall the decorative patterns of the small wooden boards that surmount Bobo masks, certain Mossi masks, and the *kanaga* masks of the Dogon. Kurumba decorative patterns are rather original and are distinguished from the checkboards and chevrons of the Bobo as well as the grille and lozenge openwork of the Mossi. But the decorative pursuit of all proceeds from the same use of painted or cut-out motifs in a composition that seeks to cover the total space and to be divided into distinctly symmetrical registers.

To the Mossi conquerors, already politically organized, the Ku-

rumba brought an infrastructure of hardworking and peaceful peasants grouped in religious societies and gathered around their earth chiefs. The ancient rituals have persisted. Antelopes and hyenas dance at the funerals of old men and notables, thus regulating the powers of the deceased. They dance during the transporting of the body and during its display in the cemetery. They dance again at the moment of the sacrifice and when the soul of the dead leaves the premises. Perhaps they also dance the history of the family that possesses the religious powers of the Kurumba, whose founder descended from the heavens wearing a mask, accompanied by his wife and his children, themselves wearers of masks of the antelope, the hare, and the hyena.

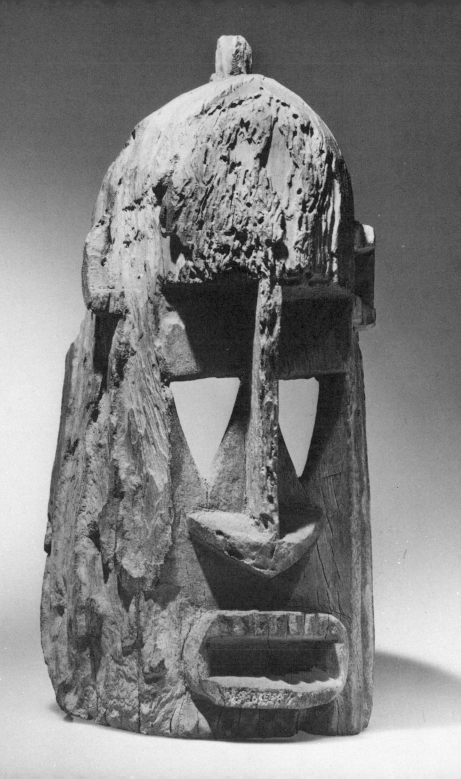

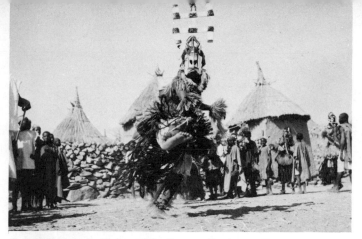

2. *Kanaga* mask. Dogon, Bandiagara district, Mali.
Photo Michel Huet.

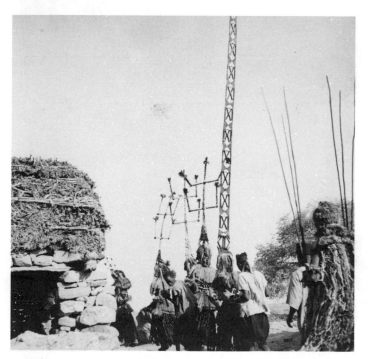

3. *Kanaga* and *sirige* masks. Dogon, Bandiagara district, Mali.
Photo Michel Huet

◄ **1.** Mask representing a *samana*. Wood. H. 13¼". Dogon, Nini village,
Bandiagara district, Mali. Museé de l'Homme, Paris. Photo José Oster.

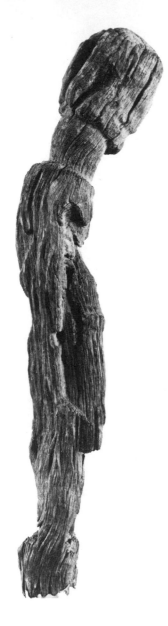

4. Sculpture "embedded in its original material." Wood. H. 27⁵⁄₁₆″. Dogon, Mali. Formerly in the collection of Marcel Evrard.

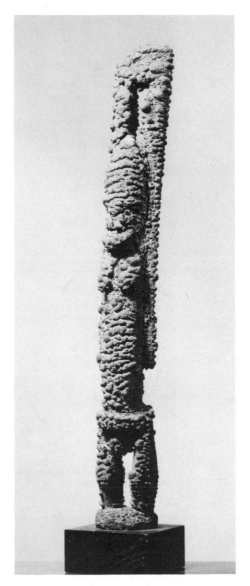

5. The *nommo* with raised arms. Wood overlaid with a sacrificial coating of blood and millet flour. H. 16⅜″. Dogon, Mali. Collection of J. Lazard.

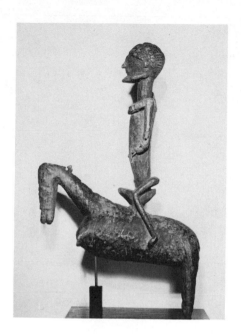

6. The *nommo* on his horse. Wood. H. 16″. Dogon, Mali. Formerly in the collection of Tristan Tzara, now in the collection of Christophe Tzara. Photo Geneviève Bonnefoi.

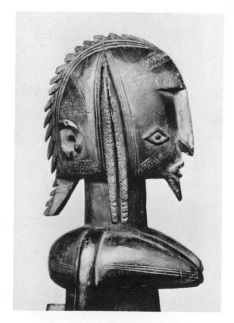

7. Bust of a statue of an ancestor. Wood. H. 26²⁹/₃₂″. Dogon, Mali. Formerly in the collection of Jacob Epstein.

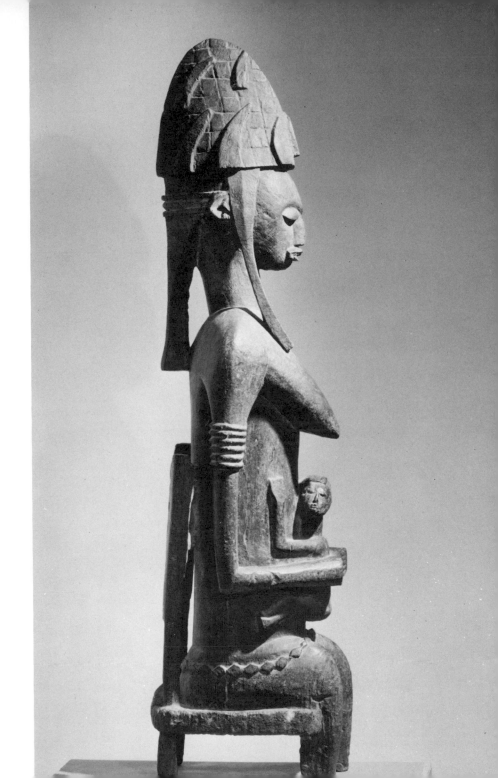

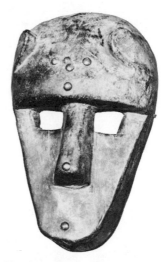

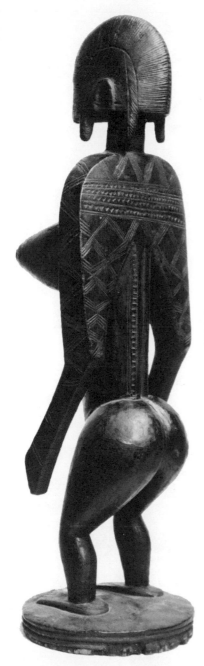

10. *Kore* lion mask. Bambara, Segu district, Mali. Musée I.F.A.N., Dakar. Photo Cissé.

9. Statue representing femininity. Wood. II. 20%2″. Bambara, Mali. Collection Boussard. Photo Robert David.

11. *Kore* lion mask. Wood. H. 11¹¹⁄₁₆″. Bambara, Mali. Formerly in the collection of Tristan Tzara, now in the collection of Christophe Tzara. Photo Geneviève Bonnefoi.

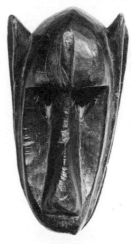

◄ 8. Large female figure representing motherhood. Wood. H. 45%2″. Bambara, Mali. Museum of Primitive Art, New York. Courtesy of the Museum of Primitive Art.

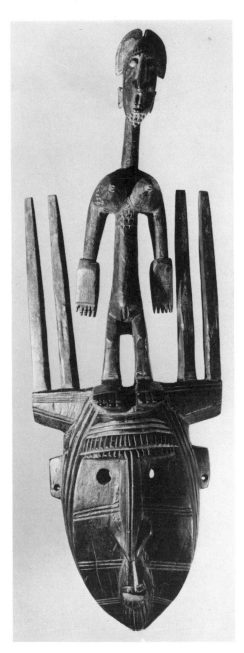

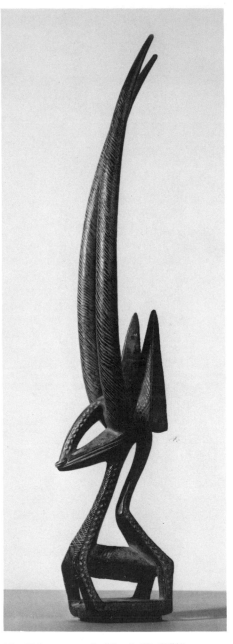

12. *Ndomo mask.* Wood. H. 25⁵⁄₁₆″
Bambara, Segu district, Mali. Musée des
Arts Africains et Océaniens, Paris.
Photo I. Bandy.

13. *Chi wara* mask. Wood. H. 29⁵⁄₈″.
Bambara, Mali. Collection of Gustave
Schindler, New York. Photo Peter Moore

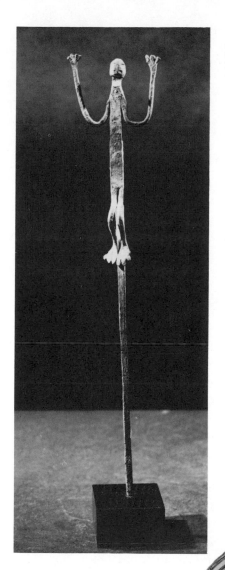

14. Iron figure of the *nommo;* the extended arms are hook-shaped. H. 3⅜″. Dogon, Mali. Collection Wunderman, New York. Photo Geza Fekete.

15. Calabash with decorative designs used in marriage ceremonies. Diam. 6¹³⁄₁₆″. Bozo, Mali. Collection of Germaine Dieterlen. Photo Musée de l'Homme, Paris.

The Volta Peoples

In the immense plain of the three Voltas, among the Mossi, who occupy part of the advantageous area where the great Sudanese empires were formed, and similarly toward the center, one finds traces of older populations that came in successive waves and whose cultural boundaries are not discernible. The "circles" marked not long ago by the colonial administration enclosed together the different groups, which devoted themselves to the same agricultural work and organized themselves around the same religious themes. Nevertheless, each society, each group of villages, or, better still, each village adapted in its own way the available cultural resources, which thereby brought about the variety of arts. The art of the Gurunsi, the Bobo, the Guin, and the Nioniossi remains generally unknown. This ethnic assemblage is habitually described as a sort of primitive mosaic whose art has not attracted the attention of the specialists. Except for the Bobo polychrome masks and the Lobi jewels and some rather simplified figures, it remains unrecognized. The sculpture of the Lobi is said to be rather coarse. Once the administrator, Henri Labouret, ordered a copy of a Baule mask, which was loaned to a Lobi sculptor and was the point of departure for the manufacture by the Lobi of dreadful little masks. Though profitable for the Lobi, they doubtless contributed among other causes to concealing the existence of more valuable art.

It is said that the Lobi are not as warm in their welcome as the Bobo. This is wrong (according to Guy Le Moal, who worked in these areas for many years). But the fact is that they do not easily confide their secrets. Like all Volta peoples, these farmers are intimately associated with nature. They are united with the river on whose banks the ritual ceremonies of the *dyoro* take place every seven years. These ceremonies establish ties between the aquatic universe and the earthly world of which the observer can only grasp some of the legendary aspects. They dedicate a cult to the deities who preside over the destiny of the earth, sky, water, and bush. Does a relationship exist between the rites and the purpose of these "fetishes in clay or wood which," writes J. G. Haumant, "appear here and there, on the terrace, in the kitchen, above the entry door"? We do not know.

None is displaced without also removing its three-legged stool, carved by the oldest at the time of the *dyoro,* or, of more recent manufacture, a small seat that could serve as a headrest. Using the lost-wax technique, the Lobi also make jewelry out of peddled copper rods. Chased serpents and chameleons, which protect the wearers of these jewels, recall Ashanti jewelry. The Ashanti border is actually rather near and the Kulango, predecessors of the Lobi in their present habitat, could have practiced gold washing, a technique that they acquired indirectly from the people of the former Gold Coast.

At the center of the marketplace are the village protectors: large clay cones against which wooden sculptures are placed. If they receive sufficient offerings, the Lobi figures guard the virtue of wives, punish thieves, fight against sickness, or protect the fields. The most beautiful, generally large with thick thighs, have a delicate face and a helmet for a headdress. The sculptor depicts in wood the bodies he sees around him. The Lobi do not wear masks even for festivals as spectacular as the funeral ceremonies of a hunter (veritable theatrical presentations in which the courageous past of the deceased is acted out) or for the septennial *dyoro*.

Further to the north, from the Black Volta to the upper part of the

Bani, lives an assemblage of peoples included under the name Bobo which, like the Lobi group, is composed of people of the bush, essentially farmers, hunters, fishermen, and, to a lesser degree, cattle raisers. Ancient peoples, they are independent and not well organized politically.

Those who call themselves Bobo Fing are found in Upper Volta north of the Bobo-Diulasso area and south of the Nuna, and also in Mali. (There are several thousand in the San and Koutiala regions.) They carve wooden masks in many styles. The most remarkable are, in fact, masks of secondary importance: ox or ram masks worn by the blacksmiths. Unique to the Bobo is a mask representing a man's head, which is surmounted with a short paddlelike, openwork superstructure treated in various ways. The mask is worn either by smiths during funeral ceremonies or by farmers at initiation rites.

Until recently still considered as Bobo, the Bwa (better known under the name of Ule) are differentiated from the Bobo by their language and by a certain number of cultural traits. Most of the objects admired by Western amateurs, particularly masks of wood, of fiber, and of leaves, are used in the *do* cult by both the Bwa and the Bobo. For a period of three years, in the time preceding winter, a sort of confrontation takes place through the different rituals between the young age grades and the oldest. The initiates and the young men who protect them find themselves opposed by the masked elders, who manifest the power of the *do*.

Certain Gurunsi and Bwa masks of the Bobo-Diulasso region are decorated with lines or chevrons in red, black, and white. The eyes are always portrayed by a double concentric circle, often in relief. An animal muzzle treated as a truncated cone may sometimes be an antelope, sometimes an ox. The crescent of the two bovine horns may surmount the aggressive beak of the hornbill. The human figure with bulging forehead, straight nose, and a diamond-shaped open mouth in relief, a figure furnished with a handle, is very characteristic. The open mouths of these masks permit their wearers to see.

In the Hundé region, the Bwa use round masks surmounted with a

painted, openwork, planklike superstructure that they purchased from the Gurunsi. Again we find eyes of concentric circles, geometric polychrome (red, yellow, white, and black), and the diamond-shaped mouth in relief of the Bobo-Diulasso. But a new motif appears: the checkerboard that adorns the superstructure. Often double, these planks are connected by a diamond on which a reptile is finely carved or small crosswise designs or other linear and perhaps stylized combinations. Called *nwo,* "hornbill," all these ancient masks require a large bird's beak. Their superstructure terminates in a crescent moon, in the middle of which a truncated cone almost always rises. Another series of masks represents the skeleton of the *bayiri,* "boa." The superstructure worked in the *nwo* style is crossed from each side with beaks bringing to mind the hornbill beak. In the same region the *bayiri* also takes the form of a long, thin, notched pole, which can exceed three meters in length and whose oval head is reminiscent of the Gurunsi mask style.

The fiber and leaf masks, the *koro,* are also *do* masks and have been observed among the Bwa of the San region. These complex and delicate figures achieve their charm through the painstaking arrangement of the dried straw of a grassy plant of the bush. They are exhibited publically at the time of the ceremonies connected with the rebirth of vegetation. There is a great temptation to set up an opposition between these natural vegetable masks accompanied by vestments of leaves and the bright-colored wooden masks with their tinted fiber costumes, between the bush and the village, which are united by the coming and going of their deity, the *do.*

The Mossi established their empire at the very heart of the Volta plain. Since the eleventh century, the feudal system of the Morho Naba expanded from the Dagomba in the former Gold Coast to Timbuctu. Mossi art reflects the character of this composite yet unified society, which is the result of the crossbreeding of the aboriginal peoples with small groups of foreign horsemen, where the archaic traditions exist beside the great Mossi pyramid, as if on both sides there was a need

to create a peaceful equilibrium between royal power and religious power. It is well known that Mossi art did not spring from the political chiefdomships and their structures, however modified by the preexisting culture. Their masks are carved in soft kapokier or bombax wood. The oval head with two antelope horns is extended by a long shaft of painted, openwork wood or is flanked by a human figure.

The sculptors and wearers of these masks belong to the Fulse (alias Kurumba) and Nioniossi peoples. Especially numerous in the Yatenga, the Fulse occupied the Volta region before the arrival of the Mossi and did not flee from them like the others, who it is said, took refuge in the Bandiagara and Hombori cliffs and formed the Dogon people. On the contrary, their patriarchs, *tingsoba* or "masters of the earth," perpetuated the fundamental traditional forms of their society of farmers and artisans, forms that the Mossi feudal mythology had to integrate into its own. The art provides us with a faithful account of the ancient relations between the indigenous societies of the Volta plain and the refugee peoples in the Nigerian cliffs. Stylistic convergences exist between the masks called Mossi with the small decorative superstructure used by the religious societies, the tiered Dogon mask, and the Gurunsi superstructure mask.

The mask-wearers in the Mossi area are dressed in a costume of baobab fibers. They hold an ax that is reminiscent of the Kurumba ancestor of Aribinda, who was sent from heaven by the spirit of the waters whose habitual form is the serpent. These masks are used in the burials of chiefs and elders but do not appear at the great Mossi periodic festivals consecrated to the new moon, the ancestors, and the earth. A persistent tradition requires that the masks act as what Louis Tauxier calls familiarly "rustic policemen," a periodic function that is limited today to guarding the chestnuts of the karité and the grapes of the *peku*. Is it not said among the Kurumba of the Sao canton in the Ouagadougou region that the souls (*siga*) of the priests transform themselves into wind around the month of October and go around beating the bush, wounding with their axes anyone who would try to pick green fruits? The antelope horns on the head of the mask

testify perhaps to the kinship that unites these animals to certain masters of the earth and to the rain. The openwork wood sculptures of the high superstructure are sometimes in the undulating form of the serpent, whose body, according to a Dagomba myth, forms the sky and whose head the sun.

Beside the Fulse with their blacksmiths, their earth chiefs, their sacred groves, their societies, and their religious paraphernalia, we see the Mossi horsemen bringing with them a solar mythology common to the peoples in the north of present-day Ghana. The art of the Kurumba masks and statuettes, on the one hand, and of the Morho Naba court, on the other, ally themselves into a sort of duet of the earth and sky, the moon and sun. As the great conquering Sudanese dynasties adopted the traditional indigenous mythologies in their feudal art, they abandoned their preoccupation with the wood sculpture of the ancient peoples and devoted themselves to metalwork, leather, and textiles, arts that flourish in the presence of political and military chiefs and their signs of power, their horses. The sun procession, which inspired the protocol of Morho Naba, is associated with the brilliant march of horses bearing the weight of engraved copper and painted and embroidered leather harnesses. The Islamic decoration of marquetry, which traveled with the caravans that furnished the leather, can be seen on all of this equipment (fly-whisk handles, bowls in decorated leather, saddlecloths, or horse blankets with appliqués of painted leather and embroidery). The old sacred paraphernalia of the masters of the earth and that of the conquerors express the peaceful character of the exchanges that were effected between this dual civilization and the passing cultures.

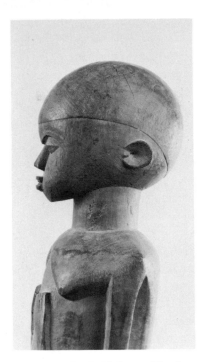

16. Bust of a Lobi figure. Wood.
H. 32$\frac{5}{16}$". Upper Volta. Formerly
in the collection of H. and
H. A. Kamer, New York.

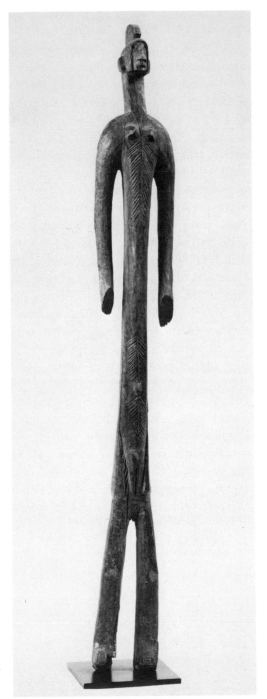

17. Bobo figure. Wood. 31$\frac{7}{32}$".
Upper Volta. Collection of
Gustave Schindler, New York.

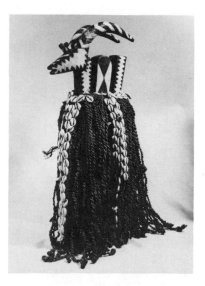

18. Crest of a headdress. Wood, string, cowrie shells. H. 22⅝″ (only the sculpted part). Gurunsi, Upper Volta. Collection Muller, Soleure. Photo Dominique Darbois.

19. Masks representing two antelopes. Kurumba, Tolou village, Mali. Photo Jean-Paul Lebeuf.

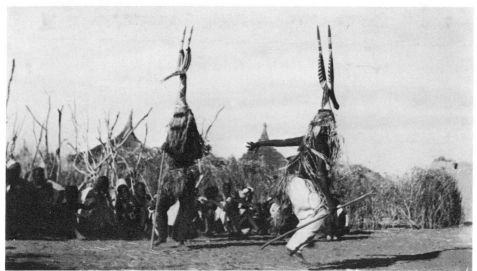

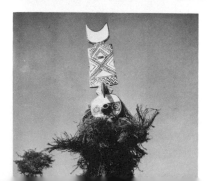

20. Bwa mask. Upper Volta. Photo Michel Huet.

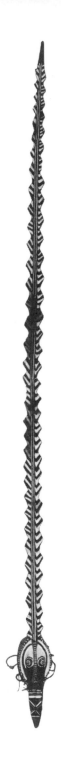

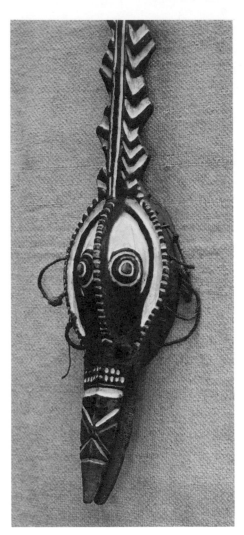

21a. Detail of *bayiri* mask.

21. Mask representing the serpent *bayiri*. Painted wood. H. 165$\frac{11}{32}$". Bwa, Upper Volta. The Minneapolis Institute of Arts, Minneapolis. Museum photo.

22. Mask reminiscent of the Dogon *satimbe* mask. Wood with a brown patina. H. 40¹⁵⁄₁₆″. Fulse-Mossi, Upper Volta. Collection Païlès. Photo Dominique Darbois.

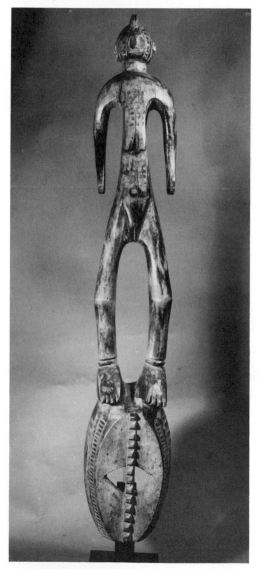

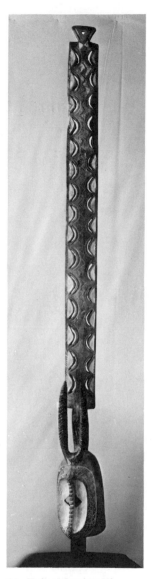

23. Fulse-Mossi mask. Wood whitened with kaolin. H. 58⁹⁄₃₂″. Upper Volta. Collection of P. Peissi. Photo C. Lacheroy.

The Coastal Peoples of Guinea

Both the first information from the Portuguese navigators voyaging south of the Rio Grande as early as the fifteenth century and recent accounts of ethnologists agree in attributing an ancient unity to the scattered group of populations that were encountered all along the coast as far as Sierra Leone. They were small independent monarchies composed of breeders, rice cultivators, gatherers, and fishermen. Some devoted themselves to active commercial trade with the Portuguese. The incursions of the island inhabitants onto the continent and the expeditions of the coastal people beyond their borders enabled them to bring back the necessary supplies for these transactions. The sea gave all these societies an original character. The *rios* carve the landscape, determine the conditions of life in the communities, and stimulate the economic comings and goings. Fernandes said their customs are similar. While they may be the Bidyogo of the archipelago, perhaps formerly inhabitants of the mainland, or migrants from Futa, Baga, Nalu, Landuman, pushed toward the sea by the Dialonke and then the Fulani invaders, a certain unity exists among all these people and their arts resemble each other. It is the art of seamen and skillful rice and tree cultivators, the art of independent men that opposition between the sea and the mainland and between the coast and the bush has distributed into a mosaic of little societies that have withstood the invaders more or less well. In all of these communities

life demands its gods and rites. Protective spirits for the warriors and mariners, spirits of the waters, goddesses of the earth, powers of spiritual beings or ancestors must assure men of relative security, and it is up to the artist to make them manifest in concrete form. Polychromy, sculpture in the round, often architectural and luxuriant composition, a tendency toward a certain fresh mimicry, which can turn into caricature but knows also how to make use of the methods of stylization, these are the general traits of this art, full of life, imagination, and often even humor.

The Bissagos Archipelago, with the indentations of the Portuguese Guinea coast, resembles a puzzle. Captain Alvares de Almada said of the inhabitants of these islands at the end of the sixteenth century, "They only know how to do three things: [make] war, build boats, and extract wine from palm." The fortified architecture of their continental neighbors testifies to the vigor of their offensive expeditions. It was necessary to resist strongly the seafaring pirates who attacked the coastal populations far inland while fiercely guarding their own coasts. In love with the sea, in love with their wild oxen, manifestations of fertility and symbols of the continuity of their tribe, the Bidyogo express all these sentiments in their adornment, architecture, sculpture, and painting. They used what are called "wooden idols," both in the cult of the earth and in the initiation rites entrusted to a leader of the ceremonies, the guardian of the sacred places. For a long time, only a small number of Bidyogo pieces have been known. Of unequal quality but always full of life, there are small figures of dancers, women bearing cups and vases, anthropomorphic and zoomorphic stools, seated ancestor figures, groups conversing or drinking, and pirogues with their oarsmen. But Bidyogo sculpture flourishes most happily in the depiction of the wild ox, symbol of force and beauty. Magnificent with its long widespread horns, it surmounted the stem of the royal war boats. A horned being overloaded with pendants and fibers, it masks the face of the dancer who mimics it ceremonially and can also be recognized engraved on calabashes and

painted on the walls of huts. For the Bidyogo, painting is a character-istic means of expression. Numerous light wood figures are enhanced with painted details, and pictorial expression is particularly rich in the decoration of the home, appearing on the mud walls of the circular huts, the exterior walls, the walls of vestibules, the door lintels, and the clay altars. The colors used are black, white, and ocher. Inside, long panels of geometric combinations predominate, blending with the stylizations of the hut roofs and nonrepresentational figures and motifs. Portrayals of familiar things run around the exterior walls of the round huts: initiates in costume, boats loaded with men, oxen, fish . . . and the latest arrivals: trucks, automobiles, and planes.

The Baga, the Nalu, and the Landuman are also river dwellers, but for them the coast was the last frontier. Although it is said that the Baga borrowed various institutions and their paraphernalia from the Nalu and that the Landuman participated similarly, the Baga, above all, command attention because they have kept a certain originality up to the present. In contrast, the other groups have tended to dissolve into an Islamized ethnic group, or into an even more dynamic group, the Susu.

The best-known Baga sculptures are long polychrome masks called *banda,* which are worn horizontally, and *nimba,* enormous wooden busts completely covered with long fibers from which emerges a large head with an aquiline nose. The travelers of the last century had already seen them evolve with their marshland decorations as well as their long grasses from the interior bush. The old chronicles described them as already mixed with a confused assemblage of other figures in wood, fabric, or straw. The *banda,* with which many other wooden masks present strong analogies, are numerous enough so that, according to B. Holas, it is not rare to find three or four of them in the same village. Plastic constraints, owed to the need to depict the complex crocodile-chameleon-antelope-man, impose formal constants that we find in each of these masks: large, elongated jaw, triangular human nose with a long bridge in relief, antelope ears and horns, between which appears the chameleon motif realistically por-

trayed in several examples. From these representations in which the elements familiar to the Baga seem to be reflected, such as water (the crocodile is one of the forms of the water spirit) and the bush (suggested by the antelope), the sculptors work as they like with the available surfaces. They modify them very often by making them more intricate and by adorning them with very dense ornamentation, which is freely geometric with many colors (red, blue, white, black). The chameleon is more or less stylized; the horns of the antelope may be multiplied; the jaw of the crocodile is furnished with a tin plate cut out to represent teeth.

The bust of the *nimba,* which can weigh up to 132 pounds and whose wearers take turns or relieve each other, is an enormous bell on four legs. Its big flat breasts are above a long, enormous fiber dress. The differences of quality are noticeable in the decoration of the head, the neck, and the visible bust, and in the delicacy and care of the modeling of the ears, the nose, and the crest, which starts from the nose, continues across the top of the head, and joins the base of the neck in the back. The *nimba,* borrowed from the Nalu like the *banda,* is very widespread along the coast. It is the goddess of motherhood, an image of fecundity that the rice farmers celebrate before the harvest, and from whom families request progeny. These same heads are found again on the statuary and on the drums supported by various characters.

All these masks are connected to an organization, the *simo,* whose activities are linked to the initiation rituals of the Nalu, the Landuman, and the Baga. The *simo,* which undoubtedly can be related to the *gpo-oro* of the Senufo or to the *poro* of the Mende, is a constant focus of authority with its presentations, its paraphernalia, and its hierarchy moving with each new promotion of initiates. In societies as fragmented and as independent as those of all the coastal people, the *simo* appears as the basis of unity. Other fraternal societies exist, particularly among the Nalu, from whom these masks were borrowed. Are they wrongly confused with the *simo,* too convenient a term at

the time naval officers made the first observations? Exact information is missing.

Formerly particularly known for the designs that are made by novices, the *bansonyi* consists of a very ornate and painted board, whose serpentine form suggests its original connection with a python myth. Decorated with streamers and supported by scaffolding in which many men move about, concealed by palms and cloths, it announces the day of circumcision by showing itself. Then it seeks refuge in the sacred wood outside the village.

The Baga not only carve masks; they are also excellent artisans, potters, basket makers, weavers, and blacksmiths. Numerous female figures are perhaps linked to a goddess of the sea and of beauty whose existence on the Guinea coast has been recognized. It is known, besides, that the Baga woman played a decisive role in the organization of work and of the family. A large number of sculptures on pedestals represent birds with long beaks. Rather close to the *banda* (because of the straight human nose and the elongated jaw of the crocodile), these sculptures, called *elek* in the village of Monchon, vary greatly. Protectors of the lineages, they change their appearance according to the circumstance. Sometimes magical use dominates the sculpture and antelope horns are substituted for the decorative patterns on the head and cheeks. Long-legged wading birds, familiar types of marigots,* also inspired the sculptors; they are the principal subjects of small, very decorated, and lively polychrome constructions in soft wood. Simple ornamental motifs, they are said to have been hung on the walls of the huts of young men.

The decorative taste is immediately perceptible upon entrance into a Baga village. The pleasing arrangement and the architectural harmony that prevail reveal the aesthetic concerns of the residents.

* Translator's note: small West African river or lake birds.

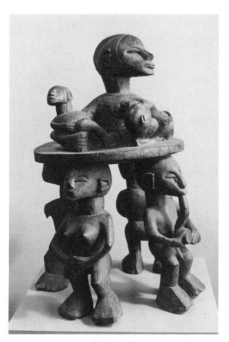

24. Bidyogo sculpture. Wood. H. 28″.
Bissagos Islands. Bernisches His-
torisches Museum. Berne. Museum
photo.

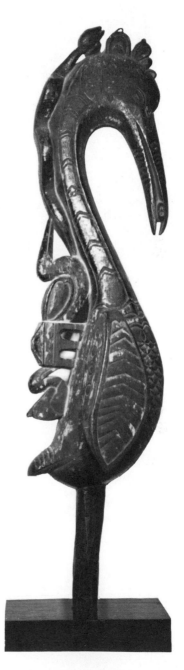

25. Painted wood bird. H. 25$\frac{11}{32}$″.
Baga, Guinea. Collection of R. Rasmussen.
Photo Geneviève Bonnefoi.

26. Mask worn for the coming-out initiation of young girls. Baga, Guinea. Photo Michel Huet.

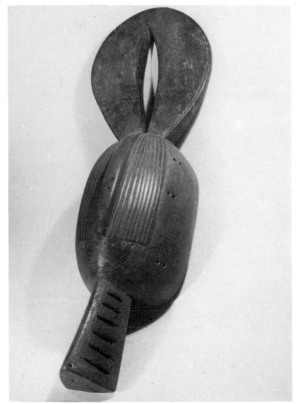

27. "Tortoise" mask. Wood. L. 31⅞". Baga, Guinea. Collection of Pierre Vérité. Photo Claude Vérité.

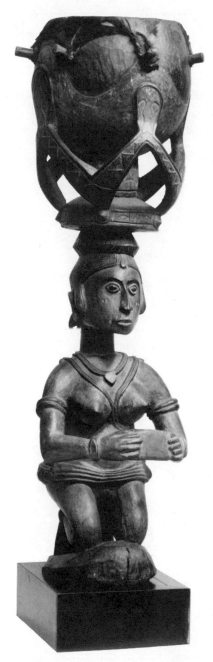

28. Drum. Painted wood. H. 44⅞".
Baga, Guinea. Collection Boussard.
Photo Robert David.

29. Mural painting in an initiation hut. Baga, vicinity of Conakry, Guinea. Photo Pierre Verger.

The Southwest
of the Sudanese Savanna
and the West Coast
of the Atlantic Forest

The south of Mali, Guinea, Sierra Leone, Liberia, and the Ivory Coast is a haven for a mosaic of natural and human environments that have never ceased to be shaken by history and on which arbitrary colonial political boundaries were superimposed. In this geography with imaginary limits, styles and functions are moving points. More than one sacred grove in the forest galleries still hides its ritual objects, but these travel very far from the enclosures that only initiates may frequent. The extreme richness of aesthetic creation, expressed especially in the wooden sculpture, only increases the possibilities for confusion. Senufo art is original, abundant, and of high quality like Dogon or Bambara art, to which it is allied in several ways; it is also a peasant art, voluntarily hieratic, and always sober. In spite of the pressure exerted by very diverse local conditions, this art preserves a number of similar characteristics throughout Senufo country.

The Senufo people, as a publication of the French Institute of Black Africa put it, are "scrapers of hard-shelled rusty soil . . . shut in on themselves and bitter toward the toil according to law common to the inhabitants of harsh regions." They are divided into about fifteen groups and occupy a large territory that extends beyond the Sikasso-Bundiali-Korhogo-Ferkessedougou triangle. The styles vary according to regions and likewise clans. The most traditional, perhaps,

belongs to the Senufo Naffara of the Sinematiali region. Although more than one blacksmith still practices carving today in response to his spiritual and practical needs, which are handed down from generation to generation, present Senufo sculpture, original high-quality art, has been degraded through the influence of a sculpture developed in modern workshops. About thirty years ago, three sculptors from the Korhogo region began to work "for the whites"; since then the commercial organization of this sculpture has been consolidated. Some of its works show the real talent of the artisan, who, however, forsakes true artistic creation for ludicrous copies. The majority show only the degeneracy of an uprooted art.

Under the influence of new imageless cults, the sculpture, with its immense retinue of forms, ceases to relate to the activities of the Senufo laborers. Only a few years ago the real significance of this sculpture was still ignored. Even so, did no one know how precise and complex the old institutions that tended to maintain the equilibrium of these societies were and what need they had of concrete representations? Today, these representations, which have no meaning except within the framework of a sacred topography (remote clearings, rock piles, and special huts), follow their new destiny as works of art.

Three types of figurines are currently made: a woman carrying a burden on her head, a woman seated on a stool, and a horseman.

The female basket (or mortar) carriers share with other Senufo female or hermaphroditic figurines upright posture and hanging arms scarcely separated from the body but joined together at the stomach or at the top of the thighs. Prognathism accentuated by the face, thin pointed breasts projecting forward, the triangular swelling of the stomach, and jutting knees are consistent with geometric, Sudanese sculpture. The hard lines are succeeded by softer ones in the roundness of the basket, the curve of the hair in a crest, and the half-circle of the shoulders and arms. There are numbers of these figurines, which differ from one another in their dimensions and in the treatment of their adornment (tattoos, hairdress, jewels, labrets). They belong to

the *sandogo,* a female divination society. When consulting, the group gathers in the afternoon at the village square. The women have painted their faces with geometric designs in white clay. One carries the sculpture on her head, and is trailed by her companions, who dance while following each other. Sometimes the file breaks up; then they dance in a circle around the figure, which is placed standing on the ground, and throw some cowries at it while invoking fate. The four-branched radiating motif, which is on the navel of most of these figures, brings to mind the abdominal incisions of young Senufo girls. In Djimini country, this sun is found again on a group of high rocks around a natural excavation and it is interpreted as "a female sex sign." More than a "sexual" symbol, this motif seems to be a symbol of fertility, since it is on all the sculptures representing motherhood; a symbolism underlined by the basket or the mortar, signs that the planting has been good and the harvests have already been made use of. Furthermore, Senufo mothers or pregnant women are the only ones qualified to plant yams and sow the millet and *fonio* * on the communal fields at the time of periodic rites.

The figure sitting on its stool is called "plowman's wife." During the yam festival, a festival for the renewal of vegetation, a competition is organized among the young men of the village and the figurine is presented to the victor. Among the Senufo of Lumana, the figurine was put in front of the fields that the young age grades had to break up for tillage. The first to reach it had to carry it farther on and then, he, or someone faster, took it up again and set it down still farther away, and so on until the entire field was cleared. The figurine was not only a reward, a promise of success for its possessor, it also assured him of his marriage to come.

The figures of men on horseback are likewise very widespread. The majority represent a horseman holding a lance. The torso is long and straight, and the headdress is generally in a crest, adorned with iron bracelets and earrings. These figures are used by certain diviners to

* Translator's note: fine millet used to make couscous.

increase the efficacy of their procedures. Formerly, when the Senufo tribes lived more ostentatiously, the jewels of the figurines were not iron but gold like those of the chiefs. Then the horsemen with their prestigious attributes recalled the power of the chiefs, whose essence was divine. Still earlier, the horseman represented the male intermediary between God and man. Much more rare, the horseman without a lance, with body leaning back as if mortally wounded, represented the slain enemy chief.

Although the general lines are rounded in numerous figures (perhaps recent), in most of the Senufo motherhood figures the direction is toward the well-known classic Sudanese sculptural style: geometric discontinuity leading to a total harmonious form that is simplified but never summary.

The large anthropomorphic statues are still too little known, doubtless because they were destined for a smaller public than the divinatory or magic figures. Recently they were still residing in their secret cult places. The figures emphasize, it seems, the oldest and most traditional features of Senufo sculpture. More than a yard in height, the figure has its arms along the body with the hands on the flat side of the thighs, a long neck around which hangs a talisman pendant, and above, a face projected forward. The female and male figures, generally paired or coupled side by side, are rarely doubled or placed man and woman back to back. Just as for numbers of masks, often only the knowledge of the *gpo-oro* enables us to define the exact function of these figures and their numerous attributes, indeed, even their origin.

In the sacred woods where the forbidden geography of the *gpo-oro* spreads out with its enclosures and entrances, its trails, huts, cones of earth, and sacrificial places, the statues stand in precise places, ready to serve. The sculptor of images conforms to the association's spiritual demands, which vary according to the village unit or the occupational group. A number of motifs expressed by the sculptors gave a feeling that time had disfigured or exchanged them for another, which is why this sculpture has preserved its mystery. These

figures rarely leave their ritual places like the large pedestaled sculptures which the dancers wield, now and then pounding the ground with the heavy base. It is probable that most of these large figures come from Sinzange, where the blacksmiths are initiated. In the southwest of the village, among the plantings of corn and millet and inside an enclosure of tree trunks, the sons of blacksmiths are initiated into their magic trade over a long period of time. The figure, with the ritual headdress of the candidate, holding in its hands a hammer or a rod used like a hammer, evokes the image of these blacksmiths or their female companions, the potters. Hermaphroditic, the figure expresses the double force of the artisans of the fire and the earth; beneath the female motif surrounding the navel hangs the leather apron of the blacksmith. Specialists in wood sculpture, the blacksmiths have undergone a supplementary initiation. They alone know how to choose among numerous entities the one that will suit the size of a sacred object or an implement, and they again know how to polish, give a patina, dye, and finally give life to all the images that the social group uses to assure its continuation.

In the imposing statue of a hornbill with spread wings and a large body like a pregnant woman's, the sculptor works boldly with the possibilities offered by a large composition of a long, curved beak, a round stomach, and triangular wings. The hornbill was one of the first terrestrial animals, which are confounded with the most remote ancestors; being the first arrivals on earth, they are very close to God. A familiar and essential character of Senufo culture, it is portrayed consistently in the figurines and on masks. Its image in wood, fixed on a very long pole carried by farmers, overlooks the proceedings of the yam feast on the communal fields.

Halfway between figure and mask, the bell masks, topped by an armless figure with a ringed body, accompany the large sculptures into the sacred groves. These mask-sculptures go in pairs. The male figure may carry a quiver on his back, perhaps evoking the aspect of the *tyolo,* an initiate into the *gpo-oro* who has not yet reached the highest grade and whose role during the funerals of a member of

the society is perhaps to represent the Senufo hunter ancestor with his money sack and his bow and arrows. The symbolism of the rings around the body of the sculpture has been overlooked; perhaps it corresponds to the python snake, one of the mythical animals that was formerly cherished and venerated in the sacred groves. Symbol of life and fertility, it unrolls its rings modeled in relief around the earth walls of the sacred huts, coils itself on a conical altar or stylized figure, on ankle rings, on iron or leather bracelets, and even on the ring decorated with little bovine masks made by the Fodono. The rainmakers use the same motif in the twisted bodies of the personalities that stand on top of some of their *poro* masks.

The two most current types of Senufo masks are the big bovine head, which is hollowed out for the wearer's head, and the small, flat, human mask, which is placed in front of the face. According to Gilbert Bochet, all the animal masks belong to the same category, called *poniugo*. Nevertheless, he says, "There is not necessarily a relationship between the form of the *poniugo* mask and its use." "In fact," he adds, "this *poniugo* form is completely adaptable; its only certain function, of a nearly ideographical nature, is to show where the head of certain ritual characters is found." The mask can be more precisely identified by the variations appearing around the common sculptural theme of the large oxlike head with half-open jaws. The different types in the *poniugo* category are distinguished by the absence or presence of teeth, or their importance, the elongation of the jaws, the possible appearance of smooth or ringed horns and aggressive fangs, and likewise, on the forehead, the arrangement of a cup intended to receive magical substances, or else sculpture in the round with motifs that generally represent the most familiar animals of the Senufo myths: the hornbill, the python snake, or the chameleon. A *poniugo*-style mask may be fixed in front of a structure made of very strong liana vines that have been bent into a semicircle and over which a stiff fiber cloth painted in a check pattern has been thrown. Father Knops calls this assemblage *kagba,* a term that Gilbert Bochet attributes

instead to the ritual itself. Its role seems linked to the symbolism of the *gpo-oro* initiations.

The extreme flexibility of the use of forms stems, perhaps, from the fact that the mask seems to escape from the most strict ritual norms of the *gpo-oro,* yet still conserves certain spiritual and moral principles for participation in the daily universe of witchcraft, to which are added those local conventions proper for this use. What appears valid for the Kembara groups will no longer be or will be only partially valid for the Naffara group.

The second series is the *gpelihe,* a small, very flat mask in soft wood. Its stylized figure is reminiscent of the female sculptures: the same hollowed-out space in the cheeks, linear eyes, tribal scarifications in the middle of the forehead, and forward projection of the jaw. On either side of the face, one or several small wings of varying forms decorate the headdress and the cheeks. At the bottom, the *gpelihe* has two extensions representing legs, recognizable, since they are bent and slightly elaborated, but most often looking like horns. The top of the mask is almost always surmounted with two ringed horns bent back, with animal or human figures, with rams' horns, with an upright moon crescent, or with different geometric motifs. The double mask is not rare (peculiar to the Kufolo group according to G. Bochet). Constantly renewed, multiplied, simplified, combined, or reinvented, all these motifs make the *gpelihe* a very ornamental mask.

Father Knops, who lived particularly among the Naffara of Sinematiali between 1923 and 1935, believed that the *gpelihe* was also called *kuliu.* This name, according to him, both designates the blacksmith sculptors of wood and signifies "eater of the dead," an allusion to the pretended necrophagous activities of these artisans. The *kuliu* is carried at the first funeral ceremonies of a *gpo-oro* initiate by participants endowed with magic power in groups of two to six, depending on the social importance of the deceased. Gilbert Bochet remarks that only the added adornment of the *gpelihe* permits an understanding of the true function of the mask. If the nape of the wearer's neck

is hidden by a simple cotton cloth, we are dealing with a *koddalu,* a mask of minor importance charged with animating any ceremony by dance. If the nape disappears under a black hairnet decorated with pompons held with a fabric bordered with cowries, we have a *korrigo,* a mask used at the time of the initiation ceremony that marks the beginning of the neophytes' acquisition of knowledge.

There also exist some very beautiful bronze *gpelihe.* These masks cast by the lost-wax process suggest contact with the brass *ndomo* carried by the Marka, a Niger River people in the Segu region.

Certain metal objects had the prerogative of expressing the supernatural power of the chiefs. Forged by the magic hands of the blacksmith, the pieces pursued their marginal destiny into the rich families of the chiefs or the diviners. In the same way as the sculpture, this metallurgy testifies to the aesthetic character of the Senufo artisan class. The area of lost-wax casting issues beyond the borders of Akan country to end in beauty in Senufo country. The beautiful pieces are quite numerous: magic lances, ritual trays, divinatory figures, necklaces, bracelets, rings, parade axes, small bells . . .

The brass figurines may represent the spirits of the bush, guardians of the forbidden; more often they represent male or female water spirits. Bearing a container on the head, the figurines of female spirits evoke the beautiful girls of the water whose legend tells that they came to the banks to search for their canaries, which had been loaned to the men at the time of the festivals.

The brass rings in the form of a python protected the kings against poisonings. Their name, *nyi-kar-yi,* denotes both an association of warriors and the brass ring mask that they carry during their activities. Their rings are ornamented with a large setting representing a horned bovine head, whose perfect geometry recalls the magnificent lost-wax objects of the Baule and Ashanti. When it is carried during funeral ceremonies, the ring, held between the teeth with the bovine face forward, acts as a mask.

There are modelings in unbaked and painted clay of various dimensions that give an imagined content to the complex itinerary of the

gpo-oro initiation of the Dieli, leather artisans of the Korhogo region. Since they do not live in the large centers, the Islamized Dieli seem to have preserved a ritual organization that is very rich in Senufo archaisms. Their carefully modeled figures, a complement to the symbols of the physical ordeals, are generally realistic so that neophytes quickly grasp the lesson. Besides familiar and mythical animals, sacred personages, and people of daily life, one finds a figurine isolated under a thatched shelter supported by four stakes. With black feathers arranged in its hair, wearing a long dress and carrying a double-pouched bag, the figurine represents a person that can be seen in ceremonies outside the sacred groves. A wood figurine dressed in a cloth sack with feathers in its hair is also an image of this very important individual.

Farther south, in the long transitional belt where vegetation becomes sparser the farther one gets from the Sudanese countryside, the existence of carved stones among the Kissi and the Mende and even among the Sherbro along the coastline posed a problem at the time when the importance of African stone sculpture was unrecognized.

The Kissi and Mende are above all "rice people." In this geographically and historically ambiguous region, the actual end of the way that abuts on the forest, cultural traits clustered at the whim of very rude shocks that came from the north or from the sea for more than four centuries and confusingly diffused their concrete forms. Kissi and Mende farmers make the same use of the stone sculptures that they find in their fields. For the Kissi, who inhabit upper Guinea and extend into Sierra Leone and Liberia, these stones, human figures for the most part, often with scarcely distinct features, are images of their dead. They keep these *pomtan* on the family altars. Sometimes the identity of the figurine is revealed by a dream or through a diviner's interrogation. The portrait of a chief or a notable, invisible in a magic bundle, it can become an instrument of divination. For the Mende, these small figures are supernatural creatures that protect the rice harvests and make them abundant. The figurines with very large noses, widespread nostrils, and globular eyes are attributed to the Sherbro,

but a number of examples of the Sherbro type appear among the very varied styles found in Kissi country. These stones form an immense collection of portraits which, coming out of the ground, do not reveal their secrets. A figure of a Portuguese harquebusier of the sixteenth century closely resembles a chief's statue whose rich attire almost resembles that on Ife chief's figures. The reproduction of a Benin bronze figure is close to a figurine with tall crest and shapeless body.

Today the Kissi do not know how to carve stone. Their attempts at imitating the *pomtan* are naïve. However, far from the roads, in the village of Mafindu in the Kissidougou area, two farmers still carve pipes and figurines, each according to his own style. Even if these figurines are very inferior in quality to the *pomtan,* nevertheless they are perhaps the survivors of those carved centuries ago, or more recently, which served at rituals that today have disappeared.

The Kissi also do not carve in wood. Can this be explained by the fact that these farmers, after having scarcely recovered from the invasions of the second half of the nineteenth century, became men without a past and without a traditional artisan class? They were obliged to borrow their institutions, which, after all, might formerly have been their own. In the forest region where the initiation ritual was purchased recently from the Toma, Toma masks were introduced. In other zones, where Malinke influence is exerted, the *komo* institution of Sudanese origin uses a big, flat, horned mask under which crouches the master of the *komo,* whose back is covered with a plank dentiled in the center along its whole length. Though the Kissi are not sculptors, their ritualistic *inclination* makes remarkable use of the virtues of music, dance, and song. Their plastic expression takes other forms than sculpture and the mask: dress and ornamentation of the body during the initiation ceremonies, geometric polychrome decoration of the façades of the initiation huts, and paintings done by women on the walls of the houses.

Among the Mende, the warrior groups are superimposed on the farmer groups and the political life is less undifferentiated than the

Kissi's. The innumerable village cults of the Kissi made way for the secret societies to exercise a control over the vaster assemblages that exceeded the precisely designated Mende society. The *poro* and other associations, generalized institutions on the scale of a country, intervene in its political as well as its cultural, military, or sexual life. The helmet masks of the *sande* (or *bundu*) worn by Mende women are also worn by the Vai, the Temne, and the Sherbro. The head shaped like a sugar loaf, spiraled around the neck opening, has a high crested headdress whose decorative complexity emphasizes the sleepy delicacy of a small triangular face. The swellings of the head of hair treated in separate ridges, in falling tresses, in tight or stylized braids, and in geometric motifs, blend with motifs that are familiar but constraining symbols for the members of the society. The high headdress is reminiscent of numerous Kissi stone heads. The black mask is dyed; somber colors dominate, contributing to effacing the personality of the wearer who has disappeared under a cloth garment with tight pant legs and flowing long sleeves, a costume over which falls a fiber robe attached to the mask. An opening arranged at the wristband allows the hand, which remains hidden under the overlong sleeve, to hold a thin whip of dried grasses. Thus masked and dressed, the women of the *bundu* incarnate the spirits of their society. The *bundu* is the women's school for the Mende society. A young girl can be married only after having been excised and having received the practical and moral information of the *bundu*. The completion of initiation is a great celebration. Their oiled skin, very stylish headdresses, rich textured loincloths, and multiple glittering jewels express the social importance of the new initiates. After a procession animated by songs and often by acrobatic dances of the maskers, each girl returns to the family hut where a stool awaits her. She remains seated there, for a long time, to be admired.

Other *bundu* carved figurines and instruments have the same plastic features that make the helmet mask original: the headdress in a crest and the spiraled neck, an image amplified by the sensitive folds of the

flesh that attract the eye of the Mende and testify to the beauty of their women, whose renown is not usurped.

In the region which at the beginning of our century was jokingly called the "Liberian Tyrol" live the Toma, western neighbors of the Kissi. In Guinea they occupy all the Macenta area and extend widely beyond the artificial line of the Liberian border. Behind the last huts of the villages, the dense forest permits the occurrence of initiations, shelters the instruments of the rituals, and easily conceals the secrets of the more or less archaic institutions. A large mask made of heavy wood calls the young into the forest and returns them to the village after the month of initiation. This mask resembles the *banda* mask of the refugees of the low Guinean coast, the Baga, the Nalu, and the Landuman. But it is not decorated with any painting and its more summary workmanship is found also in another type of smaller mask. The large mask's long, flattened, partially open jaw, where the man's head goes, becomes (in the small mask) an oval, bare and flat face. The upper part remains the same (for both): a straight, short nose and a forehead decorated in relief and extended by horns. The variable decorative treatment of the top of the mask frequently resembles the top of *bundu* masks. In addition, the sacred huts of the Toma also shelter *bundu* figurines.

The *bakorogis,* which come in pairs, play a less secret role and are more widespread than the large masks. The male mask, whose dimensions vary, has the same flat and bare lower part of the face as the large mask, but this time it is reduced and has a longer and more voluminous nose. The bulge of the cheekbones is marked by a horizontal linear projection, a protrusion that gives the cheeks a triangular profile. The always round eyes may be represented by two holes or by two protruding and perforated wooden cylinders that are bordered with a metal circle or even by two brass tubes. Three parallel lines run along the side pieces, recalling the scarifications of the cheeks. The female mask is smaller. The different parts of the face are not treated in opposition but in harmony with one another; the sculptor seemed

to be searching for continuity and mobility. The forehead scarcely bulges over the horizontally slit eyes and the ears are depicted by two delicate half-moons. The wide mouth with the upper lip close to the thin nostrils of the nose forms a protruding sensitive triangle whose creases fade out at the edge of the cheeks, which are extended by the round of the chin. A headdress of vegetable fiber tresses forms loops at the top of the forehead and falls in braids. With these last two types of mask we enter into the aesthetic area of *poro* masks.

Toma art does not only consist of the sculpture of masks. Some notes drafted at the beginning of 1910 by Lieutenant Bouet mention "a hut for minutely carved offerings . . . a fetish hut bizarrely decorated."

To speak of "the aesthetic area of the *poro* masks" is to use much too narrow a term for introducing the particularly abundant series of masks of the forest areas of upper Guinea, Liberia, and the Ivory Coast as far as the Bandama, where the Akan country begins. In 1950 G. W. Harley himself, when going over his analysis (published in 1941) of the function of the masks among the people of northeast Liberia (Manon and Gio), corrected his too restrictive notes on the Liberian *poro*. Without a doubt, the *poro* represents the social structure, at the heart of which the community's conscious personality is formed as all its members are initiated to the same values. As a result, *poro* takes in an important quantity of masks. But the mask, a form that is taken from the dead in order that it remain in the society of the living and that gathers its qualities and force, goes beyond the *poro*. The world of masks mirrors the society of men. Political chief, priest, doctor, sorcerer, judge, teacher, artist, messenger—each mask can be considered as a spiritual residence of an ancestor that the wearer knows how to animate and as a symbol whose content is both spiritual and social. The virtues of a person out of succession come to live again obligatorily in a mask; ultimately, it can become the founding ancestor of a deity.

Each individual is linked to a mask, either a miniaturized model small enough to hold in the palm of a hand, which he wears on his

chest after his initiation, or a mask inherited from a member of his family. The society itself is also linked to masks whose activities maintain its equilibrium. The mask manifests its moral function when it appears to put an end to a quarrel, to establish proof, or to protect against evil. It also acts as a temporal sign for people who have no real calendar, when, for example, its departure indicates the period of retreat into the forest or the end of initiation.

A mask perpetuates the deeds of the ancestor whose name it carries. The supreme example is the *nya-wo* mask. Nya wo, a young woman who was loved by all, was going to die. She beseeched her friends to order immediately her own mask from a sculptor so that she could be sure that she would never be forgotten by them. She liked the mask and was thus able to think about it before disappearing. It is not possible to know if this mask really represents the face of Nya wo or if it is an idealized representation of the goodness and beauty with which a particular young girl was endowed. The memory of her is henceforth imperishable and her virtues appear contagious.

In twins of the same sex, Harley tells us, only a single spirit of the ancestor returns; but bisexual (double-yolked) twins possess a dual spirit. The little personal *ma* mask of a surviving twin is the image of this dual spirit; on a single face with one pair of eyes, two noses and two mouths are carved.

In the upper Cavally (Ivory Coast), where the masks keep their supernatural and social functions, a number of them seem to depend most clearly on the personality of their possessor and group psychological initiative. The first appearance of a mask in public provokes a reaction among the spectators that determines the identity of this mask. It is given a name that may refer to the character of the owner, to his physical postures, or to the circumstances of its first appearance.

Although local history and the slave trade had already cut them up, the colonial division into three territories of people who not so long ago formed larger cultural groups does not facilitate the study of an art of which the sculpture of masks seems to be essential.

The Guerze, the Kono, the Manon, the Gio, the Geh, the Kra, and the Dan make and use masks stylistically called "Dan" masks. The Toma *bakorogi* resembles the Guerze, Kono, and Manon male *nyomu;* the characteristics of the Gwere-Webe also exist in certain Dan, Bete, and Grebo masks. In this labyrinth of roles and styles, three types of masks—the Dan, the Gwere-Webe, and the Guerze—can be distinguished, each one bringing in its wake a retinue of variations to which the term *substyle* lends an equivocal meaning.

With its oval face, gently bulging forehead, straight nose with wide but delicate nostrils, clearly and sensitively designed lips, and chin softly rounded into a point, the Dan mask offers an idealized image of the female face. It is therefore a contrast to the Gwere-Webe mask, which presents a face conceived as a violent construction.

The "classical" style centers of the Gwere-Webe are situated in the area of the midsection of the Nzo, tributary of the Sassandra. The treatment of the different parts of the face distorts its contours, transforms them into contrasting volumes, sets them into geometric protuberances, multiplies them contrary to nature, and subordinates them to strange themes, most often animal ones. This inventive exploitation of the face is quite unlimited. The forehead, ears, browridges, eyes, nose, cheekbones, mouth, and jaw are expressed by tubes, cones, globes, half-moons, etc.

In the regions situated between classical style Dan and Gwere-Webe centers, specific features of both types intermingle with each other. Rounded and stylized forms are combined with geometric forms. The innumerable possibilities offered by this association of two obviously different styles are successfully exploited. The village of Flanpleu provides an example of the importance that an artistic center can attain after several generations. Favored, no doubt, by its political and economic situation, Flanpleu, as P. J. L. Vandenhoute says, "is raised to the level of the most representative artistic center of the Ivory Coast."

The third type of mask is characterized by an oblong face and an aquiline, elongated, interminable nose. The articulated jaw disappears under an abundant beard of monkey's hair. The mask is principally

used by the Kono, the Guerze, and the Manon although it undoubtedly comes from the southern Dan. The scarcely protruding forehead, the flat cheeks with clearly defined contours, the slit eyes, today bordered with aluminum strips, all stem from Dan style; but the protuberant nose whose extremity joins the upper jaw and the plate of the movable jaw attached at the base of the cheeks are completely specific. Always accompanied by an interpreter and a band of musicians, the masker appears crowned with an imposing cylindrical headdress decorated with pieces of multicolored leather and a wreath and dressed in a blouse with long puffed sleeves and a skirt of raffia fibers. When his face is covered over with a scarlet cloth "coming from a tarboosh or an old belt of an African rifleman," the masked individual personifies completely the masculine character: venerable patriarch and monitor of the initiation ceremonies. Its partner, symbolic mother of the neophytes who are supposedly enclosed in its stomach during their retreat, a common theme of *poro* initiations, has the oval face and elongated eyes, the pattern of the lips parted by an inconspicuous set of teeth, the small ears and the slender nose of the Dan mask.

In societies such as those just mentioned, where social control, authority, and cultural values are in the hands of lineage chiefs and one or several religious associations, the masks seem to reflect through their principal characters both the conflicting and the complementary separation of men and women. The Toma, the Gio, the Manon, the Guerze, and the Kono have two principal masks: the father and mother of the masks, each of which have specific activities. The male and female faces of the Dan and Guerze masks are perhaps derived from similar prototypes. Furthermore, the distinction between the masks of young and old men reflects the division into age grades that gives these societies their structure and the bases of their economy. Worn by men on stilts, these masks acquire their real character only when they are seen dancing arrayed in all their costumes and are heard talking through the disguised voices of their wearers or through the interpretation of musical instruments. The *kpanganya* mask of the

Uyakore, Holas explains, "provokes its enthusiastic spectators carried along by an excess of joy to break their looms."

The Dan artist, or his counterpart in other tribes, is not limited to creating masks. In the domain of wood sculpture, he may execute as a cult image, or on demand, a standing female figurine with its arms along the body and a face similar to the mask face. The Dan artist also carves large wooden spoons whose handles are made into a head with a long neck, always of the same style. These spoons are the attributes of the first wives of the primary chiefs. Above all, these wives are the mothers of the future chiefs. It seems that this prestigious function is symbolized by these spoons, which are shown for the first time during initiation ceremonies in which the eldest son of the chief is among the neophytes. Stools, small objects, and staffs of the chiefs or masked dancers likewise testify to the skill of the sculptors.

Wood sculpture does not exhaust the chapter on the art of the forest regions of Guinea, Liberia, and the Ivory Coast. Familiar representations, more or less secret because of their association with copper smelters, show some of the characteristics of the faces in wood. Adornment with jewels is very rich. Finally, the walls of the round huts in upper Guinea and the remote areas of Liberia and the Ivory Coast were formerly often completely covered with ocher or clay decorations.

In the Bandama basin, the Guro, small farmers, hunters, and producers of cola nuts who are said to be indigenous, originally belonged to the Dan and the Guerze. The Baule, who buffeted them about and influenced them after their legendary migration ended at the Bandama River, indisputably dominated their religion and thereby affected their aesthetic production. At first glance, Guro art itself is also particularly manifested in wood sculpture. Their best-known masks depict fine antelope heads hollowed out just enough to cover the head of the wearer. Like many other masks of the Atlantic forest since the colonial period, these masks are used in purely secular festivals such as the Fourteenth of July. The *gye,* which remains hidden, consists of a stylized buffalo head similar to the Baule buffalo mask. Although

Baule artistic influence is preponderant, certain original Guro characteristics nevertheless do persist: linear fineness, a tendency to a conventional stylization of the face expressed by an elongation of it, and closed almond eyes, which are on all Guro zoomorphic and anthropomorphic sculpture. Along all the eastern fringe of Guro country, along the White Bandama, among the people coming from Baule country (Ayahu, Yaure . . .), one finds masks that perhaps represent a transition between what appears to be a typically Baule "style" and the characteristic Guro "style." The Guro have perhaps inversely exercised certain influences on the Baule. The proximity of the Bete and the Dan, less close, but not negligible, could have accentuated the social and aesthetic originality of the Guro in relation to the Baule.

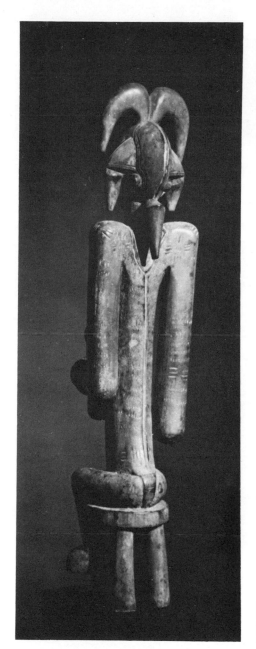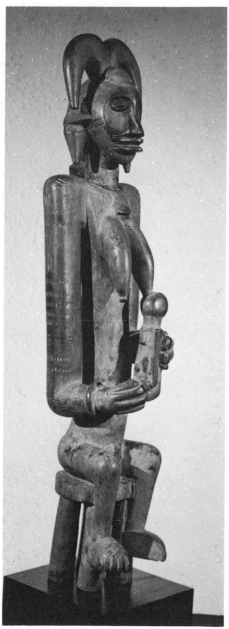

30 & 30a. Senufo maternal figure. Wood. H. 35⅞".
Ivory Coast. Formerly in the collection of Marcel
Evrard. Photo Béatrice Ullman.

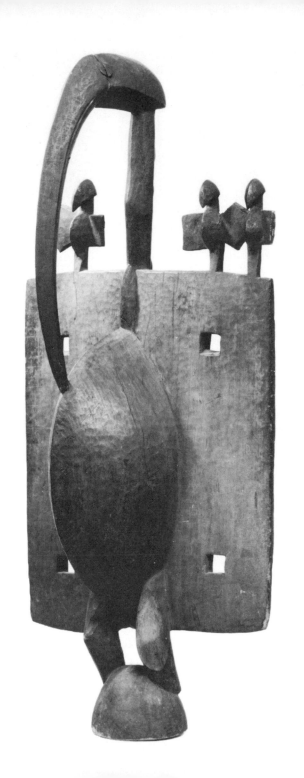

31. The large hornbill, a
mythical bird. Wood.
H. 56$\frac{11}{16}$". Senufo, Ivory Coast.
Collection Boussard. Photo
Robert David.

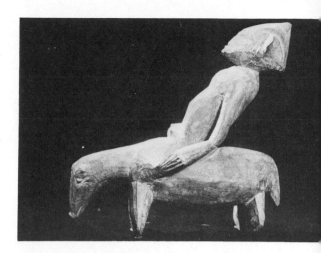

32. Wounded horseman, magic
figurine. Wood. H. 5$\frac{3}{32}$". Senufo-
Naffara, Sinematiali, Ivory
Coast. Afrika Centrum, Cadier
en Keer. Museum photo.

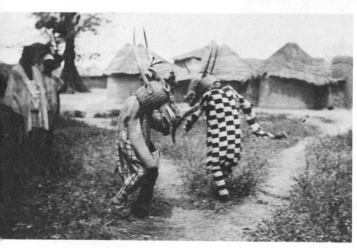

33. *Poniugo* masks. Senufo-Naffara, Sinematiali, Ivory
Coast. Photo P. Knops.

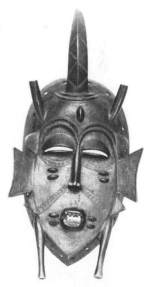

34. Brass mask preserved until 1935 by King Fandio of
Sinematiali. H. 10$\frac{17}{32}$". Senufo-Naffara, Ivory Coast.
Afrika Centrum, Cadier en Keer. Museum photo.

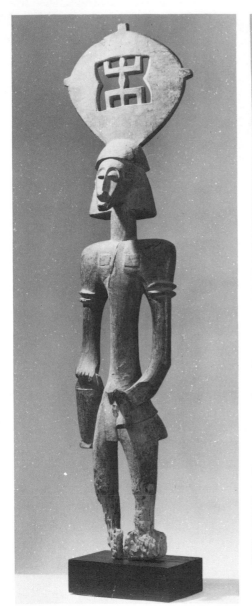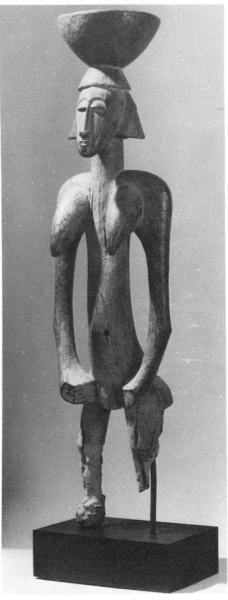

35. & 35a. Pair: man with initiation headdress, woman with basket. Wood.
H. (of man) 54¹¹⁄₃₂″; H. (of woman) 36²¹⁄₃₂″. Senufo, Ivory Coast. Collection of
René Van der Straete. Photo U.F.D. The Photo Library.

36. Stone figurine. H. 6¹³⁄₁₆″. Sherbro, Sierra Leone. Collection Muller, ►
Soleure. Photo Dominique Darbois.

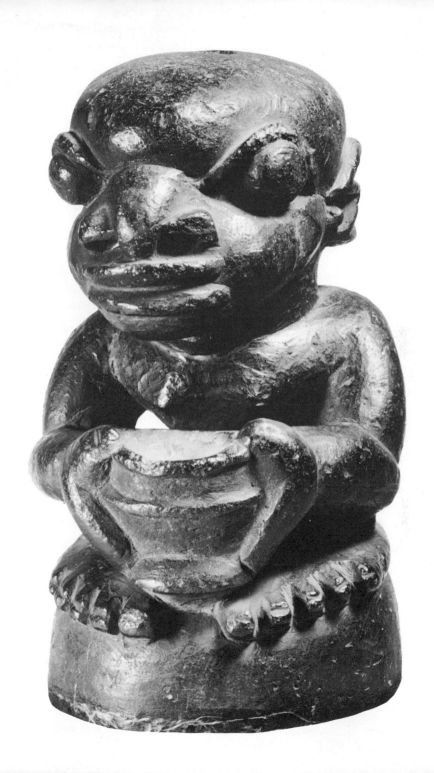

37. Helmet mask. Wood. H. 34²³⁄₃₂″. Mende, Sierra Leone. Collection of Pierre Vérité. Photo Claude Vérité.

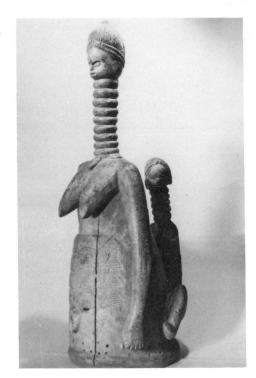

38. Spoon. Wood. H. 13¹⁵⁄₃₂″. Mende, Sierra Leone. Collection of Joseph Van der Straete. Photo U.F.D. The Photo Library.

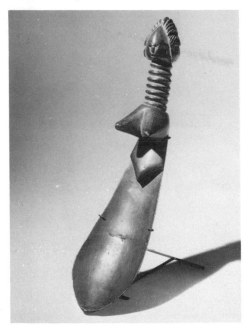

39. Statue. Wood, fabric, iron, string. ► H. 22¼″. Toma, Guinea. Musée de l'Homme, Paris. Photo José Oster.

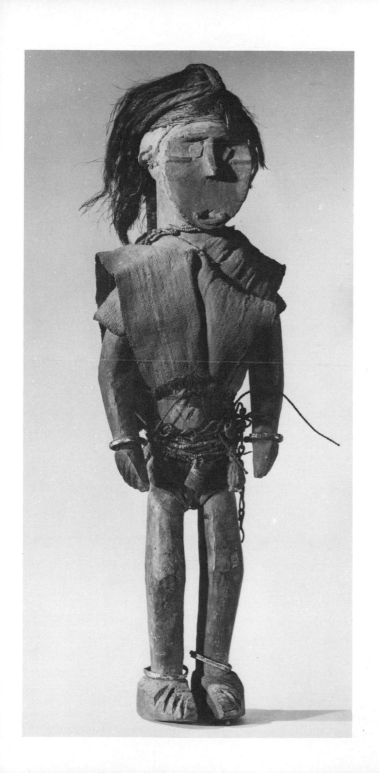

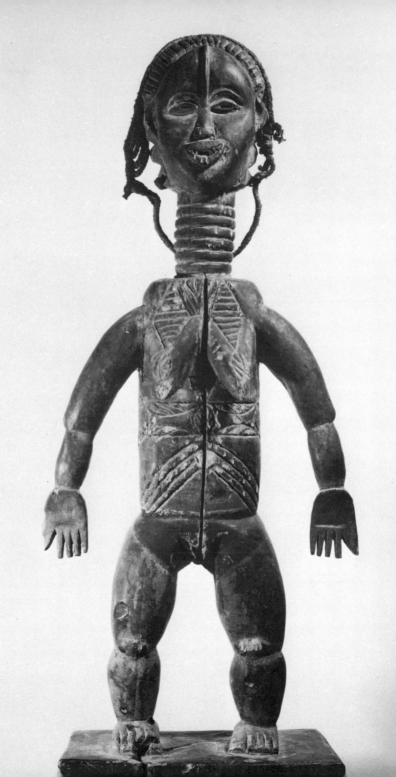

40. Statue. Wood, string. H. 28⅞". Dan, Ivory Coast.
Collection Païlès. Photo Dominique Darbois.

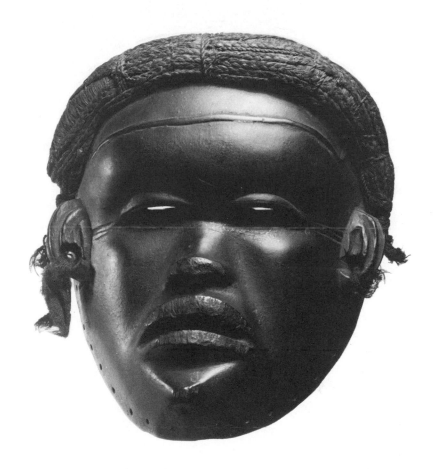

41. Mask representing Nya wo, modeled from the living
subject at her own request. Wood and cloth.
H. 9½". Gio, Liberia. Harvard University, Peabody
Museum of Archaeology and Ethnology, Cambridge.
Museum photo.

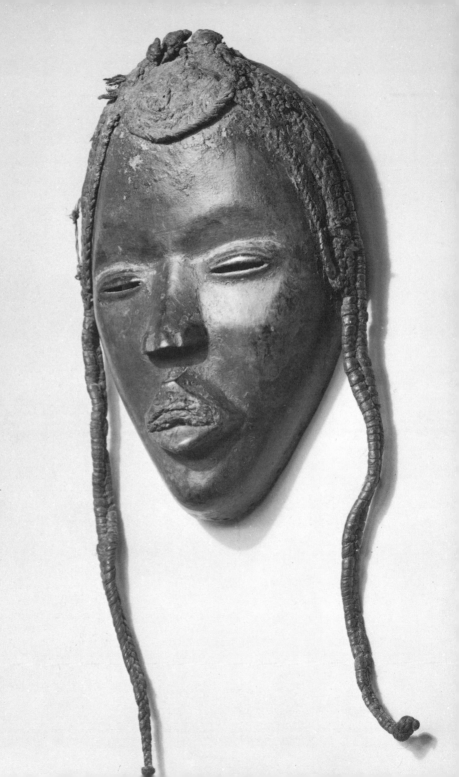

42. Mask representing a female face. Wood, fibers. H. 8³¹/₃₂″. Dan, Ivory Coast. Collection of P. Peissi. Photo C. Lacheroy.

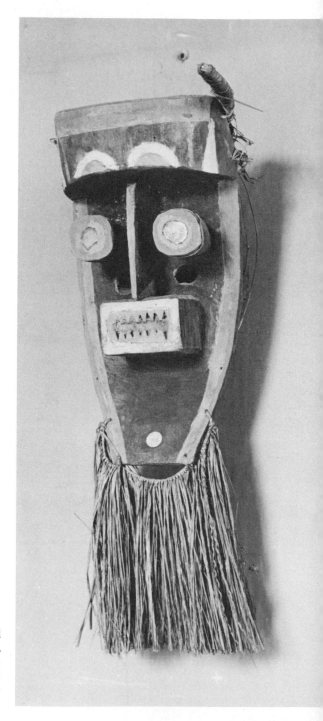

43. Mask, instrument of social control. Painted wood, fibers. H. 21¹/₁₆″. Grebo, Liberia. Musée Municipal d'Angoulême. Photo Bernard Mallet.

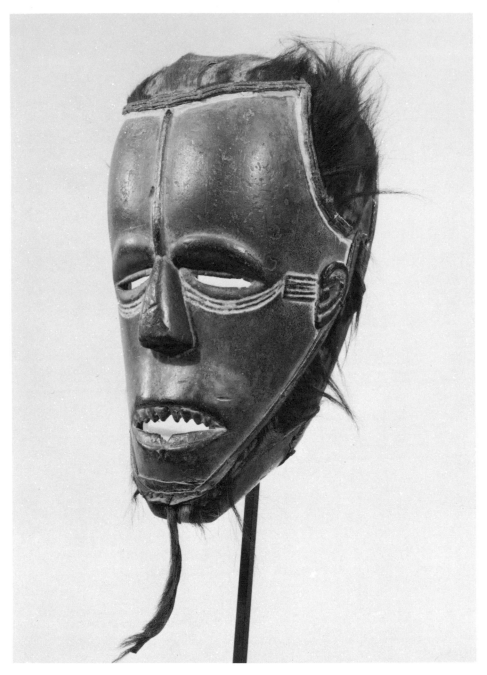

44. Mask. Wood, monkey hair. H. 13²¹⁄₃₂″. Guro, Ivory Coast. Art Institute of Chicago. Museum photo. Courtesy of the Art Institute of Chicago.

The Akan

The Akan civilization is a civilization of gold. Well before the birth of the prestigious confederation of Ashanti states between 1701 and 1750, the Akan kingdom was already founding its wealth on the use of this metal. According to one tradition, the king, like all the later hereditary princes, was sent to the distant provinces of the north to become familiar with the institutions there for the benefit of his own state. Thus Obunumankoma visited the great Sudan markets and learned about the gold trade. At his succession, he created the royal treasury, instituted gold dust as money, and made the system of weights official.

Before the domination of the Ashanti king of Kumasi, kingdoms flourished that were already organized around strict principles according to which the king, the queen mother, and the royal lineage were inseparable from the sacred symbols of the society. In the gold trade with the great foreign centers, these kingdoms found the bases of a splendid organization served by remarkable artisans grouped into professional associations. All the aesthetic effort and technique of the artists is brought to bear on this precious metal and its substitute, brass. Only private or family cults or magic are open to sculpture in wood.

The Akan people form a linguistic and cultural group that covers the forest regions of the southern half of the former Gold Coast and

extends into Togo and the southeast of the Ivory Coast. The Black Volta marks the border between the forest zone of the south, bounded by lagoons, and the territories of the north, where the Dagomba and the Mamprussi launched their expansions up to the Mossi empire. From the fifteenth century to the eighteenth century this vast spot of darkness, which spread out between the sea and the Sudanese savanna, was unknown to navigators, merchants, and agents of the large companies. Confined to the coast, established in their fortresses, the Portuguese and the Dutch conformed to the standards of exchange imposed by the local chiefs and their intermediaries from the interior. Nothing appeared from these mysterious regions where gold, and later slaves, were to come down to the European ships, which set out again after unloading their "shackles" and multicolored fabric.

When the Ashanti kingdom, already the uncontested master of the interior states, wanted to extend its sovereignty to the coastal societies, the English traders decided to contact this prestigious power of unknown territories. In consequence, T. E. Bowdich was sent at the head of an embassy to meet with *Asante Hene* in his capital. Bowdich's description of the sumptuous reception that welcomed him in Kumasi has since become famous.

Of all the gold objects that were symbols of a royalty conceived as a mirror of the life of the gods whose stars each day and night reflected extraordinary images, there remain some carefully classified and exhibited collections. But more than one Akan chief or priest possesses and still uses these emblems, formerly indispensable to his functions.

Pendants or ornamental jewels cast in lost wax are often in the shape of disks of variable dimensions. They are sometimes the size of small coins and are strung together with a braid of silk or vegetable fiber that passes through thin tubes to form necklaces, bracelets, leg ornaments, or anklets. More important plaques or plates (four inches in diameter on the average) are decorated with motifs that are often symmetrically arranged around a navel in relief. Minuscule, like gold pearls, or imposing and solitary at the end of a flattened gold thread,

these jewels testify to the astonishing dexterity of the goldsmith. Thin gold threads are wound around in a spiral to form the background on which distinct motifs are added or arranged. Trefoils, rosettes, moon crescents, spirals, stars, leaves, seeds, circles, chevrons, lozenges, and twisted fringe balance, contrast, and combine with each other to create new motifs and new groups. This limitless richness of the circular pendants also exists in the ornamental jewels, which are in the shape of rectangles, cones, cylinders, prisms, or crescents. The same decorative techniques resembling gold threads in parallel lines are used in the pendants portraying animals (scorpions, crocodiles, fish, rams, and elephants) or human masks, often with beards and headdresses in little ringed tufts, figures of kings or chiefs of conquered armies. These pendants almost always have rings to retain a cord.

These jewels were worn in all the Akan states from the southwest of the Black Volta to the coast, states organized around extremely lively capitals, cradles of the central power and focuses of art and commerce. The people of royal blood, repositories of the sacred forces of the kingdom, and the servants of the court would wear these jewels at the great periodic national festivals. The gold disks with a navel were hung on the breast of the king's substitute, his soul carrier. Smaller disks were worn by the mothers, widows, and granddaughters of the king. The king himself, in parade costume, wore a triangular plaque, a symbol of his authority springing from the creator god.

Motifs sometimes superabundantly ornament round plaques and jewels, which almost cover the body of their wearer. The same motifs appear again on many other objects such as weights for measuring gold dust, prestige weapons and insignia, ceremonial musical instruments, gold-, silver-, or brass-covered ancestor stools, printed fabrics, ceramic cult figures, beaten brass or bronze containers cast in lost wax, and the clay walls of the royal palaces and mausoleums. The most persistent motifs—circles, crosses, spirals, crescents, chevrons—seem to be linked to the symbols that probably stem from a certain number of traditions that tend to justify the royal organization's origin from a celestial mythology.

Animals appear on a large number of jewels, but they are also found on the weights, the staffs of authority, and the tops of umbrellas. Often they are substituted for openworked columns that support the stools, altars of deceased dignitaries. They are linked to the primary matrilinear families of the society, each of which are assigned an individual animal. Thus, the zoomorphic representations, depending on the circumstances, will be moral, political, or religious emblems. The leopard, reserved for the king, evokes aggressiveness, the buffalo represents wisdom, the crocodile is both the destroyer and the symbol of fertility, and the antelope is connected with heavenly phenomena.

Like the innumerable jewels, the weights for measuring gold dust are very characteristic of the Akan kingdoms, the most famous of which are the Ashanti, the Agni, and the Baule. It is said that the royal weights of the last king of the Abron were in gold and silver, the weights of ordinary subjects were one third lighter than those of the important citizens. Classified generally as weight figures, weights representing inanimate objects and geometric weights, they are manifestations not only of the weight and monetary system but also of the ideographic system. Each decorative group, each animated scene in cast brass that the goldsmith takes out of the broken clay mold and that he carefully trims possesses a conventional meaning. The antelope with long, ringed horns that unite with the tail is one of the most popular designs. "If I had known what was happening on my back!" she says, but regrets are useless, one should add.

A more secret writing is provided by the geometric weights, which abound with most of the motifs already mentioned in connection with the jewels. There are no reference points for recognizing a historical or moral allusion. The most common motifs are the Greek cross, the St. Andrew cross, the swastika, and the comb, but the spiral, star, and chevron motifs are also prevalent. Combinations of the motifs are numerous. Since the end of the last century, more than one author has been forced to decipher the system by which one assessed the counterpart in gold dust of these weights balanced on a set of scales. The gold dust was substituted as money for slim, twisted iron rods. The very

small and delicately worked brass boxes for holding minute quantities of gold dust and their inseparable decorated and openworked spoons of hammered brass are other examples of the exquisite art of the goldsmith.

The *kuduo,* bronze cists cast by the lost-wax method, like the gold weights and jewels, are classic specimens not only of Akan art but also of the priceless art of black Africa in general. Often their hemispherical bellies or truncated cones supported by three feet rest on a ringed or openworked circular base. Sometimes small rectangular boxes with four feet recall the form of the hammered copper chests of the Ashanti royal mausoleum that contain the treasures of the king. Others are also reminiscent of the hexagonal chests of smaller dimensions in which lie the royal skeletons, which are dressed in rich clothes and adorned with gold jewels, and whose bones are joined with gold thread. The periphery of these containers is decorated with figures in the round and a fine geometric pattern, either engraved or in relief. Usually a group of figurines, comparable to those of the proverb weights, is found on top of the cover. The *kuduo* is associated with the private cults of all families more common than royalty. It is the material manifestation of the *n'toro,* the male principle inherited from the father and passed on only by men. Therefore it will intervene at each moment essential to the life of an individual. A number of other painstakingly decorated vessels in hammered bronze likewise serve to hold ritual preparations, in particular water and earth of the sacred rivers, gold nuggets, and aggry beads, which are the appanage of numerous divinities.

The ceremonial or funeral pottery, which men must make, since according to a tradition reported by R. S. Rattray, "a woman potter had become sterile after having modeled figures for a pottery shrine," likewise demonstrates the very sensitive ornamental qualities of the metal objects. Figurines of heads or of people sitting on stools are of particular interest. Of reduced dimensions, the figures are attached to lids of the family pottery funerary shrines reserved for the worship of the female principle *abusua.* However, Agni statuary of the Sanwi

kingdom, in the southwest of the Ivory Coast, in particular, achieves a highly expressive quality. Fabrication of these clay figures by old Agni women persists to the present. The style is similar to certain wood figurines. These sculptures in terra-cotta were discovered partially buried, abandoned in the ancient places of worship outside the village. According to the inhabitants, they are "ancestor portraits." In the Ashanti kingdom, terra-cotta statuary seems to have been eclipsed by the extraordinary development of goldsmith work. Was it perhaps a brilliant art in the seventeenth century when women potters were subject to the authority of the Abron queen mother and could then model human figures on the cult shrines? But, in their turn, works in gold and the sacred stools were repositories of the supernatural forces of the deceased and the deities. The Agni, in the eighteenth century, knew how to reconstitute an Akan-like kingdom where art objects, which are known today, acted as manifestations of power. Agni terra-cotta figures were modeled at the time of funerals of prominent citizens or of the king of Krinjabo, the capital. The faces, which have all the presence of moving portraits, are characterized by a nose with wide nostrils, thin lips, and closed eyes depicted in relief. Scarifications are near the wings of the nose as well as the ears and between the eyebrows. The headdress is circular with the hair in tufts and the neck is ringed. These small seated figures are modeled, decorated, dried, baked (around a wooden core that will partly carbonize), blackened, and sometimes glazed. Although too often damaged, they are excellent examples of an art it would be desirable to know better.

If the ceramic art in the Akan kingdoms was apparently secondary only in appearance, what about sculpture in wood? Not only the little *akua-ba* figures and the stools, each of which had a particular name, but also certain figurines representing family deities and water or fertility spirits show that this art, too, was executed with talent.

The *akua-ba,* generally of hard wood, blackened and polished, has a disk-shaped head, and with rare exceptions, a ringed neck similar to those of the terra-cotta figures. The features of the face are extremely stylized. The body and limbs can be represented either entirely or par-

tially in various forms. If the legs do not appear, the trunk rests on a slightly protruding circular base. The delineation of the arms is very concise: no joints or hands, so that the head, held up by a very slender neck, seems to be attached to a body in the shape of a cross. For a pregnant woman, the period before birth is full of taboos. The sight of anything deformed may cause an accident. Her glance must not fall on a crudely made sculpture. On the contrary, she carries an *akua-ba* whose beauty will bring about the birth of a beautiful child. According to Eva Meyerowitz, the most schematic figures are in the image of the moon, goddess of fertility, and are given to sterile women so that they can procreate. A white *akua-ba* without legs and with raised arms is said to belong to a type reserved for the tombs of the wives of lineage chiefs. The most realistic examples, with legs bent and arms parallel to the trunk, were given to little girls to teach them how to take care of children. Are these last figures recent? Is this true also of all Akan sculpture in wood? Today a bronze maternal figure sits in the royal hut of Takyiman where she receives the prayers of sterile women. Yet, wood maternal figures exist. Are these substitutes for bronze statues or were these wood figures the property of ordinary families while the metal images were reserved to the noble families?

The stools with a rectangular base whose concave seat is supported by carved pillars are certainly the best-known Akan wood sculptures. Several decades ago, the village of Agwia near Kumasi was the manufacturing center of these stools, the work of a caste of specialists, made of the wood of a particular tree. The role of these stools in the political and spiritual life of the kingdoms was so important that it is almost certain that they alone are the repositories of the supernatural forces usually attached to figures, masks, nonfigurative altars, and emblems. Covered with gold, the royal stool contains the spiritual personality of the entire nation. The queen mother's stool is covered with silver motifs. By the way in which they are carved, the stools of natural wood express the respective social positions of their owners. When a prominent person dies, his stool, blackened with smoke or with a mixture of soot and egg yolk, joins the treasures of the family. Hence-

forth, an actual altar, it will participate in the processions of the great calendar ceremonies.

In contrast to the other groups of Akan origin, the artistic reputation of the Baule is based on their wood sculpture and not on their gold work.

It is curious that this kingdom, which preserved the themes of Ashanti hierarchical organization, developed as remarkable an art in wood to serve the state and its symbols as the Akan metallurgical art. The future queen of the Baule, Aura Poku, fled from the Ashanti country in the middle of the eighteenth century after the death of her brother, the defeated pretender to the Kumasi throne. She crossed the Comoe and, followed by her faithful, reached the Bandama valley. The first home of the Baule was established in the region of the Warebo, whose stool has always been the most venerated. But if the Baule kingdom has expanded while respecting certain traditional Akan spheres, it could not remain faithful to the military themes of this culture. Installed in an area of the savanna that forms a sort of *V* inside the forested section of the Ivory Coast, which the Senufo farmers already occupied to the north and the Guro to the west, the Baule became stubborn peasants. In contrast, the Agni, who in their turn separated from the Ashanti in the second half of the nineteenth century and founded a new kingdom on the edge of the forest, perpetuated the symbols of power in gold and silver. The Agni society, however, was hardly agricultural.

Well endowed with dynamism and originality, the Baule society has only recently been systematically studied. The origins and meanings of its art, so well represented in European collections, thus partially escape us. The Baule harmoniously absorbed the preexistent indigenous cultural element. But what precise influences did the Senufo and the Guro have on their wood sculpture? Recently, the large amount of Senufo manpower in the favorable regions of the Ivory Coast has certainly played a role in the evolution of the local arts. No doubt also the importance given to agriculture in a society

of Akan origin determined the development of this sculpture. It has the qualities of goldwork, which is exceptional in the art of sculpture in wood. The extreme refinement of the delineation of ornament (scarifications, jewels, headdress), the faithfulness of the proportions, more in the face and trunk than in the arms and legs, which are sometimes either sacrificed or exaggerated, the polished surfaces of almost all the figurines and even the masks combine to render most of the Baule sculptures highly seductive. Certain ones even qualify as "sophisticated."

Portraits are executed on order by artists known for their skill. Images of the deceased to which accrue a small part of the soul of the dead because of a positive or symbolic resemblance, these wood figures recapture the role of the stools, the pottery shrines, or the gold jewels carried off from the Ashanti.

Very different from these beloved "portraits," the half-zoomorphic half-anthropomorphic statues show deities or spirits of the bush in the form of standing individuals with bent knees, folded arms, and hands joined holding a cup. There are numerous variations of these sculptures. Sometimes the figures are simple. Sometimes they are dressed in a skirt of raffia fibers or a loincloth, adorned with belts of wood beads, rings, small round bells, bracelets, anklets, and "thunder stones" carried in pendants. They differ or resemble each other certainly, because of the imperatives of their function. They vary also, perhaps according to the extent of the sculptor's talent and initiative. The norms of this statuary—mouth projected forward, straight cylindrical trunk, offering gesture of the arms holding the cup, double curve of the lower limbs—seem to inspire the artists rather than confine them to a uniform creation.

Baule masks can be divided into two series: the buffalo-head bell mask, and a human face mask to be worn over the face of the masker. In this second series belong the very numerous blackened wood masks with a patina that have a softly bulging forehead, flat cheeks, and a long-ridged nose with fine nostrils that divides the face into two equal parts. The eyebrows are shaped in half-moons, the eyelids fall

closed, the thin lips turn up at the corners, and the chin blends with the curvature of the face. In the ornamentation of these female or male masks, perhaps portraits of the sky or earth gods, one may recognize Akan symbols, inseparable from the little masks and gold jewels. Of particular interest is the chevron line that goes around the face and also appears on the eyebrows or on the forehead. According to Eva Meyerowitz, it is the symbol of rain and motherhood, the sources of life. The very elaborate headdresses have disks with a heavy protuberance in the center, a symbol of the soul according to Meyerowitz. She also thinks that the triple-notched lines in the shape of arrows, which are found on the temples or near the mouth, suggest the luminous rays cast by celestial deities. Various motifs are often attached to the headdresses such as horns in a half-moon pointed skyward, very elaborated large disks, and birds with long beaks.

The bell masks are generally heads of bovines or, more rarely, elephant, monkey, or leopard heads. They are the opposite of the portrait masks in that they seem essentially to express the world of the bush, originally considered by the Africans as a sort of "no-man's-land" in relation to the world of cultivated lands. Spirits of the savanna, personified by animals that the hunter pursues, they are the pivotal point of more or less secret societies. Maskers, dressed in costumes of raffia fiber, exhibit them during the rites in which they take part, accompanied by their tambourine players. There may be large masks with two or several horns, double-faced masks, spotted or polychrome masks, or masks dyed black. The menacing jaws are open wide to show a tongue or fangs or close-set rows of teeth, or the muzzle may be plain and elegantly carved. They cannot but evoke the zoomorphic masks of the Senufo.

Baule sculpture in wood covers a very large domain. Doors, shutters, weaving bobbins, spoons, drums, bell hammers, staffs, and divination boxes are all carved with the familiar designs of the masks, the figurines, and the jewels.

The arts of the Akan people, taken together, thus seem the most outstanding. Yet it would be wrong to believe that they developed in

a vacuum. The important activity of the Muslim merchants established on the northern border of the Ashanti forest, which abuts the Nigerian trade route, cannot be ignored. The strong preference of the Ashanti for trade with Hausa markets rather than with coastal markets is also an important consideration. For a long time, the pre-Ashanti kingdoms also maintained economic relations with the Sudanese Muslim states and animist countries like Mali, Kong, or the Empire of Morho Naba. It is certain that these clientele for gold exercised cultural influence on the Akan and, in consequence, on their aesthetic activities.

45. Gold weight (weights for weighing gold dust). Brass. H. 25⁄32″. Agni, Ivory Coast. Musée de l'Homme, Paris. Museum photo.

46. Gold weight. Brass. H. 1¹⁵⁄₁₆″. Baule, Ivory Coast. Musée de l'Homme, Paris. Photo Studio Chaix.

47. *Kuduo*, ritual vessel. Brass. ►
H. 5¼″. Ashanti, Ghana. Museum of Primitive Art, New York. Museum photo. Courtesy of the Museum of Primitive Art.

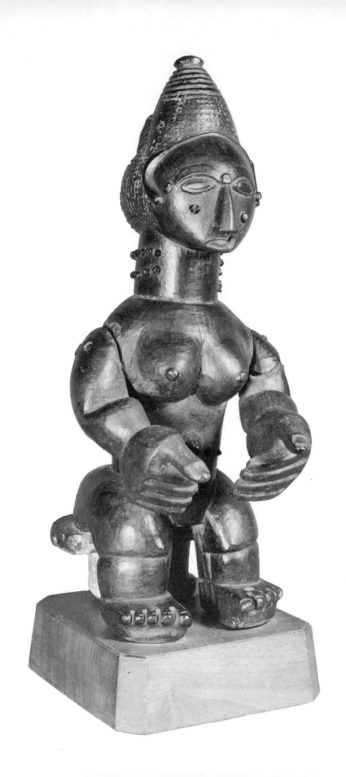

48. Figurine with jointed arms. Wood. H. 14⁷⁄₁₆″. Agni, Ivory Coast. Petit Palais (formerly the collection Girardin). Photo Bulloz.

49. Mask. Wood, monkey hair. H. 10⅛″. Attie, Great Lahu region, Ivory Coast. Art Institute of Chicago. Museum photo. Courtesy of the Art Institute of Chicago.

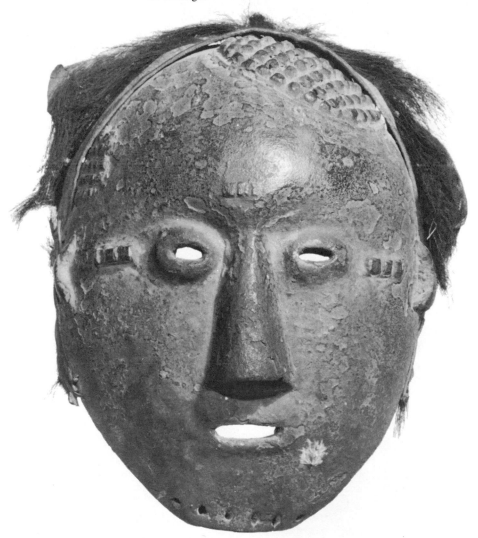

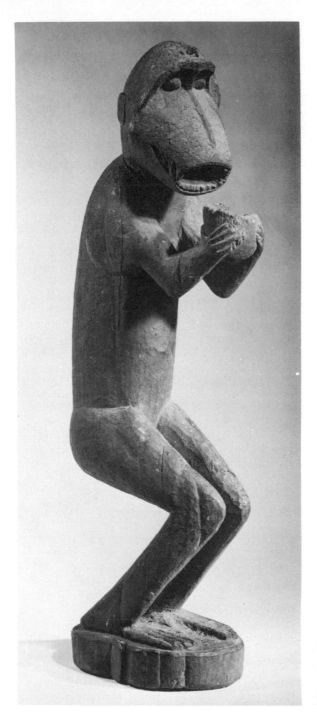

50. Cynocephalus, spirit of the bush, or deity. Wood. H. 20²¹⁄₃₂″. Baule, Ivory Coast. Rijksmuseum voor Volkenkunde, Leiden. Museum photo.

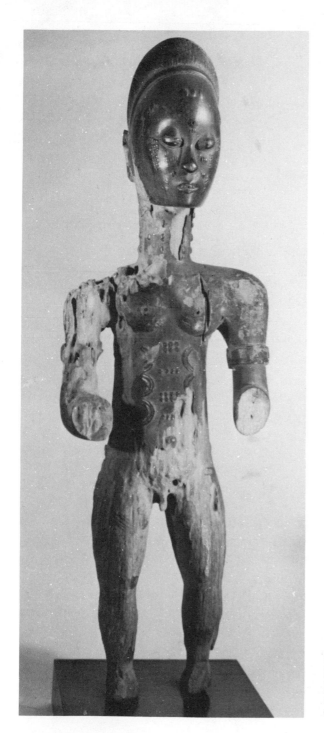

51. Statue with a face resembling a mask. Wood. H. 22⅝".
Baule, Ivory Coast. Collection
of Pierre Vérité. Photo
Claude Vérité.

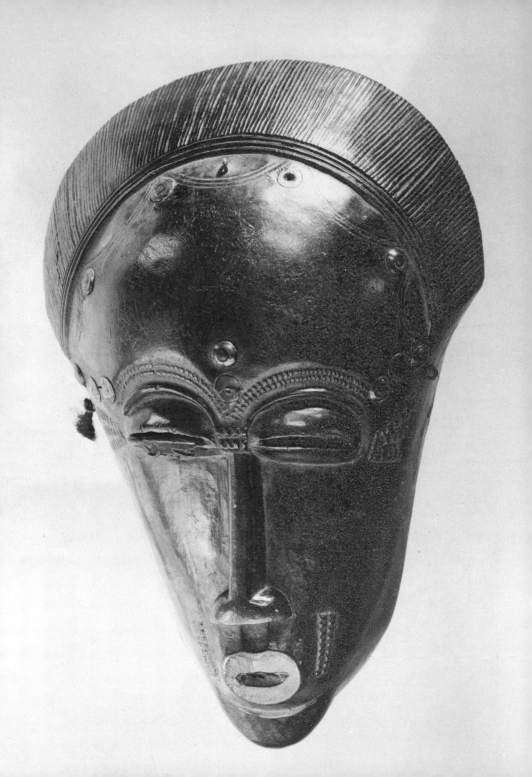

52. Mask. Wood. H. 10¹⁵⁄₁₆″. Baule,
Ivory Coast. Collection of Léonce
Pierre Guerre. Photo I. Bandy.

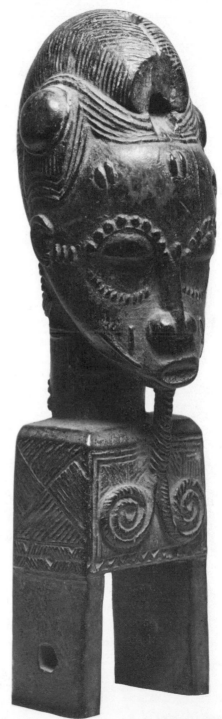

53. Loom pulley or heddle (with-
out the bobbin). Wood. H. 7″.
Baule, Ivory Coast. Collection of
H. and H. A. Kamer, New York.

Dahomey

From the beginning of the seventeenth century until the end of the last century, because of the successive efforts of ten kings of Adja stock, the kingdom of "Danhome" was constituted and flourished with both a terrible and a magnificent reputation before being extinguished, with the defeat of its last sovereign, by the French troops.

This royal chronology forms the very thread of the Dahomean arts. The history of the foundation of the kingdom, whose most remote origins are lost in legend, the panorama of its constant progression because of military bravery and audacious techniques amid innumerable obstacles, internal crises, treacheries, resistances, and counterattacks from abroad are the unique and abundant source of almost all the artistic creations served by specialized organizations in Dahomey.

The history is known not only from the travel journals of trading navigators and ambassadors but also from its faithful recounting on the clay walls, the emblazoned textiles, and the iron, brass, and wood sculptures. Undoubtedly this eventful founding, over three centuries, of a great African kingdom cannot summarize the entire aesthetic history of Dahomey. It points out, nevertheless, the most important and accessible aspects of it.

Outside the complex, but perfectly hierarchical world of the Dahomean monarchy, the arts and artists play a role and express values that form a coherent as well as an original whole. We en-

counter in this assemblage an undefined cluster of influences whose origins and independent directions did not lead to the creation of one style. The cultures of conquered peoples, each endowed with its peculiarities, intermingled there. Unquestionably too little known, these old indigenous units had to preserve the valid local arts. At the time of the Dahomean conquest, several of them were already involved in the rich cultural flow of the Yoruba civilization, which since the thirteenth century had been dominant to the east of the valley of the Oueme.

Between the course of the waters of the Mono to the west and the Oueme to the east, between the coast of lagoons to the south and the Savalou region to the north, the history of the development of the Dahomean kingdom took place and with it the history of its art. Toward the middle of the seventeenth century, the first founder of the kingdom, Ouegbadja, establishing his domination over the dispersed tribes, built a fortification to secure the site he had chosen. He had a house built for his son near his own, on the very ground where he had wanted the body of the conquered chief, the former master of the occupied land, buried. By doing this, he laid the foundations of an architecture, which was to become prestigious in the future.

The palace of Abomey formed a veritable city inside the capital. Protected by a surrounding wall, it consisted of a group of small palaces in reddish clay roofed with thatch. The brown earth of the partitions was rough plastered, waterproofed with a coating of palm oil, and whitened with kaolin. Each palace constructed by a king, south of his predecessor's palace, was bordered by a public square. It included the exterior and interior courts, state buildings, residences of the king's wives, the important courtiers, and foreigners, as well as the royal tombs and the altars of the ancestors and deities. The entire religious and political life of Dahomey is reflected in the smallest details of this complex architecture. The façades of the dwellings meant for the king were decorated with polychrome bas-reliefs of subjects that were spread out and separated from each other. Each

story is perfectly autonomous, since it relates to one single memorable event. But all these bas-reliefs—more than one hundred exist—ultimately recount one particular history, that of the victorious wars led by the bellicose monarchs of Abomey. Burned down by the last free sovereign when he had to flee his capital, the royal buildings, already for the most part in ruins, cannot yield their testimonies. The better-preserved palaces of the more recent Guezo and Glele kings have been carefully restored. Several of their bas-reliefs are continually analyzed and reproduced in the literature devoted to Dahomey. Information on the original character of these bas-reliefs and on the artists who modeled them is lacking. There are, however, numerous indications of the organization and evolution of the other royal arts, for example, the sculpture of the thrones and batons, or the brasswork.

Under the reign of Agadja, aesthetic production began to be organized in the service of the king. Is it during this period that certain sculptors of clay devoted themselves to the decoration of the façades of the royal residences? Is it possible that the style of these bas-reliefs evolved toward a more and more conventional form of expression, using for one reign after another the single theme of the struggle of the Dahomean people against the Egba army of the Yoruba kingdom of Oyo? The theme is ultimately plastically limited, for the small surface used (a square with twenty-nine and a half inches on each side) permits only a scene with a minimum of figures. The various postures of the characters according to the nature of the event alone constituted the novel element of the bas-reliefs. In other respects, they faithfully reproduced the name and emblematic devices of the kings and sometimes the image of their great deities: the thunder-god, powerful and protecting, or the serpent-god, the source of life. Some of the most constant motifs are the leopard, the hornbill, the lion, the chameleon, and the pineapple. The leopard evokes the origin of the royal dynasty and the courage of the Guezo. The hornbill and the lion are symbols of the fearlessness and the incomparable strength of the Glele. The chameleon, which walks slowly but nevertheless reaches the top of the bombax tree, is the surname of King Akaba, whose succession to

the throne of his father took so long. The pineapple recalls King
Agonglo, who one day was spared from a thunderbolt (like the pine-
apple against which it can do nothing). If making allegorical figures
gave little latitude for the fantasy of the artist, creating the combat
scenes authorized him to show his sense of observation and of move-
ment and his zest for life, so characteristic of the Dahomean arts.
But the technique of the modelers is not distinguishable from that of
the sculptors of statues and terra-cotta vases from which it stems.
This style, both naïve and precise, rich in lively colors taken from
vegetable products, is seen again in the portrayals of the deity Legba,
the funerary pottery, and the polychrome figurines of everyday people.
Some of these statues were made by Agsoba, an artist of Porto-Novo
who was by no means a potter; others (of plastic interest, though
after all mediocre) are the work of a village chief near Cotonou.
Exhibited in Paris and Marseilles in 1927, the first of these figurines
to be known in Europe, although more elaborated, resemble the
characters of the bas-reliefs in the squares on the whitewashed royal
walls. The same priority is given to posture and the same impersonal
treatment is given to the face.

Inside the royal palaces, whose doors and pillars were adorned
with sculptures, special huts and large feast rooms housed objects of
prestige: thrones, textiles, parasols, *asen,* jewels. These objects, which
the people could admire during the great ceremonies, lavishly affirmed
the immutability and force of the royal principle, through a profusion
of songs, dances, processions, offerings, and sacrifices (whose human
victims were sent to serve the ancient sovereigns in the land of the
dead, a faithful replica of the earthly world).

Most of the works, destined for cults of the royal family, conceived
as national symbols or manufactured for the pleasure of the king and
his court, conform to the same artistic standards as the bas-reliefs.
The wall paintings and the appliquéd textiles in particular illustrate
this relationship although the conventional figures are spread out on
much larger surfaces. The scenes are more animated, more dense.
They put famous historical episodes side by side with symbolic or

sometimes simply decorative motifs and emblematic objects or animals. Particular importance may be accorded to a motif: for example, the ship in the center of a large hanging of King Agadja, one of whose names was "captor of boats," recalls that he was the first to extend the kingdom to the coast, where the Europeans were established.

The making of appliquéd textiles is an ancient art in Dahomey. According to one tradition, Ouegbadja introduced weaving in Dahomey after having conquered a village whose inhabitants buried their dead in woven coverings. Under Agonglo weaving spread and became organized, especially in a quarter of Abomey where several families specialized in it. Agonglo I conceived the idea of putting appliquéd designs on fabric. During Glele's reign, the workshop of tailors included one hundred and thirty embroiderers and apprentices under the direction of a member of the Yemade family; it was the peak of Dahomean glory. The velvets, satins, and cotton fabrics, imported since the period of Agadja and of which the umbrellas were made that so many voyagers noticed, had numerous purposes. Spacious tents were set up during the annual feasts in front of the passage connecting the outside and the inside of the palace. Hammocks, like the parasols and the sandals of the king, had to be buried with the deceased sovereign. Hangings, decorative tapestries, or precious materials were offered at the end of the funeral ceremony of an important deceased to consecrate his final admission with his ancestors. Finally, covers for cushions, army banners, and warriors' headdresses were also made from these fabrics.

A staff, elaborately carved even to the end, the baton (*recade*), was carried veiled by the messenger of the king. Uncovered in front of its recipient, it signified for him the order to which he must submit. The form of the baton evolved from the simple handle of one of Ouegbadja's warrior's hoes to the crosier of the last kings of the dynasty. Sometimes in ivory or plated silver, often in the engraved and openworked forged iron of an ax, its upper end was designed with care. Like the *asen,* these *recades* have a great formal richness.

A number, always increasing in names, were awarded to each king. This brought about a development of emblematic designs for all the royal arts and thereby a stimulation of invention.

Since the reign of Agadja, the sculpture of the *recades* was monopolized by a professional group, originally a family, which also specialized in the sculpture of the thrones and the statues symbolizing the kings. The Abomey thrones, like those of the Akan kingdoms, expressed the presence of the king, the minister, or the deceased chief. Carried in procession, set out on a mat in front of the ancestor huts, they received sacrifices and offerings during the commemorative feasts that follow the yam harvest. Like the Ashanti or Baule stool to which it is related, the Dahomean stool is carved from a single block and divided into three parts: a concave seat, like the arc of a circle, curving upward; a parallelepiped shaft or pillar; and a rectangular base. But unlike numerous royal Ashanti stools or the stools of Yoruba or Bamileke chiefs, for example, these thrones do not have a central zoomorphic support. Their much higher shafts (some reach six and a half feet) have panels with a geometric openworked pattern, inside of which an animal figure is inserted, when it exists. Certain thrones, like those of Guezo and Glele, call for two levels and the raised platform is supported by four little columns. The lower step of the Glele king's throne includes a design of rosettes and palms. The palm leaf, which plays a sacred role in certain Yoruba cults, appears again on two sides of the Behanzin throne. On the posts of most of the other royal thrones, geometric decoration varies little: openwork in checks, chevron incisions, facing triangles, longitudinal or ladderlike parallel lines. Some of these patterns are also on the surface of little circular stools with four feet, which are evidently very old. The *kateke* (as the seats are called) were made prior to the introduction of the thrones and were already employed by the kings during the pre-Abomean period. These decorative elements also are reminiscent of the significant ornamentation of the divination tray rims.

Dispersed according to the requirements of the many magical or cultural purposes that constituted the framework of a popular art in

which the diversity of local conceptions was affirmed, the widely distributed statuary became a royal art in the hands of professional sculptors. Two specimens of the great statues carried in procession during the annual festivals are very famous. These allegorical representations of the kings in animal form are the statues of the Glele and Behanzin kings. Less well known by the Western public are wood statues covered with plates of iron, brass, silver, and, very rarely, gold.

The plating of pieces of iron or sheets of hammered brass shaped into scales, feathers, or decorated with dots bestows a rather extraordinary suggestive power on the wood animal form. Monopolized by a family of blacksmiths, the iron foundry produced statues by using a technique related to plating. The statues are formed from riveted plates of iron or brass, and only two examples of them are known for certain. Like all the metallurgical arts in Dahomey, they succeed in a strange way in making us aware of the presence of the blacksmith god Gu and his servants.

Consecrated to the cult of *fa,* the power that presides over the destiny of an individual, the *asen,* staffs of iron with tops shaped like a parasol, funnel, or disk-shaped platform surmounted with different figures, were also made by the royal blacksmiths. Like the stools, statues, and textiles, the metal *asen* were displayed at the time of festivals given in memory of the dead kings, for whom they were the altars. The *asen* figures are extremely varied. In iron or hammered and plated brass, they harmoniously combine with the platform disks, pendants, arms, balls, rings, and tubes that compose the different upper parts of the *asen,* and whose forms and embellishment can be symbolic. Better, it seems, than the sculptor, the potter, or the appliqué maker, the blacksmith endeavored, or was able for technical reasons, to exploit to the maximum the richness of images suggested by the royal discourse resulting in the half-hieratic, half-mobile forms that are among the most accomplished of the Abomean art.

The blacksmiths of the kings were also goldsmiths. Precious metals —first silver, then copper—were used to make numerous jewels, emblems of prestige, figurines, and varied trinkets destined not only to

enrich the royal treasure but also to be displayed at the court. These objects, executed either by lost-wax casting or by hammering and plating, included a pair of cuffs worn by the dignitaries, pendants, bracelets, anklets, necklaces, rings, boxes, pipes, tinderboxes, and scepters.

Although calabash engraving was not an aristocratic art, the most beautiful pieces reverted to the king or the dignitaries while the simply pyrographic calabashes were for ordinary use. Treated most often in parallel sections with pleasingly stylized geometric and animal motifs, numerous calabashes came from the Bariba, the Atakora, and the Borgu in north Dahomey. The more richly embellished calabashes of Abomey, which display a truly animated design on their potbellied surface, were, according to M. J. Herskovits, "principally used for amorous messages." Their narrative conception is similar to the bas-reliefs and the appliquéd textiles.

The professional organization of all these arts (with the exception of calabash engraving and especially wood sculpture) stems from their servitude to the limited and prestigious clientele of the Abomey court. From Ouegbadja to Glele, and in particular under Agadja and Agonglo, the hereditary family structure of the artisans assumed its definitive form. At the same time, important workshops, installed in sections close to the palace, were organized around patrons (heads of family or esteemed artists). Such a corporate structure was solid enough so that the artistic production could respond to a modification in the clientele.

The influence, almost throughout Dahomey, of Yoruba immigrant families, which were already there when the Adja came to occupy the arid plateau of Abomey, the influence of the Akan kingdoms, the Christian influences (European since the eighteenth century, Brazilian since the beginning of the nineteenth)—all these influences were determinants in the evolution of the Dahomean arts. Assuredly, in their pre-Yoruban and pre-Abomean form, these arts had a certain number of traditions that remain unidentified. This is why the art that did not have the benefit of the formalist but original standards

of the Abomey court, especially sculpture in wood, is extremely diverse and complex. Nevertheless, it is finally Yoruba influence that evidently dominates in this sphere of Dahomean sculpture. Not only was the Yoruba cultural contribution going on before the consolidation of the Abomey monarchy, but also the Yoruba immigrations continued unceasingly. Furthermore, the attempts at conquest of the Yoruba capitals by the descendants of the Adja (the Fon) supplied the country with captives, certain of which became artisans in the royal workshops. The diviners, rarely sold to the slave traders, perpetuated a decadent cult of the *fa*. Along the fringe west of colonial Dahomey, the kingdoms of Save, Ketu, and Porto-Novo are veritable reservoirs of artistic substyles, transmitters of the Nigerian cults that mingle their deities with the old indigenous deities that govern identical forces. Although it is easy to recognize Yoruba art in Dahomey, it is difficult today to distinguish a specifically "Fon" art. To this art, however, belongs a statue of a woman carrying a moon crescent, the only known representation of the great god Mahu, of Adja origin, the female aspect of the bisexual creator god.

The popular sculpture gives a material form to *bochio,* the guardian spirits of the household who help Legba in his protective activities. These touching sculptures, unknown in Yoruba country, seem to arrest in action a personality that is an integral part of the trunk of a tree or that appears to have just momentarily issued from it. Sometimes the *bochio* is only a simple small figure placed on the ground, covered with blood, palm oil, and several chicken feathers, or mixed in the confusion of an altar devised of stones, pottery, and irons. According to Christian Merlo, who between 1928 and 1938 studied the local plastic arts in Dahomey itself, these *bochio* are excellent examples of a popular Abomey style whose characteristics relate to Adja statuary, an ethnic group including among other people the Fon and the Gun, who played a dominant role in the ancient history of the country.

But the round stools and polychrome figures, the divination cups, trays, and bells, and the figurines of twins belong to Yoruba culture.

In Dahomey, the purest Yoruba style is preserved by the artists of the Ketu regions, where, as among the Pobe, the art of the *gelede* masks attains a rare quality.

The arts of Dahomey form a hybrid assemblage. The royal Abomey art is one of both a dynamic and a formalistic society. Its very hierarchic organization could not prevent the art from finding ways to express its major preoccupations in images that show a strong taste for movement, for daily activities as well as exceptional events, in other words a great love of life. The traditional regional arts probably could not be deprived of these qualities, and the diverse influences that they underwent contributed to their development.

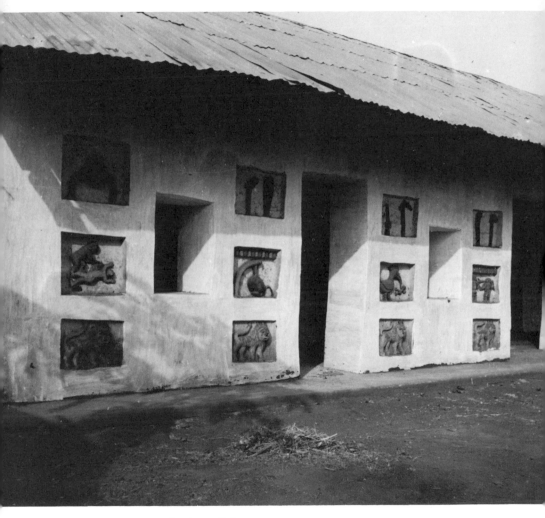

54. Wall decorated with bas-reliefs.
Palace of Abomey, Dahomey. Photo
Pierre Verger.

55. Cult place. Porto-Novo, Dahomey. Photo ►
Dominique Darbois.

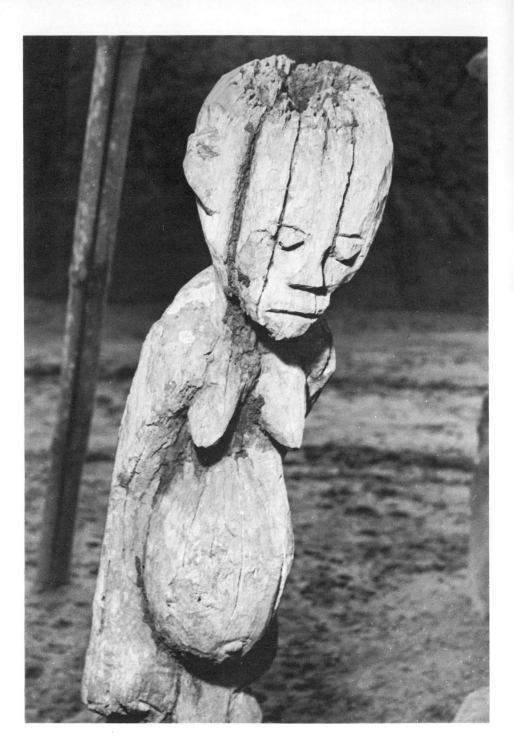

56. *Bochio.* Abomey, Dahomey. Photo
Dominique Darbois.

57. *Asen* with a representation of a chame-
leon. Abomey, Dahomey. Musée Histo-
rique d'Abomey, Dahomey. Photo
Pierre Verger.

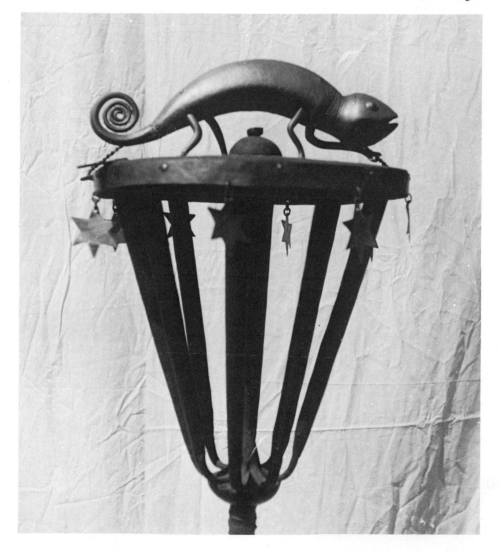

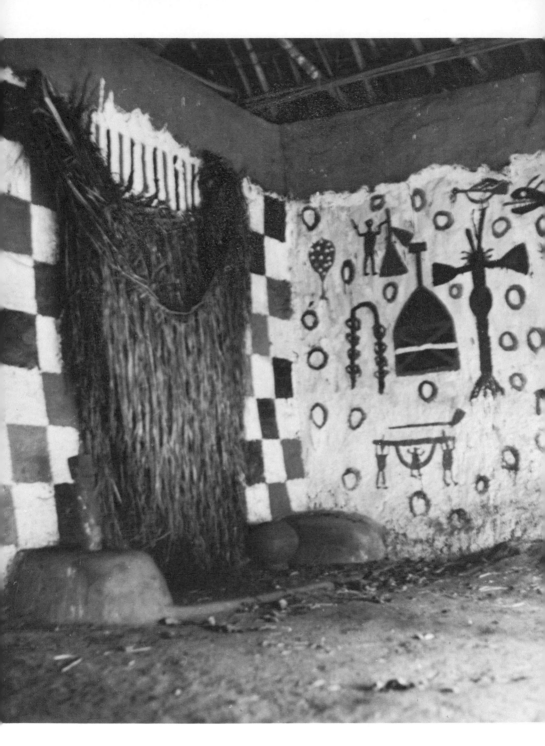

59. *Legba* in Abomey, Dahomey.
Photo Dominique Darbois.

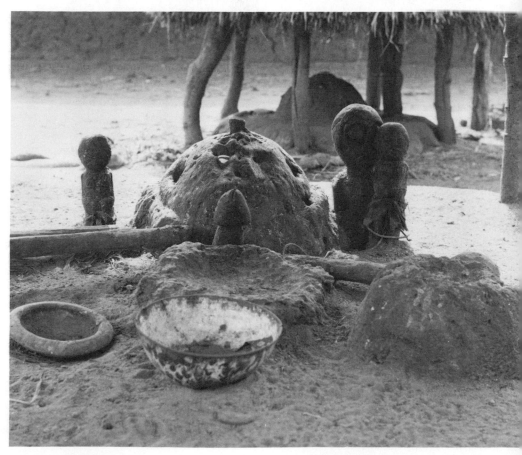

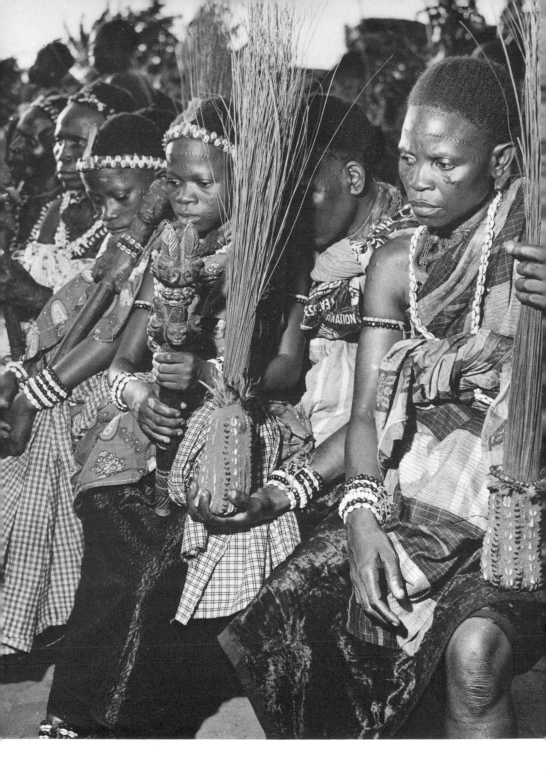

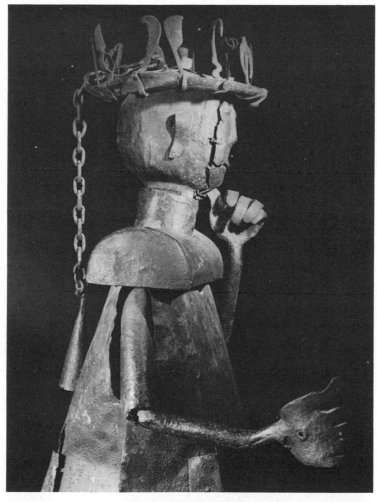

61. The deity Gu, god of arms and war. Iron. H. $64^{31}/_{32}''$. Fon, Dahomey. Musée de l'Homme, Paris. Photo José Oster.

Nigeria

The most important human concentration on the African continent
—more than twenty-three million people—is in Nigeria. In dry and
wet zones alike, the most impressive demographic densities of black
Africa are found, specifically in the Hausa and Fulani states to the
north, in the Yoruba area to the south, and particularly in the Ibo
territory of the southeast. Also, a certain number of basic historical
currents came together in Nigeria. In the north, the Sudanese savanna
was always open to the trans-Saharan trade routes, carriers of cultural
forms. The region at the confluence of the Niger and the Benue is an
ancient theatre of migrations, trade, and conquests. It is not surpris-
ing that with the particular richness of its human and physical geog-
raphy, Nigeria's environment favored the flourishing of highly diverse
artistic expressions.

Since 1911, when the inhabitants of the Bauchi plateau had to
abandon their traditional methods of tin mining for more modern
techniques, the alluvial deposits have little by little provided numerous
examples of an archaic human industry. The Jos Museum, which was
founded very early, collected cut and polished axes as well as micro-
lithic tools. Around 1931, two terra-cotta figures were unearthed, but
it was not until the spring of 1944 that new discoveries brought to
light the existence of a homogeneous stylistic assemblage. Heads and

fragments of bodies were exciting evidence of a vanished culture, or at least one become inaccessible in its ancient context since the inhabitants of the area, the Jaba, seem scarcely to pay attention to the pottery dug out of their soil and now use abstract headdresses in their rituals.

These works, discovered by Bernard Fagg and organized under the heading "Nok culture," come from villages that are somewhat apart from each other. In Nok itself, a number of pieces were found, including a head of a "monkey," a seated "monkey" with raised knees whose head and part of the bust were destroyed, a fragment of a kneeling figurine, a head with a coiffure of five chignons, and a bearded figurine with a scarred face and braided hair under a sort of skullcap with a basket-weave design. Twenty-five miles from Nok in Jemaa, two heads were dug up. One had a face with plump cheeks and lips pursed like someone whistling. A fine man's head with a short pointed beard and narrow triangular face extended by an overhanging and hypertrophic skull was found in Wamba. All the terra-cotta figures found in this region, discovered by chance at a depth of about twenty to twenty-six feet, are remarkable for the realism of numerous corporeal details, a realism which in the same work borders on the stylized treatment of another element of the pottery. This free and always very sensitive technique permits very diverse creations like the anguished head that seems afflicted with a harelip, the chubby figure that William Fagg compares to a "gargoyle on a gothic cathedral," the bearded aristocratic head, and especially the fragment of a figure reduced to its affecting base, an ornamented foot and ankle resting on part of a sphere that also supports the other bent leg with a round and supple thigh. But a certain number of characteristics common to these figures reveals their probable identical origin. In addition to their expressive quality, they often have dimensions approaching life size, a geometric treatment of the eyes and eyebrows, and finally a perforation technique of the eyes, nostrils, and ears. These works, which date from the first millennium before Christ, are for the present the oldest sculptures that have been found in black Africa.

William Fagg, formerly more circumspect, today acknowledges the relationship of Nok art with Ife art, which could have only flourished a thousand years later. Frank Willett even more precisely writes, "Everything takes place as if the art of Ife developed from that of Nok." Nok art would then be an announcement of Ife art and would testify to the existence of already well-developed aesthetic traditions a thousand years earlier.

The first known specimen of Ife art was a throne in veined quartz. It had a double platform separated by a cylindrical shaft furnished with a handle in the shape of a very large, supple loop. The throne is very reminiscent of the wooden stools of the Benin chiefs, whose two platforms were joined by the last bend of a serpent's body. Offered to the British Museum in 1896, the throne apparently did not arouse any special interest at that time.

The plaster cast of a terra-cotta head presented to this museum in 1905 attracted more attention, but it was not until the discoveries made by Leo Frobenius in 1910 that the specialists became really excited. These discoveries consisted of "large urns inside of which molded glass objects and glass beads were found . . . , art objects of quartz very painstakingly carved, representations of crocodiles, human heads, various objects from large stools to deliciously worked loops. . . ." The most remarkable objects were terra-cotta heads and torsos and a large head of cast brass.

In 1938, seventeen bronze heads were found in Ife itself. Ten years later, some terra-cotta heads came to light in Abiri, a small village on a cocoa plantation about nine miles from Ife. At the end of 1957, five bronzes and six terra-cottas were dug up at Ita Yemoo, "the place of Yemoo." More than sixty accomplished specimens should be included in the Ife work known today. Here, the technique of lost-wax casting reached unmatched perfection. Heads in bronze or terra-cotta represent men, women, and animals. Bronze full and half figures, terra-cotta torsos, bronze vases and staffs, and stone stools, figures, and animals were among the examples.

To Westerners, the human heads are certainly the most familiar Ife

art objects. But the tendency to see them only as figures conforming, as though by a miracle, to our classic canons, or resulting from Mediterranean influences leads one to ignore the astonishing series of portraits that they constitute. Indeed, the evidence of very precise forms given to the facial features clearly confirms the existence of different physical types. All the bronze heads evoke the Ethiopian type in their appearance with the straight bridge of the nose forming a very slight beak at the end. But if some of the terra-cotta heads seem somewhat similar, most differ from this type. Does the diversity of these figures correspond to certain events of the original history of the Yoruba and the people to whom they are related? Arriving in the Ife region from the east around the eleventh and twelfth centuries, the Yoruba would have found societies of hunters and farmers among whom they would intermingle. These societies already had a complicated history and the Yoruba themselves arrived in successive waves, each of which differed from the previous one. The kingdom of Ife, then, would have been organized out of complex ethnic data. William Fagg thinks today that the Yoruba must have been established in western Nigeria from the period of the Nok civilization, but that does not exclude their having subsequently received other influences.

Numerous faces of bronze or clay with different morphologies are entirely covered with closely placed lengthwise parallel scarifications. The neck is finely ringed, the almond eyes are sometimes sunken and encircled, the ears are carefully edged, and the lips are modeled with extreme sensitivity. Often, a row of holes runs along the top of the forehead from one ear to the other; another row encircles the chin and divides in two to separate the nose from the upper lip. The presence of these holes was the first indication of the African nature of Ife sculpture. The holes must have been used for attaching false hair, natural hair, animal hair, small cords, or little black glass beads. African masks frequently still show vestiges of this practice of adding material, for example, those of the Ekoi of southeast Nigeria, or the Dan, the Webe, and the Kono of the Guinea forest. More rarely the nonattached hair is part of the work as a whole. Then it extends from

the bronze tiara on the upper part of the forehead and falls down over the nape of the neck. A head wearing a skullcap with three tassels is portrayed this way.

Found by accident like all the works of Ife, during earth moving or mining, the bronzes discovered in 1957 are of greater interest because they are well preserved. An *Oni* of Ife is shown standing, dressed in his enthronement costume. The headdress, a triple-tiered beaded tiara, has in front an ornament of a rosette surmounted by a sort of braid with a pompon. This ornament is found again on the head of the Yoruba god Olokun and on other bronze heads in the British Museum. In his left hand, the *Oni* holds a horn and in his right a sort of beaded staff, which after the coronation ceremony (according to the present-day *Oni* of Ife) must be replaced by a beaded fly whisk. Other bronzes found at Ita Yemoo, which have remarkable style, are two staffs and two egg-shaped objects, probably tops of staffs that are perforated so that they could have handles. They support two inverted heads of old men who have a finger on the lower lip and who are gagged, possibly images of victims trying to utter cries that the ritual disapproves. An anthropomorphic club is the object brandished by an *Oni* coiled around a bronze cup and sitting on a high stool with a handle, similar to the thrones of Ife. The extraordinary flexibility of the spiraled body is continued in the movement of the arm, which corresponds to the indolent curve of the handle.

The bronzes and terra-cottas are not the only manifestations of the richness of Ife art, for its works in stone are also remarkable. Less than a mile from the center of the village, the path that leads to the sacred grove of Ore is adorned with upright stones dedicated to Ogun, the god of iron, and opens out onto little clearings that shelter the stone statues. One individual dressed in a loincloth with short legs and hands joined on the stomach is Idena, the wife of Ore, the mythical hunter. Her hair is iron nails, a braid hangs on her left cheek, and her neck is ornamented with two necklaces. Nearby, in another clearing, stands Ore's servant, who looks like a dwarf and also crosses his hands on his stomach. In another grove, a smaller statue of soft stone in a

kneeling position with its hands flattened on its chest is much more recent and takes up another cult.

These statues pose additional problems to those already raised by the terra-cottas and the bronze pieces. Are all these works relatively contemporary? The use of stone could at least partially account for the sensitive differences of style between this statuary and the clay or metal statues. Although archaeologists and specialists in Nigerian ethnology tend to place the stone works in a period prior to the organization of the Ife kingdom, they hesitate to attribute them either to the first waves of Yoruba migrants or to the Igbo, who already occupied the region before the arrival of the Yoruba, who then absorbed the Igbo.

This "humanist" type of stone sculpture is not unique in West Africa. In Mali, for example, in the lower Bani region (in the area of Mopti and Djenne) much smaller figurines and fragments of others (four to five and a half inches high) were found. Their faces are more summarily carved but they also have the harmonious suppleness of the Ife stones. In the Nigerian province Ilorin, in the village of Esie, nearly a thousand figures were discovered in 1934, scattered in the grass in the midst of some shrubs. Today they are crowded together on several steps under an octagonal shelter whose open-air center is a garden. Each year in March on the day of the march to Esie, the religious festival assures the population of the protective power of these statues. All these heads and seated torsos have a rather homogeneous style that is reminiscent of Nok style. Certain figures, however, evoke the Agni funerary heads, and others, the bearded masks with tiaras of the "grassland" inhabitants. The origin of Esie stone sculpture remains in question. Attention turns more toward the Nupe, whose tribal marks recall the scarifications of certain Esie heads. Incidently, the adepts among the followers of the Yoruba god Shango appear to play an important role during the annual ceremonies that take place around the stone images in the midst of hunters' gunshots and the crackling of the surrounding grass as it burns in a purifying fire.

A discussion of Ife art naturally leads to Benin art, for the kingdoms

of Ife and Benin are related by myth and political traditions. Under the reign of the sixth *Oba,* Oguola, toward the end of the thirteenth century, according to tradition, the techniques of bronze casting were imported to Benin. Like the Ife sovereigns, desiring to preserve the memory of famous events and to perpetuate the images of the chiefs as well as the symbols of their power, Oguola requested the Ife *Oni* to send one of his bronzesmiths. Igue-igha, who was the most talented one of all, came to initiate the Bini into the art of metalwork. Nowadays, the guild of bronzesmiths still pays him homage.

A very small bronze figure, found in the approaches to the *Oba*'s palace at Benin, highlights the purest tradition of the Ife artists. It has the extreme fineness and shows the same details in the clothing and ornaments as found in the terra-cotta torsos and the bronze images portraying the *Oni.* Some of its ornaments are identical with those that the present *Oni* wore during his enthronement. Is this a piece that was offered by the Ife sovereign, the spiritual chief of the Benin, to the *Oba,* or is it a specimen, miraculously preserved, of one of the first pieces made by Igue-igha, or one of his students, or by another artist coming from Ife? In the beginning, at least, artistic relations must have existed between the two great cities, Ife the initial home, and Benin the new technical center, in the form of the comings and goings of a limited number of artists.

The artists of the Benin kingdom made a considerable number of objects. This art lasted more than five centuries, from the period when it was no more than a perpetuation of Ife style and technique until its final decadence in the nineteenth century. This long period corresponds to an aesthetic evolution that certainly was parallel to the evolution of the political structures of the kingdom.

Undoubtedly, during the first phase of Benin royal history artistic influence of Ife was much stronger than social influence, which remained a prisoner of the mythical framework in which were enclosed the kingdoms that were supposedly derived from the creation of the god Odudua. The traditional links between Ife and Benin were expressed materially at the time of each enthronement or funeral cere-

mony of the *Oba*. For the coronation, the *Oni* of Ife sent prestigious gifts and emblems of power to the new sovereign. At the time of funeral ceremonies, the village in mourning received from Ife a bronze portrait of the deceased king. The art of the bronzesmiths was established very slowly in standardized production for the use of the court and its sovereign. The inspiration coming from Ife had to diminish and Benin monarchial life had to be organized. Under Ewuare in the middle of the fifteenth century, the arts of bronze and ivory, encouraged by the *Oba* himself, assumed a great importance. This first period of Benin court art is characterized by extreme fineness of casting and, in the treatment of the face, by a sensitivity that did not continue. The beautiful heads, portrayals of queen mothers, with beaded, henin-shaped headdresses, are attributed to the first half of the sixteenth century. *Oba* Esigie would have had these heads made in homage to his mother, Idia.

Two events have unquestionably influenced the evolution of the royal art of Benin: the contacts between the city and the Portuguese —ambassadors, Catholic missionaries, and merchants—and the political and economic transformations of the monarchy. Already at the peak of its glory, Bini royalty, in order to resist the tidal wave of trading and commercial competition that had invaded the states of the Gulf of Guinea, had to increase its prestige. From the end of the sixteenth century to the eighteenth a solemn nature dominates the works of art. Thinness of material is replaced by massiveness. The spiritual quality of the first works is effaced and the expression of the social values establishes itself by means of a fixed range of sculptural emblems. But the decorative and narrative techniques are developed. It is the most prolific period, nourished by the abundant flow of European bronze, which is substituted for Saharan copper, imported since time immemorial. The most famous works are certainly the rectangular bronze plaques with figures in relief and the carved ivory tusks. Nevertheless, it is difficult to draw up an exhaustive list of the different categories of objects created by the artisans of the court in bronze, brass, iron, ivory, wood, and beads: altars, standing figures, figures

seated, and on horseback, or animals (the cock and the leopard, most often); heads, plaques, pendant masks, bracelets, necklaces, belts; combs, anklets, mirror frames, key rings, fly whisks, fans, games, neck rests, lamps, stools, vases, stirrups, knives, staffs, bottles, headdresses, boxes, etc.

All the works of art were entrusted to specialized guilds. Blacksmiths, brassworkers, sculptors of wood and carvers of ivory, leatherworkers, weavers and embroiderers, and drummakers occupied separate sections of the half of the city inhabited exclusively by artisans, priests, diviners, masters of ceremonies, and numerous dignitaries of the palace. On the other side of a large avenue, the second half of the town the vast and complicated palace of the *Oba* formed an autonomous group. Each guild was affiliated with one of the associations of the palace, whose respective chiefs thus insured the contacts between the artists and the sovereign himself. Bronzework, which had received a lively stimulus from the *Oba*s Ewuare and Esigie, was practically under the total control of the king. The bronzes made to represent deceased kings on the altar were involved in a very detailed ritual process. Did not the well-being of the country depend on the rigorous fidelity of the king to the prescribed protocol and, after all, did not the *Oba* possess divine attributes in his own physical being?

In the seventeenth century, the bronzes reached the summit of decorative florescence, from which, beginning with the first half of the nineteenth century, exaggeration proclaimed the decline. The *Oba* Osemwede added bead ornaments to the bronze heads forming two wings on each side of the royal headdress, off of which extended another embellishment like a fine tusk on each cheek. At the same time, the heads became dull. The faces diminished in importance for the sake of the base, which had to support the weight of a long carved tusk.

At the end of the last century, hundreds of works in bronze and ivory found by Admiral Rawson's expedition were sent to Europe. The discovery of these works in a Benin that was bloodstained from sacrifices and massacres unfortunately linked them with the least in-

teresting period of Benin's history. These bronzes and ivories aroused such astonishment and admiration in Europe that until now the "Benin" label had to be applied to all Nigerian bronze or ivory pieces of quality and was wrongly coupled with objects originating from the tributary provinces of the kingdom and even from the autonomous regions. But today, it is known that between the delta and the confluence of the Niger and Benue rivers, centers of metallurgical art have developed independent of the center at the court of Benin. The metalsmiths of Ibo, Allabia, and Idah, for example, have applied the technique of lost-wax casting with great imaginative freedom. The bronze figures of the Tada and Jebba villages, connected with the history of the founding of the Nupe kingdom, are comparable in quality to the Ife works and also to Benin's at the time of its splendor. The Jebba archer, and especially the Tada statue called "Gara," originate from the same narrative and creative style that is admired in the small statues of the dignitaries and warriors of the Benin court. The small but perfect crouching figure of the Tada has both the sensual and the idealized appearance of the Ife figures. Carefully preserved today by the Nupe, the figures are invested with a prestige that is more magical than religious.

West of the banks of the Niger, in the swampy plains of the Uhrobo country northwest of the delta region, in the flat and sandy province inhabited by the Bini, on the Ishan plateau covered with high forests or in the granite land of the Kukuruku, east of the river among the Igala and the Idoma in the confluence region, on the two banks of the Benue among the Tiv, more to the east of the Benue among the Jukun, near and beyond the Cameroun border among the Chamba, the Kutin, the Kaka, the Mambila, and others, and, finally, halfway to the Jos plateau and the Benue current among the Mama and the Jaba—in all these regions as in the Nok area diverse traditions are the source of little-known sculpture. Great creator gods, spirits of the waters, ancestors, which in the Benin kingdom were absorbed in the royal cults, were paid faithful homage by the minor chiefs and the villagers. For

these rituals, for the village festivals, or to respond to domestic traditions, which either were local or derived from the grand themes of Benin and Yoruba culture, statues and masks were carved using the borrowed techniques of neighboring peoples, the Ijo and the Ibo of the coastal region, the Yoruba, who were the closest, and possibly those of the Ijebu, Ondo, or Ekiti provinces. The Bini made majestic wood antelope and rams' heads, which were replaced during the nineteenth century by carved copies of the royal cast-bronze heads. Worn horizontally on the top of dancers' heads, bell-shaped headdresses with a geometric face above a neck with a polychrome checkerboard pattern or with a half-animal, half-human head have the same provenance. The rams' heads are also found among the Kukuruku and the Ishan, whose works, like those of other Edo language tribes, have still hardly been investigated.

The Tiv, the Jukun, and the Chamba on one side of the river and the Afo and the Mama on the other tend to create simplified forms that are sculpturally very rich because of an extreme boldness in the combining of the various parts. The more familiar masks of the Jukun, whose divine kings were ritually succeeded every seven years, exalt the ancestor cults or the minor divinities more than the royal or cosmic cults. The mask of the spirit Akumaga, who participates in the rite of the renewal of the dead in the beyond, is a striking example of the tendencies of these societies toward abstract sculpture. The actual human figure is reconstructed into a very different image. The nose and the long loop, a neck ornament of the male Jukun, which is an object of respect, are represented by little protuberances.

Among the Tiv, the sense of beauty is very alive and their interest in an aesthetic of body ornament is expressed in many ways. The scarifications of the face are very diverse and those on the backs of women are true bas-reliefs in which very stylized representations of birds, scorpions, lizards, and fish predominate.

The ancient Afo statuary, of very high quality, suggests both the vitality and the plastic of Yoruba sculpture and the stylized hieratic intensity of the Dogon. The wood bell mask of the Mama, a small

tribe settled at the foot of the Bauchi plateau, is especially familiar. Representing a bovine creature, the bell masks are worn by dancers covered entirely with leaves during ceremonies for the reinvigoration of the social group.

Unquestionably, the Yoruba country provides the first materials for organizing a true history of traditional African art. It is certain that the persistence of the ancient political and religious traditions, supported by faithfully transmitted mythological traditions, enables this culture to be expressed through an art that reflects the unity of the demographically important Yoruba society. This art has remained essentially naturalistic. In Yoruba statuary and masks, whose crests usually also may be considered sculpture, the characteristics of the terra-cottas and the bronzes, which belong to the Nigerian past, are easily recognized. The modeling of the face is always rich; the heavy eyelids fall over the concave, almond-shaped eyes, whose whites stand out. The nose is fleshy and its bridge straight, the two lips thin and parallel. Taste and the capacity to express a certain suppleness of the body have persisted.

If this art appears homogeneous, it is because of the cohesion of the political system and the stability of the religious structures. Such conditions also permitted the flowering of local institutions. The production of original creations developing out of cultural preferences could be given free rein within the "national" framework. Systematic research revealed the existence of substyles at distinct levels: provincial, village, and individual. One particular style was developed in Abeokuta, Ondo, and Ekiti provinces, for example, no doubt in part because of the influence of several sculptors or families of local sculptors and because of the existence of professional groups organized around a chief. The techniques of artists like Ologunde in Efon Alaye, Bamgboye in Odo Owa, or Olowe of Ise are personal enough for their works to be identified by a connoisseur.

Among the Yoruba, as in most African societies that are established in the soil in a stable and orderly way, the form of art usually chosen

is sculpture in wood. There will not be a solution to the apparent continuity between the old and new works, for no decisive blow has yet been dealt to the sources of inspiration: the cults of the deities of the Yoruba pantheon (such as Shango, god of thunder and lightning; Ogun, god of iron and war; Osun, goddess of the waters and wife of Shango; Eshu, malicious god of chance and fate); cults of the local heroes; family cults (especially the cult of twins); political institutions; divinatory processes; and finally male society rituals.

The activities of the *epa* society in Ekiti province, the *gelede* society in the region located southwest of Yoruba territory and among the Nago in Dahomey, and the *egungun* society in the major part of the country require the creation of masks whose interpretation varies greatly from place to place. The same representation, for example, of a woman with child, the *epa* mask of Ekiti province can have different meanings. In one village she represents the ancestor of an old district, in another the daughter of a king, in a third the priestess of a deity, and finally she is the mother of numerous children and, in this specific case, a symbol of fertility. This *epa* mask contrasts an important naturalistic superstructure treated in a characteristic Yoruba style with a lower part, a bell mask in the shape of a human head with summary features, sometimes schematized, sometimes simply exaggerated. Upon the sign of the priest of the *ifa* oracle, the masks are carved to receive the spirit of the deceased, and the *egungun* society collects them. During June these masks come out to dance, thus permitting the ancestors to express themselves through the intermediary of a voice with the inhuman accents of the possessed wearers. Most often the *egungun* appear under forms of astonishing and fragile constructions of fabric, leather, or small threads to which monkeys' skulls, cowrie necklaces, and various medicines are attached. The dancer, a multicolored phantom, disappears under the whirling array.

The masks of the *gelede* society represent a complete human head. The face, scarred with tribal marks, is projected forward. The features are rather conventionally portrayed; the globular almond-shaped eyes,

the thin and parallel lips, the nose with a fine bridge and fleshy nostrils, typical of the specimens of the old art, are all found on these masks. They are made of light wood, which is generally painted and they are either coiffed with bonnets that extend the tilt of the face further back or are crowned with sculptural compositions. The various subjects of the superstructures enable the Yoruba sculptors to exercise their talents for animation by drawing upon daily religious traditions or even modern Western mythology. These masks appear in daylight, intervening in the least "sacred" part of the dances because the civilizing heroes embodied by the nocturnal dancers are absent. It seems that this association, whose chief, *Iyalashe,* is a woman, aimed to neutralize the eventually maleficent effects of female forces. The powers of *Iyalashe* are great and recall the prerogatives of certain female beings, substitutes, that are more or less remote from the most important woman conceivable: the mother of the king.

Masks and statues do not complete the section on Yoruba wood sculpture. The royal palaces of the various provinces are rich in carved doors and columns, in which the style of certain regions or of previously mentioned master sculptors is recognizable. There are a number of material objects known pertaining to the *ifa* oracle, a very popular institution in Nigeria and Dahomey. Circular, rectangular, or half-moon trays were made with a border decorated with anthropomorphic figures and simple motifs endowed with symbolism. On the tray covered with a vegetable powder, the diviner with the middle finger of the right hand inscribes the signs shown by a manipulation of the palm nuts that are habitually kept in carved cups. When he recites his invocations, the diviner strikes the tray with the end of a carved tusk or a piece of wood carved in the same shape. These instruments are sometimes hollowed out and provided with a clapper.

Among the Yoruba works in wood, there are also the large *agba* drums of the *ogboni* society, whose extremely stylized bas-reliefs on the sound box illustrate several themes of the ancient myths. Most of the brass figures cast in lost wax come from this same society. The best known are the *edan,* figurines ending in a pointed shaft, which

always form a pair whose heads are united with a chain. Emblems of an archaic cult, instruments of putting to death or sculpture messages, the *edan* are kept in the secret sanctuary of the cult house.

Finally, in addition to sculpture on wood and the art of metal and ivory, the most original pieces of which come from the artists of the city of Owo, the art of beading must be mentioned. It is practiced by artisans, the majority of whom originated from Efon Alaye and who traveled throughout the country, making dance headdresses, fringed crowns, and ornaments for sacred objects on demand.

Essentially a swampy zone extended by dense forest where the water ends, the provinces of the south are the home of prolific and complex arts. The artistic boldness, sometimes abstract, borders on and combines with concise caricature or surrealistic creation. The ancient peoples who came into the region, going to the sea or stopping nearby, found there a particularly rich and suggestive physical universe. Because of borrowings, a rather close relationship is evident among all these arts, although, for the most part, they tend to be original conceptions.

The Ibo society is cut up into multiple village communities, and numerous practices develop autonomously. The masked festivals, for example, according to the circumstance, enhance the carnival (a theatrical and parody-like atmosphere, total participation of the public, a spirit of competition), the sacred rite (the spirits of the ancestors, the water and earth deities are invoked and manifest themselves), or the social institution (the young people are educated by initiation to the masks; the community expresses its structure through ostentatious funerals and agrarian ceremonies). The functions of the Ibo sculpture are extremely varied and it is difficult to follow its proliferation both in Onitsha province and its surrounding area in the north and in Owerri province to the south. The masks of the *mmwo* are quite well known. These are bell masks whose feminine coiffure with a very elaborate crest could constitute a sculpture in itself. The representation of the loops of hair, the combs, and the openwork superstructures are

very accomplished. In the northern part of the country, the most spec-
tacular of the village dances, the *ayalugbe,* requires beauty and dig-
nity. During the dance, seven masks representing young girls and
their mothers are exhibited. Some of these masks, the *ijele,* for ex-
ample, combine wood cores with costumes of felt or material stuffed
with grass. The role of fabric, costume, and its trimmings is essential
and can demand the work of professional tailors or specialized artists.
Again in the north, certain masks, which are worn longitudinally,
mingle human and animal features and are related formally (plastic
coincidences exist!) to the great masks of the Baga and the Toma. In
certain southern villages each family group has one or two figures.
Carved with a geometric precision of hard wood, they are covered
with a patina of black and shiny soot. Tops of headdresses, they rep-
resent a woman seated on a stool. They end in a cylindrical base,
which, fixed to an oblong basketry cap, is worn on the top of the head
of the *ogbom* dancer, who is dressed in white cloth. Zealous bor-
rowers, the Ibo claim to owe this cult to their neighbors the Ibibio,
and in actual fact these figures are connected with the Ibibio style,
although also with that of the Ekoi. Unquestionably, the *ikenga* are
the best-known sculptures that they share with numerous neighbors.
These horned human figures are associated with good fortune and the
power contained in the right hand. The circumstantial reasons for
which the *ikenga* were made determined the details of the sculpture
as well as the colors.

The artistic talent of the Ibo is likewise evident in pottery. The big-
bellied surfaces of the vases connected with the yam cult are covered
with serpentine channels painted black or with rich, lazily geometric
moldings. Sculptors, producers of elaborate spectacles in which mas-
querade is combined with sacred drama, expert potters, and bead-
workers, the Ibo also have worked with iron for a long time. Further-
more, certain bronzes found near the village of Akwa, still famous for
its blacksmiths, bear comparison with the bronzes of Ife or Benin.

A number of Ibibio pieces are often encountered, such as figurines
with jointed limbs that are used as marionettes, masks with a movable

lower jaw, masks that are carved in high relief on a wood base or furnished with side shutters, and even masks with faces that are apparently deformed and devoured by a terrible disease. All belong to *idiong* and *ekpo,* the two most important Ibibio male societies, in which the spirits of ancestors, witch doctors, and diviners play an active role. Neighbors of the Ekoi, river people dwelling on the Cross River, the Oron, an Ibibio subtribe, give revealing and aesthetically original forms to their ancestors. On the other hand, the Ogoni of the Atlantic coast have developed a rather personal and curiously polymorphic sculptural art from the cultural themes and plastic techniques of the Ibibio, of whom they are probably the parents.

The tendency toward exuberance linked with a quest for equilibrium and even symmetry, the taste for superstructures and tiered composition are also expressed in the architecture of the Ibo and the Ibibio. Village temples, funeral monuments, and family houses have painted walls, carved doors, and ornamented pillars. In the sacred rooms, astonishing figures of the fundamental deities and beings in clay painted and dressed according to the most diverse formulas are found.

The heads of the *ekpo* society are the most familiar works of the Ekoi, who live east of the Cross River and beyond the arbitrary boundary that separates the Camerouns from Nigeria. They are covered with antelope skin and have natural hair, or hair represented by pins. The very expressive face displays metal teeth. The neck is attached to an enlarged base of stiff basketwork made with strands wrapped on hoops. Sometimes the head has horns or presents two faces back to back. Like the Ibibio and particularly the Ibo, the Ekoi (from whom their neighbors have borrowed a great deal) have also embellished their sanctuaries with remarkable mural paintings. Their facial paintings with motifs of detailed elegance, which the designs of the headdress echo, suggest the faces of the Ibo female masks. The techniques of pottery have also achieved a refined grace among the Ekoi.

In the appropriately termed delta live the Ijo, who were probably pushed toward the sea by the inhabitants of the dry area. For them,

mythology of water attains an extraordinary breadth. This archaic and conservative society has an original aesthetic that flourished uniformly in three regions: in the west, on the lower Niger, and in the Kalahari. The ancestor cults and cults of the spirits of water and earth require multiple altars furnished with anthropomorphic pottery, statues, pillars, and sculptured cylinders. Deceased chiefs are honored through the intermediary of large rectangular panels to which individuals with jointed limbs are attached. All the Ijo masks are worn horizontally, recalling, it is believed, the disposition of the marine spirits floating on the surface of the water. The cycles of the festivals of the *sekiapu* society, which evoke these innumerable water spirits, stretch out over a period of twenty-five years. Uniting the characteristics of the Ibo style with the powerful geometry of the Ijo, the *egbukele* mask of the Abua, a spirit of fertility, man, hippopotamus, or fish, epitomizes the sculptural qualities so evident in southern Nigerian art.

62. Terra-cotta head. H. 10$\frac{17}{32}$". Nok civilization. Nigerian Museums. Museum photo.

63. Terra-cotta head. H. 9¼″. Ife. Nigerian Museums. Photo British Museum, London.

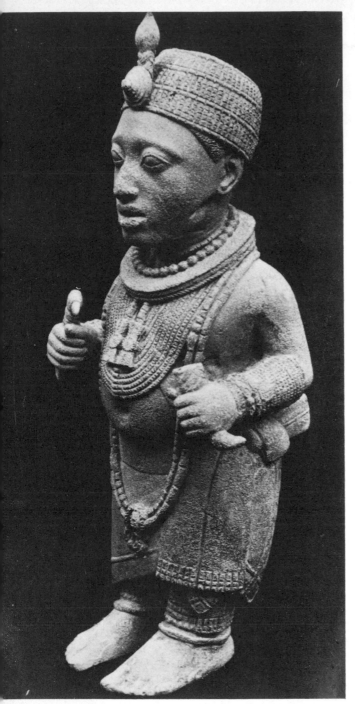

64. *Oni* of Ife in court dress. Bronze. H. 15¹⁹/₃₂″. Nigerian Museums. Photo Musée de l'Homme, Paris.

65. Ivory pendant mask. ► H. 8²⁵/₃₂″. Benin court art. British Museum, London. Photo British Museum.

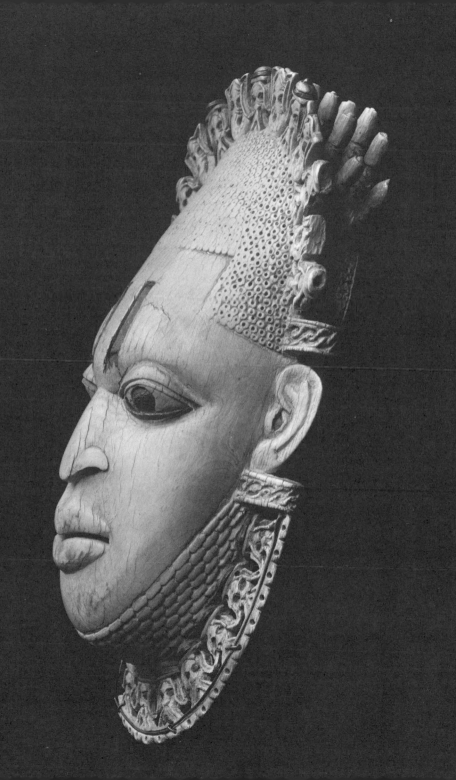

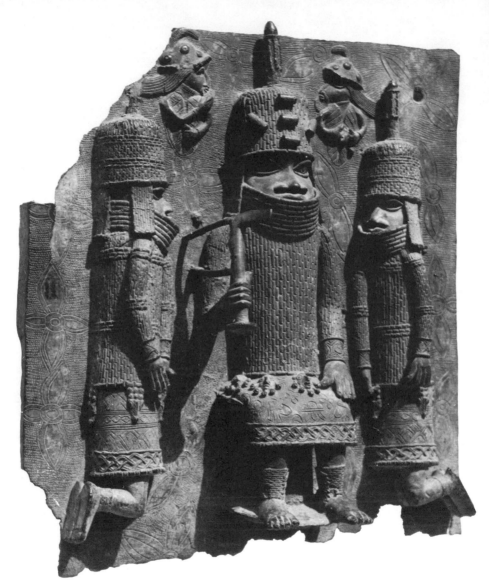

66. Bronze plaque representing a chief surrounded by two of his warriors. Benin court art. Nigerian Museums. Photo Pierre Verger.

67. Bronze head overloaded with ornamentation. Late period of Benin court art. Nigerian Museums. Photo Pierre Verger.

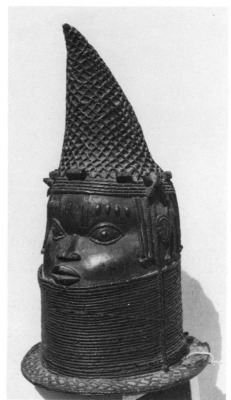

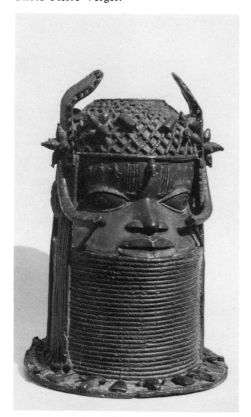

68. Bronze head representing a queen mother. Benin court art. Nigerian Museums. Photo Pierre Verger.

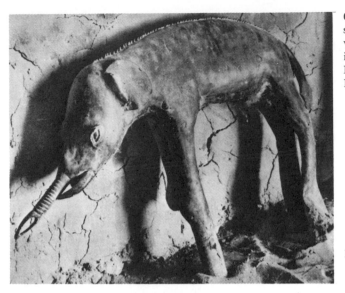

69. Elephant, one of the sacred bronzes from the village of Tada, preserved in a sacred hut. H. 23$\frac{25}{32}$". Nigeria. Photo Arnold Newman.

70 & 70a. The largest bronze statue from Tada, preserved in a sacred hut. H. 16$\frac{5}{16}$". Nigeria. Photo Arnold Newman.

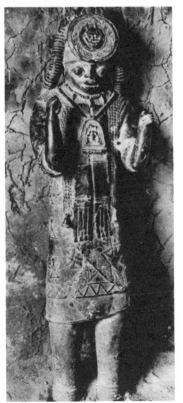 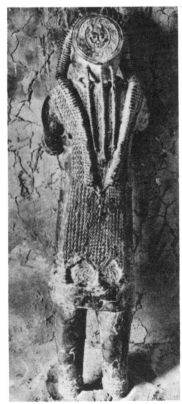

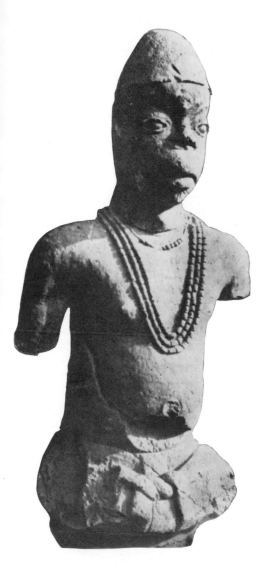

71. Esie stone figure. Nigeria. Photo of the cover of *Nigeria Magazine*, No. 87, December 1965.

72. Mask attributed to the sculptor Ochai of Otobi village. Wood, fibers. H. 8¹⁹⁄₃₂″. Idoma, Nigeria. British Museum, London.

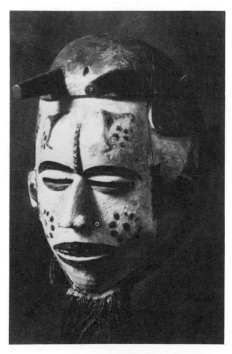

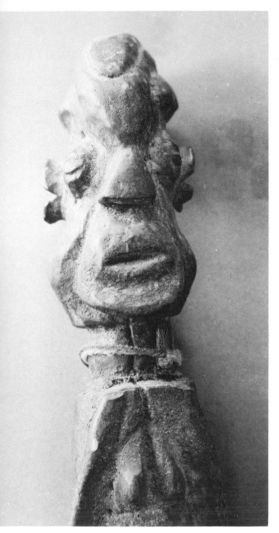

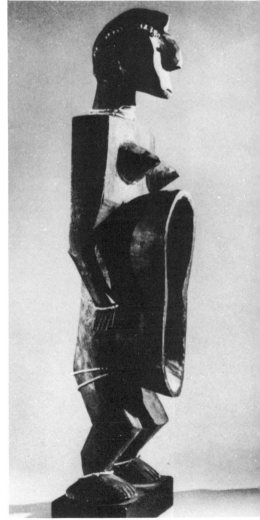

73. Top of a figurine used in sorcery-related decisions. Carved by the sculptor Sabo. H. (of the head) 4″. Kutin, Cameroun. Photo Christian Duponcheel.

74. Ritual cup for drinking palm wine. Wood. H. 23¹³⁄₃₂″. Juba, Nigeria. Museum of Primitive Art, New York. Museum photo.

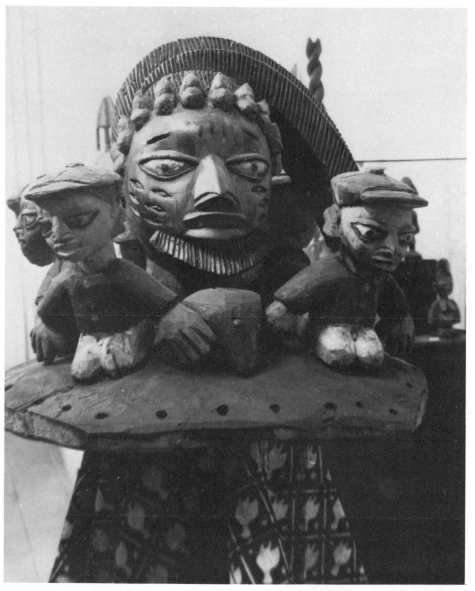

75. *Egungun* mask, carved around 1940 by
Adugboloye of Abeokuta village. The four
small figures with caps are perhaps the work of
his son Ayo. Wood. H. 14¹³⁄₁₆". Nigeria.
Photo William Fagg.

76. Pillars of the palace of Ikere carved by the sculptor
Ose of Ise village in the southern part of the Ekiti
region. Wood. Nigeria. Photo William Fagg.

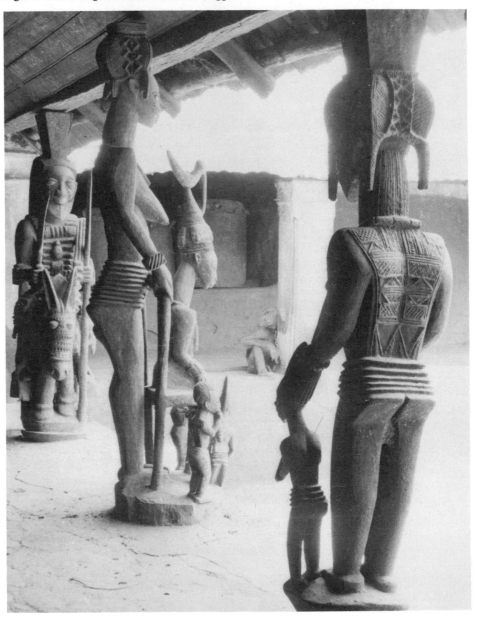

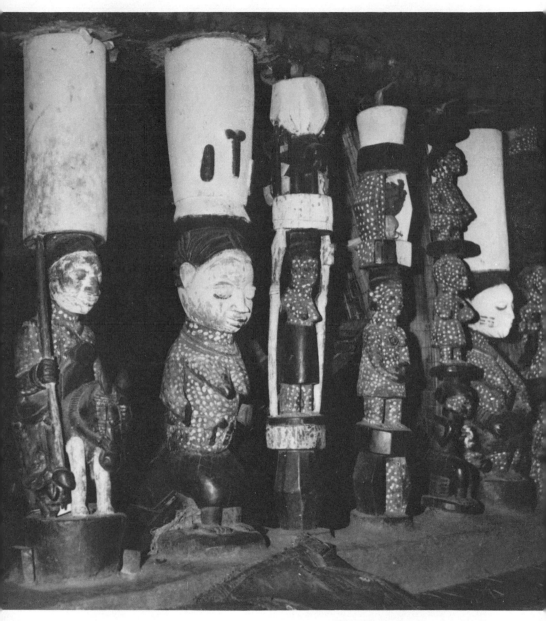

77. Pillars of a Shango temple.
Ibadan, Nigeria. Photo Pierre Verger.

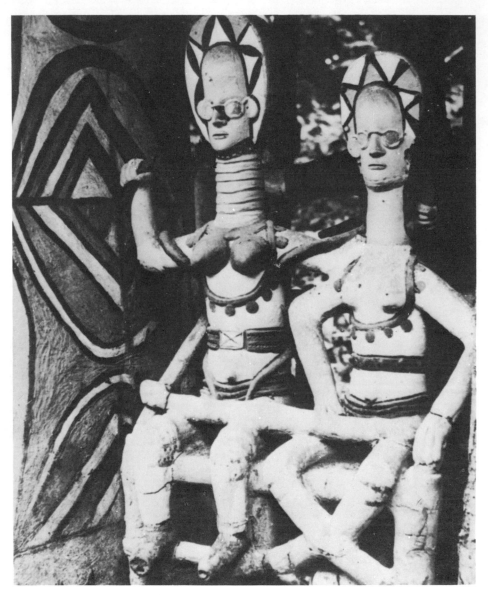

78. Clay figures representing two water spirits.
Ibo, southern Nigeria. *In situ*. Photo Ullu Beier.

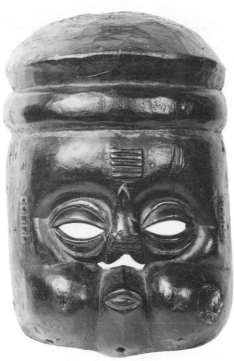

79. Mask of the *idiong* society suggesting the portrayal of a face deformed by cancer. Wood. H. 10¹¹⁄₃₂″. Ibibio, southern Nigeria. Wellcome Historical-Medical Museum, London. Museum photo.

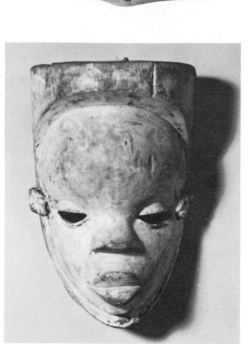

81. Ibo door. Southern Nigeria. Collection of William Fagg. Photo William Fagg.

80. Ibibio mask. Wood. Southern Nigeria. Formerly in the collection of Joseph Van der Straete.

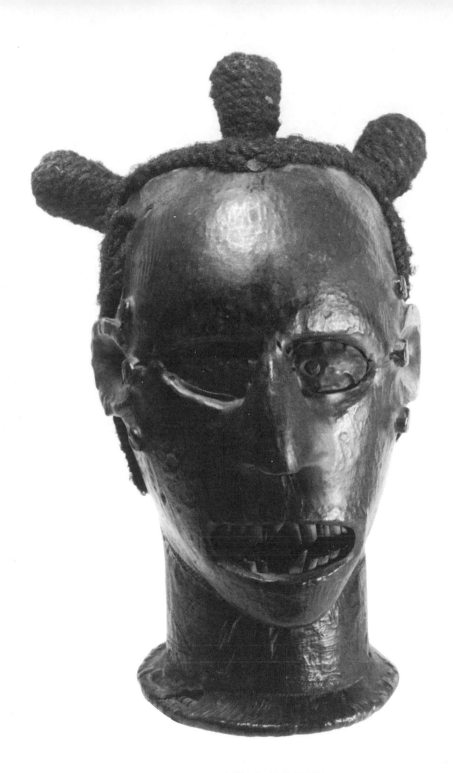

◄ **82.** Ekoi head. Wood, hide. H. 10$^{17}\!/_{32}$". Nigeria.
Collection of Jacques Kerchache.

83. Mask of the *egbukele* society for the water-spirit
cult. Wood. L. 23½". Western Ibo, Niger River
people, Nigeria. British Museum, London. Museum photo.

The Fulani[1]

Oh, my cows, wanderers, scattered and clustered on the moun-
tainsides and ridges, you climb, you descend, you eat, you gorge
yourselves with tender grass, with short grass, with tall grass of
spring and autumn, with grass that grows after a fire, oh, good
grass of prairies, reeds, hollow grasses! . . .

Like many of their other poems, this one gives an exact picture of
the character of Fulani culture. The Fulani not only express their basic
imagery in plastic creations but also in oral literature. There are pas-
toral poems, epics, tales, and satires that have the prerogative of
recounting the fate of men, of collecting their feelings, and of formu-
lating and stirring them. The rhymes and rhythms of their language
seem their only response to the social and aesthetic demands that we
seek to find again in manifestations of art in wood, metal, or clay.
What does this apparent monopoly of the language disguise?

Nomads or sedentary people, miserable shepherds of hot and deso-
late country who graze on a sea of sand, or aristocrats and literate
warriors of the rich centers of Futa-Djallon, Macina, Liptako, Sokoto,
and Adamawa, the Fulani do not seem to express themselves in dur-
able forms, important for the display of their assumed initiative and
talents. The technology of the nomads is pared down to the minimum.

[1] This chapter appears in *Cahiers d'études africaines,* IV, Ier cahier, Paris,
1963, pp. 5–13, fig.

This paring down is masked among the sedentary peoples by rich industries that give them a refined, comfortable, material foundation. But these technologies, which benefit the townspeople and even the shepherds—architectural constructions, wood sculpture, weaving, leatherwork—come to them from outside. The Fulani are fundamentally borrowers of techniques. Furthermore, they do not procure for themselves the practice of these techniques, the care of making the adopted models, but leave them to other castes, the first occupants of the region whom they conquered, or to foreign specialists who frequent the markets. Why then devote several pages to societies that appear materially so deprived, so little apt to create images and ornaments with their own hands?

It is perhaps worthwhile to set aside the societies that generously create innumerable objects reflecting their myths, their feelings, and their norms to examine a society like that of the Fulani, which stamped the local histories in the vast area from Senegal to northern Cameroun with a strong imprint. Beyond their traditional spare material forms, the importance that the Fulani attach to aesthetic phenomena is manifested through a search for beautiful language, a refined etiquette regulating attitudes, and a profound taste for nonfigurative arts like poetry, music, and song. For a rather fastidious people who are adverse to manual work, but whose aesthetic talents are expressed sufficiently in other ways, borrowing itself has its own philosophy. The few rare, permitted plastic activities, habitually considered minor, in their turn assume a breadth that cannot be ignored.

A chief of a Bambara village gave a striking description of the Fulani. Here, in black country, he said, they are like ants destroying ripe fruit, settling down without permission, decamping without saying good-bye, a race of eloquent rovers, unceasingly either about to arrive or about to leave, at the mercy of watering places or pastures . . .

This people, "loquacious roamers," does not seem a physically coherent group, easily located in space, immediately identifiable by the characteristics of its settlement pattern on the land. In addition, the aspects of its art, varying according to indications of different places,

do not elude complexity. Therefore, the difficult synthesis of this culture has never been attempted. It is always recognized, nevertheless, that aesthetic expression, which is not the monopoly of a certain type of society, reaches a very original intensity among the Fulani. All of those who have examined or studied them have been profoundly affected.

Fulani art is generally expressed in the orientation of choice and importance of the methods of the body ornamentation and the systematic uses of decorative materials, which are present in the surrounding foreign cultures. Coiffures, jewels, and clothing are constantly the objects of effort and attention. The Bororo child, naked and undoubtedly famished, who solitarily guards his herd all day long, leans, immobile, on a feeble bow of a branch, his neck ringed with a necklace of beads weighed down with pendants. Far from the villages, far into the bush of dried grass, when the wandering troop passes, the women are compared to "slender and aloof princesses." [2] Their arms are enclosed, laden with bracelets and on their heads is a large half calabash with finely carved borders from the center of which the design of the sun stands out. Indigo veils hide their bodies and are pleated under small chains and bead necklaces ending in multiform leather pendants. The young girls step forward, showing their legs ornamented with ribbed copper anklets, symbols of their status. The preoccupation with beauty breaks out everywhere, even in the fine braids of the men, which escape from their big hats with ostrich feathers. Simple details of costume or ornamentation, these heavy anklets and bell-shaped hats are still the only authentically Fulani artistic manifestations since time immemorial. Except for the art of the calabash, the rest is borrowed. Further, among Fulani townsmen these both humble and prestigious details of a traditional forgotten way of life evidently no longer exist. What then remains that is specifically Fulani? Perhaps the unchanged talent of arranging coiffures, multiplying ornaments, and moving with grace under a white or embroidered loincloth. The only raw material

[2] Henri Brandt, *Nomades du soleil,* p. 17. This author made a very beautiful film on the Bororo Fulani that has the same title as the book.

giving rise to the actual execution of an artistic style by Fulani hands is hair, which here replaces clay or the wood of the bombax. Made pliant or heavy, separated, braided, padded, held back, ornamented, it becomes a sculptural object. Melted butter, ground charcoal, cloth padding, bamboo slivers, amber balls, silver pieces, and beads are also indispensable elements. In lower Senegal, the different combinations of braids and coils of hair always form a precise design that bears a name.[3] In Liptako, the plaited hair reserves spaces alloted for geometric forms like diamonds, triangles, and rectangles. Finally, in Futa-Djallon, the *dyubade* makes one think of a Calder mobile: the braids and loops are extended forward and sometimes backward by a sort of enormous black butterfly bow; the hair of the upper part is braided in the shape of a transparent crest stretched on an arched strip of bamboo; crowns with fine rings and pieces of silver ending in twisted eardrops add their delicate glimmer to this astonishing architecture. Like all the other arts, the hair dress varies with age, place, and social condition; nor does it escape sentimental meaning. The two little braids falling on the cheeks of the Fulani woman of Dori who has just had her first child are fixed under the chin with a white bead; on the nape of her neck the braids, like multiple fringes, are ornamented at their ends with white stones; this coiffure symbolizes wisdom and calm, which become the new mother of a family.

The aesthetic of jewels, clothing, domestic objects, of the dwelling with its decorations applied to architecture and furniture is—as has been mentioned—an aesthetic of borrowing, although conditioned by often tyrannical modes to which the Fulani society brings its exclusive imprint.

In Senegal, Guinea, Niger, Nigeria, and northern Cameroun, the Wolof, the Tuculeur, the Sarakole, the Dialonke, the Bambara, the Baga, the Susu, the Songhai, the Hausa, the Djerma, and the Kirdi provide artistic techniques and decorative themes for their Fulani conquerors. But over this immense Fulani trail, which touches the

[3] For example: *kyara coco*, "branch of the coconut palm"; *bolé*, "baobab"; *letti*, "mat"; *gati dior*, "bed."

Saharan fringe in the African lands, and over these very pliant black cultures hover the Moorish and Tuareg arts. The influence of the aesthetic of Islam is taken up again, readapted, and re-created by the nomadic and the more ancient civilizations.

In Futa-Djallon, among the Fulani townspeople, one again encounters the comfortable house with a large circular veranda that contributed to the pleasing harmony of the village among the Baga. The "crinoline of thatch" [4] which covers it is made for rich men of evenly cut bunches; the tiered design thus achieved constitutes a supplementary decorative element. On these finished huts the blacksmiths put large, wood, decorated locks whose more or less stretched-out central part extends into a disk at each end. The parochial mosques also have this veranda and the springing round of the thatched roof, but this time topped with a bamboo-covered cupola. Exterior walls are rarely decorated, but the interior walls of the huts of notables and their wives are. Geometric motifs run in friezes along the walls and on the pediments of door and bed. The earth of the *banco* similarly presents a decoration. The technique is incised engraving made with a knife. The whole thing is then covered with a coat of white kaolin, possibly enhanced with colors, bloodred and light blue, that the finger of the artist traces in the grooves. The dominant motifs are the triangle and the crescent; stripes, circles, chevrons, lozenges, and spirals are also frequently represented. It seems evident that this decorative style, characterized by geometric patterns presented in homogeneous series, is of Muslim inspiration. But what importance should be attached to the influence, which today is masked, of the traditional decorative Mandé themes to the artist, who is usually of peasant origin and who charges dearly for the sought-after exercise of his talents?

In Liptako, more than one hundred years ago, all Fulani notables

[4] Expression used by G. Vieillard in his *Notes sur les coutumes des Peul du Fouta-Djallon*. This writer, who lived for many years among the Fulani of Futa-Djallon, passionately devoted himself to the study of their culture, in particular to their oral literature, "songs of griots, praises, or insults to heroes or women, sayings on the famous cities."

wanted very much to exchange their straw huts for a mud-brick house like that of the Songhai of Hombori, who had come themselves seeking the protection of the Emir. The huts with high portals, vestibules flanked with benches, flat roofs with terraces, and small courtyards bordered with walls, whose doors were decorated with polychrome motifs, seemed much more convenient and prestigious than the derivatives of the pastoral straw, pointed-roof huts to the rich Fulani, who were in the process of becoming sedentary. In north Cameroun, the inconvenience of these constructions with terraces that were too vulnerable to the tropical rains induced the Fulani to copy the harmonious huts made of clay, wood, and straw of the autochthonous Musgum and Mundang populations.

The interiors of all these dwellings show how the borrowed forms were modified according to both the practical necessities of adaptation and the desire for beauty. In the women's huts one finds again the bench where decorated calabashes are displayed, covered or not with fine disks of polychrome basketry that they make themselves. These rows of calabashes exhibited for decorative effect by the noble ladies of lower Senegal or of Adamawa, are they not a touching reminder of a very old aesthetic tradition to be found among the nomad shepherds who are so materially poor?

Clothing itself is the fruit of numerous borrowings. The Hausa embroiderers execute their refined Niger techniques in Adamawa. Certain stereotyped patterns belong to a social elite of which the Fulani are only a part, and other patterns are specific to them. The interlacing motif, ubiquitous on Hausa tunics, which are sometimes overladen with designs and highly colored, is also found on the white pants of the Niger Fulani, bordered with several rows of colored threads.

This geometric and polychrome decoration of Islamic inspiration, which not only covers the walls of the dwelling places but also appears on the fabrics, will be encountered again in the leatherwork, itself a luxury industry reserved for the richest Fulani. Production of Koran cases, saber sheathes, and sandals flourishes.

Apart from these geometric groups, the pure forms—triangles, lozenges, spiraled and nonspiraled moon crescents, disks, trefoils, and crosses—are taken up by goldsmiths and applied to copper, iron, silver, gold, and even straw (imitating gold thanks to a molded wax support). These shapes, sometimes in profusion, ornament the hair, ears, neck, chests, and limbs of both the townspeople and the pastoralists. Produced, sold, peddled in the great Sahelian markets in the same manner as basketry, calabashes, embroidered fabrics, and leatherwork, these jewels, most of which are of Wolof, Tuculeur, Bambara, or Songhai origin, provide an indispensable contribution to a snobbishness of appearance, no matter how well fostered in other ways. Undoubtedly the magic virtues of the forms and the materials still count for a great deal in these jewels, for example, the beneficial powers of copper and carnelian and the good eye in the shape of a triangle add a protective content to the ornamentation.

Aside from the appeal of the foreign specialists (on whom Fulani regional buyers often impose their tastes or who are found to have conformed in their own styles to these special demands), the little Islamized and sedentary societies have their traditional artisans, workers of caste or servile origin, specialists in wood, leather, and clay who satisfy the demands for domestic art objects. Blacksmiths, weavers, potters of Mandé or Tuareg origin, and woodworkers more or less belonging to their masters are the faithful suppliers of the Fulani, toward whom these artisans showed disdain. Thus, these Fulani societies seem parasitic to us in their work technology, but their destiny, their style of life induced them, very naturally, to multiply their aesthetic needs.

It is, in effect, normal to encounter among the sedentary Fulani (with the understanding that the boundaries between sedentary, half-sedentary, and nomad are only relatively rigid) this borrowed technology and tenacious adherence to artistic tenets. Among these former itinerant campers, peaceful herders who knew how to enrich, establish, and develop themselves with firmness and who fiercely protected their independence, Islam found an already prepared ground. In the

eighteenth and nineteenth centuries, the successive waves of organized Fulani were pushed by the Holy War into the conquest and formation of large empires. Shepherds became conquerors; pagans became propagators of Islam, but they remained Fulani. The Fulani, empty-handed, always comes "from nowhere." He moves in, establishes, goes off again, reestablishes himself, puts down roots, and spreads the tight net of his social system over the occupied country. Thus Fulani lords, military chiefs, and meditative wise men reign over the farmers and the artisans. For lack of a traditional artisan society, their aristocratic conceptions have to be expressed by autochthonous artistic skills as well as those of Muslim specialists of this vast area open to Islam culture. Perhaps the daughters of the local chiefs, whom the Fulani married at the beginning of their settlement, have aided in the diffusion of the old regional themes, in penetrating Fulani culture with several manual activities of an aesthetic nature.

Some of these rare, essentially female techniques may become well-known arts: the creation of the calabash lid in *ronier* * fibers in the middle valley of Niger, for example, or the decoration of the calabash itself in north Cameroun. Among the Lamidats of Garua and Rey Buba, Fulani women decorate calabashes, household vessels that contribute in an important way to the aesthetic quality of the trousseau. Pyrogravure and tinting allow varied decorations that range from simplified embellishments, provided, however, with chevrons or parallel stripes like the calabashes of the nomadic Fulani, to multiple geometric patterns with a preponderance of parallel and cross-hatchings like Hausa calabashes.

This calabash art brings us back into the world of the nomads, where it is replaced by pottery art and is not close to any other truly figurative technique, the arts of adornment excepted. The nomadic Fulani migrate through Niger in the Tahua, Gao, and Madua regions and extend into Nigeria among the Bororo Fulani, stubborn pagans, protecting their archaic pastoral traditions with pride. It is probably

* Translator's note: borassus palm tree.

among these people that we will find the purest Fulani characteristics along with the most spontaneous application of their aesthetic feelings. It is not that the borrowing traditions are nonexistent here, because the most basic needs demand the assistance of the sedentary people. But this time the importance of the borrowings remains minimal even at the aesthetic level and develops from the extraordinary insistence of the society on elaborating its own artistic themes from a way of life that is reduced to the essentials.

The importance accorded to beauty in itself is constant in Bororo society. But it bursts in all its vital significance in the tornado season, during the festivals that unite groups habitually dispersed by the sun in the arid grass, for several magnificent days of *gerewol,* a beauty contest at which the handsomest men of the tribe compete. All the resources of the arts, which see that the harmonious, seductive quasi-supernatural appearances are created, are put into play. The body is given to the pursuit of painting and adornment to which each adds his own sensitivity. The afternoon of the festival the young men are lined up like splendid and mobile images of deities. The face is painted red, glistening with butter with outlined motifs, triangles embellished with points at the corners of the blackened lips; the head is coiffed with a cowrie headband surmounted with a long and plumy ostrich feather; from each side of the face fall strings of ram's beard, chains, beads, rings; the neck and torso, polished like precious wood, are adorned with multiple rows of white beads, leather and cowrie pendants, and metal disks, which are also found on the dyed and embroidered loin-cloths. A solemn song is sung on a single note (the melody having been deliberately omitted) by the young men, who are balanced on their feet placed close together. The eyes are obligatorily open wide and the grin, a wide smile blocking out the impassive face, is likewise obligatory, "the eyes and the teeth being important attributes of masculine beauty." [5]

[5] The observer, Z. Estreicher, adds that during the performance of a song, one or two old women pass in front of the singers "to make fun of those who are not handsome."

The itinerant life, from water hole to water hole, frustrates and diverts the working of material and the creating of more or less permanent forms. The Bororo's passionate love of the beautiful, in addition to dance and song, could only be expressed in the application of exceptional ornamentation for the perfecting of the appearance by the daily adornment of the body and to the most elementary domestic objects.

The *kakol* baggage burden seems very removed from a plastic creation but nevertheless it is related to a sort of architecture, an assemblage of the humblest objects put together according to strict rules, with the precise aim of obtaining an effect of grandeur and beauty. It is a moving form of art that tries to make its way by means of harnessing rugs, gourds, skins, calabashes and calabash lids, leather, crosspieces of wood topped with the most beautiful engraved calabashes and held by a multitude of cords, whose network of crossings, twisted lines, and knots owes as much to chance as to effort. Bumping along on the prestigious carrier ox, all this construction is the pre-eminent aesthetic sign for the nomadic group.

This need to display, to set apart, and to exhibit for oneself and for others the few material riches that one possesses is found again in the place reserved for the display of the calabashes at the base of a thorny semicircle that serves as a house.

On a mat supported by sticks resting on two wooden crossbars, the vessels project bellies decorated with moons, suns, and calf leads painted white. The motifs, differing from each other in secondary details—the substitution of a chevron for a line, the duplication of a band, the dentiling of a moon crescent—traditionally designate the diverse origins of the families. Today, calabashes bought in the market are engraved by sedentary artisans who follow the fashionable models, and more than one family borrows the pattern of a stranger's lineage that is to his liking. This importance of fashion, which has already been noted among Fulani townsmen, will be found again among the Bororo. It is always linked on the one hand to borrowing and on the other to tendencies peculiar to Fulani society itself. But

this time these tendencies are more apparent and less smothered by external influences, as when one is established in the sedentary life, one submits to an invasion. Engraved calabashes, ankle rings, ceremonial axes for the *gerewol* dances, indigo-dyed fabric, long leather breeches ornamented with cowries, hats for adults in the shape of Phrygian headdresses—all are of Bororo style.[6]

Here, among these tireless itinerant people of Sahel, accomplished shepherds, but poor creators of technologies, it is necessary to look for the most authentically aesthetic attitudes, which do not result here in any formal realization of major importance for art in general but which exploit, to an intense degree, all the most spontaneous resources offered to the human spirit by nature and the social life. The sun and the moon in semicircles, the triangle that represents the notch made in the ear of a young calf (and by extension the calf itself), the leads (images of the cords to which the calves of less than two years are attached, true symbols for the Fulani of the ancient bond between man and cattle)—these provide a decorative geometry that does not break the schematism of the very rare human representations. Because of the constant attention that it is necessary to invest in the surrounding world, where one discovers each day a strange sector and thousands of daily fears, these figures attain greater value and crystallize in immutable forms. This decorative geometry persists in the art of the sedentary Fulani stimulated by Islam. It will appear among the artists making use of techniques of different origins intermingled with patterns with new meanings. The leads and the suns are integrated with exuberance into an embellishment essentially connected to the priority of the architectural pursuits developed by the characteristic Muslim urban style of life. But the sources of this aesthetic inspiration, glimpsed in the Bororo world, should not be forgotten.

In contrast to the peasant groups who cling to the earth from

[6] Marguerite Dupire helped us a great deal in the establishment of this part of our study by allowing us to examine her then unpublished article, *La Place du commerce et de marchés dans l'économie des Bororo (Fulbe) nomades du Niger*. This article appeared in *Études Nigériennes,* III, I.F.A.N., Niamey, 1961.

which they draw their deities and which they people with their dead, for whom their artists must carve wood images in order to keep them alive, the nomadic Fulani, followed by the sedentary Fulani, who are encumbered with neither an ancestor cult nor a weighty technological and political apparatus, have found an infinite number of chances for aesthetic invention in their style of existence.

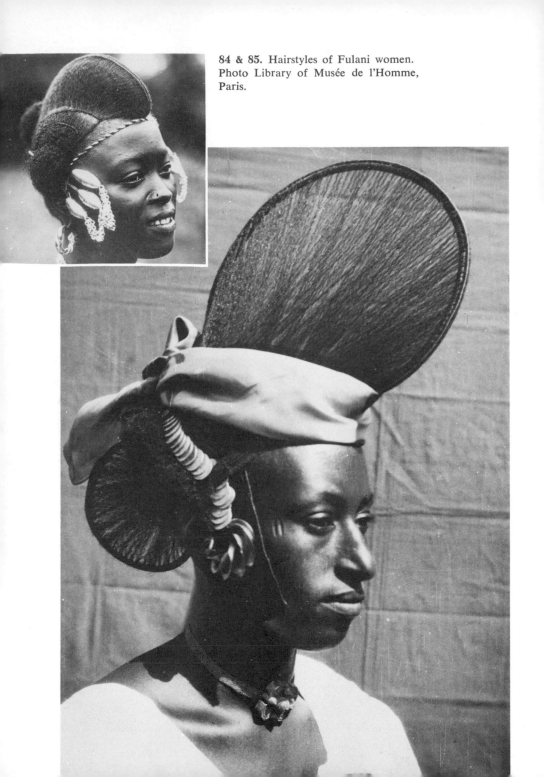

84 & 85. Hairstyles of Fulani women.
Photo Library of Musée de l'Homme,
Paris.

86. Children modeling cows with pond mud.
Fulani, Tahua, Niger. Musée I.F.A.N.,
Dakar. Photo Marguerite Dupire.

87. *Kakol,* the baggage of the carrier ox. Fulani, Tahua, Niger. Musée I.F.A.N., Dakar. Photo Marguerite Dupire.

88. Mosque of Yambering. Fulani, Guinea.
Photo Doctor Pales and Marie de
Saint-Péreuse.

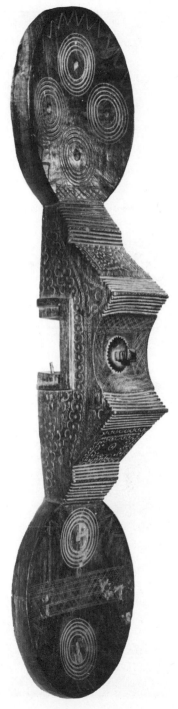

89. Detail of a fabric embroidered by the Hausa. Fulani, Niger. Photo Library of Musée de l'Homme, Paris.

90. Door latch with incised decoration. Wood. H. 27½". Fulani, Futa-Djallon, Guinea. Musée de l'Homme, Paris. Museum photo.

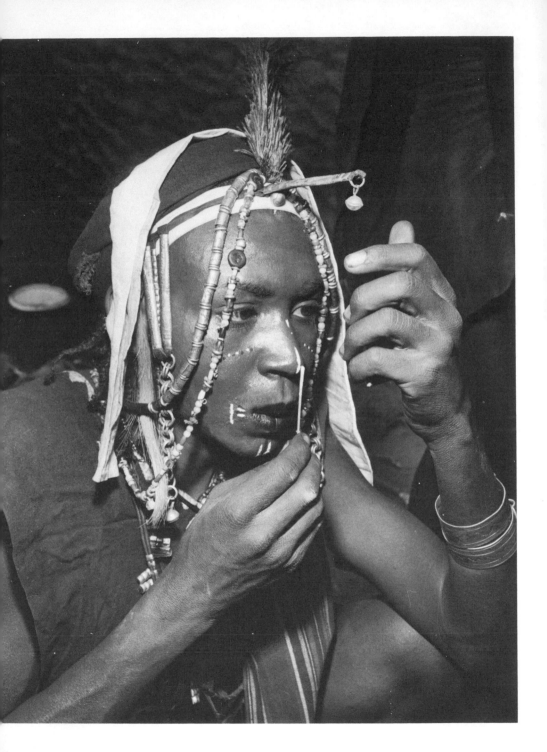

91. Bororo Fulani preparing himself for the *gerewol*. Photo Dominique Darbois.

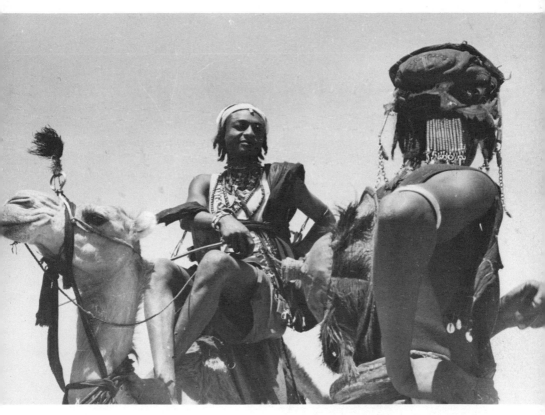

92. Bororo Fulani on his camel. Photo Comité du Film Ethnographique, Musée de l'Homme, Paris.

Central and Western Cameroun

The same aesthetic preoccupation resulting in common stylistic qualities animates the arts of all the basically agricultural grassland societies, whose obvious cultural unity is disregarded by arbitrary colonial divisions. Not only the Bamun and the Bamileke of the upper plateaus but numerous groups and subgroups established in the two Camerouns under the former mandate (the Bafum and the Bacham, for example, or the Bangwa and the Tikar of the old British province of Bamenda) possess a wide range of material creations. The flourishing of an original art, characteristic of this region, was brought about by the permanence (naturally relative, subject to many variations) of the same type of organization in most of these societies, a pyramidal organization whose chief assures the stability to which each in order contributes: chiefs of lesser ranks, kinsmen, dignitaries, servants, artisans, and so-called secret societies. Here, wood sculpture is far from being limited to the creation of figures and masks. Not only does it enter the domain of furniture objects, but it is fully integrated with architecture, a characteristic perhaps linked with a tendency toward large dimensions found elsewhere in numerous giant masks and larger-than-life statues. In the grassland, all classes of artisanry are represented: ivory sculpture, goldsmith work, ceramics, and beadwork. These arts flourished (in certain societies), served by groups of specialists who were sometimes conspicuous because of a distinc-

tively styled object. The multiplicity of handcrafts, the execution of monumental arts, and also such exacting art forms as embroidery, beadwork, reserve dyeing, and lost-wax casting, along with a decided division of labor and an enlistment of these activities into a finely formed hierarchical system of social and political relationships are the essential traits of the aesthetic life of these societies.

The importance that the sultan Njoya attributes to his own reign in the Bamun history written under his direction is evident, and he played a determining role in the evolution of Bamun arts. Njoya certainly was a lover of art, but he was first the heir to a dynasty that continued on against all odds. The first years of our century were decisive for the destiny of the kingdom. The arrival of the first expedition of Germans (missionaries) and the introduction of Islam were both threats to the cultural originality of the Bamun. But Njoya knew how to respond. With the aid of the writing he had invented, he had the traditions of his people recorded and thus prepared the situation for its final glory. A thoughtful benefactor, he had the idea of a Bamun museum of history, where sacred symbols of power and emblems of secret societies as well as war trophies were preserved. But in spite of the brilliance of his reign, we should not forget that the royal customs were elaborated during the reigns of his fifteen predecessors.

The founder of the dynasty, Nchare, came from Tikar country and settled in Foumban in the palace of the conquered chief. After his accession, this palace and the whole of the city of Foumban received a particular statute, a change that demanded the active service of many artisans for whom, in turn, were provided premises and quarters. Furthermore, the institutions associated with the person of the king and his nobles created aesthetic obligations. The style of Bamun social life itself—oriented, especially from the reign of Mbuembue, toward the conquest of surrounding chiefs' territories and raids on the neighboring countries—instigated the appearance of a warrior mythology and the proliferation of material symbols of power. The wood sculpture, very important for the Bamun as for all societies of this

region, is represented by masks, statues, stools, beds, household vessels, and musical instruments. All the characteristic forms of sculpture and the other art forms of grassland tribes are found. By progressively reinforcing in every way (political, religious, magical, and aesthetic) the power embodied in the king, the conquering culture assimilated the conquered cultures with extreme flexibility. The success of this process of unification partially explains the artistic uniformity that prevails in this area.

The human heads depicted by numerous Bamun masks are often inflated, and appear blown up. This striking style in sculpture in the round reaches a peak with the horn player, capped with a traditional headdress in the form of a tiara. The very swollen cheeks seem to bounce joyfully under big round eyes surmounted by a double arc of thick, overhanging eyebrows; separating the cheeks, which are veritable balloons, the mouth, treated in parallelepipedic relief, stands up under the heavy nose with well-modeled nostrils. Without its swellings, the Bamun mask can keep its circular rhythm or can turn into a composition of more elongated faces, whose features, always beaming and sometimes almost astonished, approach the look of actual faces. The human masks are generally the best of the masks. The heavy, carved wood is not hollow because it does not completely cover the face of the wearer but instead is on top of a sort of bamboo cage surrounded by a tufted collar made of palm fibers, which hides the masker's head. Social instruments, with a political, administrative, judicial, or theatrical function, these masks were kept in special rooms. Links with ancient religious rites are likely since they are taken out during annual ceremonies celebrating the first rains. The king himself is said sometimes to have appeared masked and he also danced. Invariably, the representation of the buffalo (although more or less associated with a hunting rite) is undoubtedly a symbol of power. It is not unusual to see buffalo heads displayed in the courtyards of village chiefs. It is also known that the person entrusted with transmitting the power to the new king first had to sit on a buffalo skull in the room of the palace where the enthronement of the king took place.

The symbolic importance of the buffalo joined, then, that of the leopard, the elephant, and the two-headed python, images of royal power that appear constantly in the decoration of the area's works of art.

The statuary is also characterized by a sort of restlessness. The carving itself aims to interpret a movement of the whole figure in which dominate the curved lines of the shoulders, the folded arms, and the nape of the neck, which is then extended by the loins, the buttocks, and the thighs. The faces look like those of the masks. The bodies are arranged in a natural pose.

The Bamun have a taste for lively decoration. The artist, applying himself to following the basic lines of a figure, usually curved, refined the natural forms offered by the local mythology. The toad and the spider, in particular, form a network of patterns that have become abstract not only in the numerous wood sculptures of domestic use but in objects made by specialists of other techniques. The bowls of giant terra-cotta pipes, ending in heads with plump cheeks, are covered with meanders arranged in geometric or curvilinear friezes in which a vestige of the toad, symbol of fertility, is scarcely perceptible. Sometimes the heads of men and python or toad heads are linked by spider's legs. The star shape of the stretched-out form is an inexhaustible source of aesthetic invention; thus, lattice patterns are executed. Very often the stem of the pipe is entirely covered with beads, which form a geometric design in lively colors, enhanced occasionally with capped heads or somewhat less stylized animals.

In the grassland, beadwork is a major art. The Bamun understood this, and in adopting it knew to establish at Foumban an active caste of beadworkers, whose talent was practiced on works in wood, clay, brass, or fabric. Masks and small figures made entirely of beads also exist. This art is not very far from that of the embroiderer who adorns with elegant geometric motifs the cotton *boubous* of the chiefs. The artisan begins with a piece of coarse material stretched across the object to be ornamented and then he sews on small multicolored beads with cotton thread. Not only embroidery and beadwork but also dyeing techniques are remarkable for their sense of decorative

composition and spontaneity of inspiration, which, after a minimum of preparation, progresses in the process of the work. The design, which may first be traced with a palette knife in black upon the white fabric, is formed by embroidery closely stitched in raffia thread.

With the Tikar, to whom they are related, the Bamun are the masters of the art of lost-wax casting. Around 1930, the voluntary exile of a few Foumban artisans into territory under the British mandate carried this technique to Bamenda country. Formerly, in Bamun country lost-wax casting was in the hands of guilds organized around master artisans employing numerous apprentices. Then, brass objects were destined for altars and ritual ceremonies. But religious traditions did not accompany the techniques outside Bamun country. Today, for the Bamun, the Bekom, and the Babanki the commercial purpose of objects prevails. Masks, pipes, and figurines constitute the basic production. The last, often of threadlike forms with naturalistic poses taken from life, are a part of the modern repertory of lost-wax casting, a repertory (as is well known) abundantly represented in the Ivory Coast, Upper Volta, Ghana, and Dahomey.

The Bamun are still excellent designers and expert painters. Their Bamileke neighbors rely on them to paint the walls of certain huts with vivid scenes that magnify the power and beauty of the chiefs, where decorative motifs derived from wood sculpture, dyeing, and embroidery are also found.

Except for painting, Bamun arts were perfected with borrowings from neighboring cultures, especially the Bamileke. The Bamileke chiefdoms had occupied the upper plateaus of western Cameroun for a long time when the Bamun subdued them. These Bamun invaders found them well-developed artisan societies from which they were able to assimilate several processes. The Islamic influence in the designs and the "expressionist" influences of Cross River people such as the Ekoi and the Anyang, who are nearby neighbors of Bamenda province, have also certainly contributed to the formation of several characteristics of grassland art.

Among the Bamileke, the art of beadwork, as accomplished as in

Bamun country and perhaps more prolific, is used for the stems of pipes and for handles with horsetails used for "whips" in the dance. It also appears on calabashes that wives of the chiefs present, carrying them upon their shoulders; each of them is said to contain the skull-bone of an ancient chief.

Tie-dye technique gives a remarkable white-on-blue pattern to large loincloths and sleeveless robes that are worn at a society's festival with beaded masks, cowrie-decorated hoods surmounted with cow's horns, beaded collars, belts and anklets, ivory bracelets, beaded fly whisks, and, finally, leopard skins, whose use by dignitaries is care-fully controlled.

The pipe bowls from the workshop of the Bamileke brass caster or from the potter's oven resemble those of the Bamun. The ancient terra-cotta pipes join patterns of geometric forms and human heads superimposed or prolonged by a bust. The more modern bowls have adopted purely geometric decoration, which is found also on beautiful pots usually made by women and apparently derived from basket-making.

For the Bamileke as for the Bamun, wood sculpture is more im-portant than all the other arts. Although it is sometimes difficult to distinguish between these two sculptural styles, there is a notable dif-ference between them. The curved line that prevails in all Bamun sculpture (the general composition as well as the particular details) ceases to play a fundamental role in Bamileke sculpture. This dis-appearance is certainly only partial. The cheeks of a mask may remain puffed out, roundness persists in the contour of the face, the large curve of the arms and legs still asserts itself, but sculpture in the round is not vaunted with such exuberance. The familiar designs give way to more severe forms. The poses are more rigid, the facial fea-tures are pared down around a mouth (usually open with two rows of pointed teeth), and the four animal legs are flexed in sharp angles. Finally, the harmonious equilibrium of the curvilinear masses is dis-solved for the benefit of a new balance. It is observed that numerous works (ancestor figures, maternal figures, stools surmounted by an

individual with a long neck) tend toward a stylization, in the sense of verticality, which is conspicuous also in Bamileke sculpture associated with architecture.

In effect, the relationships are close between wood sculpture and the interior structures of chiefs' houses. All the dwellings, the huts of the traditional societies, and the granaries have a parallelepiped form with a square base and conical thatched roofs. The chiefs' houses and those of the societies usually have partitions made of dry mud reinforced with closely placed bamboo. The exterior wall sometimes is wattled with vertically placed bamboo which is occasionally covered with horizontal bamboo poles, whose joinings make a supplementary pattern. A carved frame heightens by about twenty inches and ornaments the rectangular entrance. Carved pillars resting on the ground and rising to the circular bamboo ceiling support the framework of the roof. They form a sort of veranda, in the shade of which stand figures of ancestors or servants and drums and stools. The style of these architectural compositions demonstrates the Bamileke tendency to simplify masses and at the same time to set up an opposition between them by stressing angularity. Certain themes are noticeable on the door frames and also on the posts and shutters: the chief smoking his pipe, for example, or the victorious soldier carrying the head of an enemy, or another individual with a hand under his chin in an attitude of respect.

Could this extraordinary flowering of village architecture perhaps have been favored by the nature of the Bamileke society? This society was not unified (like the Bamun society) but was fragmented into multiple chiefdoms, which were all organized according to the same type of hierarchy around a chief who was subject to an exceptional code and whose power was limited by the religious and political laws of society. These chiefdoms, which owed their cohesion not only to the political system but to the liveliness of the traditions, had naturally tended to express the essence of their institutions in an imaginative way in the many places where the complicated mechanisms of the directing agents functioned. These places were located along the sides

of the central way leading to the great square, a good situation in comparison to another more common one: less carefully constructed dwellings dispersed in the middle of cultivated fields. The political importance of the lineage and its antiquity seems to correspond exactly with the vertical order of the skulls and of the individuals represented on the pillars and door frames.

At the opposite pole, the custom of decorating their skin indicates that the Bamileke are the heirs of the old artistic traditions of unclothed people. Because this practice fell into disuse, the less assimilated groups observed this custom the most rigorously, including the blacksmiths of Dschang, Bamendjinda, and Bandjoun, and the drum and rattle makers of Bafussam, Balengu, or Bana.

For the Bamileke, the Bamun, and all the other grassland people, it is neither the artisans' virtuosity nor their decorative sense that appears most admirable but the spontaneity with which they could adapt the language of their visual arts to the new needs stimulated by the development of the chiefdoms.

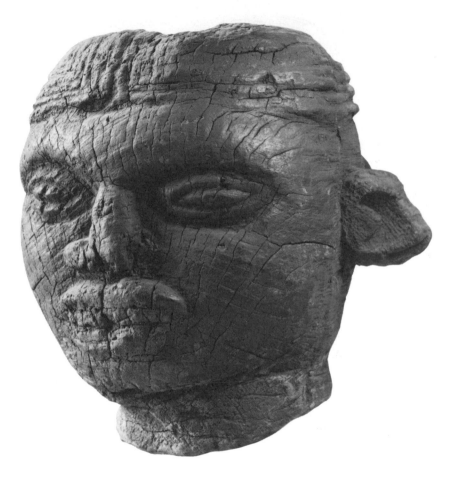

93. Architectural element? Wood. H. 7″. Bamun?, Cameroun. Formerly in the collection of Hélèna Rubinstein. Photo Franceschi.

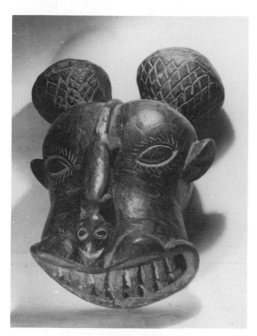

94. Mask. Wood. H.17^{15}⁄$_{16}$″. Bamun, Cameroun. Collection of Pierre Vérité. Photo Claude Vérité.

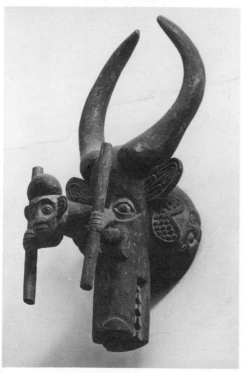

95. Mask. Wood, fibers. H. 10^{17}⁄$_{32}$″; L. 24^{9}⁄$_{16}$″. Bamun, Cameroun. Musée de l'Homme, Paris. Museum photo.

96. Ancestor figure. Painted wood. H. 24³⁄₁₆″. Bamileke, Cameroun. Formerly in the collection of Tristan Tzara, now in the collection of Christophe Tzara.

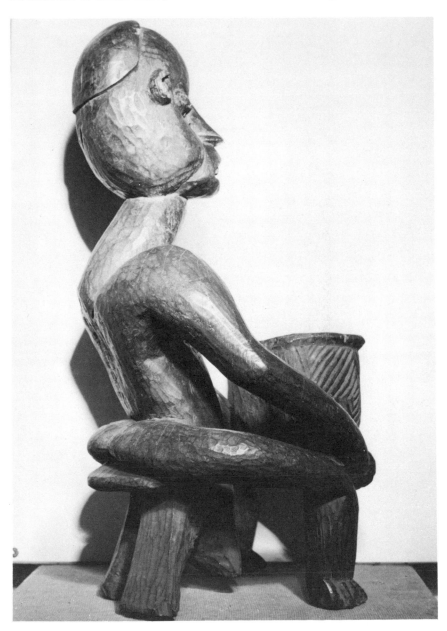

97. Head of a statue. Wood. H. (total) 24⁹⁄₁₆″. Bamileke, Cameroun. Collection of ►
H. and H. A. Kramer, New York. Photo Chris Marker.

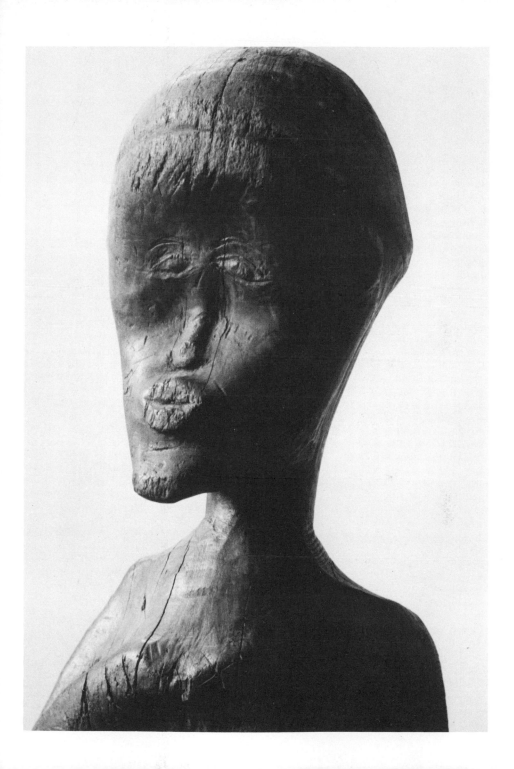

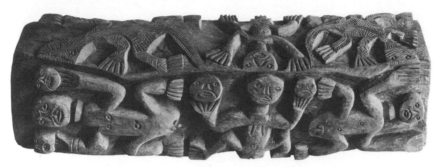

98. Part of a door frame. Wood.
L. 44¹⁵⁄₃₂″. Bamileke, Cam-
eroun. Musée de l'Homme,
Paris. Museum photo.

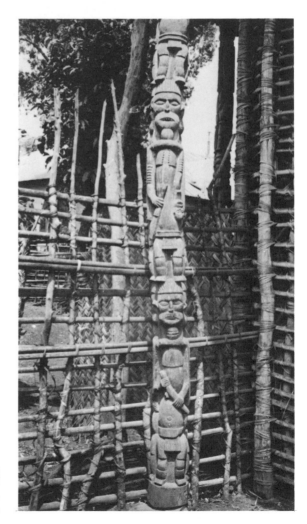

99. Carved pillar. Bamileke,
Cameroun. Photo Library of
Musée de l'Homme, Paris.
Photo Claude Tardits.

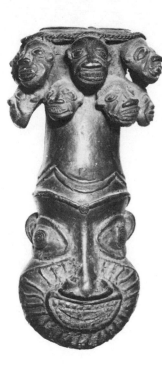

100. Brass pipe bowl. H. 8¾″. Bamileke,
Cameroun. Formerly in the collection of Tristan
Tzara, now in the collection of Christophe Tzara.
Photo Geneviève Bonnefoi.

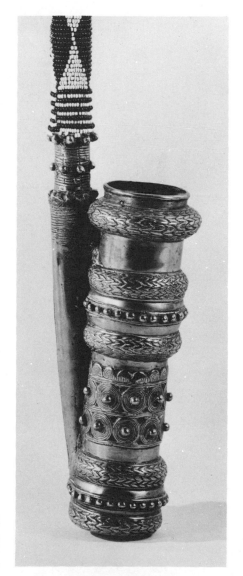

101. Brass pipe bowl; the stem is covered
with blue and white beads. H. 29½″. Bamun,
Cameroun. Musée de l'Homme, Paris. Photo
José Oster.

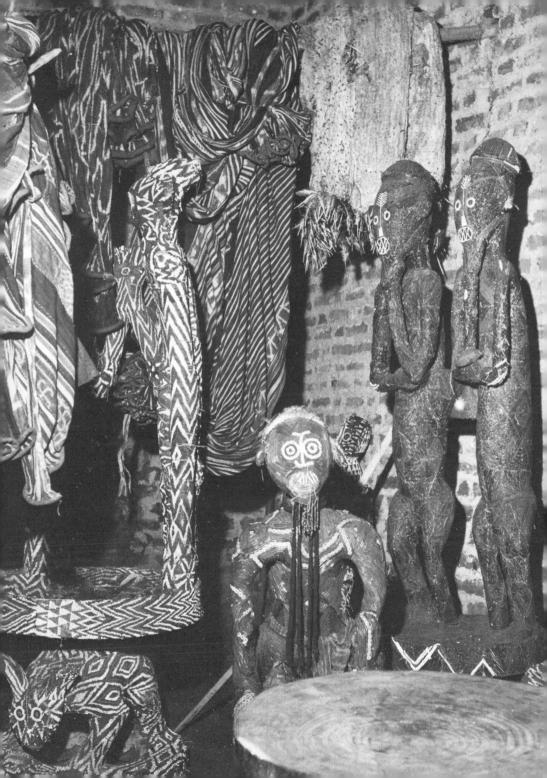

102. Interior of a house preserving the tribal treasures; beaded stools and statues, dyed fabrics. Bamileke, Bafussam district, Cameroun. Photo Dominique Darbois.

103. Beaded fly whisk. Bamun, Cameroun. Collection of Joseph Van der Straete.

The Western Congo

A broad, roughly heart-shaped area encompasses a large part of the equatorial forest. It is bordered on the south and east by the Congo River and is extended by the Sangha to the northwest and by the Atlantic coastline in the west. South of this heart, the overpowering tangle of Congolese rain forest gives way to brush and thickets forming an uneven pattern interspersed with carpets of grass.

This western region divides into two major style zones. One is under Pahouin * influence, and the other is Kongo territory. Here wood sculpture proliferates: cryptic fetishes, objects of violent magic, or ancestor figures, which are among the masterpieces of African art. The spread of Pahouin culture, the origin of which is still debated, is of primary importance for this entire area. A complex expansion, extending over almost ten generations, it was full of vicissitudes. Driven from the Amadawa plateau by the Fulani at the end of the nineteenth century, the scattered Fang tribes rejoined in the Gabonese forest and followed the Ogowe River. A few reached the estuary. Because this peculiar "colonization" brought along in its wake so many different groups, which in turn influenced their invaders culturally, it tends to conceal the original character of each of the peoples that were more or less involved in the experience.

* Translator's note: the Fang, the Bulu, and the Beti, people who are related but not a tribe.

For many years the justifiable vogue of Fang statuary contributed somewhat to the obscurity of the work of neighboring peoples regardless of whether they were under Fang domination. To whom belongs the "invention" of the stylized face? This face has eyebrows shaped like a double crescent (similar to the schematic picture of a large bird with spread wings) that protect eyes reduced to narrow almonds, which extend outward into the curve of the cheeks and join inward at the lower center of the forehead to form the root of the straight nose. A "lunar" face, it is found with almost the same details among many peoples of this area between the southern parts of the Sanaga and the Ogowe.

The same concept of death and of maleficent things animates all these peoples. Their tightly ordered struggle against evil involves, among other practices designed to detect it or to protect against it, autopsy and the recovery of the life force of the deceased. This force, which gives to the various elements of the personality the means to compose themselves as a whole and to live on, is still present in the bones and especially the skull of the deceased, which is placed at the bottom of a box or a basket together with various beneficial materials, such as shells, teeth, seeds, herbs, and sachets. For example, among the Fang of Gabon, the skull itself may be painted red or black and wrapped in a piece of raffia, bound up in a network of small strings, or adorned with a fiber coiffure. On top of this sacred bundle, a carved figure gives human form to the ancestor to whom the cult is dedicated.

Until recently, Fang *bieri* and the *m'boi* or *bwete* of the Kota, together with Bambara antelopes, Dan masks, and Baule figures, have been the most sought-after African artworks. A cylinder made of a rolled-up sheet of bark sewn together with fiber forms the main part of the box, which is enclosed by a wooden bottom and a similar cover, in which skulls and objects of magic will be placed. Described as a "statuette roughly representing the person whose skull forms the main part of the fetish" (E. Trezenem) or as "a statue of the first ancestor" (P. Alexandre), the carved wood figure on top of the box expresses

the continuing authority of the dead. The number of skulls indicates the antiquity of the group. The Fang *bieri,* kept in the hut of the head of the family, warns of danger and grants prayers. But it may also be taken outside to be presented by the elders to the young initiates of the village. For the first time they see the skulls of their ancestors and hear them talk through an intermediary, the *bieri,* during a ceremony in which they lose consciousness after partaking of a narcotic. Does not the whole mysterious power of these figures, disturbing even for Westerners, stem from the perfect blend of sculptural expression and supernatural function?—portraits of the dead placed on their very own skulls and imbued with the necessary magic force.

Often the seated figure is attached to the box by a vertical extension. When this support is absent, the legs, or the neck if the sculpture is reduced to a head, are sunk into the box cover.

The forms of these figures probably vary according to area and to artist rather than to the broader internal evolution of a style scarcely homogeneous at the outset. These figures, as they have been so often described—with always curving forms balancing in a sensual geometry the totality of the lines essential to the human body—are replaced in Kota territory by wood figures covered with copper leaf. Shapeless bundles held together by vegetable fibers and covered with hide, or wicker baskets with fiber or string covers, have replaced the bark containers, but the bones of the ancestors are always there. We know scarcely more about these figures than the incomplete specimens, figures without the reliquaries, which usually supported the sculpture. How do we interpret the different parts that surround the face, or the lozenge shape that supports the neck? The speculative enthusiasm of researchers has made them see in the plaque that crowns the figure the rays of the sun, the horns of a ram, or a crescent moon; some saw these locks of hair transformed into the pompons of a Christian standard, with the entire figure turning into a derivation of the cross! Today, according to the Kota informants of E. Andersson, this crescent-shaped plaque is called *ntsuo* ("moon") and the lateral winglike sections *baa,* a term that means "cheek." If that is true and if the

face were thus disassembled and unfolded, the sculptors of these figures would be following a concept familiar to many artists of preliterate societies, which the Cubists adopted to a certain extent: an integrated rendering of the object according to what is known about it rather than what is seen. Consequently we find the use of processes, the most prevalent of which in the so-called primitive arts are doubled representations of the image, that Franz Boas calls "split representation" and a rearrangement of the bodies and the portrayal of hidden parts by means of symbols, schematic design, or even exact representation. Here the cheek-ear configuration is spread out like a wide fan.

Again, according to E. Andersson, the extensions in the form of cylinders or locks of hair are called *atswi,* or "ears," the tubular part supporting the head *kii,* or "neck," and the sides of the lozenge *ekwawo,* or "arms." Concerning the side plaques and the half-moon crest, many specialists have naturally thought of the elaborate, highly ornamented hairstyle with braids joined together and rolled up at ear level found among the women and sometimes even the men in west as well as central Africa, and specifically among the Kota, the Pahouin, and the peoples of the lower and middle Ogowe.

For a very long time the lozenge- or diamond-shaped configuration has been seen as the lower limbs of the figures; but some of the Kota call it "shoulders," so that we should perhaps recognize here a stylized reminder of the posture of numerous statues in this area: the arms bent at the elbow and folded over the stomach, which is sometimes hollowed out to be used as a receptacle for ingredients endowed with religious or magical power. Traces of naturalism no longer remain in the face of the Mangwe Kota figure. Instead it has an almost flat surface covered with lamina and wires, out of which emerge only the eyes in the form of two round copper nails and the nose, a thin copper strip like a small knife blade applied to the carved wood.

The statues with the hollow stomach (sometimes the chest is also hollow) and the "skull box" are both based on the same principle: to form an object that will be at the same time an effigy and a recep-

tacle for sacred things. Even so, the statuette for holding magic in-
gredients, instead of being specifically the image of a dead person, can
be that of a deity or of a spiritual force that has become less distinct
with time or under pressure from various influences. We are aware of
numerous sculptures of this type among the Kota, the Bete, the Tsogo,
and the Punu. Many are painted white with kaolin or red with *tukula*
(a redwood powder), primarily ritualistic colors that are also found
on masks and on the bodies of young people at the time of their
initiation.

The masks and statues used by the people of southern Cameroun,
of north and central Gabon, and of the Congo are little known.
Borrowings, modifications, and artistic invention have formed the
patterns of a complex history. Its basic themes, migration, trade,
the slave trade, wars, and the impact of Western religions have given
the aesthetic creations surprising instability in the midst of an other-
wise rather uniform religious and judicial framework. This framework
must be considered first if one is to understand the purpose of all
these sculptures. The men's societies organized around sometimes
cruel initiations create strong, though not always apparent, ties between
societies separated by divergences. Masks and statues are indispen-
sable to the activity of these groups of initiates, an activity which, to-
day, may have lost much of its vitality but which essentially consisted
in ensuring order in the life of the community and in protecting its
members against maleficent spirits. Most of the familiar objects have
been used in the *bwiti* of the Gabonese Ngunie coastal tribes and of
the central Ogowe; in the *ngil* of the Fang of Gabon; in the *sso* of the
Ngisa and the Fang of southern Cameroun and Spanish Guinea; in
the *ngoy,* which is widespread in the midwest of the Congo and
eastern Gabon; and in many other more or less similar societies.
The white masks of the lower Ogowe (whose Far Eastern aspect is
greatly admired by connoisseurs) lack the precise functional descrip-
tion that characterizes the sculpture of this entire region. Hans Him-
melheber has seen them worn by the Sango as they walked on stilts
brandishing whips. They said that they personified a dead woman

who had returned from the country of the dead. When questioned, the sculptors assured him that the first mask had been carved to resemble a living model: "a pretty girl whose proportions they had stolen." The same masks are found among many tribes, for example, the Lumbo, the Njabi, the Punu (who were perhaps the first to make them), and the Mpongwe, shrewd traders whose relations with the Portuguese go back to the fifteenth century and who must have been active agents of cultural exchange. Andersson has bought this type of mask from the Kota. At Zanaga, they told him they used them for "funeral feasts and ancestor cults."

The masks of the Kwele, southeastern neighbors of the Kota who live on the western border of the Fang, to whom they are related, are still not well understood. Pahouin stylization is pushed to the extreme in these masks. Added to this is a many-faceted treatment of the faces, which seem to borrow their features not only from man but also from the antelope (horns), the male gorilla (transverse crest of the skull, the visor formed by the eyebrow arches), and possibly from a legendary animal. One motif is constant: the "eyes," in the shape of narrow, split almonds joined at the end and then diverging, carved on the inner face of a concave surface painted with kaolin, again the same stylized face. In the form of a broad heart, this motif occupies the greater part of a round mask or is congruent with the mask itself. Assuming the form of a cowrie, it is found also on the polychrome panels of chiefs' beds and on the carved posts.

On the right bank of the Kuyu, tributary of the Likuala-Mossaka, itself a tributary of the Congo, the Kuyu and the Mbochi use statues and dance sticks characterized by a certain aggressive or caricature-like extravagance. Formerly, among the western Kuyu, the initiation ceremonies devoted to Djo, the creator god believed to have the form of a snake, were probably invested with enormous social importance. Novices, dignitaries, and the common public attended the supernatural gyrations of the *euya* (a representation of the snake become man), persons bearing anthropomorphic staffs hidden under wide, flowing

robes of raffia out of which rose wood heads, covered with chicken feathers. Following them appeared the snake, Elongo, created by Djo, in an even more ample costume, with a smaller head than that of the *euya,* which had to rise twenty feet or so above the ground. A pair of statues, painted and adorned like the heads were then presented, representing both the image of man and the symbol of the promise of offspring, and then the progeny itself, in the form of fifteen *euya.* Finally, the ancestors of Elongo, enormous heads, gave the spectators access to the mythical time of creation. Today the snake god is forgotten, but the performance persists with its presentation of characters with carved heads and the execution of dances called *kyebe-kyebe.* The aim of the dancers is to "conquer the favor of the public, to dance in such a way that the base of the cone formed by their bodies and the costumes moves evenly along the ground," and "for the whirling to be executed in a rapid movement without losing its elegance and without being too abrupt."

It would be a mistake to limit the artistic production of the best-known tribes of the upper Congo to the art of the mask and the statue. Yet, it would be impossible to name all the secular or ritual objects of undeniable aesthetic quality that are being made in every one of these societies: musical instruments (drums, traverse horns, bowed harps), household objects (house doors, stools, bowls, spoons). In the entire western Congo, the use of minerals and metalwork are ancient techniques, even though today many foundries are no longer in use. We are aware of the rich variety of weapons used for prestige, hunting, and war, a variety manifested equally in the shape of the iron and the decoration of shafts and cases. The anthropomorphic iron cult bells of the Tsogo, without clappers, are not dance instruments but veritable statues, emblems of the prestige of their owners. The ornamentation of jewelry such as bracelets or anklets, which have perhaps served as currency (like certain surprisingly shaped iron pieces), shows that to the mastery of form, to the true sculptural vocation of these artists can be added the taste for decoration and the

studied skill of filling open spaces, a skill that is even more vividly displayed among the Kasai tribes.

With Kongo and Teke art, we enter the realm of nails and reliquaries. The nail-riddled bodies of the wood figurines or their bellies hidden under a lump of clay and resin often topped with a mirror have attracted our attention more than the specific quality of the sculpture. These art objects are scarcely delineated and are often distinguished by additions of clay, cloth, or other materials. What moves us most in Kongo art is the naturalism that very often enhances an extraordinary magical assemblage which is, in that respect, an art close to modern "collage" and found-object art. But although the Cubists, Surrealists, and others deliberately applied new means of expression to their works, Congolese sculptors shaped their figurines innocently, according to the aesthetic and social canons of the local art and independent of outside arrangements, which were the responsibility of the *nganga,* the doctor-sorcerer, or the owner of the statuette that was designed to influence events. These figures, in standing or crouching position with hands placed on the knees, have a crown-shaped headdress with a transversal crest, flat, truncated-cone-shaped beards, and cheeks striated with vertical parallel tribal scarifications.

A study could be undertaken of this well-known statuary art by a focus on the function it is called on to fill. Statuettes with nails, with "guns," with a raised knife, with mirrors, with reliquaries, with magic bundles; statuettes coated with white pond clay or with red powder; statuettes wrapped in a heavy "medicine" made of raw earth and crushed barks mixed with the blood of a sacrificial animal, a kind of plaster contained in a piece of cloth that is tied together with plant fiber—the meaning of all these figurines is linked with the general belief of the Teke and the Kongo in the beneficial force, of the ancestors, or more specifically, that their spirits, pleased by the cults that are devoted to them, will be capable of protecting or avenging their faithful descendants. These societies are extremely vulnerable to dissatisfied spirits. The *mukuya* (which means "spirits of ancestors" in

the Sundi language) that have left the *mbula*—a term that Claude Millet translates poetically as "the assembly of the tranquil dead"—are the source of all disagreeable or sorrowful things. To make the *mukuya* act in a beneficial way, resting places are created for them that are rich in magic and capable of making them comfortable. These are the *kiteki* of the Sundi, the *butti* of the Fumbu, and the *na mogango* of "all the peoples that inhabit the territory stretching from Stanley Pool to the mouth of the Congo River."

It is easier to understand the use of these figurines than their exact meaning. They seem to be receptacles for the spirit of an ancestor for the Teke and the Kongo of the old Middle-Congo and representations of nature spirits for the Mayombe people, whose cult is said to have been replaced by a cult of the departed. In any case, they deliver multiple services: protection against sickness and death, divination, acquisition of wealth, etc. Some are made for hunters and point out the location of game. Many protect against the *ndoki,* or sorcerers who eat souls, because the life forces of man cannot alone resist these evil powers. In Vili country and in Mayombe the *konde* serve as receptacles for evil spirits: dogs, or perhaps sometimes leopards, with their mouths half open showing fangs and ready to bite, or standing men (often big heavy figures more than three feet tall). Their aggressive and disturbing appearance is the result of implanted pieces of iron, which imbue them with a presence made even more obsessive by eyes formed of two pieces of mirror. All these grimacing faces, torsos full of nails, shining eyes, and reliquaries seem to testify to an anxiety that the cults of the nature deities and of the deceased chiefs are unable to appease.

Stylistic characteristics of "tribal" origin can be recognized in this statuary. It is possible, for example, to distinguish the statuettes of the Bembe, the Sundi, and the Vili, and perhaps even those of certain subtribes. But these differences are more related to the various social traditions expressed aesthetically than to real artistic concepts. Therefore, we can observe the very elaborate geometric design of abdominal scarifications of the Bembe, the Teke scarifications with their close-set parallel gashes made on the cheeks during childhood, and their

headdress, which is an extreme stylization of traditional hair arrangement. These scarifications do not exist among the coastal Kongo, where the representation of an ancestor or of the "medicine force" emerges from a conglomeration of various substances.

Many representations independent of therapeutic magic are found among the last. These are probably precious tokens of what persisted of the ancient political and religious structures of the kingdom of the Kongo at the time of the colonial penetration at the end of the nineteenth century. This kingdom—divided into six provinces around its capital, San Salvador—dominated the neighboring kingdoms of the Vili, the Woyo, and the Teke until its rule crumbled at the end of the fifteenth century. Later, the kingdoms formed by the royal provinces that had become independent fragmented, in turn, into a number of tribal units, but the principles of the royal ceremonies persisted at the clan chief level. Unquestionably these principles were manifested in the sculptured portrayals of crowned chiefs, in their emblems of prestige in wood or ivory, and in the representation of the "mother and child," an image of a mythical ancestor who gave birth to the mothers of the various ancestral lineages. These figures have changed or have blended into an assemblage of cultural forms that are on the one hand linked with Christianity and on the other with the protocol of the Portuguese court; forms that were introduced by missionaries and embassies as early as the beginning of the sixteenth century. Therefore, Kongo art is very often considered a heterogeneous art with its naturalistic tendencies owed to the influence of Western works. In reality, the Kongo imitations of European objects, though certainly numerous, are reinterpretations rather than copies: the gunpowder flasks and even the sixteenth- and seventeenth-century crucifixes are there as proof. In general, does not Kongo art seem to be a kind of transcription of their past and present life in a script that is more secular than esoteric? The scenes engraved in low relief on the panels of young Mayombe initiates, the sculpture in the round on top of the Woyo "casserole" covers from the Portuguese enclave Cabinda, the drums mounted on a complex scaffolding of polychrome sculpture, the

hut-supporting pillars covered with figures—all are indicative of the narrative and almost didactic nature of this art, of which commemorative statuary constitutes an important part. The same is true of the *mintadi* of the Mboma region; large tiles, rounded and polished by water, carved in relief and used as tombstones. The *matadi,* from the same area, are also similar, figures in soft stone represented in familiar poses and placed on the graves (of the common people, as Father J. Vissers specifies, the royal tombs being decorated with Portuguese ceramics, which were considered precious objects by the Kongo) or even in Mayombe funerary "chapels," which shelter monumental coffins of the chiefs as well as altars adorned with little figures and utensils recalling the nature and activities of the deceased.

The world of masks is more closed to us. The Teke, with their religion and political organization of hereditary kings, dominated their neighbors, until, though retaining their ritual preeminence, they had to cede to the Kongo the right to occupy and work their lands. Attributed to the Teke is a disk-shaped polychrome mask whose upper half overhangs slightly. The nose is placed exactly in the middle of the face, which is decorated around its border with half-moon motifs painted in kaolin and a central motif in the form of eyes. To be truthful, the origin and the meaning of this indeed remarkable mask pose a problem. To date there is no study that allows us to place it within the framework of Teke culture.

The monstrous masks of the Loango region, formerly worn above ample grass costumes, today are said to represent the ugliness of the white man. From missionary to administrator, are they not the subjects of numerous caricatures, likenesses carved in soft wood and usually painted?

The Mayombe masks, sensitive female faces coated with white clay, recall somewhat the masks of deceased Lumbo and Punu women. Here again is evidence of the richness of Kongo art: an extreme vitality nourished by humor and an acute sense of observation allied with a sure taste for the composition of harmonious and expressive forms.

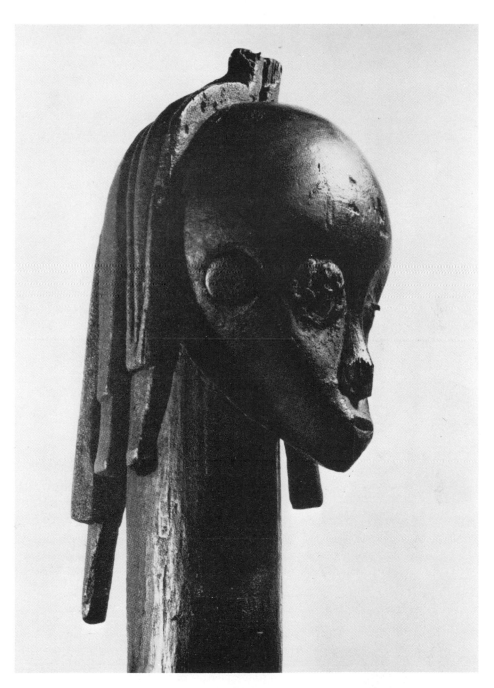

104. Reliquary head. Wood. Fang, Gabon. Formerly in the collection of Jacob Epstein.

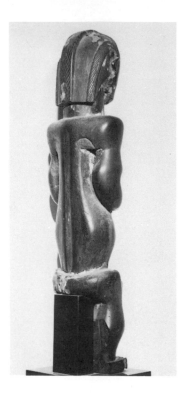

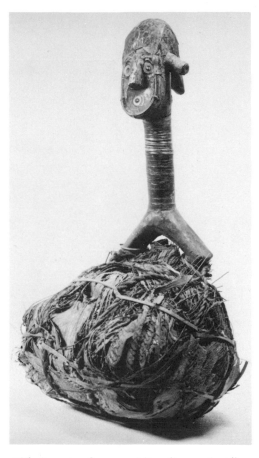

105. Ancestor figure (back view). Wood. H. 18²⁹⁄₃₂″. Fang, Gabon. Formerly in the collection of Tristan Tzara, now in the collection of Christophe Tzara. Photo Geneviève Bonnefoi.

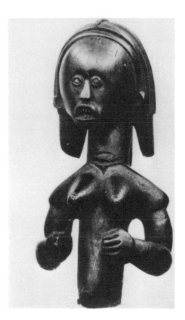

107. Ancestor figure and its reliquary bundle. Wood, fibers, copper. H. 12½″. Sango, Gabon. Collection of André Fourquet. Photo Jeanbor.

106. Bust to be placed in a reliquary bundle. Wood. H. 21½″. Fang, Gabon. Harvard University, Peabody Museum of Archaeology and Ethnology, Cambridge. Photo from catalogue of the exhibition "Masterpieces of African Art," Brooklyn Museum, New York, 1955, fig. 205.

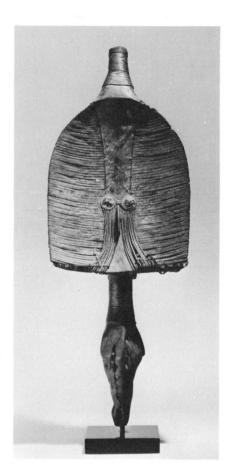

108 & 108a. Recent style of reliquary figure (front and back views) attributed to "Osyeba." Wood, copper. H. 25$^{17}\!/_{32}$". Gabon. Collection of Paul Tishman, New York. Photo Library of Musée de l'Homme, Paris.

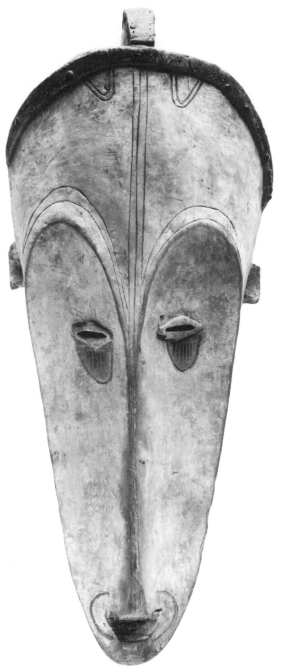

109. Mask of the *ngil* society. Wood whitened with kaolin. H. 26²⁹⁄₃₂". Fang, Gabon. Musée de l'Homme, Paris. Museum photo.

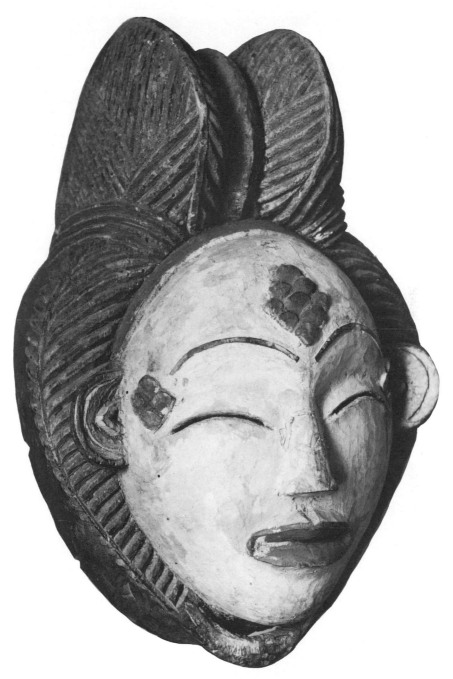

110. Mask. Wood whitened with kaolin. H. 11⁵⁄₁₆″. Punu, Gabon. Collection of
P. Peissi. Photo C. Lacheroy.

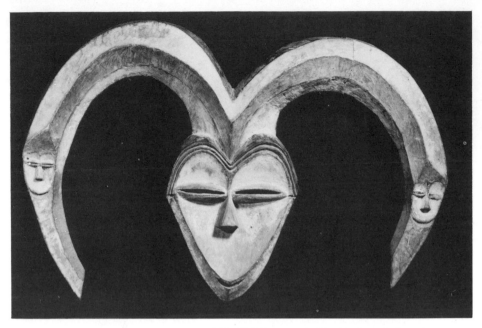

111. Half-human, half-animal mask. Wood whitened with kaolin. L. 24³⁄₁₆″. Kwele, Congo. Collection Muller, Soleure. Photo Dominique Darbois.

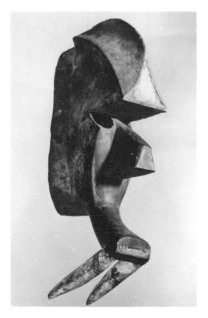

112. Half-human, half-animal mask. Wood. H. 16¾″. Kwele, Congo. Musée des Arts Africains et Océaniens, Paris. Photo I. Bandy.

113. Carved polychrome door *in situ*. Vuvi, Gabon. Photo Philippe Guimiot.

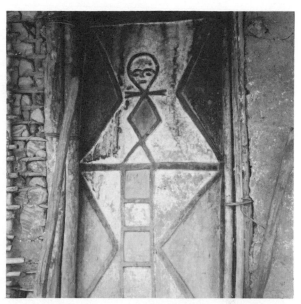

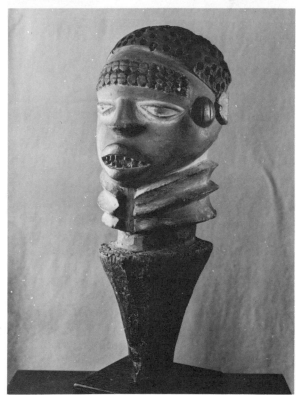

114. Ancestor figure, baton used as the top of a mask. Painted wood. H. 7¹³⁄₁₆″. Kuyu, Congo. Collection of P. Peissi. Photo C. Lacheroy.

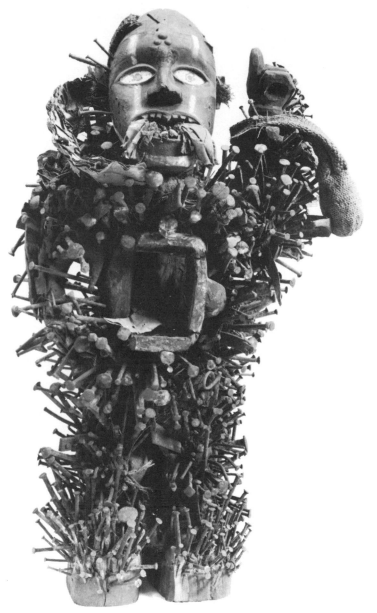

115. Fetish figure. Wood, iron. H. 22⅝″. Kongo, Loango region. Musée de l'Homme, Paris. Museum photo.

116. Maternity—the presence of the baby and the pot suggests the ideas of fertility ▸ and womanhood. Wood whitened with kaolin. H. 21⁷⁄₁₆″. Kongo, Mayombe region. Collection of Clark Stillman. Photo courtesy of the Museum of Primitive Art, New York.

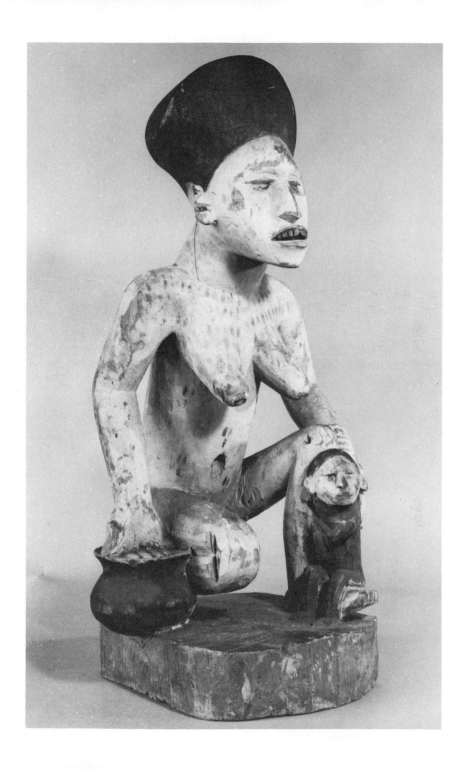

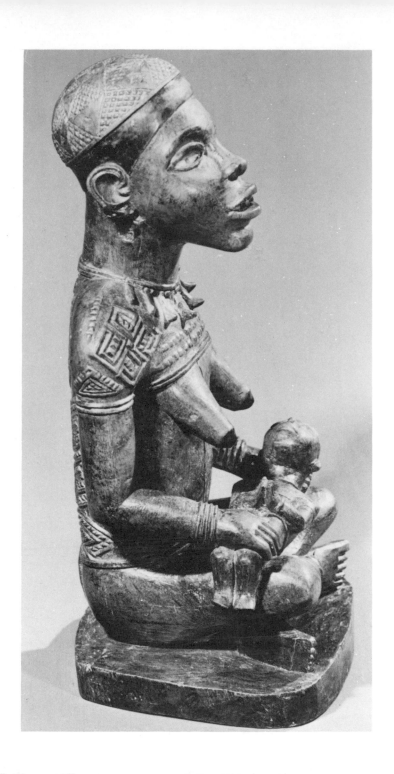

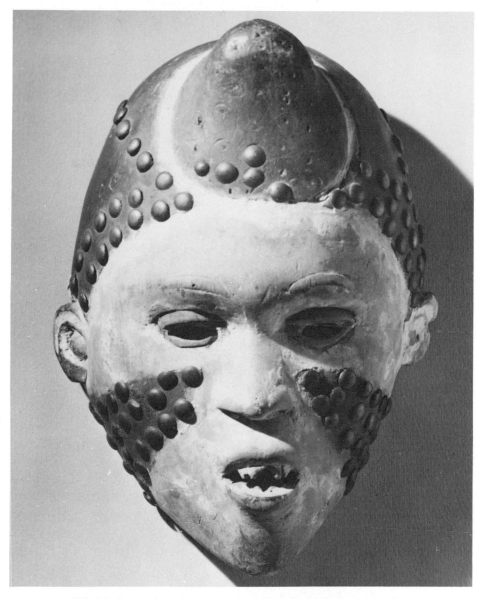

118. Mask used in a divination ritual. Wood whitened with kaolin, copper nails. H. 10⅛″. Kongo, Lower Congo. Collection of Joseph Van der Straete.

◄ **117.** Mother and child figure. Wood. H. 10¹¹⁄₃₂″. Kongo, Lower Congo. Musée Royal de l'Afrique Centrale, Brussels. Museum photo.

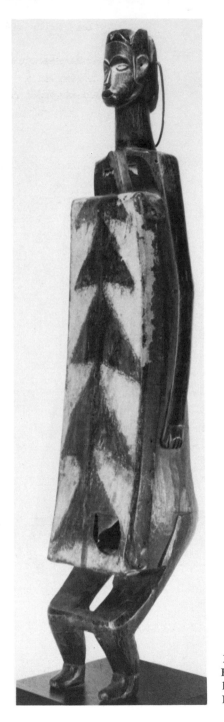

119. *Bwiti* harp. Painted wood. H. 27⁵⁄₁₆″. Sango, Gabon. Collection of André Fourquet. Photo Bordas.

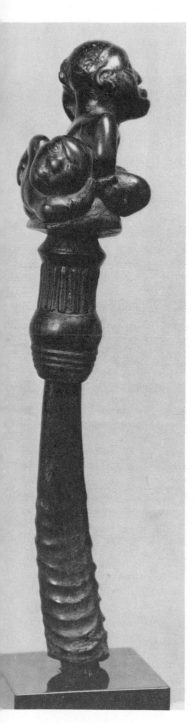

120. Whistle. Wood, antelope horn. H. 6¼". Kongo, Lower Congo. Collection of Jean Roudillon. Photo Dominique Darbois.

121. Caricature of a European. Painted wood. H. 11½". Kongo, Lower Congo. Musée Royal de l'Afrique Centrale, Brussels. Museum photo.

122. Steatite (soapstone) sculpture portraying a scene of adultery; the husband has killed the lover and is preparing to strangle his wife. H. 14⁷⁄₁₆″. Kongo, Massif de Novi, Angola. Collection Hilgers, Brussels.

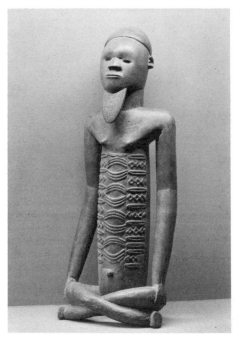

123. Ancestor figure (for magical use?). Wood. H. 22⅝″. Bembe, Congo. Sammlung für Völkerkunde der Universität, Zurich. Photo Hélène Adant.

124. Ancestor figure. Wood. ►
H. 15²⁵⁄₃₂″. Teke, Congo. Collection
Païlès. Photo Dominique Darbois.

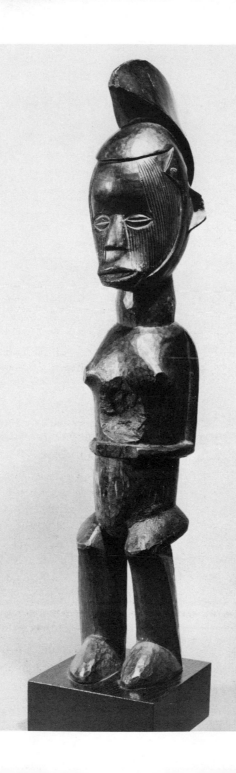

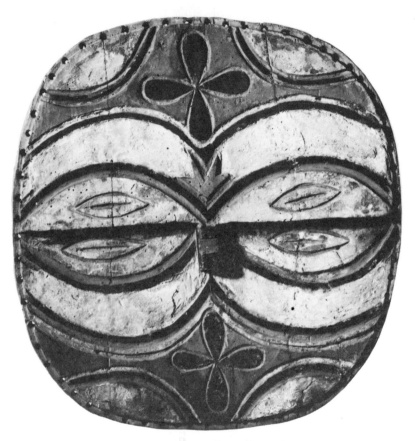

125. Mask. Painted wood. H. 13¼". Teke, Congo.
Collection Païlès. Photo Dominique Darbois.

The Central Congo

The lands of the Kwango, the Kasai, Katanga, and northeast Angola are perhaps the richest artistic regions of the Congo. There, in the enormous space that opens up where the jungle gradually recedes in favor of the grassy savanna, thanks to the whims of altitude and water, live agriculturists whose ancestors long ago built powerful kingdoms. This environment turned out to be favorable for a flowering of the arts, illustrated by works of which several rank with the "classics" of world sculpture.

In this advantageous area, four art centers can be roughly distinguished: the Luba in the east, the Kuba in the center, the Pende-Yaka-Suku-Mbala in the west, and finally the Chokwe-Lunda in the south.

The lands between Lake Tanganyika and Lake Mweru to the west and the Sankuru and the Lubilash on the east were conquered from the sixteenth to the end of the nineteenth centuries by great Luba chiefs, whom legend has turned into heroes and even gods.

For a long time Luba plastic arts, especially wood sculpture, have been considered a homogeneous style group, in which style variations had blurred into one general approach that merely retained a rounded treatment of forms, a respect for the proportions of the human body, the care to represent the different elements of dress, and, apparently, a quest for psychological expression.

It is true that the nature of the objects linked with the prestigious aspects of the lives of the chief and his functionaries, and also devoted to the cult of the royal ancestors, leads us to believe in this homogeneity. Examples of such objects are statues of men and women, caryatid stools, headrests, batons, staffs, weapons, and arrow holders. However, the second Luba empire could not have occupied all the land between the Maniema and Tanganyika without grouping together very dissimilar populations whose specific temperaments have, in some cases, more or less resisted the process of "balubalization." This is one of the reasons for the stylistic variety shown by the arts in these regions, with authentically "classical" Luba art finally limited to central Katanga. Albert Maesen tells us (in a personal letter dated March 6, 1962) that he thinks it possible to distinguish "approximately" ten more or less recognizable styles. But he prudently insists: ". . . we must add to these an infinite number of local or even individual variables which often show fundamental differences from the principal local styles."

It is in connection with Luba art that for the first time one speaks seriously of the personality of an African artist. In classifying the stylistic regions of the Congo, Frans M. Olbrechts, struck by the remarkable stylistic unity of a dozen sculptures, chiefs' stools and statuettes, came to isolate "the Buli long-face style." "We are not confronted here," he wrote, "by a regional substyle, but indeed by the work of one and the same artist or at least of the same school or workshop." Buli female statuary departs from the classical Luba style (that of the women with the beautiful, rounded, and smooth foreheads with eyes in the form of heavy cowries, with a cross-shaped headdress, and with bellies scarified from the chest to below the navel). The cup bearer of the Tervuren Museum, long called "the beggar," and the stool bearers of the British and Darmstadt museums, for example, are surprising in the angular aspect of their faces, with half-closed eyes drawn out under little, sharply arched eyebrows, protruding cheekbones, gently ridged noses whose nostrils widen abruptly, and pointed chins.

Magic, divination, and, above all, religious conceptions have inspired Luba sculpture to a great degree; this sculpture otherwise also owes much to the world of political institutions. Here, contrary to what is found in certain West African states, for example, where centralization of power seems more or less to absorb the diverse creative sources of village art in favor of a single, royal art, the two spheres of artistic inspiration are not mutually exclusive. The chief embodies a maximum of sacred forces: those attached to the esteemed dead of his lineage, and those associated with the numerous, always dynamic and latent spirits. A craftsman, although only a functionary of the king, fabricates the emblems of the chief: drums, stools, weapons, and domestic utensils. The dignitaries of the secret societies wear the rich symbols of their functions and employ remarkable sculptures for the initiation ceremonies. Dressed with care and coiffed with beaded diadems trimmed in multicolored feathers, their necks and shoulders laden with necklaces, the diviners and magicians are also equipped with fly whisks and axes with carved handles. But the supernatural and powerful world of the *vidye* spirits seems to play a role sufficiently independent of the political world (which is undoubtedly still not very centralized) so that the arts abound at several levels of the social life. The use of charms is inseparable from daily living, whether technological and concerned with hunting, fishing, or medicine; or social and concerned with law; or religious, involving relations with the spirits of the dead, legendary heroes, and ancestors. The fabrication of the charms remains an inexhaustible source of artistic creation.

Luba statuary is rich in abnormal personages with specific characteristics, such as figurines with two heads, or those whose heads are upside down, and especially numerous hermaphroditic characters that seem to incorporate the major virtues of both sexes, namely the political power of the male and the procreative power of the female.

Finally, in all Luba art the woman occupies a dominant place. She lends her form to royal insignia, to magical instruments, and to religious representations. Her constant presence in the sculpture testifies to the essential role she plays in the society: the guardian of sacred

emblems and associated with the myths of creation of the secret socie-
ties, she participates in the administration of village affairs as the
wife of the chief. She is, moreover, the heroine of the story that re-
lates the founding of the society.

Luba sculptures, and particularly the numerous insignia of prestige
produced by artists or blacksmiths who were held in high esteem by
their village, hardly conceal their meanings. This, unfortunately, does
not hold true for the masks, whose exact functions remain unknown.
Such is the case of a famous mask attributed to the Luba of northern
Katanga, a bell mask representing a head whose exquisitely rounded
volume is set off by the no-less exquisite details of the face and the
hair. In the west, toward the Lomami region, an undefined area marks
the passage from Luba to Songye style.

The cultural influences among the Kasai and Katanga Luba and
the Songye have been reciprocal. In Songye statuary, the addition of
magical elements often amounts to a paroxysm, which may be due to
the importance assumed by medicine and magic to the detriment of
an ancestor cult, which, singularly, is not very apparent here. Another
characteristic of this style is the very geometric treatment of the human
face, which is segmented into distinct volumes. In the *kifwebe* society
mask, the artist succeeds in projecting forward a mouth in the form
of a rectangular box, a nose like a triangle, and eyes as semispheres,
while the sugarloaf-shaped head is divided in two by a ridge that
lengthens the bridge of the nose. These masks are to be found in Luba
territory, but in a rounded form and without the violent forward pro-
jection of the facial elements. All are covered in a striated, curvilinear
design of alternating colors. What formerly was the exact function of
the society that employed these masks? We are as uninformed in this
matter as we are concerning the great statues laden with charms for
protection or attack, figures that have a fearsome appearance and
are at times almost monumental.

In contrast to the Luba, the Songye almost never work in ivory.
However, from even before the time their migrations brought them to
the region they inhabit today, they have always been known as "the
most skillful blacksmiths of the Congo." The iron they found in the

mines of surrounding mountains and the copper they took from journeys across Katanga, once melted and forged, became prestigious instruments.

The art of the Kuba, like that of the Benin and the Ashanti, for example, serves a divine king surrounded by a court of dignitaries in a capital where specialized groups are in charge of many types of artisans. Kuba art is striking for its profligate use of decorative fill-in patterns in all the plastic arts: architecture, sculpture, metallurgy, basketry and weaving, dyeing, and beadwork. Only pottery seems to be missing; moreover, there is hardly any so-called pottery clay to be found in Kuba territory.

Texts that are already old, such as those written by Leo Frobenius and E. Torday at the time of the decadence of the traditional empire, granted a major place to the aesthetic feeling of the Kuba. The importance they give to the "beautiful" seems to exist beyond the extravagant demands of an organized, royal hierarchy and equally beyond any religious or magic beliefs. Aesthetics seems to be a major preoccupation with these people, and those who have spent time in the area have profoundly sensed the privileged role that the fine arts play in Kuba life. L. Achten, among other enthusiastic travelers, noted:

> Crafts are highly honored among the Bakuba. History has preserved the name of the *nyimi* who introduced the weaver's and blacksmith's arts, of those who found a new decorative motif, a new model of a basket or gong. . . . Many chiefs or notables practice one craft or another. Mention is made of the creator of a beautiful wood sculpture. Almost everyone knows how to braid mats, to adorn *luketi* and masks, and make beautiful dance costumes. Everyone knows the multiple designs, how to group them and to alternate the colors. As soon as you introduce a Bakuba into a European dwelling, he wants to look very closely at and touch our knickknacks.

Jan Vansina goes even further: "Symbolism does not seem to be a determining factor in the composition of these decorations. Pleasure

in decorating appears to be the only motive which induces the Bakuba
to ornament their objects of daily use."

The Kuba kingdom was a federation of small tribes and not a true
centralized state. Little by little, the Bushong group, established in the
plain situated between the Sankuru, the Kasai, and the Lulua, suc-
ceeded in dominating all the chiefdoms. In the seventeenth century,
the Bushong empire reached the summit of a cultural expansion whose
premonitions of decline did not appear until the first third of the nine-
teenth century. The traditions carefully preserved by dignitary special-
ists tell of the succession of the different *nyimi* and the principal events
that occurred under their reigns, particularly in the technological and
aesthetic domains: the introduction of metallurgy, the weaving of raffia
fibers, the creation of sculptural styles, the new types of masks, etc.
The entire social life is concerned with the "beautiful" and this can
be partially explained by the dynamism of Kuba economy. For quite
a long time, an active external trade assured the exchange of ivory,
iron, copper, pottery, *tukula,* and raffia. "The variety of products
manufactured and sold in the regional markets was astonishing: dance
costumes, velvets, headdress masks, carved objects, parade weapons,"
writes Vansina. The prestige of men is a function of their wealth, but
wealth does not consist purely of an accumulation of treasures: the
quality of the possessions plays a considerable role. "Every household
owns more than one hundred different objects," and, to meet this de-
mand, specialization in crafts is greatly intensified, there being guilds
of wood sculptors, weavers, tailors, basketmakers, stringmakers,
blacksmiths, and leatherworkers. Specialization continues inside each
of these industries. Alongside the basketmakers and stringmakers, the
mat weavers and netmakers are also represented at court. Are not
both a specialist of pipe bowls and one of pipestems mentioned for
the same village?

Kuba art is an aristocratic art in the sense that only a part of the
society could be assured of the possession of luxury objects, the mass
of the people contenting themselves with items of lesser quality. But

this art ranged through all levels, so one can find the motifs of a popular artisanry like weaving even in the most elaborate decorations.

There are no known Kuba statues of religious inspiration, but there is instead a type of carved object used for divination. Generally representing a quadruped, more rarely a human figure, this object is turned upside down by the diviner to see if he has spoken fairly. A moistened disk placed on the back of the object should remain stuck to it if he has.

Kuba statuary is limited to the representation of kings, the oldest of which reigned at the beginning of the seventeenth century. But it seems that only a few of these effigies are contemporary with their prestigious models. All show the king seated, cross-legged, holding the unchanging emblems of his authority bestowed through divine essence. In front of the base is a personal attribute, evidence of that particular king's contribution to the cultural life of the kingdom: a standing drum, an anvil, a game of *lela*. . . . These statues, which were kept in secret and far-removed places, have not been seen in their place by any investigator, and their exact function is still almost unknown. According to A. Maesen, the most recent investigations establish that "the carved effigy of the living king was, at his final illness, placed at his bedside to gather the metaphysical force of the dying 'god on earth.' " But this evidently only applies to the contemporary statues of the kings under consideration. This same author also thinks that the newly enthroned had to be confronted with these statues in order to breathe in their particular forces.

The best known of the Kuba masks are employed during initiation rites. According to Vansina, all the ritual apparatus—temporary constructions, masks and clothing, weapons, and the materials utilized, especially raffia—converge in the symbolic representation of the creation that was initiated by God and completed by Woot, the first ancestor, who married his sister and founded the dynasty. For the Bushong, the royal power comes from God, and the most important masks represent simultaneously the mythical heroes with heavenly essence and the king himself, his wife, and their sons. The three masks,

Mwaash a mbooy, Mboom, and *Ngaady mvaash,* form a veritable tri-umvirate, all linked together and possessing a symbolic function that varies according to the aspect of the myth implied in the unfolding of the ritual. The royal mask *Mwaash a mbooy* is made of a skeletal framework of split palm ribs covered with bark cloth and raffia fabric to which are attached more or less complex and sumptuous decorative assemblages of beads and cowries. The small face, usually made of leather or metal, is extended by a pointed top, what is thought to be an elephant's trunk. *Mboom,* a wood bell mask covered with copper plates, pieces of cloth, untanned skins, beads, and cowrie, has a strange power that seems to be born simultaneously of the materials of his composition, especially the hard and luminous copper, and of the harmonious importance given to his bulging forehead and large nose. Associated with, and opposed to, the royal mask, *Mboom* is desirous of *Ngaady mvaash,* the incestuous sister of Woot, represented by a mask of painted wood, embellished with triangular and curvi-linear motifs, and topped with a headdress of cloth decorated with beads and cowries. *Ngaady mvaash* is known; other Kuba subgroups, who used her for different rites, gave her another face.

Kuba sculpture has acquired a just fame for the creation of useful objects rarely equaled in quality and quantity in Africa, such as cups, goblets, stools, boxes, hoe handles, adze handles, pipes, spoons, head-dresses, posts, ridge pieces for the roofs of huts, etc. The elementary motifs derived from weaving or borrowed from the world of nature suggest an inexhaustible play of combinations. Here, the diverse arts seem to interpenetrate each other intimately: the wood sculpture of vessels borrows its forms from pottery and basketweaving, metallurgy takes up the designs of sculpture in wood, and even architecture finds a correlation between the arrangement of the ribs of palm leaves fixed on a trellis of branches and the designs obtained from the methods of assembling threads or fibers to make cloth or a basket. Embroideries are executed on canvas made from dyed raffia; by the cutting with scissors of every thread of the embroidery passed beneath the woof of the material, a type of velvet is obtained. Unquestionably, the dif-

ferent motifs appear with strongest emphasis in these embroideries, possibly because in this occurrence their unique role is to lend life to a pliant surface.

The Ndengese of the northern bank of the Sankuru have traditions, likewise said to have been preserved in the court of the Bushong king, which state that the Ndengese conquered the Kuba country. Whatever the case, their statuary presents certain affinities with that of the Bushong, chiefly in the treatment of the face and the decoration of the body. These statues, possibly serving as guardians of tombs of high officials, and indiscriminately attributed to the Yaelima or to the Ndengese, are similar to those of the Bushong.

The Bena Lulua, one of the most important peoples in Kasai province, divide themselves into multiple autonomous lineages. Bena Lulua statuary is well known in Europe, particularly one of its most attractive forms, in which the representation of scarifications is exploited to the point of determining the artistic nature of the sculpture. The most elaborate works represent warrior chieftains bearing prestige insignia. This marvelous engraving is also found on many other statuettes of varying dimensions, for example, on the very moving maternal figures, which sometimes possess a lower part shaped into a point. These are carried by the pregnant woman under her belt or in her folded-back loincloth to prevent miscarriage, to facilitate birth, and to protect the child until weaning or even puberty. In addition to protection or divination figurines there are also hunting figures, provided with a vessel on the head and laden with ingredients hidden in a tiny calabash placed on the stomach or a small horn or basket fixed to the arm. Most of these statuettes are dusted with a red powder that heightens the relief in the play of the motifs on their slender volumes.

The same decorative technique is found in many other works, particularly tobacco mortars, pipes, and cups, which are bold anthropomorphic conceptions. As for the masks, which the Lulua wear at their initiation rites, there is still a question whether these were invented by the Lulua themselves or borrowed, possibly from the Kuba if not from the Chokwe, and then reinterpreted. The influences

succumbed to by the Lulua have, indeed, been multiple, before and even after the efforts of one chief, Kalemba Mukenge, who, attempting to realize a certain unity around 1880, in the process caused the destruction of the traditional religious sculptures. Whatever the case, the artistic genius native to the Lulua should not be questioned. "The Lulua sculptors," write J.-A. Fourche and H. Morlighem,

> are held to be "men of powers and secrets." . . . it is their realm to express the invisible forms. . . . One day we inquired of a local artist where he had gotten the idea for an extraordinary figure he was chiseling out. The sculptor shook his head several times, implying that we must have been mocking him, then, faced with our insistence, he emitted this Baudelairian answer, which he evidently took quite literally: "Do you not ever look at the clouds?"

The art of very tiny, sometimes ancient groups in the Kasai region is best characterized by their conception of mask sculpture. Despite the pressure of cultures as insistent as those of the Kuba, the Lulua, the Chokwe, and the Pende, these peoples have been able to retain their individuality. The Biombo carve masks of diverse types. Certain masks are related to the female Kuba masks, to Lulua masks, and perhaps to those of the Pende through their use of geometric patterns, usually light on a brown background. Others are easily mistaken for Kete masks, having diamond-shaped faces painted black, with two large areas whitened with kaolin around the eye slits and with nose, mouth, and chin projecting forward their harmonious volumes. This composition, analogous to that used by the Songye, is likewise employed, but always with original variations, by the Mbagani and the Lwalwa.

The Salampasu, who resisted the migration of the Lunda and found refuge in upper Kasai, are the northwestern neighbors of the Lwalwa. They too elaborated upon an original sculpture, characterized in the art of the mask and wood statuary by the power given to the facial features and by the use of metal and fiber. There is also known to be

a type of mask made entirely of vegetable fiber, a happy example of a work tradition whose artistic results often equal those of wood sculpture. A choice of different fibers, together with the application of coloring substances, is submitted to a veritable composition born not solely of the weaving technique of basketmaking, but also of the arrangement of the various materials. Such a composition leads to the masterpieces of straw and resin that we will find in Kwango and Angola.

Between the region of the Kuba-Lulua to the east and the Kongo to the west, in the territories included between western Kasai and the valley of the Kwango, sculpture still plays a privileged role among the Pende, the Yaka-Suku, the Holo, and the Mbala.

Although statuary and the other arts are brilliantly represented here, the art of mask making, because of the importance of its series, its variety, and even its function, whose aspects vary depending upon the tribe, proves to be a preeminent aesthetic and social tradition.

Among the Pende, whose art has been studied by Father L. de Sousberghe, the most characteristic masks, which have eclipsed many other masks, are those having gently rounded foreheads, curved eyebrows united where the bridge of the triangular turned-up nose begins, heavy eyelids, thin lips open to show the teeth, and pointed chins. In the chiefdom of the Katundu, the most important of the Kilembe region to the southeast of the Kwilu, a considerable number of wood masks are made. There sculptors of neighboring, that is to say "stranger," chiefdoms come to learn their craft. In the Kwilu Pende's northern confines, a zone not entirely Pende, a chief, an "amateur of Pende art," ordered a stork to be put on top of his hut, like those on the Pende chieftains' dwellings. At the time of his investiture in 1924, this chief bought what was very probably the "last Pende chair existing in the country" from a sculptor of a neighboring chiefdom, states Father de Sousberghe.

The *mbuya,* masks of carved wood, are distinguished from the *mingandji,* masks made of raffia strands. Today, in Katundu land, the

mbuya exhibit themselves for purposes of entertainment during the festivals organized for the return of the circumcised; they act out a true human comedy. Although they are numerous and include the Epileptic, the Clown, the Hunter, the Chief's Wife, the Flirt, the Ugly Old Woman, the Prostitute, the Murderer, the Lunatic, the Drawer of Palm Wine, etc., they appear at each session in groups of three or five. Although merely theatrical today, these masks nonetheless are still invested with a certain force, undoubtedly a vestige of their former religious personality. The masks with long wooden beards are those most readily copied by neighboring sculptors.

The masks of the Kasai Pende are less well known. Only the bell mask with plate-shaped chin and thin, protuberant nose presents a characteristic style. Kept in the chief's hut, this mask exercises a beneficent influence over the village. On the left bank of the Kwilu, an important bell mask predominates; its small face is often reduced to a depression in the form of a heart, which is also found in the center of a disk of wood or basketry. In order to protect themselves against the complex influences of the masks or to prolong the therapeutic character of some, the guardians of the mask, the sculptors and members of their families wear a miniature reproduction of the *mbuya* around their necks. The finest of these, made of ivory, are replicas of the long-bearded mask or of the mask wearing the three-pointed chief's headdress.

The Pende sculptor has become attached mainly to the art of portraying faces, and the beautiful, sensitive heads of the *mbuya* are found again on the oracular instruments called *galukoshi*. Quality statuary hardly exists; sculpture appears more as an element of decoration, notably in the chiefs' dwellings, where it serves to emphasize the sacred nature of the place. Pende roof-ridge statues, door-frame sculptures, and interior paintings; Hungana carved doors; Suku door lintels; and Holo huts in the shape of bees' nests, ornamented with bundles of straw regularly cut and laid out in stages, open in a circular arc and are surmounted with a panel of plant strips harmoniously interlaced and painted—such refined techniques demonstrate the ef-

forts devoted to the chief's habitation throughout Kwango. The Nkanu, on the other hand, decorate their initiation huts. Their walls or decorative panels, endowed with polychrome paintings of geometric motifs, serve as background to important figures carved in high relief, a style related to that of the Yaka masks.

The Yaka masks are used in the *mukanda,* the circumcision enclosures, and in the villages where the newly circumcised present themselves. Each consists of a wood face, usually small, which is extended by a handle hidden under a collar of fibers. The mask is topped with a headdress, a true basketry sculpture, which is covered by raffia cloth coated with resin and then painted. The form of the headdress varies according to the rank of its wearer and his order in the dance exhibition. M. Plancquaert writes of the sculptor that "every new lot [of circumcised] furnishes him with the occasion to execute in these creations the modifications suggested by his fantasy." But the only visible result his quest for beauty has for the spectator is a sort of palette, whose central relief forms a face of powerful features, in particular a nose that is often turned up to an extreme degree. Among the Suku, *mukanda* masks in the form of bell masks are also found with a rounded face, a small and pointed nose, and closed eyes. The Suku leaders of the circumcised group wear the "giant" masks, as is the case with the Yaka and the Nkanu.

In the Kwango area, statuary does not lend itself well to definition. The work of the Nkanu, the Yaka, the Suku, the Holo, the Mbala, and the Hungana (who formerly carved ivory pendants whose function remains unknown) begins with some conventional plastic norms, which are then often rendered indistinct by a clever, creative fantasy. An entire rich and strange world of statuettes exists on the fringes of the best-known series of sculptures: deformed figurines or those of rudimentary design, or complex personages stylized in connection with magic charms. Precise information is lacking concerning these magic instruments, while the world of political institutions has been more accessible.

For the Mbala, the chief's investiture implies both a retreat and an

initiation. On the eve of his consecration, the young inheritor of the throne is led into the "fetish hut." There the future chief passes the night in the company of statues that represent a musician, usually a xylophone player, and a mother holding her infant. Another theme, the childbearer, also probably related to the mythology of power, intervenes for the Kwango. Everywhere, traditional attributes of authority are in use, even among such people as the Holo, where the chief's function has not withstood European administration.

From the beginning of the seventeenth century to the middle of the nineteenth century, the regions situated between the Kwango-Kasai, southwest Angola, and Zambia witnessed the formation and then the subsequent fragmentation of the great Lunda empire. There new communities were created after the establishment of Lunda emigrants among people who offered no resistance, for example, the expansionist chiefdoms of the Chokwe hunters, in the territory of Cangamba in southwest Angola, or the stable chiefdoms of the Luena fishermen, more to the west and in the district of the Balovale in northeastern Zambia.

The plastic arts of the Lunda are extremely rich, even though those of the Chokwe of the southern plateau of Angola have attracted more attention. It is difficult to establish stylistic distinctions between the art of the northern Lunda, the southern chiefdoms (whose history is less well known), and the related tribes adjacent to the Chokwe homeland. The cultural imprint of Chokwe expansion (although influenced by Lunda political models) was such that it is primarily striking for its homogeneity, which is exceptional for such a large area. In this pliantly luxuriant style, each of the original volumes that enter into the composition of an object seems to be separated into fragments that are completely and diversely worked. The entire material universe, both everyday and special, lends itself to the artisan polyvalence of the Lunda-Chokwe, whose arts are reminiscent of the Kuba (with whom the Chokwe had trade relations at the beginning of this century) as well as the Luba (related to the Lunda through the sharing of a small

part of history). The relationship between Lunda art and the Congolese art of the Kasai is marked by the very decorative nature of an aesthetic applied to the most varied domestic art and by the creation of an expressive anthropomorphic sculpture that approaches portraiture.

In one of the rare, truly aesthetic studies dedicated to black African art, Marie-Louise Bastin allows us to grasp what is original in Lunda-Chokwe art: a remarkable understanding of the design implied in each object and a constant use of geometric decoration, whose motifs are always related to natural reality through a tight network of correspondences.

The art of the mask and statuary benefits a great deal from this decorative and symbolic bent, but even more do all the accessories, humble or noble, of the technological and political life: axes, adzes, clubs, staffs, spatulas, knives, spears, baskets, calabashes, pottery, mortars, belts, pins, combs, headrests, stools, chairs, snuffboxes, fly whisks, etc. Each object becomes an aesthetic creation, a pretext for decorative embellishment. Here, possibly because numerous collected documents permit better understanding, the personal sensitivity of the artist seems to intervene to a great extent in the choice of motifs he makes. The Chokwe sculptor, basketmaker, or painter makes use of a properly classified repertory of motifs. Straight lines and curves combined in crosses, angles, chevrons, rosettes, interlacings, and festoons refer back to elements of the vegetable or animal world or even to man, his body, or its adornment (scarifications, hair arrangement, or jewelry) or again to abstract forms themselves: curvatures, meanders, and undulations. Each motif is designated by a name that brings to mind the thing evoked. Many variants of classical decorative motifs end up by coinciding, and it is not surprising that certain designs may be confused. The artist's inspiration is engaged upon a course posted with traditional landmarks, it finds, however—and for the very reason of the evocative power of this decorative universe—the way to create new and fascinating formal combinations. To the extent that the symbolic value of certain ornaments has become attenuated, Marie-Louise

Bastin notes that "at present their use becomes increasingly gratuitous, the sought-after purpose being above all to embellish the functional object." The very honorable trade of carving has been passed down in certain families. The artist, sculptor, or blacksmith made ritual as well as domestic objects.

The decorative calling of Chokwe-Lunda art is particularly noticeable in the prestige implements that are carved in abundance for chiefs and dignitaries: batons and staffs of authority with a beautiful patina, whose tops are fine heads in which the type of coiffure plays an important role; ceremonial spears with shafts carved in the form of a personage, furnished with scrolls of copper and with blades decorated with a burin; axes with elegantly cut-out blades that always lend themselves to subtle compositions of stipple engraving; clubs with carved heads; and the large chiefs' chairs with back and arms, derived from European chairs and ornamented with genre scenes.

The already ancient influence of Europe on Chokwe art reveals itself through the adoption of certain forms sometimes bordering upon a sort of "rococo" and by a tendency to excess. Here, as elsewhere, the beautiful creations made for the chiefs' courts have disappeared. Only the mask seems to have endured, possibly because it retains a living function. One mask once sacred in the initiation ritual, though now a clown's mask, does not cease to draw from traditional aesthetic sources. This is the case of the *pwo* mask, which is worn by a man and represents "woman" and is displayed in mime and dance scenes with a mask representing an old man. The *pwo* mask with its expressive face, formerly modeled in resin and today carved in wood, wears a wig of fibers in imitation of the different traditional female coiffures: the hair in small plaits dressed and covered in little pellets of earth, or arranged in parallel and horizontal braids coated separately in red clay; there are crested coiffures and some with large puffs, accompanied by a fringe of braids or rolled locks of hair collected at the nape of the neck and stiffened by a cosmetic made from red clay and castor oil.

Masks constructed on a framework of basketry covered with bark

cloth with faces coated with resin and delineated with bits of colored cloth, with a tower coiffure or even one with wings and painted disks, make their appearance at circumcision rites. The men who wear them are dressed in a tight-fitting net costume woven of natural or painted fibers.

Although forked branches and posts at the center of the initiation camp represent different spirits, the most important tutelary spirit, a spirit of fertility, which is invoked by sterile women and hunters, is represented by a mask, the *cikunza,* which has a tall hair arrangement in the shape of a pointed tower. The large *cikungu* mask, with large wings spread out above its forehead, represents "the ancestors of the earth chief" and can be worn only by the latter or by his sister's sons. It is also used in the ceremonies for the initiation of the earth chief. The obligation of watching over the well-being of children devolves upon other masks made of fibers and resins with polychrome fan-shaped coiffures. Once the seclusion of the circumcised has been ended, a retreat that today lasts one and a half years, the masks are burned like the camp itself, thus marking the definitive passage of the adolescents into the world of the adults.

The mask personages are also found in the statuary. The celebrated hunting ancestor of the Luba founder, Tshibinda Ilunga, whose head-dress recalls the *cikungu,* furnished the subject matter for the most beautiful examples of this art, of which high-quality specimens are today altogether too rare.

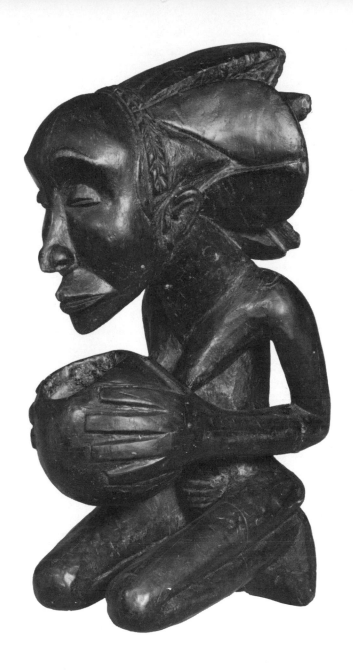

126. Woman presenting a cup, figure used for divination. Wood. H. 18¹¹⁄₃₂″. Luba, Buli style, Katanga, Zaïre. Musée Royal de l'Afrique Centrale, Brussels. Museum photo.

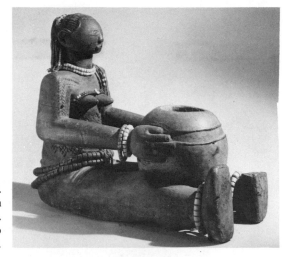

127. Woman cup bearer. Wood. H. 14″. Luba, Zaïre. Collection of Joseph Van der Straete. Photo U.F.D. The Photo Library.

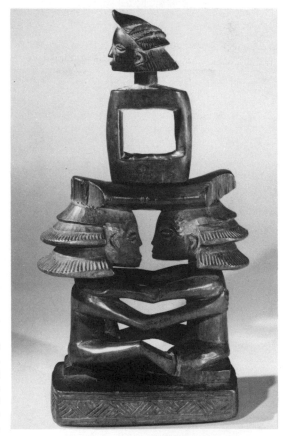

128. Headrest surmounted by a *katakora* (divination object). Wood. H. (of headrest) 6⅝″; H. (of *katakora*) 4¹³⁄₁₆″. Luba, Zaïre. Musée Royal de l'Afrique Centrale, Brussels. Museum photo.

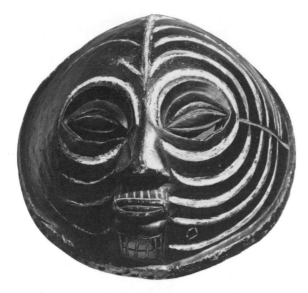

129. Mask attributed to the *kifwebe* society. Painted wood. H. 14⁷⁄₃₂″. Luba, Zaïre. The Museum of Primitive Art, New York. Photo courtesy of the Museum of Primitive Art.

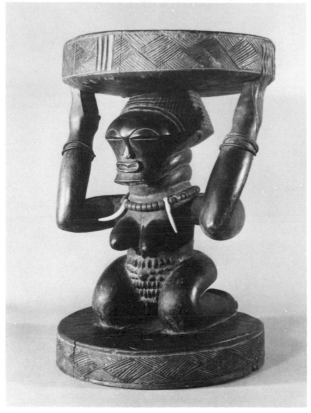

130. Chief's stool. Wood. H. 18¹⁷⁄₃₂″. Songye, Lomami region, Zaïre. Collection of Clark Stillman. Photo courtesy of the Museum of Primitive Art, New York.

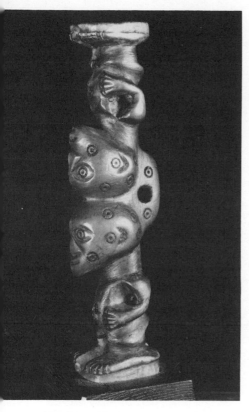

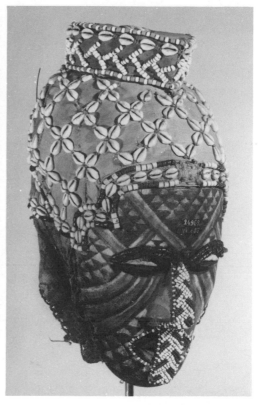

131. Ivory magic object. H. 5¹¹⁄₃₂″.
Songye, Lomami region, Zaïre.
Formerly in the collection of Paul
Guillaume, now in the collection of
Clark Stillman. Photo L. Segy.

132. *Ngaady mvaash* mask. Wood,
beads, cowrie shells, fabric. H. 13¹⁵⁄₁₆″.
Kuba, Kasai, Zaïre. Musée Royal de
l'Afrique Centrale, Brussels. Museum
photo.

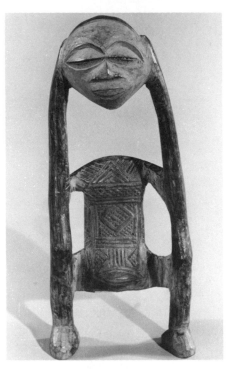

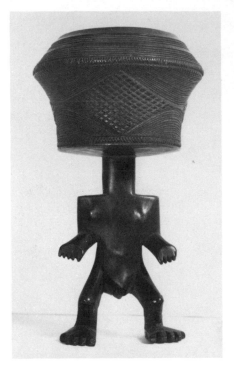

133. Figurine. Wood. H. 10⅛″. Kuba, Kasai, Zaïre. Musée Royal de l'Afrique Centrale, Brussels. Museum photo.

134. Figurine whose head forms a cup. Wood. H. 5²¹⁄₃₂″. Kuba, Kasai, Zaïre. Collection of J. Mestach. Photo Thielemans.

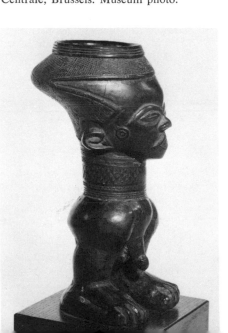

135. Goblet. Wood. H. 8⅜″. Kuba, Kasai, Zaïre. Musée de l'Homme, Paris. Museum photo.

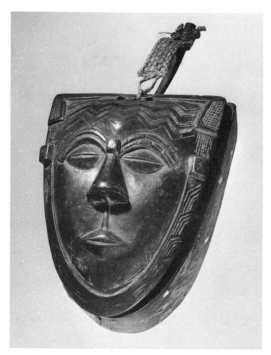

136. Makeup box; the cover is carved in the image of a variety of *Ngaady mvaash* mask. Wood. L. 7¹³⁄₁₆″. Kuba, Kasai, Zaïre. Formerly in the collection of André Lefèvre, now in Musée de l'Homme, Paris. Museum photo.

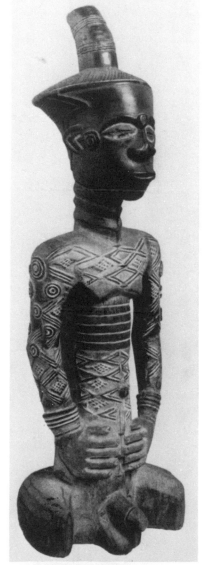

137. Ancestor figure. Wood and tracings of kaolin. H. 26½″. Ndengese, Zaïre. Sammlung für Völkerkunde der Universität, Zurich. Museum photo.

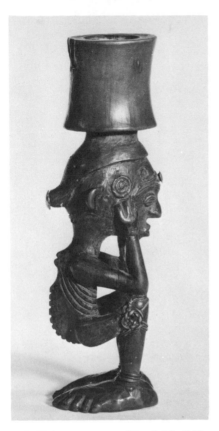

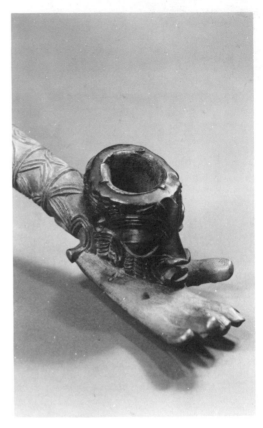

138. Tobacco mortar. Wood. H. 5¼″.
Lulua, Kasai, Zaïre. Formerly in the
collection of André Lefèvre, now in
Musée de l'Homme, Paris. Museum
photo.

139. Pipe; the stem in the form of an arm with
scarifications is extended by the hand supporting
the bowl, which is carved to represent a head.
Wood. L. (total) 17¹³⁄₁₆″. Lulua, Kasai, Zaïre.
Ethnografisches Museum, Antwerp. Photo
Frans Claes.

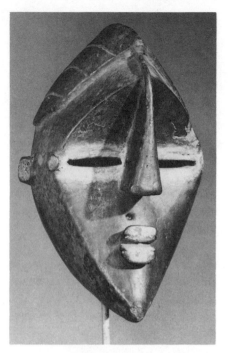

140. Mask representing "Man," worn during initiation ceremonies. Wood. H. 14⅛″. Lwalwa, Kasai, Zaïre. Musée Royal de l'Afrique Centrale, Brussels. Museum photo.

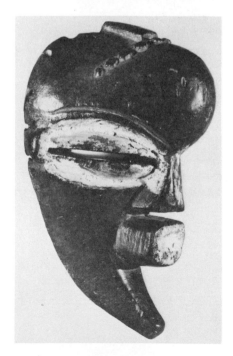

141. Mask worn during initiation ceremonies. Wood whitened with kaolin. H. 12½″. Mbagani, Kasai, Zaïre. Musée Royal de l'Afrique Centrale, Brussels. Museum photo.

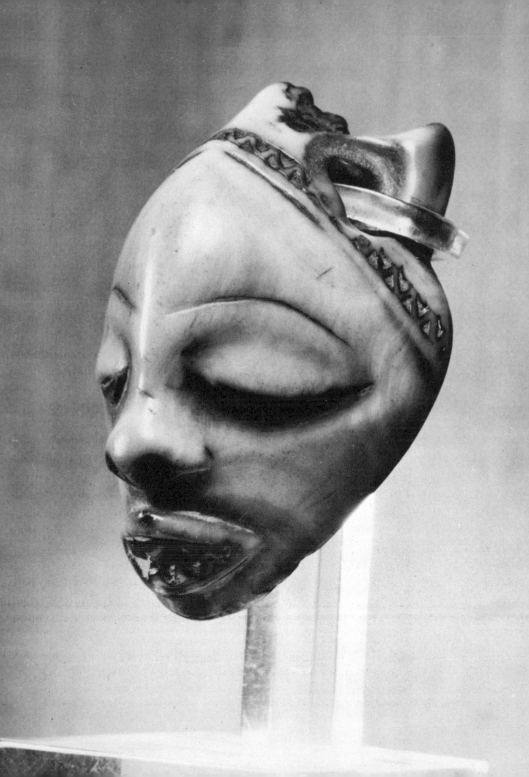

142. Small ivory pendant mask used to protect the sculptor of masks. Ivory and metal. H. 2⁵⁄₃₂″. Pende, Kwango, Zaïre. Collection of J. Roudillon. Photo Dominique Darbois.

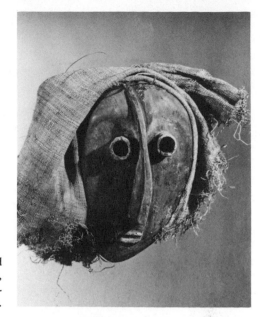

143. *Mbuya* mask representing "the Old Flirt." Wood. H. 11¹¹⁄₁₆″. Pende, Kwango, Zaïre. Musée Royal de l'Afrique Centrale, Brussels. Museum photo.

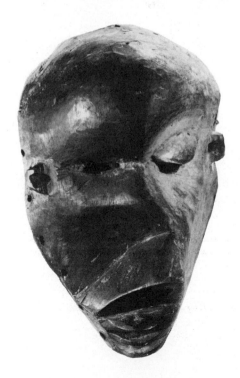

144. *Mbuya* mask representing "the Epileptic." Wood. H. 12⁵⁄₁₆″. Pende, Kwango, Zaïre. Musée Royal de l'Afrique Centrale, Brussels. Museum photo.

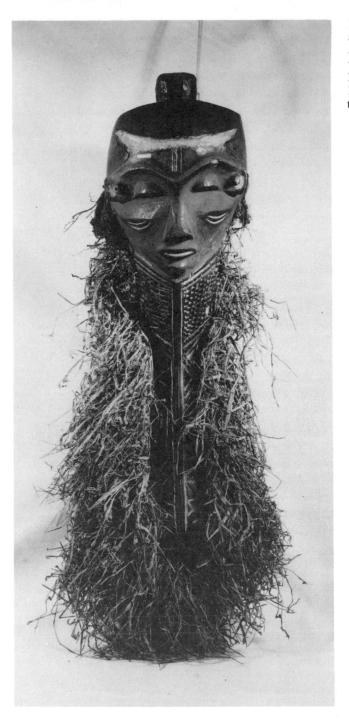

145. *Mbuya* mask with an extension representing a long beard. Painted wood, red-dyed fibers. H. 25¹¹⁄₃₂″. Pende, Kwango, Zaïre. Collection Muller, Soleure.

146. Divination instrument. Wood. H. 12⁹⁄₃₂″. Pende, Kilembe region, Kwango, Zaïre. Musée Royal de l'Afrique Centrale, Brussels. Museum photo.

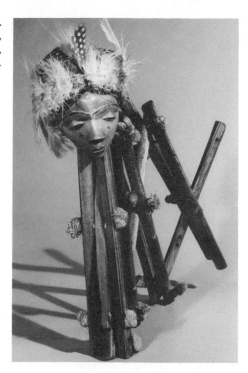

147. Interior of an initiation hut. Nkanu, Kwango, Zaïre. Photo Musée Royal de l'Afrique Centrale, Brussels.

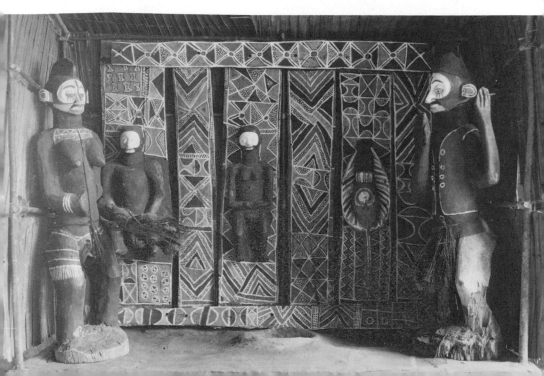

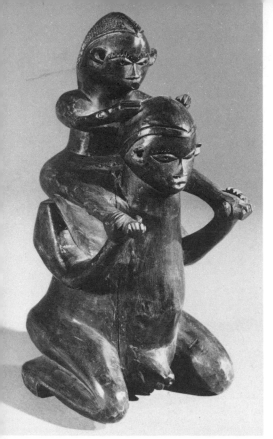

148. Figurine used in an enthronement ceremony. Wood. H. 8½″. Mbala, Kwilu, Zaïre. Photo Musée Royal de l'Afrique Centrale, Brussels.

149. Figurine carved in the image of Christ. Wood. H. 8¹¹⁄₁₆″. Mbala, Kwilu, Zaïre. Collection R.R.P.P. Jesuites de Louvain. Photo Musée Royal de l'Afrique Centrale, Brussels.

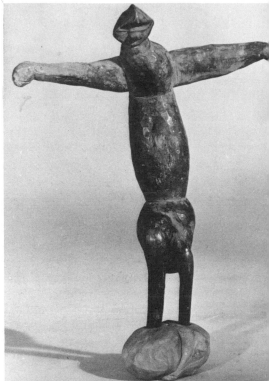

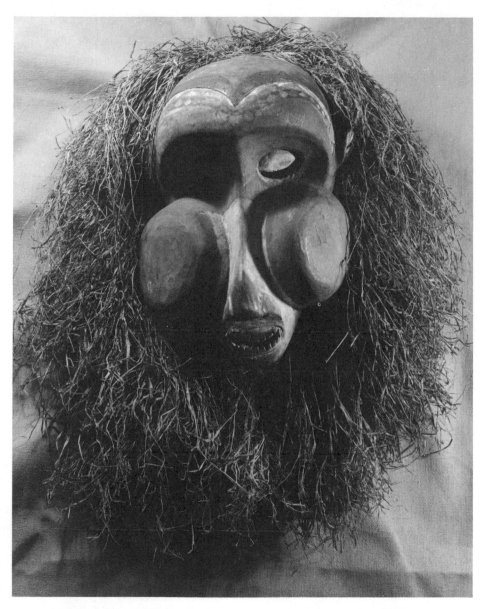

150. *Kakunga* mask worn by the counselor of a class of initiates. Wood, fibers. H. 16⅜″. Suku, Kwango, Zaïre. Collection of H. and H. A. Kamer, New York. Photo Kamer Archives.

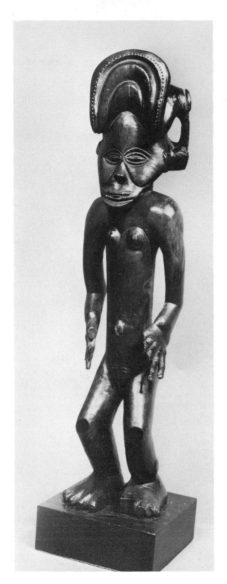 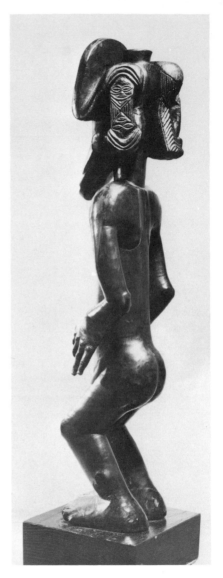

151 & 151a. Wearer of the *cikungu,* a mask representing the ancestor of the earth chief. Wood. H. 18⅛″. Chokwe, Angola. Collection Païlès. Photo Dominique Darbois.

152. Pipe bowl. Wood, copper, beads, fibers. H. 7¹³⁄₁₆″. Chokwe, Angola. ►
Collection J. Roudillon. Photo Dominique Darbois.

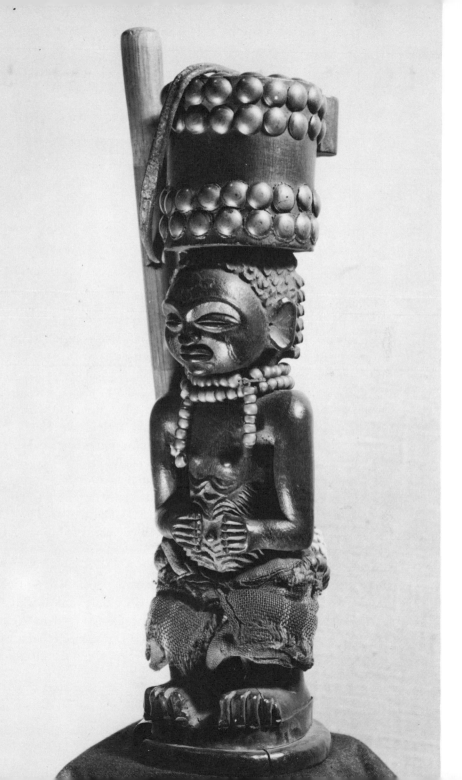

The Eastern Congo

Although, as Frans M. Olbrechts wrote, the proximity of the desert to the north and also the type of economic activities (hunting and fishing) imposed by the forest had to exert a negative influence from the artistic point of view, still, numerous examples of artistic production are found in the area bounded in the north by the Ubangi River, its tributary the Mbomu, and the province of the Mongala, and, to the south, by a border which, but a short distance from the Congolese savanna, would ideally join Lake Leopold II to Lake Kivu. This equatorial amphitheatre, girdled by plateaus of thinly scattered forest, harbors a real ethnic puzzle composed of old clusters and more recent communities whose upheavals have been numerous and incessant. Here, however, the plastic arts show an almost astonishing homogeneity, except, perhaps, for those of the Lega and the Bembe of the south central forest of Maniema, which can be considered to mark the transition between the arts of the north Congo and those of Kasai and Katanga.

In the northeast of the Congo, two conquering peoples of Sudanese origin, the Zande and the Mangbetu, who were able to deal with the Arab and Egyptian traders and slavers on equal terms, show a close cultural kinship. Among these two peoples, the presence of an aristocratic hierarchy and the great prestige of royalty and the chiefdoms encouraged the burgeoning of the applied arts.

The propensity of the Zande to embellish their own persons as well as their material environment is not surprising for such a traditionally aristocratic and warlike society. They were contained outside the forest galleries and wooded plateaus by the Mangbetu, from whom they made such successful borrowings. The Zande link up with the Chad area, from which successive waves of immigrants came: the Ngbandi, the Nzakara, the Bandia, and, finally, the Mbomu invaders under the leadership of their chiefs belonging to the dominating nobility, the Vungara. The Zande political system maintained the subdued Bantu lands in the interior of a kingdom divided into provinces that were separated by waterways. At the end of the eighteenth and the beginning of the nineteenth centuries, solidly administered provinces were in the hands of the Vungara nobility. Possibly the ancient Zande first expressed their talents in their warrior equipment, the military caste manifesting its superiority by certain bodily signs: smoothed and anointed skin, and a luxuriant, elaborate coiffure held in place by long pins with lanceolate, cross-, disk-, or fork-shaped heads to which a small number of jewels were attached. Later, when Zande society had consolidated its political empire and fed upon the rich contributions of the Bantu and the Mangbetu peoples, the taste became marked by a large number of constructions and furnishings: granaries, kitchens, dwellings whose rooftops (strung shells scattered on a branch, or a play of forms produced by the tight encircling of blades of grass) surmount an elegant hive shape, which tops a clay cylinder set on a beaten-earth ground. Further examples include the granary walls supported by piles, disk-shaped stools on openwork feet, wooden vessels with incised geometrical designs, whistles, bells, and, above all, anthropomorphic harps, whose long, gently curving necks end in finely carved heads wearing the headdress of the nobility. This elegant harp is to be found among the Mangbetu, the Ngbandi, the Nzakara, and the Ngbaka.

Another well-known accessory is the *kpinga,* a throwing knife, whose multiple blades assume the form of delicately decorated leaves. It was attached to the inside of a large, oval rattan shield, itself very

skillfully worked and ornamented with black motifs. In the entire throwing-knife area, which extends from Chad to the Ubangi, the Zande *kpinga* represents one of the most beautiful examples of the art of ironwork. The Mangbetu, the most talented blacksmiths of the region, produced it. But how will it ever be possible to recognize the part played by the client's taste and that by the taste of the artisan?

The Zande possess a sure aesthetic vocation. Borrowing a term used by Georg August Schweinfurth concerning the Dinka of the Upper Nile, it could be said that the Zande have a "dandyism." In addition, the practice of the abstract arts, most particularly music and poetry, plays an essential role in this society. The development of sung poetry probably expresses the psychology of the Zande society, which is overladen with summarily manifested magical techniques but deprived of a true religion requiring representations of its deities. Where the sculptor is absent, the chances are great for meeting the poet or the ballet master.

Among the Mangbetu, the technique of the female coiffure is reminiscent of the weaving of a delicate, cylindrical, flat basket. A fiber framework supports a chignon pulled obliquely and elongated with false hair. This gracious structure, often enhanced by plumed ornaments, inspires all the material anthropomorphic creation: wood or ivory harps, vases, knives, pipes, bark boxes, statues.

Similar to that of the Zande, the development of Mangbetu art is related to the political structure. The building of large kingdoms at the end of the eighteenth century under the authority of the chiefs of the Mangbetu clan corresponds to the waves of conquests of the Zande chiefs. Beginning with the reign of Nabiembali, the royalty multiplied the material bases of its prestige. The beauty of the royal residences inspired the admiration of neighboring peoples, and many Zande chiefs or others demanded that the Mangbetu builders construct their homes.

The organization of an ostentatious court, the setting up of a page system, the daily playing-out of a refined etiquette, and the incessant activity of artists and artisans gave a prodigious effulgence to Mang-

betu culture. The royal festivals, which took place in great vaulted sheds, allowed for a luxurious exhibition of persons and objects. The women—seated on small stools with varyingly carved feet; their bodies painted and adorned with checks, stripes, stars, diamond shapes, and beauty spots; their faces made majestic by the false chignon, tall and upright—surrounded the arrayed and dancing sovereign. We also find examples of this sense of embellishment on the exterior walls of dwellings, which are covered in multicolored geometric patterns and in the bark work transformed into fascinating and complex finery.

The Zande, and especially the Mangbetu, developed a figurative sculpture applied to everyday objects rather than a statuary. Further, if masks of Zande origin have been catalogued in various collections, they are generally considered to be recent. Nothing in traditional Zande culture makes it possible to give them a real identity. Although differing somewhat from each other in the painting of the face, the form of the eyes, and the presence or absence of ears and teeth, they all make use of the same plastic norms as the masks of the northeast Congolese peoples: the Boa, the Ngbandi, the Ngbaka, and indeed, farther south, the Lega. These norms include the roundness of the head, the open mouth, and the fine-bridged nose. It is interesting to note that most of these masks come from the Bondo region, in the lower Uele, a region occupied by the Zande of Bandia origin. Certain of these masks have been seen brought to the festivals of the *mani* secret society, whose development is related to the establishment of the colonial government. Whistles, divinatory objects, and statuettes of carved wood can be found being used in these same secret societies of the lower Uele, but not in those that flourished among the Zande and the Zande-ized of ancient Anglo-Egyptian Sudan, where only vegetable fiber and small blue glass beads are used.

Southern neighbors of the Zande, the Boa, who inhabit a somber, wooded, and swampy region between the Uele and the Bomokandi rivers, have tenaciously resisted first the conquering Zande wave and then the Europeans. Farmers, hunters, and warriors, they made use of painted-wood masks. These masks, whose function is little known (it

is said that they were associated with war rituals or were designed to frighten enemies), are characterized by disproportionately large ears. Enormous disks with a wide perforation, these ears are painted white on the outside and black on the inside. Like the Mangbetu, who reproduce in their sculpture the artificially elongated form of their skulls, the Boa thus recall the excessive dimensions of their ears, obtained by the insertion of a disk of wood or an ivory ring whose horned base has been removed. Undoubtedly, the sculptors wanted to reproduce this abnormal form in an exaggerated manner, so as to make themselves identifiable to all strangers, potential enemies.

It is unfortunate that so little information is available concerning the sculpture and the other arts of the regions that form, to the north, a stylistic fringe where the elaborated representations of the human being come to die by stages. In the northwest, a certain number of Ngbandi and Ngbaka sculptures are known. Among the latter, besides pipes, anthropomorphic harps, stools, and carved headrests, a pair of statuettes is found that recalls those used in the Zande *mani:* representations of the first man and woman, cultural heroes, beneficent spirits. Like their neighbors the Banda, from whom they have borrowed them, the Ngbaka also carve large wooden drums with hollow interiors, which represent a bovine creature or an antelope whose heavy flanks, separated by a narrow gap, form a resonance box. Finally, among the Ngbaka a few clay statues, painted and erected on the tombs of notables, are still encountered. Comparable statuary occurs sporadically farther to the north in the land of the Mongo.

Among the Nkundo of the west, in the province of Coquilhatville, there was an institution, which today has disappeared, which involved the making of coffins representing the deceased of noble origin. This occupation devolved upon a society of sculptors, the *bongana,* which was not a strictly professional organization since this hierarchical group also exercised judicial functions. The manufacture of these coffins was carried out in secret and sometimes lasted several months,

concluded by a triumphal presentation accompanied by songs: "Come see . . . we who do good work, our workmanship," an indication that it was not only a social activity, but also an aesthetic one. The upper plank of Nkundo caskets represents a chief carrying his display knife. Their neighbors, the Eleku, who are riverside residents and not land dwellers, also carve coffins, but they take the forms of a pirogue and water birds. These openwork sculptures with the bent legs of a giant insect ornamenting the poop and prow, which are separated by a dentiled crest, realize an original plastic conception: an unrestrained accumulation of motifs is stylized to an extreme and in such a manner that this combination of elements issuing from a dislocation of natural forms, for Westerners, results in a form apparently born out of pure imagination. "The crest of Eleku caskets," writes G. E. Hulstaert,

> represents the dorsal fin of a fish (or of a crocodile?); the curved point represents the beak of an aquatic bird (a heron, for example). The openwork extensions of the prow represent the fish's gills, while the corresponding posterior pieces recall the tail. The white stippling is reminiscent of the speckled black and white coloring of a fisher martin. . . . On the two planks of the cover are attached miniature copies of a present-day tool kit.

Among the Eleku, the manufacture of these caskets is not surrounded with any mystery and offers no occasion for any ceremonial exhibition.

The Mbole, the Jonga, the Metoko, the Lengola, the Komo, and the Pere are mostly forest people established to the west of Tshuapa and to the east of the Great Lakes. Not long ago, these people, more homogeneous than the successive waves of immigrants, were pushed, dispersed, and divided up by groups who were themselves invaded by the Zande.

In the Mid-Lomani, the Mbole carved statuettes representing standing personages for the rites of the *lilwa,* a secret society uniting the sons of notables. Tied to a kind of stretcher, these statuettes were carried in processions before the new initiates. They are said to represent the members of the *lilwa* who were hanged for not having

known how to keep the secrets of the association. The leaning pose of the effigies, whose feet are slightly oblique and sometimes even shackled, must have left an impression on the spectators, who had already been led far away from everyday life by the different ordeals of the initiation.

Among the Metoko and the Lengola, small figures are used in the *kota* society during ceremonies that mark the passing from one grade to another, higher one. Lengola sculpture, which unquestionably has a symbolic function, is less representative than that of the Mbole and shows (as Albert Maesen noted) "a certain affinity with Lega sculpture."

Finally, there are several sculptures coming from the Pere, who are inhabitants of the northwest of the forest and probably kin of the Komo. These, somewhat varied but similarly schematic, are apparently interrelated as a result of belonging to the same initiation system.

The arts of the Lega and the Bembe and the Buyu of the area northwest of Lake Tanganyika are near the best-known art centers of the central Congo. Already several indications appear announcing the rich plastic art of the Kuba and the Luba, but the stripped-down severity of north Congolese styles persists.

Lega masks and statuettes are transmitted inside each of the different grades of the *bwame,* an association open in principle to "any individual, provided he be circumcised" and that, until 1948, the date of its abolition, gave the Lega kinship organization its entire political structure. It is only upon the initiations into the superior grades (*kindi*) that ivory masks are used. Wood masks are reserved for the preceding grade (*yananio*). Each time, the *kindi* possess certain wood figurines, limited in number, whose significance assumes a great deal of importance. The ivory mask, with chin garnished with a long beard, can be attached to the face, to the forehead, and to the side of the head. It can also simply be carried in the hand or placed on the ground. Ivory or wood masks are kept in the name of the title holders of the corresponding grade by the last initiated into this grade. There

is still no exact information as to what these masks of varying dimensions (between an inch to a foot) represent. Albert Maesen writes, "The name under which the mask is designated *dimu* established a rapport with the world of the ancestors"; but, according to D. Biebuyck, these masks are likewise called *munuma,* which means "indispensable for the initiation," and again, *kikuni,* that is, "the beautiful." Not accompanied by a costume, not always worn and seldom in front of the face, these masks do not seem to have any specifically spectacular function but remain inseparable from the world of abstract representations in the form of rites and varying obligations experienced by the members of the *bwame.*

Information concerning the statuettes is more explicit. There are several types, which differ according to the grade and sex of the owner. Certain especially important statuettes are rare, but more common ones are preserved along with other objects in great baskets carefully enclosed with a cloth or a monkey skin. They are taken from the basket and oiled to give them power at the time of the dances in which they serve. They cannot be disassociated from the songs that identify them to the initiates. The meaning of the figurine, which is always relative to the events or situations from which the society must draw a moral, is not understood from either its name or its form. But once the allusions corresponding to certain sculptures are known one admires the close relationship that the artist knew how to establish between the form of the object and its symbolic meaning. Throughout the great adventure of stylization, the realistic vigor of the meanings so boldly attempted by the Lega sculptors persists. Something of the concrete charm of the rebus lingers in these exceptional plastic creations. The figurine with arched back, legs reduced to feet, and knees on which the hands are stretched out, terminating the arms, which bear the sagging shoulders, represents "the little old man bent beneath the weight of initiatory objects." As for the statuettes with raised arms, they represent the despairing gesture of a sick man "prey to the destructive forces of his wife's sorcery," to quote Biebuyck again.

At the southern limit of the Maniema, the funerary art of the Bembe

and the Buyu is of great interest. Although many traces of the plastic vision of the Lega and the people of the northern Congo exist in this art, the more human aspect of the statuary, particularly in the treatment of the face, already forecasts one of the characteristics of Luba art.

For both the Buyu and the Bembe, the spirits of deceased chiefs continue to live in wood effigies that are invoked as soon as difficult circumstances arise. The ancestor statues of the royal clans, placed in special huts close to the personal dwelling of either the kings or the queens, are evidence of the ancient state of this culture. The monumental aspect of some of these statues, which can reach three feet in height, is fascinating: the large, round head with enormous, closed eyelids (recalling the large, round Luba masks) and the chest forming a huge block suggest that all of the dead chief's power is now contained in the sculpture. Elsewhere, a royal throne has been found among the Kihanga, the dynastic clan of the Buyu: a round stool with a decorated circumference and supported by caryatids.

The round form of the face and the representation of the eyes as slits or half-moons inside two circles appears in many Bembe-Buyu masks. The best known is the one that represents Kalunga, spirit of the waters for the Buyu and genie of the forest for the Bembe. As soon as Kalunga is accused by the diviner of being the source of a misfortune, a sculpture executes his image: a bell mask of wood composed of two identical attached parts. Each of these parts is the plastic reduction of the round elements of the face, which now has become two eyes on a circular base treated as a hollow and with the whole decked with plumes and papyrus fibers.

153. The wandering minstrel: engraving after G. Schweinfurth. "Au cœur de l'Afrique" in *Le tour du monde,* 1874. Vol. I, p. 356.

154 & 154a. Harp (and detail). Wood. H. 4$\frac{11}{16}$". Zande with Mangbetu influence, Upper Ubangi. Rietbergmuseum, Zurich. Photo Ernst Hahn.

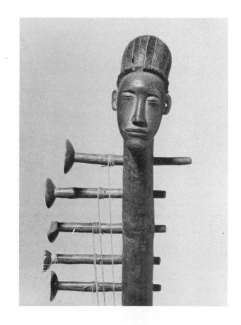

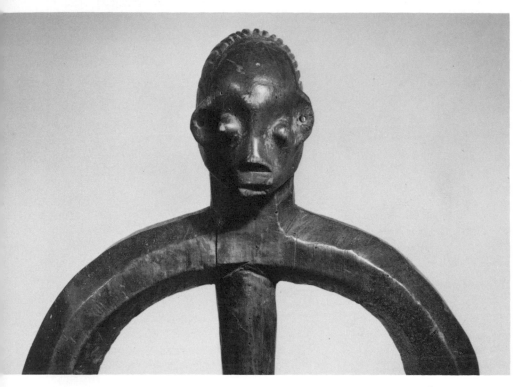

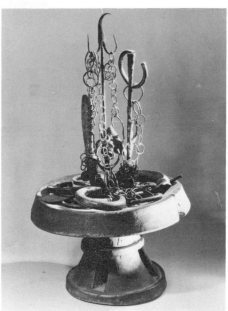

155. Top of a bell attributed to the Zande. Wood. H. 17⅝₂″. Upper Ubangi. Ethnografisches Museum, Antwerp. Museum photo.

156. Spirit altar, cult probably of Ngbandi origin. Iron. H. 2⅜″. Lower Uele region, Zaïre. Collection of René Van der Straete. Photo U.F.D. The Photo Library.

157. Bark box. Wood, bark. H. 18¾".
Mangbetu, northeast Zaïre. Formerly at the
Wellcome Historical-Medical Museum,
London, now at the University of California,
Los Angeles. Museum photo.

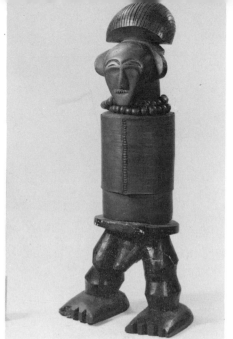

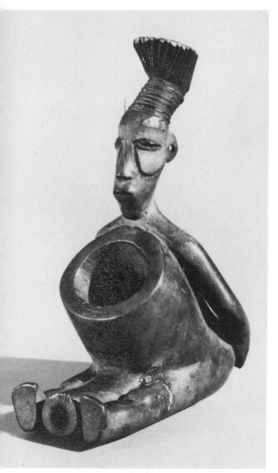

158. Wood pipe, with a human figure as
setting for the bowl. H. 4¹⁄₁₆". Mangbetu,
northeast Zaïre. Musée Royal de l'Afrique
Centrale, Brussels. Museum photo.

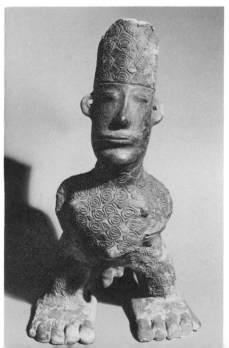

159. Terra-cotta figurine. H. 10⅛". Mang-
betu, northeast Zaïre. Collection of J. and
F. Verheyleweghen. Photo
J. Verheyleweghen.

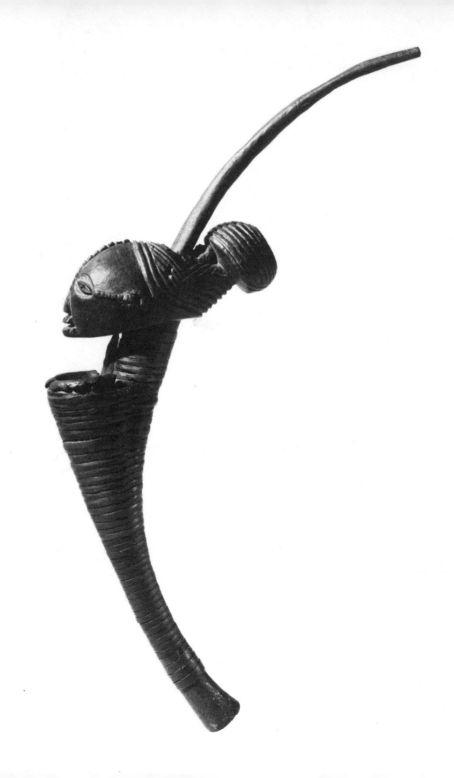

160. Pipe. Wood. H. 17⁵⁄₃₂″. Ngbaka, northeast Zaïre. Collection of Joseph Van der Straete. Photo U.F.D. The Photo Library.

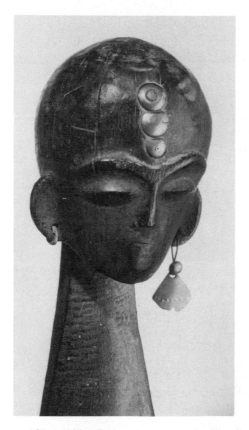

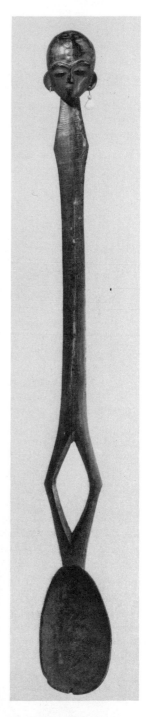

161 & 161a. Large spoon (and detail) offered by a company of warriors to a princess of royal blood in recognition of her good attentions. Wood. H. 40⁵⁄₃₂″. Nzakara, Upper Ubangi. Collection of Anne Laurentin-Rethel. Photo Musée de l'Homme, Paris.

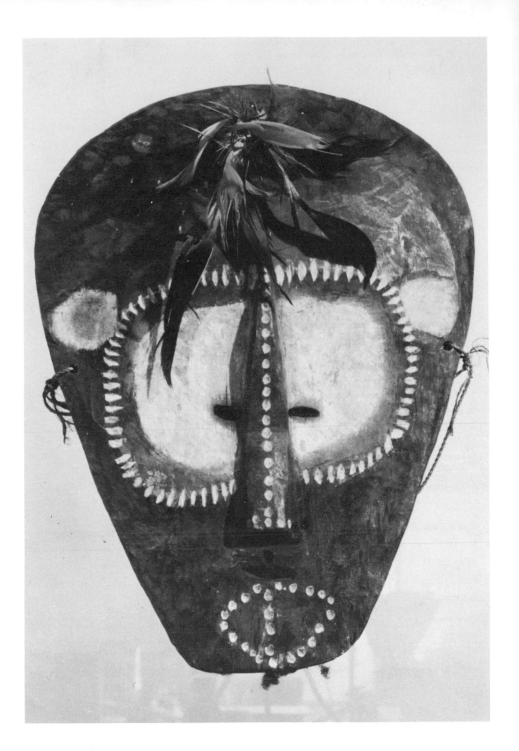

162. Mask used in initiation rites. Wood, kaolin, feathers. H. 14⅞″. Ngbaka, Upper Ubangi. Musée Royal de l'Afrique Centrale, Brussels. Museum photo.

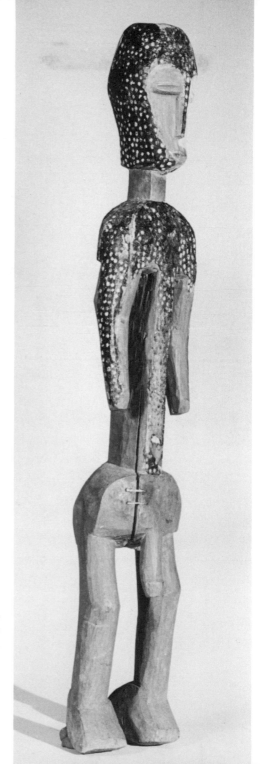

163. Large figure, probably used in the rites of a very hierarchical and prestigious initiation society. Wood with kaolin painting. H. 40 5/32″. Lengola, Lualaba region, Zaïre. Musée Royal de l'Afrique Centrale, Brussels. Museum photo.

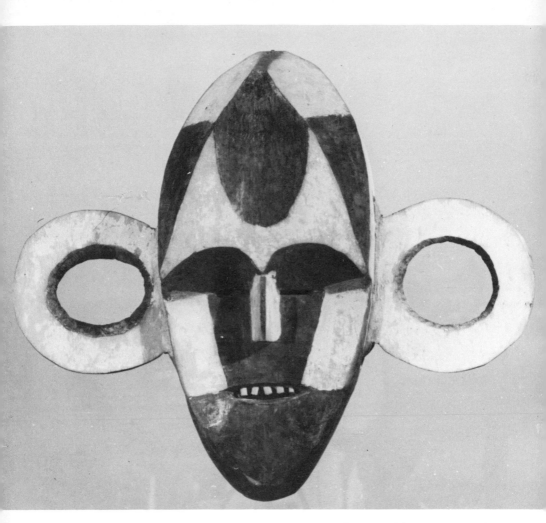

164. War mask, portraying the head of a man with deformed ears, as is the practice. Painted wood. H. 11²³⁄₃₂″. Boa, Uele region, Zaïre. Musée Royal de l'Afrique Centrale, Brussels. Museum photo.

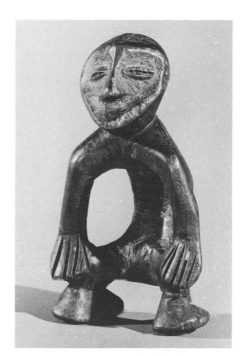

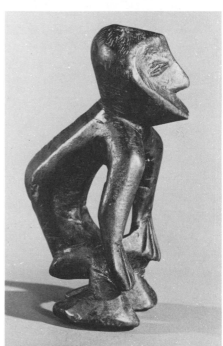

165 & 165a. Symbolic figurine of the *bwame*
society. Wood. H. 6⁷⁄₁₆″. Lega, Pangi region,
Zaïre. Musée Royal de l'Afrique Centrale,
Brussels. Museum photo.

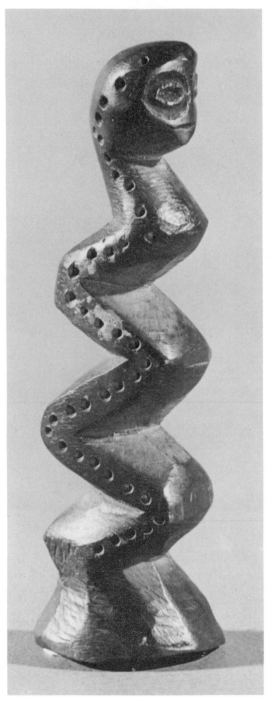

166. *Bwame* figurine, undoubtedly representing the water serpent *ngembe*. Ivory. H. 4″. Lega, Pangi region, Zaïre. Musée Royal de l'Afrique Centrale, Brussels. Museum photo.

167. Painted bone mask. H. 10¹¹/₃₂″. Lega, Zaïre. Musée Royal de l'Afrique Centrale, Brussels. Museum photo.

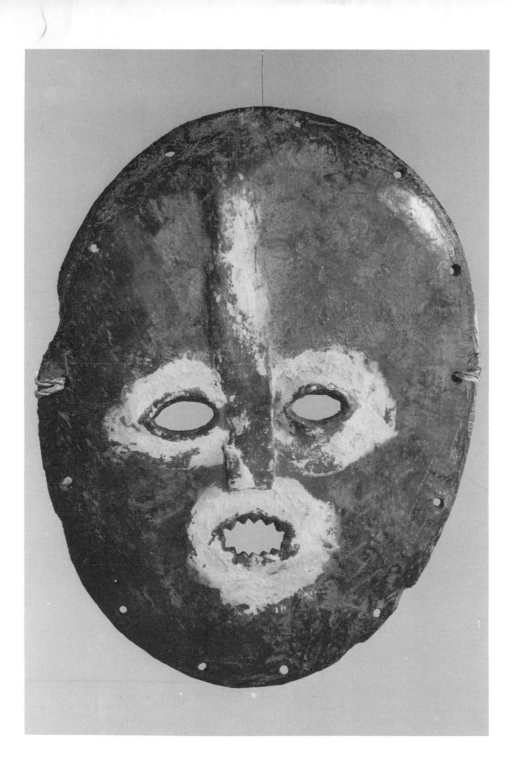

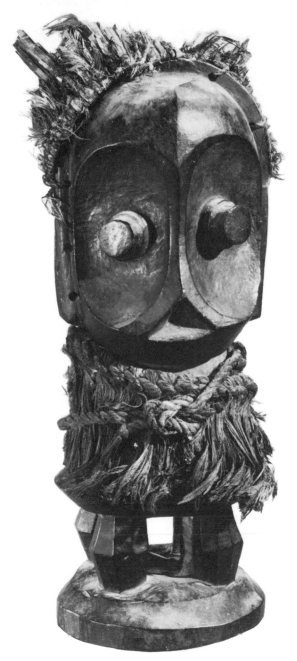

168. Double-faced figurine representing a mythical being; the face resembles a mask portraying the *kalunga* spirit. Wood. H. 12²⁷⁄₃₂″. Bembe, north of Lake Tanganyika, Zaïre. Musée Royal de l'Afrique Centrale, Brussels. Museum photo.

East Africa

From the Nilotic provinces to the lands of the south, from the great and small lakes of the eastern border to south of the Zambezi, from the Zimbabwe ruins to the point of the Cape, original arts, branches of a relatively homogeneous culture, have been developed.

Most of these societies, so well described by Jacques Maquet, adhere to a system of values involving the two poles of attraction for the community, which, moreover, are closely dependent upon each other: specifically, the possession of livestock and the practice of war. Whether they are exclusively pastoral populations or groups already partially devoted to a limited agriculture, whether they are independent, dispersed, and extremely mobile clans, or mixed societies with a feudal structure based on a contract between conquering shepherds and subservient cultivators, and finally, whether they are peoples who organize themselves around a divine king or rainmaker chiefs aided or not by chiefs of the earth, these values persist, are predominant, involving notably a form of aesthetic life comparable to that of the Fulani and the Zande-ized.

In contrast to the arts of western and central Africa, objects that have had attention for a long time, those of East Africa are still not well known. The bad habit of neglecting regions apparently poor in sculptural production and the dispersion of extremely rare documents in different museums and their placement in storage have greatly contributed to this imbalance in our knowledge.

257

The Nilotics, usually very tall and slim people, produce a kind of sculpture made of hard wood, often reddish and sometimes yellow, that is a representation of a man with visible genitals, more infrequently of a woman. The torso is always stretched out on long straddled legs, stiff like the arms, which are equally long and stuck to the body. The nearly absent neck supports a round or sometimes pyramidal head. Commonly referred to as "crude," this treatment of the human form can result in an evocative and powerful schematization whose echoes are encountered in so-called Zande statuary and its north-Congolese sources, as well as in central Sudan, in northern Nigeria, and in Togo.

More than three quarters of a century have passed since Wilhelm Junker made a drawing of six statuettes found in a Bari hut, but our acquaintance with this statuary has scarcely been enriched since. Beneath his drawing, Junker noted, "preserved in huts, sheltered from the sun, where they are designed to commemorate dead kin, these statuettes receive libations and can be used only by a 'feticheur.' " These effigies can be reasonably associated with all the funerary sculpture in use among the numerous populations of the upper Nile: forked branches, notched posts, torsos carved in relief at the level of the navel, standing near tombs and embodying the personality of the dead. Among the Bongo, who were studied by A. Kronenberg, each notch corresponds to an animal killed by the deceased or by one of his kin, and the part of the wood thus treated is elongated into a long torso and an always round head. The same tomb can encompass many variations, starting with a simple funerary pole. Depending on the individual case, the sculptor creates the effigy of the dead man himself, that of the deceased twin, or even that of the vanquished enemy, "the statues portraying the victims being more frequently carved with the representations of the legs and feet."

Now, among the Bongo the "primitiveness" imputed to the statuary of the Bari-language tribes of the west bank of the Nile is seldom encountered. The acculturation experienced by certain communities is probably not foreign to this sculpture's evolution toward a sort of

academicism. Do not the Bongo, today, decorate their cement tombs with an excessive number of notched poles and carved figures that have no relationship to the actual accomplishment of the dead man or a member of his family? Encouraged, at present, by the sale of zoomorphic sculptures to Tong traders, they nail various animals that are not part of their traditional bestiary to the tops of their funerary poles.

The Gato and the Konso of southwest Ethiopia carve posts whose top is an oval human head wearing, among the Gato, a pointed or crested skullcap and for the Konso, a mushroom-shaped one. These are phallic images found on head ornaments, rings, tops of huts, or, more precisely still, suggested by short batons used by the Galla dancers during the rites of passage from one age grade to another. Among the Gato, the posts are found in a cemetery at the center of the village. Among the Konso, they stand at the entrance to the village, indicating the site of a tomb: a compact row of hieratic figures interspersed with wood sculptures representing lances and shields. Carved during the life of the subject, and often by himself, the effigy comprises attributes that indicate the exact social position of the departed. After the death of his father, the eldest son erects this effigy. Currently, wooden images of a less significant nature tend to replace the pile of stones, standing stones, and notched posts designed to honor the dead.

If Nilotic statuary is little known, what then can be said of the mask, which is not altogether absent in these regions? The all-too-rare specimens scattered in the museums of Rome, London, Cambridge, Hamburg, Leipzig, and Berlin are not always identified with precision. Certain ones, attributed to the Bari, seem to be very closely related to Zande-style masks. In several of these museums, a type of mask portraying a leopard's head is found, which is believed to be Shilluk. A piece of a calabash whose round concavity is covered in mud and cow dung and is painted and molded to indicate the bridge of the nose separating the crescent-shaped ears, the gourd mask has

wide openings forming the round eyes and the mouth, which show one or several teeth.

Another leopard's-head mask originates in Somaliland. A piece of leather cut out and painted, it recalls the masks of a small community of professional hunters, the Eile, who inhabit the south of formerly Italian Somalia. The Eile goatskin masks have holes for eyes, nose, and mouth; their surface is blackened with charcoal and sprinkled with white spots. A moustache is fixed on with beeswax, and a goat's-hair beard is attached to the head of the dancer, who performs a simultaneously erotic and warlike dance.

The leopard, whose association with chiefs' families is made concrete in various forms, again appears in a very accomplished piece speckled in white and kept in the British Museum. Attributed to the Shilluk, it shows hardly any characteristics similar to the clay bovine creatures that serve as their fertility amulets.

Although these people, when carving the portraits of their dead, adhere to the tree trunk shape and may give their heroes the form of long bamboo stalks dressed in cloth and coiffed with ostrich feathers, they transform their own bodies and their weapons into veritable objects of art integrated into grandiose warrior ballets.

In the entire Great Lakes region, the great pastoral migrations brought into the large spaces not merely herds of long-horned animals but at the same time an art of living of an aristocratic nature. Here the role of wood sculpture fades, but costume, music, dance, and poetry absorb in part the inventive faculties of the artists of these societies, for whom concern for the beautiful remains constant. The even distribution and the diversity of arts such as basketry, bead-work, and pottery, and numerous decorative efforts in wood, leather, or calabash for domestic, military, or ritual use, make East Africa a provocative area, further enriched by an insufficiently known anthropomorphic wood sculpture and a mud-figure art. A few examples will have to suffice for the arts often practiced with great refinement in Uganda, Rwanda, Kenya, Tanzania, and Malawi (formerly Nyasaland), and in Mozambique as far as the Zambezi.

The baskets fashioned by the noble Tutsi women "during their leisure hours" are probably to be ranked among the most beautiful basketry objects in Africa. The delicateness of the form—a cylindrical box crowned with a pointed hat—the firm slimness of the first layer, the intertwining of the shoots, the needlework fineness of the spirals, the sober but very harmonious use of decoration obtained with the aid of black-dyed fibers—all characterize these containers. Their plaiting is tight enough to hold milk, but often the lid is used by itself to cover a wooden vase. In Nyoro country, women of royal blood braid truncated-cone baskets or supports designed to hold milk containers. The geometrical decoration of the basketry, black chevrons or tapered triangles on a natural background, seems like a modern tapestry. Some of these baskets are used to present gifts of coffee beans "to distinguished visitors" and Jacques Maquet specifies that the finest are made only "to be offered and to permit the appreciation of the mastery of the craftsman."

As throughout West Africa, the Cameroun, and the Congo, the art of beadwork in these East African kingdoms is associated with the luxury of court life. Among the Nkoli, the Ganda, and the Nyoro of Uganda, the sacred objects of the royal house, which are carefully kept in special huts and are intended to serve at a king's enthronement or funeral, are covered in a beadwork embroidery that makes use of the geometrical patterns used in the basketry. Small, brilliantly colored trading beads cover crowns, musical instruments (drums and horns), batons, and vessels of various shapes that accompany the stool, the swords, the bow, and the wooden vases for the ritual feeding, inseparable from the royal personality. Considered to be eminently decorative and prestigious, beads and cowrie, accumulated in the treasury during an entire reign, thanks to obligatory gifts required of all newly promoted chiefs, ornament the lower jaw of the deceased monarch, which is then deposited in a vessel specially carved to receive it.

Beaded embroidery on leather is used in mask ornamentation all the way to the extreme south of Africa and is also used in the embellishment of dolls, indeed, it constitutes one of the essential ele-

ments of festive dress among the northern Nilotics, the Bantu-speakers of the Great Lakes region, in Zambia and in Rhodesia, and even among the numerous people of South Africa. Large chest ornaments, pendants, belts, loincloths, necklaces, bracelets, when not made from ivory or metal, have their entire surface covered in beadwork whose polychrome designs complement the almost-naked, shaved, oiled, painted, and adorned body. With the coiffure, however, the aesthetic imagination applied to body art may have surpassed itself. The hair, treated with colored clay or kaolin, supports multiple and elegant combinations attained by the attaching of plumes, seeds, horns, beads, shells, and metallic ornaments. J. H. Driberg, who was able to trace the evolution of hairdressing among the Lango as far back as the fifteenth century, noted a succession of at least six greatly differing fashions.

War, a true institution, was able to become an exalting force of artistic invention. The parading Nilotic warriors of northern Uganda and Kenya, for example, offer an extraordinary spectacle. Often wearing extremely fantastic, differing finery, they brandish their spears, long staffs with fine leaf-shaped blades, symbols of their power, and their oval wooden shields ornamented with earth-tinted motifs, or designs made on hide by the shaving of the hair in patterns. These patterns, which indicate the age grade and the territorial origin of the warrior, transform the shields into real nonrepresentational pictures.

Dwellings are also objects receiving attention to minutiae. For example, the palisades of the Ganda royal enclosures are made of wild fig branches and reeds placed to form a restrained and harmonious design. Elsewhere, the Hima paint the interior walls of their huts with traditional repetitious geometric patterns whose meanings today are lost. In Tanzania, the walls of Sukuma initiation huts frequented by snake-charmer societies are enhanced with figurative paintings.

The ceramic art of the Ganda like that of the Nyoro attains a rare delicacy. The shape of the vessels, round bodies mounted with a small, slightly turned-back neck, or with a long neck imitating a cala-

bash, is enhanced by a geometric design obtained by the impression of a roller or a small wheel, or by incisions made with a fine metal point. A polishing after baking and then a graphite patina lend an exceptional beauty to the material quality of certain examples of this pottery. Here, pottery-making is man's work, and women are kept away at the crucial moments of the manufacture of the vessels, which are protected by grave taboos. Among the Ganda, the king's pottery makers owned special titles and privileges and wore the insignia of their guilds on their leather aprons.

Figurative sculpture, when it becomes better known, will surely offer an opportunity for interesting observations. Already, Konde masks and statues (and those of their related neighbors) are represented in a few museums by characteristically vigorous specimens of quality. The representations of a woman—with face interrupted by a labret, arms frequently bent, hands held horizontally at chest level, legs slightly apart, knees at an acute angle—occur as a constant in Konde statuary. The preeminence of the female representation is explained by the tradition that maintains that all the Konde were born of a female sculpture come to life (those of Tanzania as well as those of Mozambique, inhabitants of the plateau situated to the south of the Rovuma River). A man, whose body had never been washed, whose hair had never been cut, and who hardly ate or drank, appeared one day in the thick bush of the plateau. From the wood of a tree he carved a statue in the form of a woman from which he never thereafter separated himself, keeping it always by his side. One night she came alive. Together they proceeded toward the river, where she gave birth to a stillborn child; then they walked to the bottom of a valley, where, again, the infant she brought into the world was dead. So they returned to the forest of the plateau, and an infant born there lived. All the children procreated by this couple were the ancestors of the Konde. Probably representations of this primal mother, the statuettes have a function analogous to that of many other Congolese and Sudanese statues. The problems on which the vitality of the group and the happiness of each family and every individual depend are

submitted to these statues. They are placed upright close by the huts. Certain ones, attached by a bond to their owner, accompany him during the course of his travels.

Formerly the entire social structure of the Konde was focused on the woman. She played an essential role in all areas of life, leaving merely a secondary role to the husband. The male societies, the custodians of masks into which the young men will be initiated, express a reaction against this state of things. The man, with camouflaged body and face hidden by a mask of hollow wood, becomes a supernatural being who frightens the women and torments their souls. Very often the Konde masks, with a sensitive naturalism, reproduce the female faces, which are ornamented with geometric scarifications and blue-tinged by the insertion of charcoal between the lips. In contrast, many masks distort the facial features, while others refine them and draw the contours more schematically. Still other masks, the faces of animals or grimacing faces, loom out of a bamboo framework, dressed in cloth and looking like terrifying beings.

Few masks are known in the lake region besides those of the Konde and related people. Attributed to the inhabitants of the Bukoba region in the Kibiza kingdom situated on the western shore of Lake Victoria-Nyanza, the best-known masks, which resemble Zande masks in style, were worn by the clowns of the court of the Hima shepherd princes. Nevertheless, they were carved by Bantu-speaking peasants, the first occupants of the land.

Many statues have been collected in the lands included between Lakes Victoria to the north and Nyasa to the south, Lake Tanganyika to the west and the coast to the east. This is an area where Arab influence exerted itself, first between the thirteenth and fifteenth centuries, a period of regular maritime traffic between the commercial cities of the coast and the markets of south Arabia, but more importantly after the Portuguese period of the sixteenth and seventeenth centuries. What resulted from this influence for the local arts and notably for sculpture? A difficult problem. The arts directly introduced

by the Arabs—the architecture and the gold- and silverwork of Zanzibar, for example—will not be considered here.

The statuary in question presents very differing aspects. Certain figures seem to be tied in with those of north-Congolese origin, whose style is the least naturalistic. On others, several fine touches of the sculptural traditions of the Luba-Lunda can be seen. The concave treatment of the face in Anguru statuary of the south of Malawi recalls Lega faces. Numerous specimens show analogies with Nilotic anthropomorphic statuettes. Finally, in the ethnographic museums of Berlin and Hamburg, there are several figures with articulated limbs like those found in southern Nigeria and also in Wasaramo. Such extreme heterogeneity in a not very prolific statuary shows that it belongs to an area of dense interrelationships where different influences have joined together and intermingled: those of the north, those of Southern Rhodesia and the Congo, and those of the eastern coast, which is open to Arabian cultural currents.

We are not well acquainted with the function of these statues, which all come from little-studied groups. The Sukuma of the south of Lake Victoria and the Washambala of the Usambara Mountains to the northeast of Lake Tanganyika are cultivator-herders, some of whom have ancestor-cult rituals and specialized secret societies and others a cult of royal ancestors and ceremonial systems assuring the continuity of the royal lineage. The Nyamwezi of central Tanzania, organized into several independent monarchies, reserve certain objects for their sovereigns, particularly seats, which in former times were small, round stools standing on inward-curving feet but which today are mounted—undoubtedly in imitation of foreign chairs—with a high back from which a figure in low relief stands out and whose forearms reach out from behind the chair back as if to receive the crowned chief.

The figurines of unbaked mud used in inland Tanzania by the many Bantu-language peoples during the puberty rites of girls and boys are primarily interesting for their teaching function and the somewhat loose way in which their form responds to it. Hidden under

a cloth in a corner of the initiation hut, which is the real school for forming adults, these figurines are uncovered and presented to the young people. Associated with songs that must be learned by heart and tied to regularly received lessons, they are, in a way, the résumés of these. The moral or practical themes evoked by each one are the object of the lesson, and the modeling is not artistically imperative so the sculptor can follow his own conceptions. He draws upon, to his own liking, the sum of the concrete and abstract elements placed at his disposal by history or by the theme that is to be illustrated.

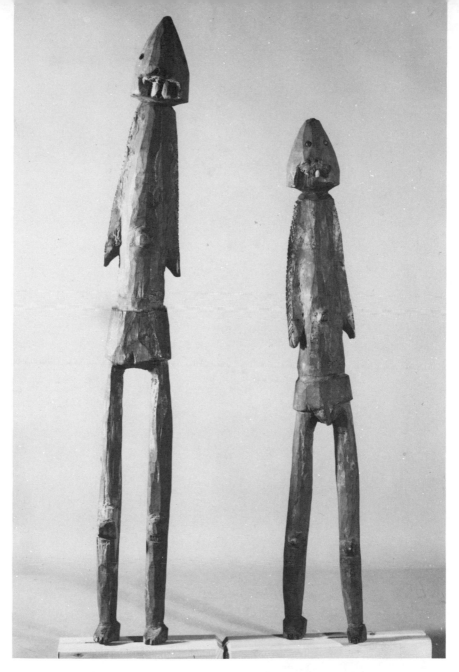

169. Figures usually carried by their owners; sometimes they were carried, for example, as a sign of mourning, to bring fertility to sterile women, to help children grow, and also "against the whites." Wood, teeth. H. 21 $7/16$ and $17^{15}/_{16}$". Bari, Upper Nile. Collection Hansel, 1882, Museum für Völkerkunde, Vienna. Photo Dominique Darbois.

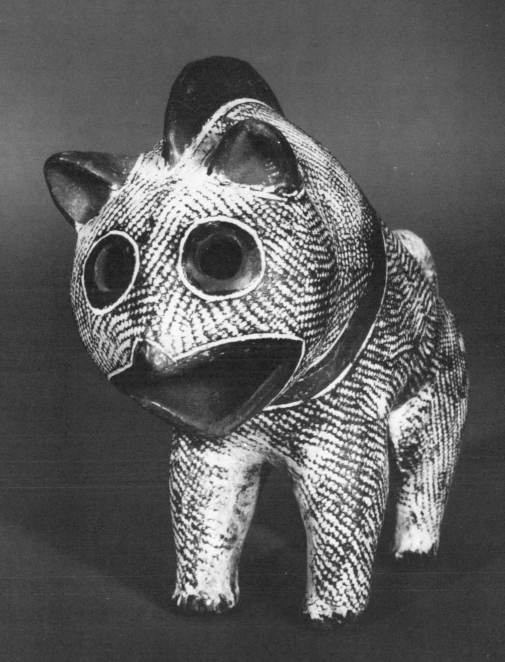

170. Painted pottery figure portraying a lion (or a leopard?). H. 5⁵⁄₁₆″; L. 6¹¹⁄₃₂″. Shilluk, Upper Nile. British Museum, London. Photo Dominique Darbois.

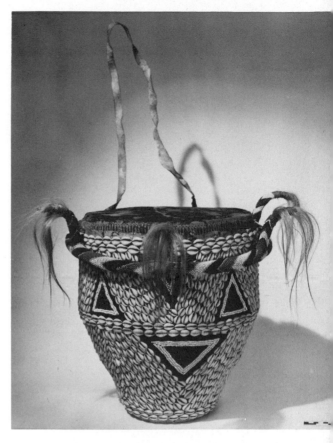

171. Royal drum. Wood, hide, shell. Ganda, Uganda. Harvard University, Peabody Museum of Archaeology and Ethnology, Cambridge. Museum photo.

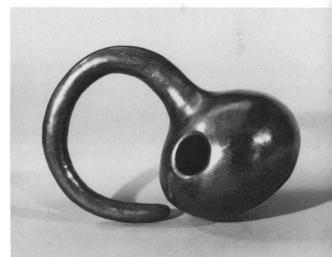

172. Terra-cotta vessel with a graphite finish; copy of a calabash. H. 7¹³⁄₁₆″. Ganda, Uganda. British Museum, London. Photo Dominique Darbois.

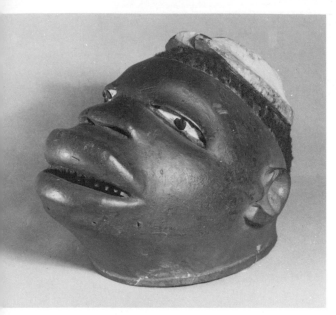

173. Helmet mask pertaining to a male association. Wood painted deep red. H. 7¹³⁄₁₆″. Konde, Tanzania. Linden Museum, Stuttgart. Photo Dominique Darbois.

174. Mask pertaining to a male association. Wood. Linden Museum, Stuttgart. Photo Dominique Darbois.

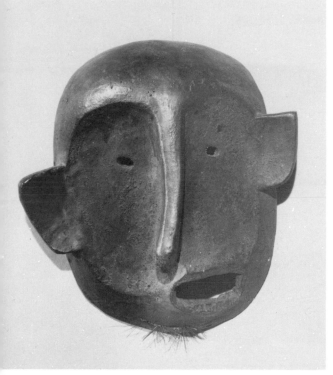

175. Mask said to be worn by the clowns of the royal Bukoba court. Wood. H. 10¹⁹⁄₃₂″. Tanzania, west coast of Lake Victoria. Musée de l'Homme, Paris. Museum photo.

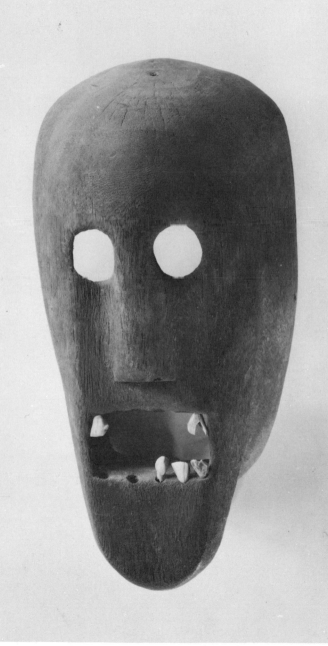

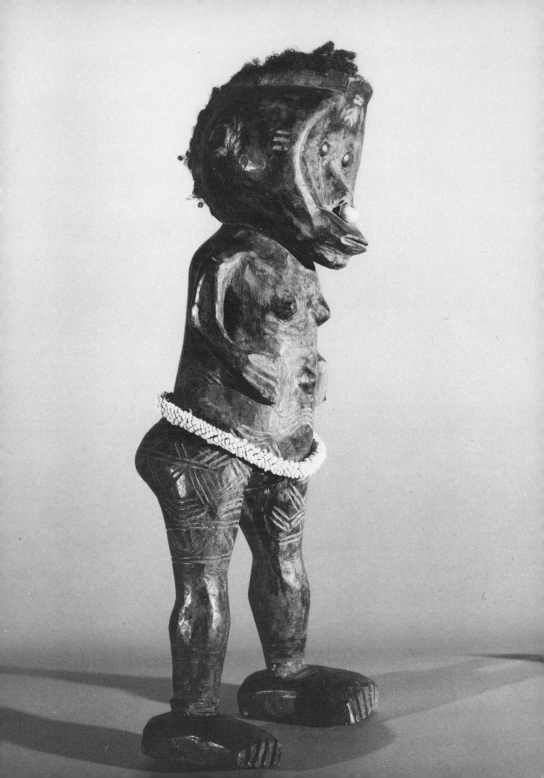

176. Figurine portraying a beautiful woman of the village. Wood, beads, cowrie shells. H. 13²¹⁄₃₂″. Anguru, Malawi. Museum für Völkerkunde, Berlin-Dahlem. Photo Dominique Darbois.

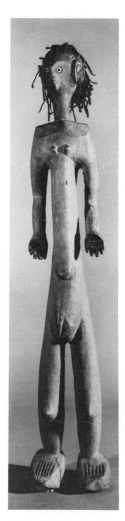
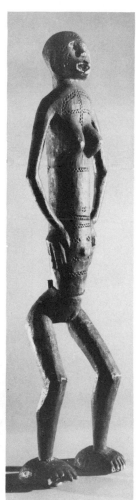
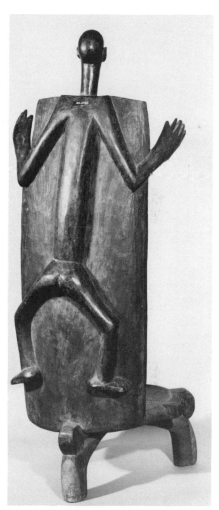

177. (Above, left) Statue. Wood, string. H. 19½″. Sukuma, Tanzania. Linden Museum, Stuttgart. Photo Dominique Darbois. 178. (Above, center) Statue. Wood, blue paint. H. 21²⁷⁄₃₂″. Maraui, Malawi, south of Lake Nyasa. Museum für Völkerkunde, Berlin-Dahlem. Photo Dominique Darbois. 179. (Above, right) Chief's seat. Wood. H. 42⅛″. Nyamwezi, Tanzania. Museum für Völkerkunde, Berlin-Dahlem. Photo Dominique Darbois.

180. Terra-cotta figures, probably used in initiations. H. 6¹⁄₃₂″. Tanzania. Linden Museum, Stuttgart. Photo Dominique Darbois.

South Africa

In 1911, a volume of about one hundred and fifty pages appeared, dedicated by the pastor Frederic Christol to *Art in South Africa*. It is surprising how little notice is taken of this work, although it was one of the first to consider "native" fine arts seriously and, what is more, is to this day the first and last to deal with the art of southern Africa. This area is the most forgotten of black Africa, ignored equally by the specialists of aesthetic surveys and by the expedition organizers. Bushman painting attracts all the attention thus diverted from the Bantuspeaking peoples who occupy the lands between the Cape of Good Hope and the banks of the Limpopo. Otherwise, from the Limpopo to the Zambezi, the preoccupation is basically with the remains of the ancient cities, such as Zimbabwe.

The sculptural products of the inhabitants of the Zambezi region are ignored less than those of peoples who live farther south. The imprecise label of "Zambezi," which many collections too often use as the only indication of origin, includes an immense territory from the border of Katanga to the Indian Ocean through which the great river twice traces a lazy loop. Different cultures succeed each other from Zambia, passing through Southern Rhodesia to the south of Mozambique. Here, as farther south, the European presence—evangelists, settlers, gold seekers, who have been joined since World War I by tourists—has upset many traditions. In this part of Africa, whose

history is already complicated enough, an actual European coloniza-
tion and a systematic missionary inculcation have modified the human
landscape.

The region called upper Zambezi, actually the Barotse Plain, is
connected with Angola by more than one feature of the cultures that
it supports. At the end of the last century, the Lozi or Rotse kingdom
welcomed Luena, Chokwe, and Lunda groups that had emigrated
from Angola, but the Mbunda, also from the west, had already been
absorbed by the Lozi as early as the beginning of the same century.
It is not surprising, therefore, that Rotse land bears the mark of
Angolan cultures, while one finds nothing similar to this in Shona,
Zulu, Suto, Tswana, Tonga, or Venda territories. The Chokwe initia-
tion rituals and divinatory systems rejoined those of the Zambezi
people in northeast Zambia, bringing with them masks and statues.
The beautiful domestic utensils and meticulously fashioned weapons
followed this same flow, which brought an ample repertory of forms
and decorative combinations. Unfortunately, the art of the southern
Lunda and their kin has not been analyzed as Chokwe art has been.
The few specimens of masks attributed to the Mbunda come from this
art, which seems complex enough to merit a special study. To what
degree have the Chokwe-Lunda plastic traditions (whose historical
ties with the Luba are known) exerted an influence on the Rhodesian
societies—indeed, even on those of the eastern and Portuguese coast?
To appraise this influence, it would have to be possible to remove the
screen placed by a century of European indoctrination between the
ancient aesthetic traditions of the Ila, the Tonga, the Venda, the
Ngoni, the Suto, and their present activities. The consequences of
this intrusion had already been foreseen by Christol: "The amateurs
of local culture will do well to make haste, because everything which
presented some ethnographic interest becomes scarce. . . . It will
become increasingly difficult to study native art and to recognize the
industriousness and practical sense of the blacks of southern Africa."
Again, concerning the Suto: "It must be said that civilization, by its

commercial facilities, has taken away a great part of their artistic sense."

To speak of a culture of the bead, of iron, leather, and feather would be to render greater justice to these peoples than to judge them by their wood sculpture, which only gives a mediocre picture of their aesthetic life. The patient, painstaking efforts that the Lozi bring to the preparation of skins; the skillful handling of beaded decoration for a myriad of objects (wooden dolls, calabashes, snuffboxes, and jewels) among the Tonga, Zulu, Suto, and Tswana; the delicacy of the geometric weaving of brass wires on wood or on calabash among the Lozi and the Zulu; the elegance of the weapons; and everywhere the importance of costume (animal skins, plumes, beads), particularly among the Zulu—these are many of the characteristic features of a homogenous and attractive ensemble in which, more often than not, delicate suggestions give birth to beauty. In the last century, the Zulu, under the leadership of Chaka, a cruel but far-reaching conqueror, and then under other war chiefs, played a considerable role from Natal to the south of Mozambique. For these same Zulu, courting young girls is a true institution. The man of this society must make himself handsome and adorn himself with beads offered by the hoped-for love. Each colored bead has a meaning and the multicolored balls are at the same time a jewel and an official avowal of sentiments.

Of all the different techniques, pottery has unquestionably been made the art par excellence by every society of the Zambezi and South Africa. It inspires the best of wood sculpture, of cooking pots, and the very beautiful, tight, spiraling basketry of varying vessels of more or less spherical shape. The Rotse and the Suto, or, more precisely, their women, prove themselves to be the most talented potters. The forms and dimensions of the Rotse vessels vary agreeably. The modeling is done on an inverted plate and the final baking is carried out most often on a fire of dry bark or cow dung. These vessels are often finished with slip, so areas of ocher alternate with transparent areas to form diamond shapes and circular bands; but other vessels, which are not slipped, are ornamented with black triangles traced on

the clay by a flat shell taken from the river. The Suto frequently use pottery of a totally different conception: ocher-patinaed cooking pots with a very pure spherical belly hemmed with a thin bell-mouthed neck. In the fifth century A.D., the first Suto and Tswana migrations to Southern Rhodesia introduced a neolithic civilization characterized by the practices of animal breeding and agriculture and the making of pottery, a technology that could be developed and diversified with time.

The perfection of the ceramic forms is rediscovered in harmonious hardwood demispheres, joined and polished, which are covered with a flat lid upon which two similar animals (familiar images of livestock or of the poultry yard) stand one behind the other. The theme of a succession of two animals (or of two identical personages) is taken up again on the cover of great, elaborately carved wooden pots with handles and also on the long handles of spoons. Goblets with bent feet, and especially stools with openwork sculptural design or geometric decoration in very low relief link up more or less with those of Lunda country. Many of these sculptures exemplify the "Zambezian" predilection for a sawtooth motif or for chevrons used as design and not as a simple fill-in element. The diversity of neck rests is surprising, their decorative patterns appear in great number and are ingeniously recombined, but one of them always recurs particularly frequently: two series of concentric circles placed on the same plane, which, occasionally treated in relief, recall two breasts.

Although all the traditional art of south-Zambezian Africa and, even more, of the southwest remain generally uninvestigated, in Southern Rhodesia, however, not far from the route adjoining Salisbury and Johannesburg, vestiges stand that excited curiosity to the extent that their presence at the heart of black Africa appeared incongruous. The mysterious granite ruins of the capital of Monomotapa, with their elliptical ramparts, their conical tower, and their chevron-decorated walls, present a style of architecture which, actually, the modest stone kraals of the country's ancient inhabitants perhaps partially foretold. Now that the ruins of Southern Rhodesia, and

very precisely those of Zimbabwe, step out of legend to enter into history, the technological and aesthetic aspects of the different cultures that succeeded each other in these regions cease, a priori, to be held foreign to this prestigious civilization. Here is, then, all that is known today regarding the various arts (architectural, sculptural, and so on) of the Suto, the Tswana, the Shona, the Venda, the Tonga, and the Rotse that are confronted with the evidences of Rhodesian archaeology.

Predatory birds become sacred symbols and thunder birds as fertility deities play not a negligible role in the culture of the Venda, the Suto, the Shona, and the Rotse; these birds mark the ties that connect the southern Rhodesian empires to local cultures. Thus the hieratic birds of Zimbabwe reunite on the still largely open record with the prestigious testimonies to the black African past, the most beautiful sculptures of the ancient Nok civilization, of the old Sao culture, the Ife and Benin kingdoms, the Nupe centers of Jebba and Tada, and the Mopti and Djenne regions in the present republic of Mali.

181. Neck rest with a movable platform; the platform is
connected to the base by a pair of rings joined
together like the links of a chain; the base includes a
shaft, the top of which is lodged in a small hole
hollowed out in the middle of the lower side of the
platform. Wood. H. $4^{21}/_{32}''$. Shona, Zambia. Musée de
l'Homme, Paris. Museum photo.

182. Calabash snuff holder. Copper decoration. H. 3½". Zulu, Southeast Africa. Collection Kegel and Konietsko. Photo Dominique Darbois.

183. Tonga couple. Wood. H. (of man) 22⁷⁄₃₂″; H. (of woman) 21⁷⁄₁₆″.
Southeast Africa. British Museum, London. Photo Dominique Darbois.

184. Upper part of a figure; the man wears a sort of crown on his head, an emblem of dignity given by the chief. Wood. H. 27⁵⁄₁₆″. Zulu or Tonga, Southeast Africa. Rijksmuseum voor Volkenkunde, Leiden. Photo Dominique Darbois.

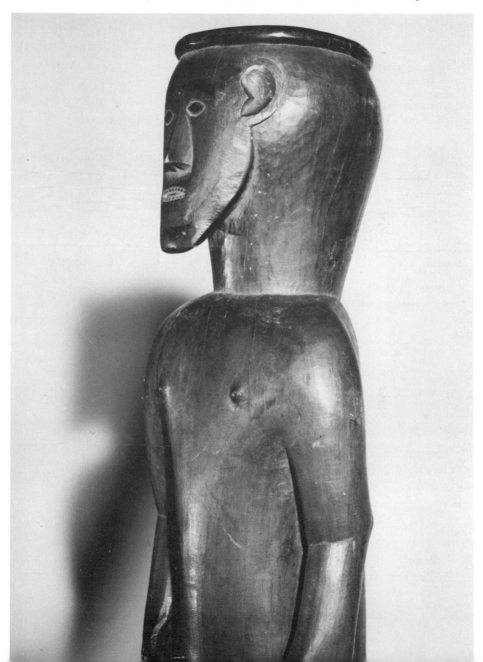

187. Wall decorated with chevrons. ►
Zimbabwe, Southeast Africa. Photo
Hélène Kamer.

185. Representation of a
woman. Steatite. H. 16".
Zimbabwe, Southeast Africa.
British Museum, London.
Museum photo.

186. Doll, mother and child. Black fabric,
multicolored beads. H. 4⁹⁄₃₂". Suto,
Southeast Africa. Musée de l'Homme,
Paris. Museum photo.

188. Zimbabwe ruins. Southeast Africa.
Photo Hélène Kamer.

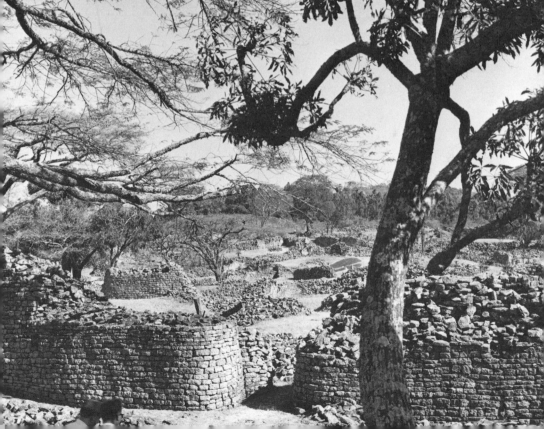

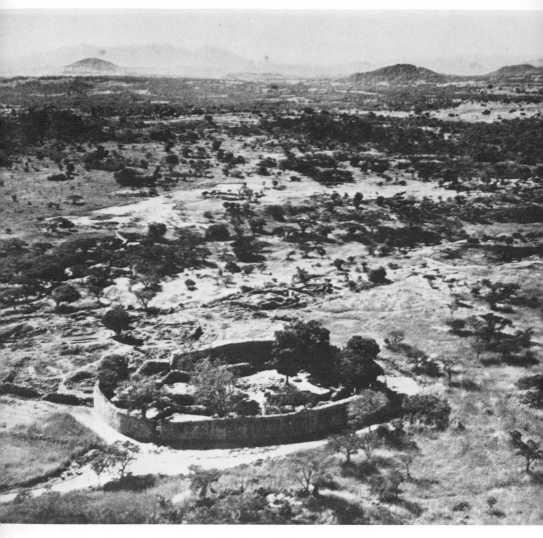

189. General view of Zimbabwe. Southeast Africa.
The Photo Library, Musée de l'Homme, Paris.

190. Conical tower. Zimbabwe, Southeast Africa. ►
Photo Hélène Kamer.

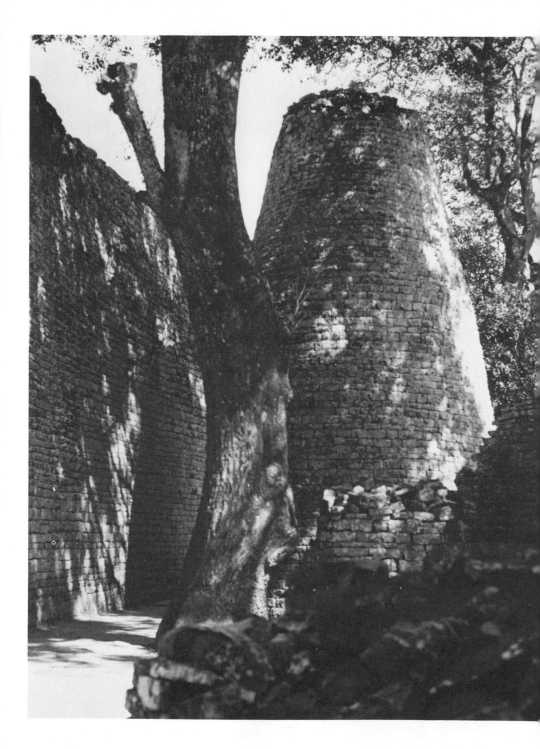

Conclusion

On the threshold of her conclusion, the author finds herself faced with cruel theoretical problems that the heat of research and the internal logic of assembling the documents had led her to neglect temporarily. So now, after having thought only of the difficult pursuit of facts and their arrangement, she must concern herself with giving a name to the puzzle she has more or less succeeded in reorganizing.

To establish an inventory of the plastic arts for three quarters of a continent that our historical knowledge today illuminates with a still too diffuse light is an overly ambitious enterprise. Though more modest, the present attempt at cataloguing remains very imperfect: it leaves entire areas in shadow, or it passes too rapidly past the borders of a society that a later systematic study might possibly show to have played an essential role in the evolution of an art source considered "classical." Although incomplete, nevertheless this inventory of various plastic creations, within the very context of the communities that gave birth to them and in which they live more or less intensely, was necessary.

Except for Nigeria, where the relationship between the art of the past and the art of the present provides an important and model illustration of history, this work does not deal with the archaic or ancient art of black Africa. Our goal was not (nor, moreover, were we equipped) to present a picture of prehistoric art and of African

sub-Saharan archaeology, subjects of numerous research projects zealously conducted by all-too-rare specialists in very few regions. What we desired above all was to penetrate into the aesthetic universe of the Melano-African societies, which are still very much alive, and to attempt to grasp this universe in such a way that it could be simultaneously treated with preference and yet be tied basically to other aspects of life.

To wish to penetrate this aesthetic universe was to impose arbitrary limits on ourselves from the beginning, because it was necessary to take into account only the ethnic groups for which material documents, writings, and investigations could provide sufficient clues and thereby to sacrifice important areas that future research will not be able to ignore. We know nothing of southwest Africa, and we know only a little about the art of east and southeast Africa, to cite entire regions among those missing from the structure we hope to build. To the degree that we have felt constrained by large margins of unknowns, we have exerted a particular effort toward generally abandoned horizons. From these, admittedly, we have obtained great pleasure and often discover there the best of the aesthetic lessons that all these peoples give us.

Our choice of the different centers of art starts from the point of an imperfect fan. From there, divisions and regroupings had to be founded on culture, the least contestable unity of reference. By *culture* we understand the community of experiences at all possible levels (economic, technological, social, historical . . .) that constitutes a line of kinship between several societies. When changing cultures, one passes to another style of experiences.

In the artistic production of many African societies, the art of the wood sculptor plays such an important role that the other talents— those of the potter or the painter, the architect or the goldsmith, the basketmaker or the weaver—seem to occupy the scene as merely accessory elements. In reality, all these arts are intimately connected, often interfering with each other, and music, dance, and poetry (which we did not deal with) never cease, furthermore, to provide support

or stimulus to the plastic arts. Sometimes the supposedly minor activities take the spotlight. However, wood sculpture does not seem, in consequence, to be less preeminent. Is it possible that the importance we grant to it is caused in part by our insufficient knowledge of the other arts, and also by the large role it has played in our own plastic universe since the beginning of the twentieth century? But is it not questionable that the extraordinary, high-quality production of more or less specialized sculptors, or more often village blacksmiths, is characteristic of the type of civilization that predominates in black Africa, a civilization of forest or savanna cultivators, tree cutters, patient hoers, often very astute technicians of an ungrateful soil that first had to be burned?

When the land (or water in regions crossed by a river or stream) is not solicited with as much insistence and fervor, the wood carvings, which gather the force of supernatural beings indispensable to men—primordial ancestors, mythical genies, specialized deities, deceased chiefs—more or less disappear. They do not leave behind an empty place but are replaced by another art.

The preeminence of wood sculpture and the fact that this art has been so marvelously prolific and varied has led us to consider pertinent the social and ideological mechanisms of numerous cultural groupings. In contrast, we have ignored certain sufficiently large and well-studied regions inhabited by cultivators or fishermen, because their strictly sculptural creations and other aesthetic activities were too scant or fragmentarily known for their documentation to be articulated into the subject of an autonomous chapter. The absence of south Cameroun and Chad in our overview is thus explained. In addition, the arts attributed to the "legendary Sao" were excluded, since a discussion of them would have been based on pure archaeology. These very ancient arts (the last carbon-dating analysis tends to attribute a greater age to them than the tenth-to-seventeenth-century date previously assigned by specialists) of terra-cotta and tin and copper lost-wax casting bring an essential contribution to the history of African art, particularly bronzework.

In his work on the prehistory of Western art, and apropos of the "mobile arts," André Leroi-Gourhan notes:

> Since one judges African art from the point of view of modern French art, and one discovers in the former what one looks for and not what was originally put there, the prehistorians have come to create, especially in the heroic times of science, a Magdalenian thought which very much resembled that of a petrified nineteenth-century buffalo slayer.

We do not know if we have succeeded in sufficiently bringing to life what we believe should be known of the real and unreal surroundings of the different forms of black African artistic creation. But we hope to have said enough so that African artists do not appear to be inspired portraitists behind their easels or poets prey to the marvelous deliriums of Surrealism. What we have sought above all is the restoration of patterns of living that have given birth to aesthetic activities that persist with obvious intensity. Although these activities arise from an eminently collective source, it has been possible to pursue them with less impersonality than that to which we have often relegated the artists of these distant lands, who as a result were the victims of a backward notion of "primitive art."

Only accumulated facts, better-defined concrete problems, and the subject matter itself, which is now better known owing to an ample iconography and to an increasing number of regional studies, will make possible more fruitful discussions and theoretical views, which are now conceded to be the result of too fragmentary experiences and poorly founded attempted comparisons. For this reason, before we approached the perilous but fascinating domain of hypotheses and generalizations, it appeared imperative to retrace the paths dealt with in the different chapters and to take from them certain features which, to a certain extent, give the tone to each of these texts and furnish solid reference points for a considered synthesis.

The material for the first chapter on the art of the upper and middle Niger was remarkable for the abundance of ethnographic information

on iconographic material, which seemed almost "suffocated" by the number of possible explanations. It must be admitted that promising discoveries and the profusion of documents gathered over a period of so many years on the Dogon and the Bambara are deceiving in their immediacy. The studies conducted by Dominique Zahan on Bambara initiation societies, which greatly aid in understanding the psychological content of the mask, are an exception, but, unfortunately, only two have been published.

We are better acquainted with the blacksmith beneath his mythical aspect of civilizing hero than beneath that of wood sculptor and metal forger. These two activities seem to be performed by clearly separate artisans. According to Denise Paulme, who has given us most of the actual sociological information on the Dogon, this tribe distinguishes between two kinds of blacksmiths: blacksmiths who live in communities inhabiting separate villages or segregated sections within villages, and isolated blacksmiths. Only the first forge iron. The isolated smiths purchase the iron from the foundry. Producing usually on demand, they work the iron and the wood, for the cutting of which they alone possess the necessary metal tools. No research has yet been done on the context of the traditional teaching, apprenticeship, and performance of plastic activities in Dogon territory, whether it be a question of blacksmith-sculptors of both utensils and statuettes, or of young men who carve masks for commemorative ceremonies. An entire vocabulary, a total knowledge of technique, and possibly an entire small —simple or complex—world of particular ideas, feelings, and emotions escapes us, while what seem to be the most esoteric aspects of this culture are delivered to us as common currency.

We are indebted to the ethnologist Guy Le Moal and to the published works of Jean Capron for information on the peoples of Upper Volta (especially the Bobo). This information brings to light two precise facts that we believe can be held as a valuable example for many other societies: first, the acquisition by purchase of a series of masks, and, second, the apparently functional or symbolic diversity

of the materials utilized for the fabrication of ceremonial masks. When, for what occasion, why, and how did the Bwa buy the polychrome wood masks of the Gurunsi? All the processes of such a passage of a mask from one society to another ought to be examined. The masks of wood, woven leaves, and fibers seem to be related to precise representations and to have very distinct patterns of use. Further, the wood masks seem not to be the most important. We sense well the logic of this world of masks, but we are far from being able to take apart its subtle mechanism. The research conducted in these areas will surely permit a better systematic knowledge.

In Mossi territory, the oscillating balance that seems to exist between the aesthetic activities of the first occupants of the land and the conquering peoples, a phenomenon that we will encounter elsewhere, demands a study based on ample documents taken from history and ethnography.

The importance that we assign to the sculptural art of the Senufo should not be surprising since it testifies to the remarkable vocation for sculpture of this ethnic group situated southeast in the Sudanese savanna and west of the Atlantic forest. Fairly recent documents have permitted us a closer approach to these works, which until today were presented as issuing from a single cultural level, because of an absence of historical references. Actually, however, the Senufo have experienced various influences, the exact origins of which are not often known and which divide them up into numerous subtribes, each of which possesses original characteristics.

Certain remarks concerning Senufo masks made by Gilbert Bochet are very enlightening and show the complexity of problems with which many art amateurs, with their impatient demands for explanations, are unacquainted, so that they are often misled, obtaining only an honest silence in response to their question on a stylistically well-known series of objects, whose precise role remains an enigma.

The identity of the carved wood mask called *gpelihe* is not, writes Gilbert Bochet, determined by its form but by its use. Depending upon its use, accessory elements are added to the mask (costume and

ornaments, for example), which are the very signs of its function. The bare mask, as seen in private collections or museum showcases, is described, then, with a series of possible functions. This multifunctional capacity, remarkable when it is a question of the same mask (undoubtedly similar for many other masks), leads us to the possibly more current example of masks that are formally distinct but whose form, at the outset, does not depend on its function. In upper Cavally, in the western part of the Ivory Coast, the spectators confer their identity upon the masks when they first appear, based on their first gestures.

The conclusion that the author draws from his example appears each time to be a bit hasty: "No ideological context has determined the sculptured forms, which only serve as available and interchangeable instruments. . . . The mask as object, as sculpture, is absent in initiation thought." Investigation has not been directed in such a way that we can know the place reserved for sculpture as such within, and also outside of, initiation thought. The absence of ideological constraint and the availability of the instrument-form, of which Gilbert Bochet speaks, possibly offer a certain unconventional margin of technological and aesthetic experiences to the sculptor.

Equally interesting is the difference that the same author observes between the techniques of the body related to the wearing of a *poniugo* or a *gpelihe* mask. The *poniugo,* specifically an animal, moves slowly, proceeding by "posturings" rather than by "steps," as "apparitions" rather than as "bodies in movement." The *gpelihe,* a mask with a human face, whose two types suggest woman, is inseparable from dance. One sees that the correlation between form and content is defined by the pattern of gesture, which here plays the role held elsewhere by a figurative or symbolic motif, or again by a recitation.

Apropos of the Dan *poro* and the Senufo *gpo-oro* or *poro,* one can state that for lack of clear ideas at the beginning, the documents painstakingly acquired in the field alone permit us to know what aesthetic materials and which intellectual traditions relating to them are owed to a determined association or overflow its framework, or

have only a vague affinity with it. In a general sense, two movements are possible: certain spiritual or political moral values proper to the entire cultural unity could have been absorbed and then systematized within an institution, or, to the contrary, this institution could have succeeded in creating values specific to it which, in turn, left a mark on the culture of the entire community.

The plastic arts that flourished in the Akan and Abomey kingdoms (also the Benin kingdom) are evidently inseparable from major themes that support authority. The symbolic sources in which this authority finds its justification and its reasons for persisting and affirming itself seem to be linked more closely with a cosmogony among the peoples of Akan origin than among those of the Abomey kingdom, although the commercial development of European countinghouses along the coastline in the seventeenth century influenced the evolution of both monarchies equally. In addition, the sacred symbols of power are more easily found in the Akan plastic arts (especially goldsmith work, whose scope has been exceptional) than in those of Abomey, which are characterized by a personality cult particular to each king.

No doubt the archaeologists, historians, and ethnologists working in Nigeria are in the presence of the most extensive materials to date, those that one day will possibly permit the reconstruction of an important sequence of the African past. At present, the problem is to locate the intermediaries by which, from the Nok civilization to the quasi-contemporary institutions of the Yoruba, a certain heritage of technological and spiritual traditions has been able to maintain itself.

The problem posed by the unprecedented existence of such centers of naturalistic art in ancient Africa can only be treated with respect for the very material of these works created from clay and bronze. What could wood sculpture have been like at the time of the Ife? What inspirations gave birth to objects that will be forever unknown to us? And to what stylistic norms could these objects have more or less conformed? This naturalistic plastic tradition, admirable in the

terra-cottas and the "bronzes," has persisted until now: the sensitive faces of the *gelede* masks and the heads of Yoruba wood ritual statues re-create the formal characteristics of the most archaic Benin heads, these latter offering certain very affecting similarities with the heads excavated near the palaces of the Ife *Oni* at Wumonije. This naturalistic characteristic that is expressed in contemporary Yoruba art does not exclude, in certain substyles, application of the "abstract." The same is true for Nok art, where, already, the most realistic and the most schematic styles converge.

Bamun and Bamileke art belong to a common plastic tradition, characterized by the harmonious coexistence of a very important decorative universe and a rich anthropomorphism that is both informal and sensual. The taste for a complex embellishment that makes use of a symmetrical repetition of themes is, here, inseparable from the taste for sculpture—in the round or in high relief—of vigorous design and with full, living forms that are often humorous. Although the Bamun and Bamileke sculpture appears to be very similar, there are several interesting differences.

The important role played by architecture for the Bamileke seems to be related to the very hierarchical nature of the society, whose organization, articulated by relationships of dependence, translates itself into constructions grouped according to an unchanging topography. The ordering of these constructions in the space constituted by the hamlet is significant in itself. The subchiefdoms or chiefdoms are fulfilled by a kind of architectural quest that gives to each hut, and above all to the most important, its entire personality. Here, then, a sculpture intervenes whose characteristics are found in statuary as well as in the masks. Cultist statuary, exemplified by ancestor effigies placed beneath the porch roofs of the huts, offers a striking example of this intimate relationship between architecture and sculpture. The development of Bamun society, which was accomplished by successive conquests of neighboring tribes, favored the flowering of a system of authority that was less complex and fragmented than that of the

Bamileke. Plastic creation, then, is oriented to less systematic architectural manifestations, which are more flexible and fed by the original contributions of populations absorbed into an established kingdom. At the beginning of the twentieth century, the Bamun had reached the point of establishing a fairly large state with a capital sufficiently large to qualify as a city. They also conceived of the idea of "artistic treasures" worthy of preservation.

In western Congolese territory there are many problems that require thorough field studies and for which hypotheses are difficult. The gist of this chapter is easily divided into two very distinct parts, one devoted to Pahouin art, the other to the art of the lower Congo. At first encounter, the striking impression is of a fundamental difference between these two artistic universes. The predominating forms among the Pahouin, the people of the lower and middle Ogowe (Fang statues or Punu Sango masks, for example), are those whose harmonious naturalism is corrected at certain perceptible points by schematic procedures that refer back to symbols and attest to a long aesthetic tradition. A vigorous blow of an adze overlooks the modeling of the face and treats it as a discreetly sensuous surface (which carried to an extreme can become a triangle), animated by the nose and the two arcs of the eyebrows evoking the stylized image of a bird in full flight. Among the coastal peoples, and more to the interior, among those of the lower Congo, the linear play (basic to Gabon sculpture) has given way to sensual volumes. This passage from one plastic conception to another seems to correspond to a difference in attitude toward the supernatural world: stripped of particular sacred characteristics, art has become oriented toward more practical aspects. There is a great temptation to try to find contrasts of a sociological order to account for the plastic differences between these two ethnic groups of Bantu-speakers who inhabit the western border of the Congolese basin. But our acquaintance with both the local institutions and the local plastic arts remains much too insufficient for us to feel on solid ground. Nevertheless, let us emphasize that on many points the aforementioned

plastic differences are almost systematic. The Fang, above all else, traveled an extensive area, so their social organization could only have been circumstantial. The essential element, preserved with force, was reduced to the preeminence of the elder within a patrilocal group at the village level. This preeminence of the oldest created a spiritual and social link between the living members of the lineage and the deceased patriarchs that the itinerant life could not break. The cult of skulls, evidence of genealogies and verification of the foundations of the community, made manifest this tie. Otherwise, the diverse initiation societies brought their own values, which aided in the maintaining of cohesion. In the lower Congo, and into Teke country, even before the Kongo kingdom was constituted in the fifteenth century, there were states founded on the organization of clan groups into chiefdoms, which formed an interdependent nucleus based on a matrilocal lineage. Probably already highly personalized, these provinces or kingdoms were stable enough to resist being passively absorbed in the foreign intrusion that followed the period of the Portuguese discoveries, embassies, and commercial transactions. The Fang warriors, migrators grouped in patrilocal clans, achieved their conquests by alliances and assimilated the different cultural forms they encountered. In contrast, the Kongo cultivators, gifted in the activities of the market, were grouped in matrilocal clans within chiefdoms that were dependent upon a kingdom and whose leaders apparently tried to adapt their own culture to that which came from abroad. Did Kongo art have a proclivity for naturalism that contact with European art and craft might have stimulated? Was the court art of the coastal kingdoms already clearly oriented toward the production of somewhat stereotyped "portrait statues"? Should one concede the existence of a relationship between the artistic naturalism of the peoples of the lower Congo and that of the peoples of Gabon and the middle Congo so that one could think that the remarkable harmonious sensuality of Fang art or of the middle Ogowe peoples appears again in Kongo territory but stripped of its marvelous geometrical treatment?

Whatever the case, the abstract world of the Kota copper figures,

the long white heads of the *ngil* masks, the heart- or W-shaped faces of the Kwele gives way, in Kongo territory, to much more realistic works. These works express intermingled truths: values relative to the chiefdom or to the matrilineage, a morality consistent with its retinue of mottoes and proverbs. Another shift concerns the skull basket, a reservoir of force and religious and magic virtues; it will be replaced by animals and men of carved wood, covered with nails and laden with relics.

The great arts of Katanga, Kasai, and Lunda are created among peoples whom history has revealed to have been organized into kingdoms with centralized political structures since the end of the fifteenth century. The divine nature of royalty and the narrow ties uniting social functions with the religious life strongly mark the institutions of all these peoples and contribute to their cultural homogeneity, which is further emphasized by their economic affinities. It is not a question here of a court art like the one in Ashanti country or those of the Dahomey and Nigerian capitals. Among the Kuba, the Lunda, the Chokwe, and most of all the Luba, an exciting synthesis between what springs spontaneously from sources of peasant inspiration and what is born progressively of the usages accompanying the building of a great kingdom seems to be realized in wood sculpture. Here, every petrification of invention seems to be avoided, owing to an exceptional talent that the restriction to too-narrow imperatives has not brought to its crystallization. In-depth, very localized studies and comparative essays on the political structures of all these ethnic groups and their evolution during the course of very complex events that unfolded in central Africa between the sixteenth and the end of the nineteenth centuries are extremely effective tools for the understanding of the aesthetic phenomena in these regions.

An ethnologist and historian, Jan Vansina, was able to bring to light the role of art in the Kuba society, which he knew especially well. He stressed the existence of an acute aesthetic feeling widespread throughout the entire society, and also the important role played by

the exceptional economic bases in stimulating artistic production. What seems to us equally to characterize the motivations of Kuba art, if one considers the motivations of other arts of the great central African kingdoms, is the absence, in the case of the Kuba, of a true ancestor cult and a cult of the forces of nature. Instead of applying himself to the creation of a magic and religious substance, the artist employs his talents to satisfy the constant and varied material demands of his group, for whom the prestigious value of beauty is imperative. As for Kuba statuary, it amounts to the almost portrait-like representation of the king.

What is striking in Songye art is the exuberance of its magical character. Here again, one of the possible explanations is offered by a trait of the political organization. Although the Songye also had a king and royal functionaries, the power belonged, rather, to a religious society, the *bukishi*. The centralized authority of an aristocratic-style government was replaced by a spiritual framework favorable for the blooming of activities directed toward the ambiguous world of supernatural forces.

Among the Chokwe, the fortunate conjunction of at least three important facts has given birth to plastic and graphic arts of an inexhaustible invention: the borrowing of political forms from the Lunda, which furnished the craftsmen with a clientele animated by aristocratic needs; the antiquity of commercial activities, which, permitting very early contact with Europeans, placed a new cluster of forms at the disposal of talented and creative artists; finally (and not necessarily the least important of the three factors), the original state of the Chokwe people, formerly a small hunting people who merged with the natural environment from which they knew how to extract the most sensitive aesthetic elements for their own benefit. It is these elements that the later direction of Chokwe culture fixed in a repertory of motifs whose creation finally became oriented toward the baroque, indeed, even toward sophistication.

With the art of the region we have designated "eastern Congo," we reach a stylistic fringe beyond which the representation of the human

figure tends to disappear, first in the Nilotic creations, then in the so-called pole sculpture of the Bongo of the southwest and in Sudan, and of the Gato and Konso in southwest Ethiopia. Whether it be in Lega country or in Mongo or Zande country, the refined representation of the human body again reveals numerous plastic influences of the central Congo. The original communication maintained by the Zande and Mangbetu societies, whether between themselves or with Bantu ethnic groups, are not very clear; if these relationships were better known, it seems we could understand the circulation of certain formal elements and aesthetic values, and also whether these two are fundamentally linked. Let us cite two examples: the throwing knife, which one can trace from Chad to the upper Ubangi, and above all the anthropomorphic harp, encountered not only in the upper Ubangi but also in Pahouin country and in the middle Ogowe. Are the Zande peoples, among whom, according to Eric de Dampierre, the musician poets "have a high opinion of themselves, aware that they belong to a species apart," responsible for the remarkable figurative character of this harp? ("If you won't have me," said one of them, "be on your way. Would you possess the food of life which one eats so as not to die? I do not like those ways, I am a musician.") Or does the anthropomorphism characteristic of the instrument depend on other sources or other cultural combinations?

From Nilotic Africa to southeastern Africa, passing through the extensive region of the Great Lakes, the homogeneous style of various cultures is expressed in an aesthetic in which wood sculpture has ceased to play a primary role. A warrior and pastoral aristocracy predominates here. Particular interest is given to the appearance of the body, and the reputedly most humble arts in themselves constitute an engaging aesthetic universe. Basketry, in Rwanda and Zambezi territory, for example, attains such a refinement in the invention of interlacings and in the conception of forms that a basket could become the equivalent of a carved and ornamented object. Pottery finds its most discriminatingly elegant grace in Uganda or in the southern part of the continent. Furthermore, are not basketry and pottery quite

often modest but compelling inspirations in the great centers of sculptural art? And one can ask oneself whether it is not the aesthetic activities of societies that are apparently the most deprived of the possibility of elaborating a system of stable and complex forms that most clearly illuminate the artistic traditions of great sculptural peoples!

Somewhat unmethodical, this recapitulation results in a small inventory of disparate facts drawn from different levels of information and dependent on very diverse disciplines of thought. The absence of a historical guideline, which gives the writings concerning the "classical" arts their apparent coherence, seems to deny a legitimate desire for understanding. However, it seems does it not that the elements we have chosen to emphasize and the divergent directions in which they appear to lead finally leave us in a rather salubrious state for reflection, since we have not been encountering open doors all along but instead, we, more attentive and ready than if the paths were already in the least bit laid out, must seek to open them.

The questions that we were obliged to pose to ourselves reveal quite harshly that one never really knows how to grasp the exact meaning of these works in their original context. Nevertheless, it seems that answers to a number of these questions, or some elements of an answer, will one day be given because of a more exact knowledge of these environments, studied in all their aspects. Too much attention focused upon one isolated element of a society ends in conferring a disproportionate emphasis upon it. Such an absence of balance in the knowledge that we have of Dogon society (described in numerous studies, but in the light of traditions touching upon the cosmogony rather than of documentation covering the various aspects of Dogon life) makes the approach to the arts of this people so difficult.

To the lack of historical information, particularly about the political development of these peoples, we must add our ignorance of numerous traits of the material culture, even present ones, and of the economic organization. Because of this, we are in a bad position to resolve cer-

tain problems. Let us take the example of the Lunda and the Chokwe, chosen from a privileged area of our research. Here, although these peoples are well known owing to serious historical and ethnological studies, the following question remains open: What part of the aesthetic traditions are proper to the aristocratic Lunda culture and which arose from an original evolution of this culture after the formation of the Chokwe people?

Formulating the hypothesis (relative to the birth and evolution of the so-called court art in central Africa) of a fundamental difference between the matrilinear peasant domain and that of societies of sacred royalty, Luc de Heusch writes:

> Starting with the patrilinear Luba, then, and at a period impossible to pinpoint, the sacred royalty spreads itself out from east to west through the intermediary of conquering peoples on this substrata of matrilinear peasant societies. The vigorous realistic artistic traditions probably owe nothing to this recent historical movement because statuary is entirely absent in the pastoral states of the Great Lakes. The art of the Bantu of the Savanna cannot be reduced to a court phenomenon. The Lunda conqueror who directly received the sacred royalty of the Luba extended their domination over diverse vassal provinces in Angola and in ancient Northern Rhodesia. They founded, notably, the Bemba kingdom to the south of Lake Tanganyika. Now they brought no plastic tradition to this matrilinear peasant society, which was itself lacking such a tradition. On the other hand, where they enter into contact with the Chokwe (Angola), they take up again their artistic traditions without one's being able to distinguish what belongs to the Chokwe and what to the Lunda.

Even if the hypothesis is clear, what specifically concerns the relationship between Chokwe and Lunda art remains vague. There was no "meeting" of the Lunda conquerors and the Chokwe. According to Jan Vansina, the Chokwe were formed (around 1600) from a wave of emigrating Lunda chiefs who refused to recognize the sovereign presented by the Lunda queen, Lueji. She chose to place the insignia

of power in the hands of her husband, the son of the Luba hunter Tshibinda Ilunga and thus provoked the anger and exile of her brothers and numerous other chiefs. Some of them established themselves in Angola, where the autochthonous peoples found themselves absorbed. We are probably close to the truth with Marie-Louise Bastin. This author notes in a study dedicated to Tshibinda Ilunga, civilizing hero, "If the Lunda are at the origin of the formation of the great Chokwe chiefdoms, it is undoubtedly the conquered populations to whom one ought to attribute the tradition of a sculptural language." If the "tradition of a sculptural language" must be attributed instead to populations anterior to the arrival of the Lunda-Chokwe, we do not know the diverse aspects of the material culture of these populations at the time of their conquest. Moreover, the Chokwe certainly did not come with empty hands, and besides, it is difficult to imagine that the Luba contributions to the Lunda chiefdoms (organized from before the founding of the kingdom) had not stimulated the expansion of an already elaborated plastic art. It is these Luba-Lunda traditions, resulting from complex interminglings, that were probably blended in with the traditions of the conquered peoples which permitted the development of a Chokwe culture, so homogeneous and original that today the Chokwe, although dispersed in multiple kingdoms, present the quick impression of belonging to what we could call a "nation." We return then to the question posed at the start: What is the part in this plastic creation that stems from the aesthetic or cultural models offered by the Lunda and what is the part owed to local particularisms of the Chokwe? Marie-Louise Bastin shows us that it is only in the Chokwe domain that effigies were consecrated to the hunting hero Tshibinda Ilunga, but these effigies recall the ancestor effigies and caryatids of the Luba. In contrast, Mesquitela Lima in his not-yet-published thesis on the "Fonctions sociologiques et significations esthétiques des figurines 'Hamba' dans la culture et la société tshokwe" presents the hypothesis that these *hamba* figurines with a religious and magic function have furnished the Chokwe "court" statuary with its fundamental plastic models and that they are located at the

most archaic level of Chokwe culture. He himself proposes the study, in future research, of groups of non-Lunda origin that are still accessible today, as well as of the archaeological and historical evidence that could permit the reconstruction of the evolution of Chokwe material culture and plastic arts.

This example, which we have dwelt upon because of its significance, shows all that can be expected from studies analogous to those of the two previously cited authors. Finally, here are studies systematically oriented toward the knowledge of the art instead of treating it merely as supplementary to such-and-such aspect of the collective life considered to have priority. Far from neglecting material united by history and sociology, such studies gather this with particular care and, still demanding more, engage in research into the past and observation of the present. But here one feels the entire weight of the difficulties that are possibly avoidable in other types of research. This observation of the present should be profound and complete because not only does it touch upon a domain still little explored by sociology but it also confronts this domain where the determining influences of past and present collective facts and the most intimate personal experience are rejoined, fit themselves together, and express themselves in the most spectacular manner. If one considers that most of the societies with which we are concerned are precisely those held to be the least disengaged from elementary determinism, to be the least conscious of their art, and, according to some, to be the most modestly gifted in creative capacities, one will understand how delicate the exercising of an ethnoaesthetic proclaims itself to be.

Ethnoaesthetics, or the sociology of art in the civilizations without writing, is not a vain word destined to be added to the already sufficiently complex nomenclature of the anthropological disciplines. This category of studies exists, and although it proves still unobtrusive and indecisive in its methods and principles, the itinerary it traces has already been borrowed by several investigators, a few of whom we have already indicated in passing. Let us cite other examples: the many works of William Fagg on Nigerian art, in particular his biog-

raphy of seven Yoruba sculptors, a work that he has not entirely completed; the inquiries and analyses being undertaken by Roy Sieber on the sculpture of a group of northern Nigerian tribes; Leon Siroto on the masks of the Kwele; Philippe de Salverte-Marmier on Baule art; Eberhardt Fischer on Dan art; Daniel Biebuyck on Lega art and culture. The most rigorous example to date of research in this domain concerns not black Africa but New Guinea. Adrian A. Gerbrands lived for eight months in an Asmat community in order to study the *wow-ipits,* the sculptors of the village of Amanamkai, and it is because he approached the personality of the artists and observed their working techniques that he felt himself capable of understanding the meaning of art in the culture and life of this population of seven hundred individuals, of which twenty were sculptors.

If art, as Claude Lévi-Strauss indicated during one of his interviews with Georges Charbonnier, "constitutes at its highest point this taking possession of nature by culture which is the very type of phenomena studied by the ethnologists," the ethnologists, for all this, are not hastening toward those privileged places of experience and reflection, which, instead, have been traditionally monopolized by philosophers. However, a tentative analysis as rich and conscientious as that of Franz Boas in his *Primitive Art* published in 1927, as well as the important part reserved for aesthetics by Marcel Mauss in his *Instructions d'ethnologie descriptive,* presented to impassioned students at the Institut d'Ethnologie between 1926 and 1939, should have aroused more devotees. No one more than Marcel Mauss merits the title of precursor—he who, beyond his courses dedicated to aesthetics, did so much in all his work to prove that the individual psyche and the social structure are complementary.

Nevertheless, let us acknowledge that it is possibly fortunate that ethnologists and sociologists have not rushed headlong into these studies, and it is not without a certain uneasiness tinged with melancholy that we participate in sudden conversions of interest. Indeed, and this we emphatically affirm, one must love formal beauty and love it profoundly to study it; if not, one would not know to recognize it

and still less know what sort of language is fittingly applied to those who create it.

One can ask oneself whether a sociology of art has a harmful influence upon our admiration and aesthetic pleasure, in destroying the mystery of a work with small patient thrusts of objective explanations. It seems to us that, on the contrary, if one imagines the research of historical, sociological, and psychological determinism (including the psychology of the unconscious) pushed to the utmost, and the attainment of general structural laws through an almost superhuman effort of logic, the work of art, to our amazement, will still offer itself intact. This is because in the creation itself something unforeseeable is produced: something which every artist knows well when he contemplates with surprise the result of his efforts. Once the sociological experience is exhausted, there remains this margin of mystery, of which, writing of literature, Maurice Blanchot speaks, expressing what we ourselves could say about artistic creation: "It appears as a way of discovery and an effort not to express what one knows, but to experience that which one does not know."

Epilogue

When it was originally published in 1967, the French version of *The Art and Peoples of Black Africa* attempted to provide the reader with a panoramic view of the visual arts in black African societies. Between 1967 and 1973 a great deal of new research has been undertaken, so much that adding a valid commentary now as an "epilogue" would really amount to writing a whole new book. Given the richness and diversity of these studies, such a synthesis would, in fact, be premature; we lack the methodological distance necessary to sift out information and place it within a coherent context in a manner faithful to the spirit of this book.

So strongly is the universe of visual experience rooted in all the other dimensions of a people's social life that we wished the conclusion of our book to encourage future research, which would, taking the visual object as a center, trace all of its vectors of meaning, thus forming radiating links with the other activities of the community. Since then, some points have been confirmed, others denied, by research in the field. But it seems to us that the problematic basis, the point of view, remains as valid and necessary as it was in 1967.

Today, numerous questions that we raised not so long ago have been given at least partial answers through the concerted efforts of more numerous and specialized researchers. It is in this way that the copper-plated reliquary figures, the *bwete* of the northern Kota and the *m'boi* of the southern Kota, the white Gabonese masks of the

Ogowe River and the southern area (the Punu Mukundji or the Vuvi Mvundi, for example), the sensual, geometric *bieri* of the Fang, and the disk-shaped polychrome masks of the western Teke, the Tsaye, have been studied or are now being closely examined. In Ghana and the adjacent regions of the Ivory Coast the funerary Akan terra-cottas, the Nafana masks with high superstructure called "bedu" and the *do* masks of the Ligbe are now better known. In Nigeria, the bronzes and the wood sculptures of the Benue Valley and the arts of the Ibo and the Yoruba have been the object of exemplary studies, as have also the works of numerous chiefdoms of the grasslands and of Angola. Important progress has also been made concerning the works of the Lega, the Buyu, and the Bakikasingo of the eastern Congo. The most recent work on the Dogon culture, despite the lack of certain published documents and the impossibility of preparing a critical text in the mythological sequences, has permitted a more complete understanding of the system of analogies in which visual creativity takes place. These examples represent only a small proportion of the studies that have given a valid identity to works that were, only a short time ago, poorly known and associated under the wide, vague names of large ethnic divisions.

A great deal of controversy is hidden within the wave of information that has, while widening our field of knowledge, confirmed the specific nature of the research methods necessary to study visual expression in black Africa. The arrogant but nonpertinent distinction between "high arts" and "minor arts" as well as the exotic distinction between precontact plastic creations called traditional and those that belong to contemporary reality have lost their colonial privileges. The vitality of the forms that each community conceives, executes, and animates has slowly become intelligible as a unified cultural dynamism rather than as a sum of detached elements similar to branches cut from the trunk that carries the life-giving sap.

The study of visual expression as distinct from the analysis of art objects can follow highly divergent paths. Between an approach that

considers the objects produced by a given society as factors contributing to the very structure of a specific cultural system and an approach that sees these same objects as simple elements of information about a society, there is an enormous gap. But once all the documents can be gathered together, all of these various approaches will probably contribute to a greater understanding of various peoples' creative activity. At present the approaches seem to gravitate toward one of three poles—various morphological analyses, studies of space conceived as a sociological entity in which objects are situated, and historical research, which attempts to master oral, written, and archaeological sources.

And yet it seems to us that the most important aspect of the methodologies that have grown up since 1967 is not the validity of their results but rather the cast of mind that they reflect. Now the objects that are studied and presented to the public have lost much of their former museum quality, their use as ritual or magic fetishes through which Western man attempted to regain his paradise lost or to establish the closed values of his elite society. Once at the service of Western values, the museum object now demonstrates the actual presence of the African peoples and thereby has enlarged our understanding of the contemporary world.

JACQUELINE (DELANGE) FRY

Université de Montréal

Distribution of Peoples

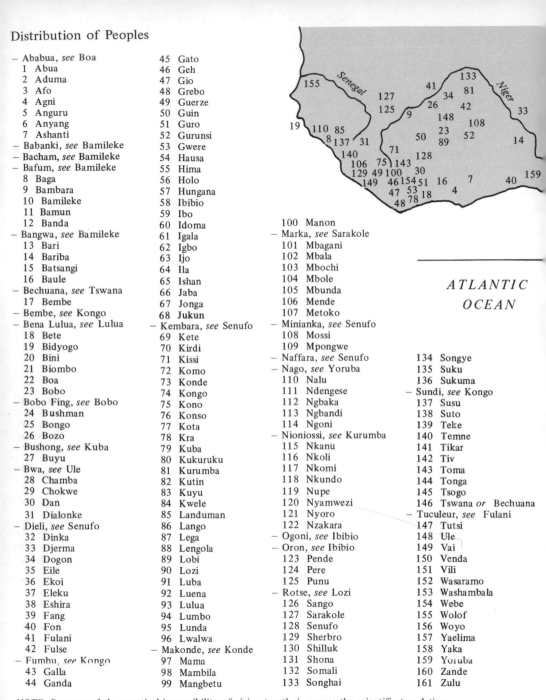

ATLANTIC OCEAN

— Ababua, *see* Boa
1 Abua
2 Aduma
3 Afo
4 Agni
5 Anguru
6 Anyang
7 Ashanti
— Babanki, *see* Bamileke
— Bacham, *see* Bamileke
— Bafum, *see* Bamileke
8 Baga
9 Bambara
10 Bamileke
11 Bamun
12 Banda
— Bangwa, *see* Bamileke
13 Bari
14 Bariba
15 Batsangi
16 Baule
— Bechuana, *see* Tswana
17 Bembe
— Bembe, *see* Kongo
— Bena Lulua, *see* Lulua
18 Bete
19 Bidyogo
20 Bini
21 Biombo
22 Boa
23 Bobo
— Bobo Fing, *see* Bobo
24 Bushman
25 Bongo
26 Bozo
— Bushong, *see* Kuba
27 Buyu
— Bwa, *see* Ule
28 Chamba
29 Chokwe
30 Dan
31 Dialonke
— Dieli, *see* Senufo
32 Dinka
33 Djerma
34 Dogon
35 Eile
36 Ekoi
37 Eleku
38 Eshira
39 Fang
40 Fon
41 Fulani
42 Fulse
— Fumbu, *see* Kongo
43 Galla
44 Ganda

45 Gato
46 Geh
47 Gio
48 Grebo
49 Guerze
50 Guin
51 Guro
52 Gurunsi
53 Gwere
54 Hausa
55 Hima
56 Holo
57 Hungana
58 Ibibio
59 Ibo
60 Idoma
61 Igala
62 Igbo
63 Ijo
64 Ila
65 Ishan
66 Jaba
67 Jonga
68 Jukun
— Kembara, *see* Senufo
69 Kete
70 Kirdi
71 Kissi
72 Komo
73 Konde
74 Kongo
75 Kono
76 Konso
77 Kota
78 Kra
79 Kuba
80 Kukuruku
81 Kurumba
82 Kutin
83 Kuyu
84 Kwele
85 Landuman
86 Lango
87 Lega
88 Lengola
89 Lobi
90 Lozi
91 Luba
92 Luena
93 Lulua
94 Lumbo
95 Lunda
96 Lwalwa
— Makonde, *see* Konde
97 Mama
98 Mambila
99 Mangbetu

100 Manon
— Marka, *see* Sarakole
101 Mbagani
102 Mbala
103 Mbochi
104 Mbole
105 Mbunda
106 Mende
107 Metoko
— Minianka, *see* Senufo
108 Mossi
109 Mpongwe
— Naffara, *see* Senufo
— Nago, *see* Yoruba
110 Nalu
111 Ndengese
112 Ngbaka
113 Ngbandi
114 Ngoni
— Nioniossi, *see* Kurumba
115 Nkanu
116 Nkoli
117 Nkomi
118 Nkundo
119 Nupe
120 Nyamwezi
121 Nyoro
122 Nzakara
— Ogoni, *see* Ibibio
— Oron, *see* Ibibio
123 Pende
124 Pere
125 Punu
— Rotse, *see* Lozi
126 Sango
127 Sarakole
128 Senufo
129 Sherbro
130 Shilluk
131 Shona
132 Somali
133 Songhai

134 Songye
135 Suku
136 Sukuma
— Sundi, *see* Kongo
137 Susu
138 Suto
139 Teke
140 Temne
141 Tikar
142 Tiv
143 Toma
144 Tonga
145 Tsogo
146 Tswana *or* Bechuana
— Tuculeur, *see* Fulani
147 Tutsi
148 Ule
149 Vai
150 Venda
151 Vili
152 Wasaramo
153 Washambala
154 Webe
155 Wolof
156 Woyo
157 Yaelima
158 Yaka
159 Yoruba
160 Zande
161 Zulu

NOTE: Because of the practical impossibility of giving to ethnic names the scientific translation proper to each of them, we have retained the names in use in the country under discussion.

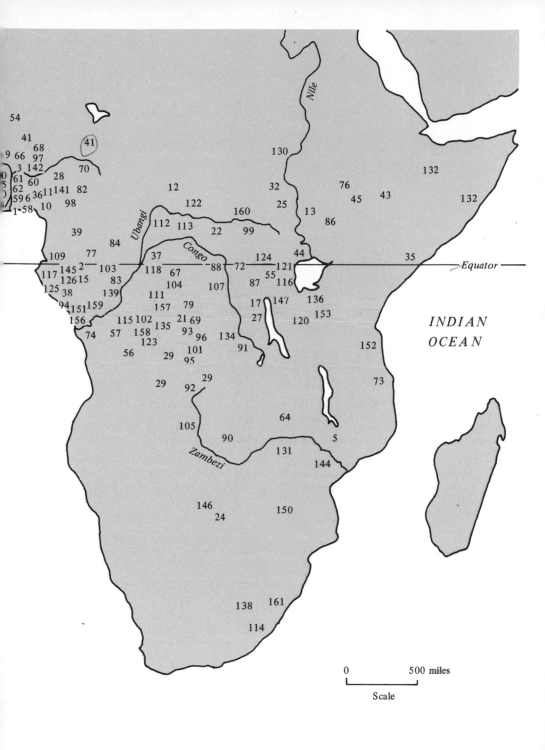

Bibliography

compiled by Alexandra Darkowska-Nidzgorska

UPPER AND MIDDLE NIGER

BA (A. H.): "Note sur les chasses rituelles bozo." In: *Journal de la Société des Africanistes,* 1955, t.* XXV, pp. 89–97, fig.

CALAME-GRIAULE (G.): *Ethnologie et langage. La parole chez les Dogon.* Paris, Gallimard, 1965, 593 p., fig., pl. (Bibliothèque des sciences humaines.)

DESPLAGNES (L.): *Le plateau central nigérien. Une mission archéologique et ethnographique au Soudan français.* Paris, Larose, 1907, 488 p., pl.

DIETERLEN (G.): *Essai sur la religion bambara.* Paris, Presses universitaires de France, 1950, XVIII–240 p., fig., pl. (Bibliothèque de sociologie contemporaine.)

DIETERLEN (G): "Les rites symboliques du mariage chez les Bambara (Soudan français)." In: *Zaïre,* 1954, vol. VIII, no. 8, pp. 815–841.

DIETERLEN (G.): "Parenté et mariage chez les Dogon (Soudan français)." In: *Africa,* London, 1956, vol. XXVI, pp. 107–148, fig.

DIETERLEN (G.): "Contribution à l'étude des forgerons en Afrique occidentale." In: *Ecole pratique des hautes études, section des sciences religieuses—annuaire 1965–1966,* t. LXXIII, pp. 5–28.

DIETERLEN (G.) et LIGERS (Z.): "Un objet rituel bozo: le maniyalo." In: *Journal de la Société des Africanistes,* 1958, t. XXVIII, pp. 33–42, pl.

GANAY (S. de): "Rôle protecteur de certaines peintures rupestres du

* The abbreviations for the word *volume* are t. (tome) and Bd. (Band) in French and German, respectively.

Soudan français." In: *Journal de la Société des Africanistes*, 1940, t. X, pp. 87–98.

GANAY (S. de): *Les devises des Dogons*. Paris, Institut d'ethnologie, 1941, VIII–194 p., pl. (Université de Paris. Institut d'ethnologie. Travaux et mémoires, 61.)

GOLDWATER (R.) introd.: *Bambara Sculpture from the Western Sudan*. New York, Museum of Primitive Art, 1960, 64 p., fig., pl.

GRIAULE (M.): "Calebasses." In: *Arts et métiers graphiques*, 1935, no. 45, pp. 45–48.

GRIAULE (M.): "Blasons totémiques des Dogons." In: *Journal de la Société des Africanistes*, 1937, t. VII, pp. 69–78, pl.

GRIAULE (M.): *Masques dogons*. Paris, Institut d'ethnologie, 1938, 896 p., fig., pl. (Université de Paris. Institut d'ethnologie. Travaux et mémoires, 33.)

GRIAULE (M.): "Notes complémentaires sur les masques dogons." In: *Journal de la Société des Africanistes*, 1940, t. X, pp. 79–85.

GRIAULE (M.): "Le Domfé des Kouroumba." In: *Journal de la Société des Africanistes*, 1941, t. XI, pp. 7–20, pl.

GRIAULE (M.): "Notes sur les masques des Kouroumba (Soudan français)." In: *Journal de la Société des Africanistes*, 1941, t. XI, pp. 224–225.

GRIAULE (M.): "Un masque du mont Tabi." In: *Journal de la Société des Africanistes*, 1944, t. XIV, pp. 25–32, pl.

GRIAULE (M.): *Arts de l'Afrique noire*. Paris, Éd. du Chêne, 1947, 128 p., fig., pl. (Arts du monde.)

GRIAULE (M.): *Dieu d'eau. Entretiens avec Ogotemmêli*. Paris, Éd. du Chêne, 1948, 270 p., fig., pl.

GRIAULE (M.): "Mythe de l'organisation du monde chez les Dogons." In: *Psyché*, 1947, no. 6, pp. 443–453.

GRIAULE (M.): "L'arche du monde chez les populations nigériennes." In: *Journal de la Société des Africanistes*, 1948, t. XVIII, pp. 117–126, fig.

GRIAULE (M.): "L'image du monde au Soudan." In: *Journal de la Société des Africanistes*, 1949, t. XIX, pp. 81–88, fig.

GRIAULE (M.): "Signes graphiques des Bozo." In: GRIAULE (M.) et DIETERLEN (G.): *Signes graphiques soudanais*. Paris, Hermann et Cie, 1951, pp. 79–86, fig. (L'homme, 3.)

GRIAULE (M.): "Systèmes graphiques des Dogon." In: GRIAULE (M.) et DIETERLEN (G.): *Signes graphiques soudanais*. Paris, Hermann et Cie, 1951, pp. 7–30, fig. (L'homme, 3.)

GRIAULE (M.): "Réflexions sur des symboles soudanais." In: *Cahiers internationaux de sociologie,* 1952, vol. XIII, pp. 8–30.

GRIAULE (M.): "Rôle du silure Clarias senegalensis dans la procréation au Soudan français." In: *Afrikanistische Studien* . . . Berlin, Akademie-Verlag, 1955, pp. 299–311, fig. (Deutsche Akademie der Wissenschaften zu Berlin-Institut für Orientforschung. Veröffentlichung, 26.)

GRIAULE (M.): "L'Afrique." In: *L'art et l'homme.* Publ. sous la direction de René Huyghe. Paris, Larousse, 1957, vol. I, pp. 87–90, fig., pl.

GRIAULE (M.) et DIETERLEN (G.): "La mort chez les Kouroumba." In: *Journal de la Société des Africanistes,* 1942, t. XII, pp. 9–24.

GRIAULE (M.) et DIETERLEN (G.): *Le renard pâle.* T. I, fasc. 1. Paris, Institut d'ethnologie, 1965, 544 p., fig., pl. (Université de Paris. Institut d'ethnologie. Travaux et mémoires, 72.)

HENRY (Abbé J.): *L'âme d'un peuple africain: les Bambara.* Münster, Verlag der Aschendorffschen Buchhandlung, 1910, v–240 p., pl. (Bibliothèque-Anthropos, t. I, fasc. 2.)

LANGLOIS (P.): *Arts soudanais. Tribus dogon.* Bruxelles-Lille, 1954, 62 p. fig.

LAUDE (J.): *Fers du pays dogon (République du Mali).* Paris, s.d., 17 f. dactylographiées (texte déposé au Département d'Afrique noire, Musée de l'homme, Paris).

LAUDE (J.): "La statuaire du pays dogon." In: *Revue d'esthétique,* Paris, 1964, t. XVII, no. 1–2, pp. 46–68, pl.

LAUDE (J.): "Esthétique et système de classification: la statuaire africaine." In: *Sciences de l'art,* 1965, no. 2, pp. 57–85, pl.

LEBEUF (J.-P.): "La circoncision chez les Kouroumba." In: *Comptes rendus sommaires des séances de l'Institut français d'anthropologie,* 1940–1943, no. 6, p. 11.

LEIRIS (M.): *La langue secrète des Dogons de Sanga (Soudan français).* Paris, Institut d'ethnologie, 1948, XXXII–536 p. (Université de Paris. Institut d'ethnologie. Travaux et mémoires, 50.)

LEM (F.-H.): *Sculptures soudanaises.* Paris, Arts et métiers graphiques, 1948, 46 p., pl.

LIFSZYC (D.) et PAULME (D.): "Les fêtes des semailles en 1935 chez les Dogon de Sanga." In: *Journal de la Société des Africanistes,* 1936, t. VI, pp. 95–110, pl.

LUTTEN (E.): "Poupées d'Afrique occidentale recueillies par la mission Dakar-Djibouti." In: *Bulletin du Musée d'ethnographie du Trocadéro,* 1933, no. 5, pp. 8–19, fig.

MONTEIL (Ch.): *Les Bambara du Ségou et du Kaarta* . . . Paris, E. Larose, 1924, 404 p., pl. (Gouvernement général de l'Afrique occidentale française. Publications du Comité d'études historiques et scientifiques.)

PAULME (D.): *Organisation sociale des Dogon (Soudan français).* Paris, Domat-Montchrestien, 1940, 603 p., fig., pl. (Études de sociologie et d'ethnologie juridiques, 32.)

SCHWEEGER-HEFEL (A.): "Die Kunst der Kurumba (Haute Volta, Westafrika)." In: *Archiv für Völkerkunde,* 1962/1963, Bd. 17/18, pp. 194–260, fig.

ZAHAN (D.): "Les couleurs chez les Bambara du Soudan français." In: *Notes africaines,* 1951, no. 50, pp. 52–56.

ZAHAN (D.): *Sociétés d'initiation bambara: le N'Domo, le Korè.* Paris-La Haye, Mouton & Co., 1960, 439 p., fig., pl. (Le monde d'outre-mer passé et présent. 1re série: études, 8.)

ZELTNER (F. de): "La bijouterie indigène en Afrique occidentale." In: *Journal de la Société des Africanistes,* 1931, t. I, pp. 43–48, pl.

THE VOLTA PEOPLES

CAPRON (J.): "Quelques notes sur la société du do chez les populations bʷa du cercle de San." In: *Journal de la Société des Africanistes,* 1957, t. XXVII, pp. 81–129, fig., pl.

CHERON (G.): "Les Bobo Fing." In: *Bulletin du Comité d'études historiques et scientifiques de l'Afrique occidentale française,* 1916, t. I, pp. 215–261.

CREMER (J.): *Matériaux d'ethnographie et de linguistique soudanaise* . . . *les Bobo* . . . Paris, P. Geuthner, 1923–1927, 4 vol.

DIM DELOBSOM (A.): "Les 'Nioniossé' de Goupana." In: *Outre-mer,* Paris, 1929, 1re année, no. 4, pp. 419–446; 1930, 2e année, no. 1, pp. 3–21.

DITTMER (K.): *Die sakralen Häuptlinge der Gurunsi im Obervolta-Gebiet, Westafrika.* Hamburg, Cram, De Gruyter and Co., 1961, VIII–176 p., pl. (Mitteilungen aus dem Museum für Völkerkunde im Hamburg, 27.)

FUCHS (P.): "Les figurines en métal d'Ouagadougou." In: *Notes africaines,* 1960, no. 87, pp. 76–82, fig.

HAUMANT (J.-C.): *Les Lobi et leur coutume.* Paris, Presses universitaires de France, 1929, 180 p.

LABOURET (H.): *Les tribus du rameau lobi.* Paris, Institut d'ethnologie,

1931, VIII–510 p., fig., pl. (Université de Paris. Institut d'ethnologie. Travaux et mémoires, 15.)

LABOURET (H.): *Nouvelles notes sur les tribus du rameau lobi: leurs migrations, leur évolution, leurs parlers et ceux de leurs voisins.* Dakar, Institut français d'Afrique noire, 1958, 295 p. (Mémoires de l'Institut français d'Afrique noire, 54.)

LE MOAL (G.): "Note sur les populations 'bobo.'" In: *Bulletin de l'Institut français d'Afrique noire,* Dakar, 1957, t. XIX, série B, no. 3–4, pp. 418–430.

OUEDRAOGO (J.): "Les funérailles en pays mossi." In: *Bulletin de l'Institut français d'Afrique noire,* Dakar, 1950, t. XII, no. 2, pp. 441–455.

SIDIBE (M.): "Famille, vie sociale et vie religieuse chez les Birifor et les Oulé (région de Diébougou, Côte-d'Ivoire)." In: *Bulletin de l'Institut français d'Afrique noire,* Dakar, 1939, t. I, no. 4, pp. 697–742.

SKINNER (E. P.): "An Analysis of the Political Organization of the Mossi People." In: *Transactions of the New York Academy of Sciences,* 1957, vol. 19, no. 8, pp. 740–750.

TAUXIER (L.): *Le Noir du Yatenga: Mossis, Nioniossés, Samos, Yarsés, Silmi-Mossis, Peuls.* Paris, E. Larose, 1917, 790 p. (Études soudanaises.)

ZAHAN (D.): "L'habitation mossi." In: *Bulletin de l'Institut français d'Afrique noire,* Dakar, 1950, t. XII, no. 1, pp. 223–229.

THE COASTAL PEOPLES OF GUINEA

ALMADA (A. Alvares d'): *Tratado breve dos rios de Guiné do Cabo-Verde desde o rio do Sanaga ate'aos baixos de Sant'Anna* etc. etc. . . . *1594.* Publ. por Diego Köpke. Porto, Typ. Commercial Portuense, 1841, XIV–108 p.

APPIA (B.): "Masques de Guinée française et de Casamance." In: *Journal de la Société des Africanistes,* 1943, t. XIII, pp. 153–182.

APPIA (B.): "Note sur le génie des eaux en Guinée." In: *Journal de la Société des Africanistes,* 1944, t. XIV, pp. 33–42.

BERANGER-FERAUD (Dr): "Note sur la secte des Simos chez les peuplades de la Côte occidentale comprises entre le Sénégal et le pays de Sierra-Leone." In: *Revue d'anthropologie,* Paris, 1880, t. III, pp. 424–440.

BERNATZIK (H. A.): *Im Reich der Bidyogo* . . . Innsbruck, Kommissionsverlag Österreichische Verlagsanstalt, 1944, 200 p., fig., pl.

"Cérémonie (Une) funèbre à Kataco." In: *La voix de Notre-Dame,* Conakry, 1926, 1ʳᵉ année, no. 6.

CHEVRIER (M.-A.): "Note relative aux coutumes des adeptes de la société secrète des Soymos, indigènes fétichistes du littoral de la Guinée." In: *L'anthropologie,* 1906, t. XVII, pp. 359–376, fig.

COFFINIERES DE NORDECK: "Voyage aux pays des Bagas et du Rio-Nuñez." In: *Le tour du monde,* 1886, t. LI, pp. 273–304.

DELANGE (J.): "Le bansonyi du pays baga." In: *Objets et mondes,* 1962, t. II, fasc. I, pp. 3–12, fig.

DIALLO (O.): "Les 'Koré' et les 'Simo' au Fouta Dialon." In: *Notes africaines,* 1947, no. 33, pp. 2–5.

FERNANDES (V.): *Description de la Côte occidentale d'Afrique, Sénégal au Cap de Monte, archipels . . . (1506–1510) . . .* Ed. et trad. par Th. Monod, A. Teixeira da Mota, et R. Mauny. Bissau, Centro de estudos da Guiné portuguesa, 1951, x–227 p. (Publicações do Centro de estudos da Guiné portuguesa, 11.)

HOLAS (B.): "Danses masquées de la Basse-Côte." In: *Études guinéennes,* 1947, no. 1, pp. 61–67.

LESTRANGE (M. de): "Génies de l'eau et de la brousse en Guinée française." In: *Études guinéennes,* 1950, no. 4, pp. 1–24.

MEO (Dr): *"Études sur le Rio Nuñez."* In: *Bulletin du Comité d'études historiques et scientifiques de l'Afrique occidentale française,* 1918, t. IV, pp. 281–317, 341–369.

MOTA (A. Teixeira da) e NEVES (M. G. Ventim): *A habitação indígena na Guiné portuguesa.* Bissau, Centro de estudos da Guiné portuguesa; Lisboa, Sociedade industrial de tipografia, 1948, 565 p., fig. (Centro de estudos da Guiné portuguesa, 7.)

PAULME (D.): "Structures sociales en pays baga (Guinée française)." In: *Bulletin de l'Institut français d'Afrique noire,* Dakar, 1956, t. XVIII, série B, no. 1–2, pp. 98–116, fig.

PAULME (D.): "Des riziculteurs africains: les Baga (Guinée française)." In: *Les cahiers d'outre-mer,* 1957, t. X, pp. 257–278, fig., carte.

PAULME (D.): "La notion de sorcier chez les Baga." In: *Bulletin de l'Institut français d'Afrique noire,* Dakar, 1958, t. XX, série B, no. 3–4, pp. 406–416.

SCHNELL (R.): "La fête rituelle des jeunes excisées en pays baga (Basse Guinée)." In: *Notes africaines,* 1949, no. 43, pp. 84–86.

WIXON (W. D.): "Two African Tribal Sculptures." In: *Bulletin of the Cleveland Museum of Art,* 1961, vol. 3, pp. 38–47, fig.

THE SOUTHWEST OF THE SUDANESE SAVANNA AND THE WEST COAST OF THE ATLANTIC FOREST

BOCHET (G.): "Le poro des Diéli." In: *Bulletin de l'Institut français d'Afrique noire,* Dakar, 1959, t. XXI, série B, no. 1–2, pp. 61–101, fig.

BOCHET (G.): "Les masques sénoufo, de la forme à la signification." In: *Bulletin de l'Institut français d'Afrique noire,* Dakar, 1965, t. XXVII, série B, no. 3–4, pp. 636–677, fig.

BOUET (F.): *Les Tomas.* Paris, Comité de l'Afrique française, 1912, 119 p., fig.

CLAMENS (G.): "Notes d'ethnologie sénoufo." In: *Notes africaines,* 1953, no. 59, pp. 76–80, fig.

CLAMENS (G.): "Les nyi-kar-yi de Watyene." In: *Notes africaines,* 1953, no. 60, pp. 108–110, fig.

COULIBALY (Sinali): *Les paysans senoufo de Korhogo (Côte d'Ivoire).* Dakar, Faculté des lettres et sciences humaines, s.d., 38 p., fig., cartes. (Travaux du Département de géographie, 8.)

FISCHER (E.): "Künstler der Dan. Die Bildhauer Tame, Si, Tompieme und Sòn—ihr Wesen und ihr Werk." In: *Baessler-Archiv,* 1963, neue Folge, Bd. X, pp. 161–263, fig.

GOLDWATER (R.) ed.: *Senufo Sculpture from West Africa.* New York, Museum of Primitive Art, 1964, 126 p., pl.

HARLEY (G. W.): *Notes on the Poro in Liberia.* Cambridge, publ. by the Museum, 1941, 39 p., fig., pl. (Papers of the Peabody Museum of American Archaeology and Ethnology, Harvard University, vol. 19, no. 2.)

HARLEY (G. W.): *Masks as Agents of Social Control in Northeast Liberia.* Cambridge, publ. by the Museum, 1950, XIV–45 p., pl. (Papers of the Peabody Museum of American Archaeology and Ethnology, Harvard University, vol. 32, no. 2.)

HASELBERGER (H.): *Bautraditionen der westafrikanischen Negerkulturen* . . . Wien, Herder, 1964, 176 p. fig., pl. (Wissenschaftliche Schriftenreihe des afro-asiatischen Institutes in Wien, 2.)

HIMMELHEBER (H.): *Negerkunst und Negerkünstler* . . . Braunschweig, Klinkhardt, und Biermann, 1960, VIII–436 p., fig., pl. (Bibliothek für Kunst- und Antiquitatenfreunde, 40.)

HIMMELHEBER (H.): "Die Masken der Guéré im Rahmen der Kunst des oberen Cavally-Gebietes." In: *Zeitschrift für Ethnologie,* Braunschweig, 1963, Bd. 88, H. 2, pp. 216–233, fig.

HIMMELHEBER (H.): "Die Geister und ihre irdischen Verkörperungen als Grundvorstellung in der Religion der Dan (Liberia und Elfenbeinküste)." In: *Baessler-Archiv,* 1964, neue Folge, Bd. XII, pp. 1–88, fig.

HIMMELHEBER (H.): "Deutung Bestimmter Eigenarten der Senufo-Masken (nördliche Elfenbeinküste)." In: *Baessler-Archiv,* 1965, neue Folge, Bd. XIII, pp. 73–82, fig.

HOLAS (B.): *Les masques kono (Haute-Guinée française), leur rôle dans la vie religieuse et politique.* Paris, P. Geuthner, 1952, 203 p., fig., pl.

HOLAS (B.): *Mission dans l'Est libérien (P.-L. Dekeyser—B. Holas, 1948). Résultats démographiques, ethnologiques et anthropométriques.* Dakar, Institut français d'Afrique noire, 1952, 566 p., pl. (Mémoires de l'I.F.A.N., 14.)

HOLAS (B.): "Note sur la fonction rituelle de deux catégories de statues sénoufo." In: *Artibus Asiae,* 1957, vol. XX, no. 1, pp. 29–35, fig.

HOLAS (B.): *Cultures matérielles de la Côte d'Ivoire.* Paris, Presses universitaires de France, 1960, 96 p., fig., pl.

KNOPS (le Père): "Contribution à l'étude des Sénoufo de la Côte d'Ivoire et du Soudan." In: *Bulletin de la Société royale belge d'anthropologie et de préhistoire,* 1956, t. 67, pp. 141–168, fig.

KNOPS (le Père): "L'artisan sénufo dans son cadre ouest-africain." In: *Bulletin de la Société royale belge d'anthropologie et de préhistoire,* 1959, t. 70, pp. 83–111.

KNOPS (le Père): "Rituel funéraire sénufo." In: *Bulletin de la Société royale belge d'anthropologie et de préhistoire,* 1961, t. 72, pp. 129–148.

LITTLE (K.-L.): "The Role of the Secret Society in Cultural Specialization." In: *American Anthropologist,* 1949, vol. 51, no. 2, pp. 199–212.

MAUNY (R.): "Masques mende de la société Bundu (Sierra Leone)." In: *Notes africaines,* 1959, no. 81, pp. 8–13, fig.

MOCKERS (P.) et CLAMENS (G.): "Hauts-lieux et gravures rupestres en pays djimini (Côte-d'Ivoire)." *Notes africaines,* 1950, no. 46, pp. 35–36, fig.

NEEL (H.): "Statuettes en pierre et en argile de l'Afrique occidentale." In: *L'anthropologie,* Paris, 1913, t. XXIV, pp. 419–443.

PAULME (D.): *Les gens du riz, Kissi de Haute-Guinée française.* Paris, Plon, 1954, 236 p., fig., pl. (Recherches en sciences humaines, 4.)

PAULME (D.): "Peintures murales et pierres kissi." In: *Marco Polo,* 1956, no. 20, pp. 43–54, fig., pl.

SCHAEFFNER (A.): *Les Kissi, une société noire et ses instruments de musique.* Paris, Hermann et Cie, 1951, 88 p., pl. (L'homme, 2.)

SCHWAB (G.): *Tribes of the Liberian Hinterland* . . . Ed. by G. W. Harley. Cambridge, Peabody Museum of American Archaeology and Ethnology, 1947, xx–526 p., fig., pl. (Papers of the Peabody Museum of American Archaeology and Ethnology, Harvard University, 31.)

VANDENHOUTE (P. J. L.): *Classification stylistique du masque dan et guéré de la Côte d'Ivoire occidentale, A.O.F.* Leiden, E. J. Brill, 1948, 48 p., pl. (Mededelingen van het Rijksmuseum voor Volkenkunde, 4.)

VERHEYLEWEGHEN (F. & J.): "Objets du culte yakouba associant la corne 'fétiche' au masque ancestral." In: *Bulletin de la Société royale belge d'anthropologie et de préhistoire,* 1958, t. 69, pp. 220–232, fig.

THE AKAN

ABEL (H.): "Déchiffrement des poids à peser l'or en Côte d'Ivoire." In: *Journal de la Société des Africanistes,* 1952, t. XXII, pp. 95–114; 1954, t. XXIV, pp. 7–23, fig.

ABEL (H.): "Poids à peser l'or en Côte d'Ivoire." In: *Bulletin de l'Institut français d'Afrique noire,* Dakar, 1954, t. XVI, pp. 55–82, fig.

AMON D'ABY (F. J.): *Croyances religieuses et coutumes juridiques des Agni de la Côte d'Ivoire.* Paris, Larose, 1960, 184 p., fig.

ARKELL (A. J.): "Gold Coast Copies of V–VIIth Century Bronze Lamps." In: *Antiquity,* 1950, vol. XXIV, pp. 38–40, fig.

BARDON (P.): *Collection des masques d'or baoulé de l'I.F.A.N.* Dakar, Institut français d'Afrique noire, 1948, 22 p., pl.

BEART (Ch.): "Diffusion ou convergence: à propos des poupées akua ba de la Gold Coast." In: *Notes africaines,* 1957: no. 75, pp. 83–84.

BOWDICH (T. E.): *Voyage dans le pays d'Aschantie, ou Relation de l'ambassade envoyée dans ce royaume par les Anglais* . . . Trad. de l'anglais par le trad. du *"Voyage de Maxwell . . ."* (C.-A. Defauconpret). Paris, Gide fils, 1819, 527 p.

BUSIA (K. A.): "The Ashanti." In: *African Worlds,* 1954, pp. 190–209.

DAVIES (O.): "Human Representation in Terracotta from Gold Coast." In: *South African Journal of Science,* 1956, no. 6, pp. 147–151, fig.

DELANGE (J.): "Un kuduo exceptionnel." In: *Objets et mondes,* 1965, t. V, fasc. 3, pp. 197–204, fig.

GOODY (J.): "Ethnohistory and the Akan of Ghana." In: *Africa,* London, 1959, vol. XXIX, pp. 67–81.

GROTTANELLI (V. L.): "Asonu Worship Among the Nzema, a Study in Akan Art and Religion." In: *Africa,* London, 1961, vol. I, pp. 46–60, fig.

HOLAS (B.): "Note sur le vêtement et la parure baoulé." In: *Bulletin de l'Institut français d'Afrique noire,* Dakar, 1949, t. XI, no. 3–4, pp. 438–457.

HOLAS (B.): "Sur l'utilisation rituelle des statuettes funéraires en royaume de Krinjabo (Côte d'Ivoire)." In: *Acta tropica,* 1951, vol. 8, pp. 1–17.

HOLAS (B.): "Une genitrix baoulé." In: *Acta tropica,* 1952, vol. 9, pp. 193–203, fig.

HOLAS (B.): "Sur quelques divinités baoulé de rang inférieur, leurs figurations, leur rôle liturgique." In: *Bulletin de l'Institut français d'Afrique noire,* Dakar, 1956, t. XVIII, série B, no. 3–4, pp. 408–432, fig.

HUGOT (H. J.): "Un vase en bronze d'origine inconnue." In: *Notes africaines,* 1960, no. 87, pp. 71–72, fig.

KJERSMEIER (C.): "Ashanti Gold Weights in the National Museum." In: *Nationalmuseets skrifter,* 1941, etnografisk roekke I, pp. 99–106, fig.

LABOURET (H.): "Notes contributives à l'étude du peuple baoulé." In: *Revue d'ethnographie et de sociologie,* 1914, t. 5, pp. 73–91, 181–194.

LABOURET (H.) et SCHAEFFNER (A.): "Un grand tambour de bois ébrié." In: *Bulletin du Musée d'ethnographie du Trocadéro,* 1931, no. 2, pp. 48–55, fig.

LINDHOLM (B.): "Les portraits baoulé et leur base sociale." In: *Etnografiska museet,* Göteborg, 1955 och 1956, pp. 40–53.

MENALQUE (M.): *Coutumes civiles des Baoulés de la région de Dimbokro.* Paris, Larose, 1933, 74 p.

MEYEROWITZ (E. L. Lewin-Richter): *The Akan of Ghana, Their Ancient Beliefs.* London, Faber and Faber, 1958, 164 p., fig., pl.

MEYEROWITZ (E. L. Lewin-Richter): *The Divine Kingship in Ghana and Ancient Egypt.* London, Faber, 1960, 260 p., fig.

NIANGORAN-BOUAH (G.): *La division du temps et le calendrier rituel des peuples lagunaires de Côte d'Ivoire.* Paris, Institut d'ethnologie, 1964, 164 p., fig., pl. (Université de Paris. Institut d'ethnologie. Travaux et mémoires, 68.)

NKETIA (J. H.): "The Role of the Drummer in Akan Society." In: *African Music*, 1954, vol. 1, no. 1, pp. 34–43.

RATTRAY (R. S.): *Ashanti*. Oxford, Clarendon Press, 1923, 348 p., fig., pl.

RATTRAY (R. S.): *Religion and Art in Ashanti* . . . Oxford, Clarendon Press, 1927, xvIII–415 p., fig., pl.

SIROTO (L.): "Baule and Guro Sculpture of the Ivory Coast." In: *Masterpieces of African Art* . . . New York, Brooklyn Museum Press, 1954, pp. 22–25.

DAHOMEY

BEIER (U.): "The Bochio, a Little Known Type of African Carving." In: *Black Orpheus*, 1958, no. 3, pp. 28–31, pl.

BERTHO (J.): "Coiffures-masques à franges de perles chez les rois yoruba de Nigeria et du Dahomey." In: *Notes africaines*, 1950, no. 47, pp. 71–74.

BERTHO (J.): "Habitations à impluvium dans les régions de Porto Novo et de Ketou (Dahomey)." In: *Notes africaines*, 1960, no. 47, pp. 74–75, fig.

GRIAULE (M.) et DIETERLEN (G.): "Calebasses dahoméennes, documents de la mission Dakar-Djibouti." In: *Journal de la Société des Africanistes*, 1935, t. V, pp. 203–216.

HERSKOVITS (M. J.): *Dahomey, an Ancient West African Kingdom*. New York, J. J. Augustin, 1938, 2 vol., xxII–402 + xvI–407 p., fig., pl.

HERSKOVITS (M. J.) and FRANCES (S.): "The Art of Dahomey": I. "Brasscasting and Appliqué Cloths"; II. "Wood Carving." In: *American Magazine of Art*, February 1934, pp. 67–76; March 1934, pp. 124–132.

LE HERISSE (A.): *L'ancien royaume du Dahomey. Mœurs, religion, histoire*. Paris, E. Larose, 1911, 384 p., fig., pl.

LOBSIGER-DELLENBACH (M.): "Figurines en terre modelée du Dahomey." In: *Archives suisses d'anthropologie générale*, 1945, t. 11, no. 2, pp. 215–238, fig.

MAUPOIL (B.): *La géomancie à l'ancienne Côte des Esclaves*. Paris, Institut d'ethnologie, 1943, 686 p. (Université de Paris. Institut d'ethnologie. Travaux et mémoires, 42.)

MERCIER (P.): "Evolution de l'art dahoméen." In: *Présence africaine*, 1951, no. 10–11, pp. 185–193, pl.

MERCIER (P.): "Images de l'art animalier au Dahomey." In: *Études dahoméennes,* 1951, no. 5, pp. 93–103.

MERCIER (P.): *Les asẽ du Musée d'Abomey.* Dakar, Institut français d'Afrique noire, 1952, 98 p., fig. (Catalogues de l'I.F.A.N., 7.)

MERCIER (P.): "The Fon of Dahomey." In: *African Worlds,* 1954, pp. 210–234.

MERCIER (P.) et LOMBARD (J.): *Guide du Musée d'Abomey.* Porto-Novo, Institut français d'Afrique noire, 1959, 40 p., pl. (Études dahoméennes.)

MERLO (Chr.): *Un chef-d'œuvre d'art nègre: "le buste de la prêtresse."* Auvers-sur-Oise, Archée, 1966, 46 p., fig.

MERWART (E.): *L'art dahoméen.* Marseille, Moullot, 1922, 24 p., fig.

QUENUM (M.): "Au pays des Fons." In: *Bulletin du Comité d'études historiques et scientifiques de l'Afrique occidentale française,* 1935, t. XVIII, pp. 141–335.

REAL (D.): "Notes sur l'art dahoméen." In: *L'anthropologie,* 1920, t. XXX, pp. 369–392.

VERGER (P.): "Rôle joué par l'état d'hébétude au cours de l'initiation des novices aux cultes des Orisha et Vodun." In: *Bulletin de l'Institut français d'Afrique noire,* Dakar, 1945, t. XVI, no. 3–4, pp. 322–340.

VERGER (P.): *Notes sur le culte des Orisa et Vodun à Bahia, la Baie de Tous les Saints, au Brésil et à l'ancienne Côte des Esclaves en Afrique.* Dakar, Institut français d'Afrique noire, 1957, 570 p., pl. (Mémoires de l'I.F.A.N., 51.)

VERGER (P.): "Note on the Bas-Reliefs in the Royal Palaces of Abomey." In: *Odù,* 1958?, no. 5, pp. 3–13, fig.

WATERLOT (Em. G.): *Les bas-reliefs des bâtiments royaux d'Abomey (Dahomey).* Paris, Institut d'ethnologie, 1926, vi–10 p., fig., pl. (Université de Paris. Institut d'ethnologie. Travaux et mémoires, 1.)

NIGERIA

AKITOLA AKPATA (Chief): "Benin Notes on Altars and Bronze Heads." In: *Ethnologia Cranmorensis,* 1937, no. 1, pp. 5–10.

ALFRED (C.): "A Bronze Cult Object from Southern Nigeria." In: *Man,* 1949, vol. 49, no. 47, pp. 38–39.

BEIER (U.): "Ibo and Yoruba Art, a Comparison." In: *Black Orpheus,* no. 8, pp. 46–50, pl.

BEIER (U.): "The Palace of the Ogogas in Ikerre." In: *Nigeria Magazine,* 1954, no. 44, pp. 303–314, fig.

BEIER (U.): "Ibibio Monuments." In: *Nigeria Magazine,* 1956, no. 51, pp. 318–336, fig., pl.

BEIER (U.): "The Egungun Cult." In: *Nigeria Magazine,* 1956, no. 51, pp. 380–392, fig.

BEIER (U.): *The Story of Sacred Wood Carvings from One Small Yoruba Town.* S. l., D. W. Macrow, 1957, 22 p., pl. (A special *Nigeria Magazine* production.)

BEIER (U.): "Gelede Masks." In: *Odù,* 1958, no. 6, pp. 5–23, fig.

BEIER (U.): "Sacred Yoruba Architecture." In: *Nigeria Magazine,* 1960, no. 64, pp. 93–104, fig., pl.

BEIER (U.): *African Mud Sculpture.* Cambridge, University Press, 1963, 96 p., fig., pl.

BERTHO (J.) et MAUNY (R.): "Archéologie du pays yoruba et du Bas-Niger." In: *Notes africaines,* 1952, no. 56, pp. 97–114, fig.

BOHANNAN (P.): "Beauty and Scarification Amongst the Tiv." In: *Man,* 1956, vol. 56, no. 129, pp. 117–121, fig., pl.

BOSTON (J. S.): "Some Northern Ibo Masquerades." In: *The Journal of the Royal Anthropological Institute of Great Britain and Ireland,* 1960, vol. 90, pp. 54–65, fig.

CHADWICK (E. R.): "Wall Decorations of Ibo Houses." In: *Nigerian Field,* 1937, vol. 6, no. 3, pp. 134–135.

CLARK (J. D.): "The Stone Figures of Esie." In: *Nigeria,* 1938, no. 14, pp. 106–108.

DANIEL (F.): "The Stone Figures of Esie, Ilorin Province, Nigeria." In: *The Journal of the Royal Anthropological Institute of Great Britain and Ireland,* 1937, vol. 67, pp. 43–50, fig., pl.

DARK (P.): "Preliminary Catalogue of Benin Art and Technology, Some Problems of Material Culture Analysis." In: *The Journal of the Royal Anthropological Institute of Great Britain and Ireland,* 1957, vol. 87, pp. 175–189.

DUPONCHEEL (Chr.): "La statuaire des Kutin de l'Adamaoua camerounais." In: *Objets et mondes,* juillet 1967 (à paraître).

EGHAREVBA (J. U.): *A Short History of Benin.* 2d ed. revised and enlarged. Benin, publ. by the author (print. at the Ibadan University Press), 1953, xii–118 p., pl.

FAGG (B.): "A Preliminary Note on a New Series of Pottery Figures from Northern Nigeria." In: *Africa,* London, 1945, vol. XV, pp. 21–22, pl.

FAGG (B.): "Archaeological Notes from Northern Nigeria." In: *Man,* 1946, vol. 46, pp. 49–55.

FAGG (B.): "A Fertility Figure of Unrecorded Style from Northern Nigeria." In: *Man,* 1948, vol. 48, no. 140, p. 125, fig., pl.

FAGG (B.): "New Discoveries from Ife on Exhibition at the Royal Anthropological Institute." In: *Man,* 1949, vol. 49, no. 79, p. 61, fig., pl.

FAGG (B.): "A Life-Size Terracotta Head from Nok." In: *Man,* 1956, vol. 56, no. 95, p. 89, pl.

FAGG (B.): "The Nok Culture." In: *West African Review,* 1956, vol. 27, no. 351, pp. 1083–1087, fig.

FAGG (B.) and FAGG (W.): "The Ritual Stools of Ancient Ife." In: *Man,* 1960, vol. 60, no. 155, pp. 113–115, fig., pl.

FAGG (W.): "The Antiquities of Ife." In: *Image,* 1949, no. 2, pp. 19–30, fig.

FAGG (W.): "A Bronze Figure in Ife at Benin." In: *Man,* 1950, vol. 50, no. 98, pp. 60–70.

FAGG (W.): "De l'art des Yoruba." In: *Présence africaine,* 1951, no. 10–11, pp. 103–135, pl.

FAGG (W.): "L'art nigérien avant Jésus-Christ." In: *Présence africaine,* 1951, no. 10–11, pp. 91–95.

FAGG (W.): *Merveilles de l'art nigérien.* Photogr. de H. List. Paris, Éd. du Chêne, 1963, 39 p., pl.

FAGG (W.) and UNDERWOOD (L.): "An Examination of the So-Called 'Olokun' Head of Ife, Nigeria." In: *Man,* 1949, vol. 49, no. 1, pp.1–7, fig., pl.

FAGG (W.) and WILLETT (F.): "Ancient Ife, an Ethnographical Summary." In: *Odù,* 1960, no. 8, pp. 21–35.

FORMAN (W. and B.) and DARK (P.): *Benin Art.* London, P. Hamlyn, 1960, 64 p., pl.

JEFFREYS (M. D. W.): "Ibo Club Heads." In: *Man,* 1957, vol. 57, no. 63, p. 57.

JEFFREYS (M. D. W.): "Negro Abstract Art or Ibo Body Patterns." In: *SAMAB,* Durban, 1957, vol. 6, no. 9, pp. 218–229, fig.

LUSCHAN (F. von): *Die Altertümer von Benin . . .* Berlin und Leipzig, W. de Gruyter & Co., 1919, 3 vol., xii–522 p., fig., pl.

MURRAY (K. C.): "Fröbenius and Ile Ife." In: *Nigerian Field,* 1943, vol. XI, pp. 200–203.

MURRAY (K. C.): "The Wood Carvings of Oron (Calabar)." In: *Nigeria,* 1946, no. 23, pp. 113–114.

MURRAY (K. C.): "The Chief Art Styles of Nigeria." In: *Première conférence internationale des Africanistes de l'Ouest. Dakar. 1945—*

Comptes rendus. Paris, Adrien-Maisonneuve, 1951, vol. 2, pp. 318–330, fig.

MURRAY (K. C.): "The Decoration of Calabashes by Tiv (Benue Province)." In: *Nigeria,* 1951, no. 36, pp. 469–474, fig.

PITT-RIVERS (Lieutenant-General A. H.): *Antique Works of Art from Benin.* London, Harrison and Sons Print., 1900, IV–100 p., pl.

SCHWEEGER-HEFEL (A.): "Zur Thematik und Ikonographie der geschnitzten Elfenbeinzähne aus Benin im Museum für Völkerkunde in Wien." In: *Archiv für Völkerkunde,* 1957, Bd. 12, pp. 182–229, fig.

SIEBER (R.): *Sculpture of Northern Nigeria* . . . New York, Museum of Primitive Art, 1961, 30 p., fig.

SIMMONS (D. C.): "The Depiction of Gangosa on Efik-Ibibio Masks." In: *Man,* 1957, vol. 57, no. 18, pp. 17–20.

SYDOW (E. von): "The Image of Janus in African Sculpture." In: *Africa,* London, 1932, vol. V, pp. 14–27, pl.

SYDOW (E. von): "Zur Chronologie von Benin-Ornamenten." In: *Ethnologischer Anzeiger,* 1935, Bd. IV, pp. 31–38.

SYDOW (E. von): "Ancient and Modern Art in Benin City." In: *Africa,* London, 1938, vol. XI, pp. 55–62, pl.

TALBOT (P. A.): "Note on Ibo Houses." In: *Man,* 1916, vol. 16, no. 79, p. 129, pl.

WILLETT (F.): "Bronze Figures Ita Yemoo, Ife, Nigeria." In: *Man,* 1959, vol. 59, no. 308, pp. 189–193, fig., pl.

WILLETT (F.): "Ife and Its Archaeology." In: *The Journal of African History,* 1960, vol. 1, no. 1–2, pp. 231–248, fig., pl.

THE FULANI

BA (A.-H.) et DAGET (J.): *L'empire peul du Macina.* I. (*1818–1853*). [Bamako], Institut français d'Afrique noire—Centre du Soudan, 1955, 306 p. (Études soudanaises, 3.)

BRANDT (H.): *Nomades du soleil.* Lausanne, Clairefontaine, 1956, 150 p., fig., pl.

CREACH (P.): "Notes sur l'art décoratif architectural foula du Haut Fouta-Djallon." In: *Première conférence internationale des Africanistes de l'Ouest. Dakar. 1945—Comptes rendus.* Paris, Adrien-Maisonneuve, 1951, vol. 2, pp. 300–312, fig.

DELMOND (P.): "Dans la boucle du Niger: Dori, ville peule." In: *Mémoires de l'Institut français d'Afrique noire,* Dakar, 1953, no. 23, pp. 9–109, fig.

DUPIRE (M.) : "Contribution à l'étude des marques de propriété du bétail chez les pasteurs peuls." In: *Journal de la Société des Africanistes,* 1954, t. XXIV, pp. 123–143, fig.

DUPIRE (M.) : *Peuls nomades* . . . Paris, Institut d'ethnologie, 1962, VI–338 p., pl. (Université de Paris. Institut d'ethnologie. Travaux et mémoires, 64.)

DUPUIS-YAKOUBA (A. V.) : "Notes sur Tombouctou (vie journalière, habillement, mobilier, etc.)." In: *Revue d'ethnographie et de sociologie,* 1914, t. 5, pp. 248–263.

DUPUIS-YAKOUBA (A. V.) : *Industries et principales professions des habitants de la région de Tombouctou.* Paris, E. Larose, 1921, 111–193 p. (Publications du Comité d'études historiques et scientifiques de l'Afrique occidentale française.)

DURAND (O.) : "Les industries locales au Fouta." In: *Bulletin du Comité d'études historiques et scientifiques de l'Afrique occidentale française,* 1932, t. XV, pp. 42–71.

ESTREICHER (Z) : "Chants et rythmes de la danse d'hommes bororo." In: *Bulletin de la Société neuchâteloise,* 1954–1955, vol. 51, no. 5, pp. 57–93.

GABUS (J.) : *Initiation au désert.* Lausanne, F. Rouge et Cie, 1954, 236 p., pl. (Vie et documents du XXᵉ siècle, 2.)

GABUS (J.) : *Au Sahara.* Vol. 2. *Arts et symboles.* Neuchâtel, La Baconnière, 1958, 408 p., fig., pl.

JEST (C.) : "Décoration des calebasses foulbé." In: *Notes africaines,* 1956, no. 72, pp. 113–116, fig.

LACROIX (P. F.) ed.: *Poésie peule de l'Adamawa.* Paris, Julliard, 1965, 2 vol. (Classiques africains, 3 et 4.)

LAFON (S.) : "La parure chez les femmes peul du Bas-Sénégal." In: *Notes africaines,* 1950, no. 46, pp. 37–41.

MALZY (P.) : "Les calebasses." In: *Notes africaines,* 1957, no. 73, pp. 10–12, fig.

NICHOLSON (W. E.) : "The Potters of Sokoto, N. Nigeria." In: *Man,* 1929, vol. 29, no. 34, pp. 45–50.

PATENOSTRE (Dr) : "La coiffure chez les Peuhls du Fouta Djallon." In: *Outre-mer,* 1931, 3ᵉ année, no. 4, pp. 406–419, fig.

POUJADE (J.) : *Les cases décorées d'un chef du Fouta-Djiallo.* Djibouti, Centre de recherche culturelle de la route des Indes, Centre I.F.A.N.; Paris, Gauthier-Villars, 1948, 40 p., fig. (Documents d'ethnographie terrestre, 1.)

STENNING (D. J.): *Savannah Nomads. A Study of the Wodaabe Pastoral Fulani of Western Bornu Province, Northern Region, Nigeria.* London, International African Institute (Oxford University Press), 1959, 266 p., fig.

URVOY (Y.): *Histoire des populations du Soudan central (colonie du Niger).* Paris, Larose, 1936, 350 p., pl. (Publications du Comité d'études historiques et scientifiques de l'Afrique occidentale française, série A, 5.)

VIEILLARD (G.): "Notes sur les Peuls du Fouta-Djallon." In: *Bulletin de l'Institut français d'Afrique noire,* Dakar, 1949, t. II, no. 1–2, pp. 85–210, pl.

ZELTNER (F. de): "Note sur les Laobés du Soudan français." In: *Bulletins et mémoires de la Société d'anthropologie de Paris,* 1916, t. VII, pp. 165–169.

CENTRAL AND WESTERN CAMEROUN

"Bamenda Brass." In: *Nigeria Magazine,* 1957, no. 55, pp. 344–355, fig.

BINET (J.): "L'habitation dans la subdivision de N'Kongsamba." In: *Études camerounaises (Bulletin de la Société d'études camerounaises),* 1948, t. I, no. 21–22, pp. 35–48.

BOUCHART (M.): "L'habitat au Cameroun." In: *Notes documentaires,* Paris, 1958, no. 29, pp. 43–64.

BUISSON (E.-M.): "Les tatouages bamiléké." In: *Togo-Cameroun,* Paris, février 1931, pp. 107–116.

BUISSON (E.-M.): "La céramique bamiléké." In: *Togo-Cameroun,* Paris, février 1931, pp. 117–118.

BUISSON (E.-M.): "Quelques réalisations animales chez les Bamiléké." In: *Togo-Cameroun,* Paris, février 1931, pp. 119–121.

BUISSON (E.-M.): "L'art chez les Bamilékés." In: *Arts du Cameroun* . . . Paris, Agence économique des colonies autonomes et des territoires africains sous mandat, 1934, p. 22.

FROBENIUS (L.): *Der Kameruner Schiffsschnabel und seine Motive.* Halle, E. Karras, 1897, 95 p., pl. (Nova acta. Abh. der Kaiscrl. Leop.-Carol. Deutschen Akademie der Naturforscher, Bd. 70, Nr. 1.)

GERMANN (P.): "Das plastisch-figürliche Kunstgewerbe im Grasland von Kamerun. Ein Beitrag zur afrikanischen Kunst." In: *Jahrbuch des Städtischen Museums für Völkerkunde zu Leipzig,* 1910, Bd. 4, pp. 1–35, pl.

Histoire et coutumes des Bamum. Réd. sous la direction du sultan Njoya. Trad. du pasteur Henri Martin. Douala, Institut français d'Afrique

noire—Centre du Cameroun, 1952, 275 p., pl. (Mémoires de l'I.F.A.N.—Centre Cameroun. Série: populations, 5.)

JEFFREYS (M. D. W.): "Le serpent à deux têtes bamum." In: *Bulletin de la Société d'études camerounaises,* 1945, no. 9, pp. 7–12, fig.

JEFFREYS (M. D. W.): "The Bamum Coronation Ceremony as Described by King Njoya." In: *Africa,* London, 1950, vol. XX, pp. 38–45.

Catalogue de l'exposition de la mission au Cameroun de M. H. LABOURET . . . Paris, Musée du Trocadéro (Impr. de Vaugirard), 1935, 56 p., fig., pl.

LA ROZIÈRE (S. de) et LUC (G.): "Une forme peu connue de l'expression artistique africaine: l'abbia. Jeu de dés des populations forestières du Sud-Cameroun." In: *Études camerounaises,* 1955, no. 49–50, pp. 3–52.

LECOQ (R.): "Quelques aspects de l'art bamoun." In: *Présence africaine,* 1951, no. 10–11, pp. 175–181, pl.

LECOQ (R.): *Une civilisation africaine: les Bamiléké.* Paris, Aux Éditions Africaines, 1953, 217 p., fig., pl.

PARE (I.): "L'araignée divinatrice." In: *Études camerounaises,* 1956, no 53–54, pp. 61–73.

REIN-WUHRMANN (A.): *Mein Bamumvolk im Grasland von Kamerun.* Stuttgart, Evang. Missionverlag; Basel, Missionsbuchhandlung, 1925, 159 p., fig.

SYDOW (E. von): "Die abstrakte Ornamentik der Gebrauchskunst in Grasland von Kamerun." In: *Baessler Archiv,* 1932, Bd. XV, pp. 160–180.

TARDITS (C.): *Les Bamiléké de l'Ouest Cameroun.* Préf. du gouverneur H. Deschamps. Paris, Berger-Levrault, 1960, 135 p. (L'homme d'outre-mer, nouvelle série, 4.)

TARDITS (C.): "Panneaux sculptés bamoun." In: *Objets et mondes,* 1962, t. II, fasc. 4, pp. 249–260, fig.

TRUITARD (S.): "Les arts au Cameroun. Arts et artisanats bamoun." In: *Chronique coloniale,* Paris, 1933, no. II, pp. 268–269.

THE WESTERN CONGO

ALEXANDRE (P.) et BINET (J.): *Le groupe dit pahouin (Fang-Boulou-Beti).* Paris, Presses universitaires de France, 1958, VIII–152 p. (Monographies ethnologiques africaines.)

ANDERSSON (E.): *Contribution à l'ethnographie des Kuta. I.* Uppsala, Almquist & Wiksells boktryckeri ab, 1953, XXIII–364 p., fig., pl. (Studia ethnographica upsaliensia, 6.)

Avelot (R.): "Notice historique sur les Ba-Kalé." In: *L'anthropologie,* Paris, 1913, t. XXIV, pp. 197–240.

Balandier (G.): *Sociologie actuelle de l'Afrique noire. Dynamique sociale en Afrique centrale.* 2ᵉ éd. mise à jour et augmentée. Paris, Presses universitaires de France, 1963, xii–532 p. (Bibliothèque de sociologie contemporaine.)

Bittremieux (le Père L.): "Symbolisme in de Negerkunst." In: *Congo,* 1930, vol. II, no. 5, pp. 662–680; 1934, vol. V, no. 2, pp. 168–204.

Bittremieux (le Père L.): *La société secrète des Bakhimba.* Bruxelles, G. Van Campenhout, 1936, 327 p., pl. (Institut royal colonial belge, section des sciences morales et politiques. Mémoires, collection in-80, t. V, fasc. 3.)

Bonnefond (le Père) et Lombard (J.): "Notes sur les coutumes lari." In: *Bulletin de l'Institut d'études centrafricaines,* 1950, nouvelle série, no. 1, pp. 141–177.

Bruel (G.): "Les populations de la Moyenne Sanga: les Pomo et les Boumali." In: *Revue d'ethnographie et de sociologie,* Paris, 1910, t. I, pp. 3–32, fig., pl.

Compiegne (le Marquis de): *L'Afrique équatoriale. Okanda, Bangouens, Osyéba.* Paris, E. Plon, Nourrit et Cie, 1885, viii–360 p., pl.

Doutreloux (A.): "Fétiches d'investiture au Mayumbe." In: *Folia scientifica Africae centralis,* 1959, vol. 5, no. 4, pp. 69–70.

Dugast (I.): *Inventaire ethnique du Sud-Cameroun.* Douala, Institut français d'Afrique noire—Centre du Cameroun, 1949, xii–159 p. (Mémoires de l'I.F.A.N.—Centre du Cameroun. Série: populations, 1.)

Eckendorff (J.): "Note sur les tribus des subdivisions de Makokou et de Mékambo (Gabon)." In: *Bulletin de l'Institut d'études centrafricaines,* 1945, t. I, no. 1, pp. 87–96.

Even (A.): "La circoncision chez les Babambas-Mindassa d'Okondja." In: *Bulletin de la Société des recherches congolaises,* 1933, no. 18, pp. 97–104.

Even (A.): "Le caractère sacré des chefs chez les Babamba et les Mindassa d'Okondja (Moyen-Congo)." In: *Journal de la Société des Africanistes,* 1936, t. VI, pp. 187–195.

Even (A.): "Les confréries secrètes chez les Babamba et les Mindassa d'Okondja." In: *Bulletin de la Société des recherches congolaises,* 1937, no. 23, pp. 31–113; no. 24, pp. 235–237.

Faure (H.-M.): "Rites mortuaires chez les M'Bérés." In: *Journal de la Société des Africanistes,* 1931, t. I, pp. 111–115.

GAUTIER (le Père): *Étude historique sur les Mpongouès et les tribus avoisinantes* . . . Brazzaville, Institut d'études centrafricaines, 1950, 71 p., fig. (Mémoires de l'Institut d'études centrafricaines, 3.)

GLENISSON (M.): "Les royaumes de la côte congolaise avant l'arrivée de Brazza." In: *Liaison,* Brazzaville, 1953, no. 36, pp. 37–40.

GREBERT (F.): *Au Gabon, Afrique équatoriale française.* 2e ed. revue et augmentée. Paris, Société des missions évangéliques, 1928, 228 p., fig.

GREBERT (F.): "Arts en voie de disparition au Gabon." In: *Africa,* London, 1934, vol. VII, pp. 82–88.

HOTTOT (R.): "Teke Fetishes." Prepared for publ. by Frank Willett. In: *The Journal of the Royal Anthropological Institute of Great Britain and Ireland,* 1956, vol. 86, pp. 25–36, pl.

KIENER (L.): "Notice sur les fétiches des populations Bassoundi habitant la subdivision de Pangala." In: *Bulletin de la Société des recherches congolaises,* 1922, no. 1, pp. 22–27.

LAMAN (K. E.): *The Kongo.* Stockholm, V. Petterson; Uppsala, Almsquist & Wiksell, 1953–1962, 3 vol., fig., pl. (Studia ethnographica upsaliensia, 4, 8, 12.)

LAVIGNOTTE (H.): "L'evur, croyance des Pahouins du Gabon." In: *Cahiers missionnaires,* Paris, 1936, no. 20, 77 p.

LEKACK (B.-C.): "Les Bakouélé; habitat, mœurs et coutumes." In: *Liaison,* Brazzaville, 1953, no. 34, pp. 31–34, fig.

MACLATCHY (A.): "Quelques motifs ornementaux utilisés par les indigènes de la N'Gounié (Gabon)." In: *La terre et la vie,* 1932, t. II, pp. 668–672.

MAES (J.): "Les figurines sculptées du Bas-Congo." In: *Africa,* London, 1930, vol. III, pp. 347–359, pl.

MILLET (C.): *Dossier Technique,* déposé au Département d'Afrique Noire, Musée de l'Homme, Paris.

OLBRECHTS (F. M.): "Une curieuse statuette en laiton des Ba-Teke." In: *Congo-Tervuren,* 1955, vol. 1, no. 3, pp. 103–104, fig.

PERROIS (L.): "Note sur une méthode d'analyse ethnomorphologique des arts africains." In: *Cahiers d'études africaines,* 1966, vol. 6, 1er cahier (no. 21), pp. 69–85, fig., pl.

PITRES (J. M.): *Les derniers artistes sauvages: Bakota, Ossyeba-Bakota, Ossyeba.* Bruges, s. n., 1960 [13] F. dactylographiées communiquées à l'auteur.

POUPON (A.): "Etude ethnographique de la tribu Kouyou." In: *L'anthropologie,* Paris, 1918–1919, t. XXIX, pp. 53–88, 297–335, fig.

RAPONDA-WALKER (A.) et SILLANS (R.): *Rites et croyances des peuples du Gabon*. Paris, Présence africaine, 1962, xx–377 p., fig., pl. (Enquêtes et études.)

TESSMANN (G.): *Die Pangwe. Völkerkundliche Monographie eines West-afrikanischen Negerstammes. Ergebnisse der Lübecker Pangwe-Expedition 1907–1909 und früherer Forschungen 1904–1907*. Berlin, E. Wasmuth, 1913, 2 vol., 275 + 402, fig., pl.

TREZENEM (E.): "Notes ethnographiques sur les tribus Fan du Moyen Ogooué, Gabon." In: *Journal de la Société des Africanistes*, 1936, t. VI, pp. 65–93.

TREZENEM (E.): "Contribution à l'étude des Nègres africains: les Bateke Balali." In: *Journal de la Société des Africanistes*, 1940, t. X, pp. 1–63, fig.

TRILLES (le Père H.): *Le totémisme chez les Fân*. Münster, Aschendorffsche Verlags, 1912, xvi–653 p. (Bibliothèque-Anthropos, t. I, fasc. 4.)

TRILLES (le Père H.): "Le totémisme chez les Fang." In: *Anthropos*, 1914, vol. IX, pp. 630–640.

TSAMAS (S.): "Le kyebé-kyebé." In: *Liaison*, Brazzaville, 1957, no. 59, pp. 61–65, fig.

VAN WING (le Père J.): "Bakongo Magic." In: *The Journal of the Royal Anthropological Institute of Great Britain and Ireland*, 1941, vol. 71, pp. 85–97, pl.

VERLY (R.): *Les Mintadi, la statuaire de pierre du Bas-Congo (Bamboma-Mussurongo)*. Louvain, Zaïre (impr. M. et L. Symons), 1955, 83 p., pl.

VISSERS (le Père J.): "Zeg het met . . . deksels." In: *Bode van de H. Geest*, Missiehnis Rhenen, 1948, 44ᵉ Jg, no. 2, pp. 12–14, 25–28, 35–37, 56–57, 82–83, 98–99, fig.

WALKER (Abbé A.): "Coutumes ishogos . . ." In: *Bulletin de la Société des recherches congolaises*, 1927, no. 8, pp. 139–143.

WALKER (Abbé A.): *Notes d'histoire du Gabon*. Introd., cartes et notes de M. Soret. Brazzaville, Institut d'études centrafricaines, 1960, 158 p. (Mémoires de l'Institut d'études centrafricaines, 9.)

WANNYN (R. L.): *L'art ancien du métal au Bas-Congo*. Champles par Wavre, Ed. du Vieux Planquesaule, 1961, 99 p., pl. (Les vieilles civilisations ouest-africaines.)

THE CENTRAL CONGO

ACHTEN (L.): Manusc. inédit. D.E. 394, Farde 22, *Arts et Métiers*, p. 1. Musée royal de l'Afrique centrale, Tervuren, Section d'Ethnographie.

BASTIN (M.-L.): *Art décoratif tshokwe*. Lisboa, Companhia de diamantes de Angola, 1961, 2 vol., 396 p., fig., pl. (Publicações culturais da Companhia de diamantes de Angola, 55.)

BASTIN (M.-L.): "Un masque en cuivre martelé des Kongo du Nord-Est de l'Angola." In: *Africa Tervuren*, 1961, t. 7, no. 2, pp. 29–40, fig.

BASTIN (M.-L.): "Quelques œuvres tshokwe des musées et collections d'Allemagne et de Scandinavie." In: *Africa Tervuren,* 1961, t. 7, no. 4, pp. 101–105, fig.

BASTIN (M.-L.): *Tshibinda Ilunga: héros civilisateur.* S. l., s. n., 1966, 2 vol., 169 + LIII f., fig.

BOONE (O.): *Les tambours du Congo belge et du Ruanda-Urundi* . . . Tervuren, Musée du Congo belge, 1951, 2 vol., 121 p., fig., pl. (Annales du Musée du Congo belge. Nouvelle série in-40. Sciences de l'homme, ethnographie, 1.)

BOONE (O.): *Carte ethnique du Congo quart Sud-Est.* Tervuren, Musée royal de l'Afrique centrale, 1961, XVI–271 p. (Annales du Musée royal de l'Afrique centrale. Série in-80. Sciences humaines, 37.)

BURTON (W. F. P.): *Luba Religion and Magic in Custom and Belief.* Tervuren, Musée royal de l'Afrique centrale, 1961, x–193 p., pl. (Annales du Musée royal de l'Afrique centrale. Série in-80. Sciences humaines, 35.)

CLOUZOT (H.) et LEVEL (A.): *L'art du Congo belge.* S. l., s. n., 1921, 12 p., fig.

DE SOUSBERGHE (le Père L.): "Cases cheffales sculptées des Ba-Pende." In: *Bulletin de la Société royale belge d'anthropologie et de préhistoire,* 1954, t. 65, pp. 75–81, pl.

DE SOUSBERGHE (le Père L.): "Forgerons et fondeurs de fer chez les Ba-Pende et leurs voisins." In: *Zaïre,* 1955, vol. 9, no. 1, pp. 25–31.

DE SOUSBERGHE (le Père L.): *L'art pende* . . . Bruxelles, Académie royale de Belgique, 1958, IX–165 p., pl. (Beaux-arts, t. IX, fasc. 2.)

DE SOUSBERGHE (le Père L.): "Cases cheffales du Kwango." In: *Congo Tervuren,* 1960, vol. 6, no. 1, pp. 10–16, fig.

FOURCHE (J.-A. Tiarko) et MORLIGHEM (H.): *Les communications des indigènes du Kasai avec les âmes des morts.* Bruxelles, Impr. M. Hayez, 1939, 78 p. (Extrait des *Mémoires,* publ. par l'Institut royal colonial belge, section des sciences morales et politiques. Collection in-8, t. 9.)

Bibliography 337

FROBENIUS (L.): *Im Schatten des Kongostaates.* Berlin, G. Reimer, 1907, 468 p., fig.

GAFFE (R.): *La sculpture au Congo belge.* Paris, Bruxelles, Éd. du Cercle d'art, 1945, 73 p., pl.

HIMMELHEBER (H.): "Art et artistes batshiok." In: *Brousse,* 1939, no. 3, pp. 17–31, fig.

HIMMELHEBER (H.): "Les masques bayaka et leurs sculpteurs." In: *Brousse,* 1939, no. 1, pp. 19–39, fig.

HIMMELHEBER (H.): "Art et artistes bakuba." In: *Brousse,* 1940, no. 1, pp. 17–30.

HUBER (H.): "Magical Statuettes and Their Accessories Among the Eastern Bayaka and Their Neighbors (Belgian Congo)." In: *Anthropos,* 1956, vol. LI, no. 1–2, pp. 265–290, fig.

JADOT (J. M.): "Rapport sur le travail de M. Jean Vanden Bossche, intitulé 'Madya, graveur de calebasses.'" In: *Académie royale des sciences coloniales—Bulletin des séances,* Bruxelles, 1955, nouvelle série, t. I, no. 4, pp. 602–610.

JONGHE (E. de): "Formations récentes de sociétés secrètes au Congo belge." In: *Africa,* London, 1936, vol. IX, pp. 56–63.

KOCHNITZKY (L.): "Masques géants, masques miniatures." In: *La revue coloniale belge,* 1953, 8e année, no. 175, pp. 53–55, fig.

KOCHNITZKY (L.): "Un sculpteur d'amulettes au Kwango." In: *Brousse,* 1953, nouvelle série, no. 3, pp. 9–13, fig.

LEYDER (J.): *Le graphisme et l'expression graphique au Congo belge* . . . Avec la collaboration de A. CAUVIN, J.-M. JADOT, J. MAQUET-TOMBU, FL. MORTIER, G.-D. PERIER. Préf. de J. H. DE LA LINDI. Bruxelles, Société royale belge de géographie, 1950, 156 p., fig.

MAES (J.): *Aniota-Kifwebe, les masques des populations du Congo belge et le matériel des rites de circoncision.* Anvers, De Sikkel, 1924, 64 p., pl.

MAES (J.): "La métallurgie chez les populations du lac Léopold II-Lukenie." In: *Ethnologica,* Leipzig, 1930, Bd. IV, pp. 68–101.

MAES (J.): "Le tissage chez les populations du lac Léopold." In: *Anthropos,* 1930, vol. XXV, pp. 393–408.

MAES (J.): "Les statues de rois bakuba." In: *Les Beaux-arts,* 1936, 7e année, no. 215, pp. 18–21.

MAES (J.): "Figurines mendiantes dites 'kabila' des Baluba." In: *Brousse,* 1939, no. 2, pp. 10–17.

MAESEN (A.): "La sculpture décorative." In: *Les arts plastiques,* Bruxelles, 1951, 5e série, no. 1, pp. 16–30, fig.

MAESEN (A.): "Les Holo du Kwango . . ." In: *Reflets du monde*, 1956, no. 9, pp. 3–16, fig.

MAESEN (A.): "Styles et expérience esthétique dans la plastique congolaise." In: *Problèmes d'Afrique centrale*, 1959, no. 44, pp. 85–95, fig.

MAESEN (A.): *Umbangu. Art du Congo au Musée royal du Congo belge* . . . S. l., Cultura, s. d., 26 p., pl. (L'art en Belgique, 3.)

OLBRECHTS (F. M.): "Le Congo au XVIe siècle." In: *Les arts plastiques*, Bruxelles, 1951, 5e série, no. 1, pp. 31–36, fig.

OLBRECHTS (F. M.): "Découverte de deux statuettes d'un grand sous-style baluba." In: *Institut royal colonial belge—Bulletin des séances*, Bruxelles, 1951, t. XXII, no. 1, pp. 130–140, fig.

OLBRECHTS (F. M.): "La statuaire du Congo belge." In: *Les arts plastiques*, Bruxelles, 1951, 5e série, no. 1, pp. 5–15, fig.

OLBRECHTS (F. M.): *Quelques chefs-d'œuvre de l'art africain des collections du Musée royal du Congo belge, Tervuren*. Tervuren, Musée royal du Congo belge, 1952, 1 p., pl.

OLBRECHTS (F. M.): "Rapport sur le travail de M. Jean Vanden Bossche, intitulé 'Madya, graveur de calebasses.'" In: *Académie royale des sciences coloniales—Bulletin des séances*, Bruxelles, 1955, nouvelle série, t. I, no. 4, pp. 581–583.

OLBRECHTS (F. M.): *Les arts plastiques du Congo belge*. Bruxelles, Erasme, 1959, 161 p., fig., pl.

PLANCQUAERT (M.): *Les sociétés secrètes chez les Bayaka*. Louvain, Kuyl-Otto, 1930, 131 p., fig. (Bibliothèque Congo, 31.)

REDINHA (J.): *Paredes pintadas da Lunda*. Lisboa, Companhia de diamantes de Angola, 1953, 16 p., pl. (Publicações culturais da Companhia de diamantes de Angola, 18.)

SEGY (L.): "Bakuba Cups, an Essay on Style Classification." In: *Midwest Journal*, 1951–1952, vol. IV, no. 1, pp. 26–49, fig.

THOMAS (T.): "Les 'itomkwa,' objets divinatoires sculptés." In: *Kongo Tervuren*, 1960, t. 5, no. 3, pp. 78–83.

TIMMERMANS (P.): "Les Sapo Sapo près de Luluabourg." In: *Africa Tervuren*, 1962, vol. 8, no. 1–2, pp. 29–53, fig.

TORDAY (E.): "Note on Certain Figurines of Forged Iron Formerly Made by the Bushongo of the Belgian Congo." In: *Man*, 1924, vol. 24, no. 13, p. 17.

TORDAY (E.) et JOYCE (T. A.): *Notes ethnographiques sur les peuples communément appelés Bakuba, ainsi que sur les peuplades apparentées: les Bushongo*. Bruxelles, Ministère des Colonies, 1910,

291 p., fig., pl. (Annales du Musée du Congo belge; ethnographie, anthropologie. Série 3. Documents ethnographiques concernant les populations du Congo belge, t. 2, fasc. 1.)

VAN GELUWE (H.): "Préliminaires sur les origines de l'intérêt pour l'art africain et considérations sur le thème de la femme dans la sculpture congolaise." In: *Africa Tervuren,* 1961, vol. 7, no. 3, pp. 71–81, fig.

VAN OVERBERGH (C.): *Les Basonge (état ind. du Congo).* Bruxelles, A. de Witt; Institut international de bibliographie, 1908, XVI–564 p., fig. (Collection de monographies ethnographiques, III.)

VANDEN BOSSCHE (Adr.): "La sculpture des masques bapende." In: *Brousse,* 1950, no. 1, p. 11.

VANDEN BOSSCHE (Adr.): "Art bakuba." In: *Brousse,* 1952, nouvelle série, no. 1, pp. 11–26, fig.

VANDEN BOSSCHE (J.): *Madya, graveur de calebasses.* Bruxelles, Académie royale des sciences coloniales, 1955, 47 p., pl. (Académie royale des sciences coloniales, classe des sciences morales et politiques. Mémoires, collection in-80; nouvelle série, t. VI, fasc. 2.)

VANSINA (J.): *Les tribus Ba-Kuba et les peuplades apparentées.* Tervuren, Musée royal du Congo belge, 1954, XIV–64 p. (Annales du Musée royal du Congo belge. Série in-80 Sciences de l'homme. Monographies ethnographiques, 1.)

VANSINA (J.): "Les valeurs culturelles des Bushong." In: *Zaïre,* 1954, vol. VIII, no. 9, pp. 899–910.

VANSINA (J.): *Les anciens royaumes de la savane.* Léopoldville, Université Lovanium, 1965, 193 p. (Institut de recherches économiques et sociales. Études sociologiques, 1.)

VARHULPEN (E.): *Baluba et Balubaïsés du Katanga* . . . Anvers, L'Avenir belge, 1936, 534 p., pl.

THE EASTERN CONGO

BAUMANN (H.): "Die materielle Kultur de Azande und Mangbetu. Beiträge zur kulturhistorischen Stellung zweier Völker des nördlichen Kongogebietes." In: *Baessler Archiv,* 1927, Bd. XI, pp. 3–129, fig.

BIEBUYCK (D.): *Signification d'une statuette lega.* In: *La revue coloniale belge,* 1953, no. 195, pp. 866–867, fig.

BIEBUYCK (D.): "Some Remarks on Segy's 'Warega Ivories.'" In: *Zaïre,* 1953, vol. VII, no. 10, pp. 1076–1082.

BIEBUYCK (D.): "Function of a Lega Mask." In: *International Archives of Ethnography,* 1954, vol. 47, part. 1, pp. 108–120, pl.

BOELAERT (P.) et HULSTAERT (G. E.): "Les manifestations artistiques des Nkundo . . ." In: *Brousse,* 1939, no. 2, pp. 18–21.

BURSSENS (H.): "The So-Called 'Bangala' and a Few Problems of Art-Historical and Ethnographical Order." In: *Kongo-Overzee,* 1954, vol. 20, no. 3, pp. 221–229, fig., pl.

BURSSENS (H.): "La fonction de la sculpture traditionnelle chez les Ngbaka." In: *Brousse,* 1958, no. 2, pp. 10–28.

BURSSENS (H.): *Les peuplades de l'entre Congo-Ubangi* . . . Tervuren, Musée royal du Congo belge, 1958, XI–219 p. (Annales du Musée royal du Congo belge. Série in-80. Sciences de l'homme. Monographies ethnographiques, 4.)

BURSSENS (H.): "Enkele maskers iut Ulele." In: *Congo-Tervuren,* 1960, vol. 6, no. 4, pp. 101–108, fig.

CALONNE-BEAUFAICT (A. de): *Les Ababua.* Bruxelles, Dewit, 1904.

DAMPIERRE (E. de): ed.: *Poètes nzakara.* Paris, Julliard, 1963, 222 p., fig. (Classiques africains, 1.)

DE LOOSE (J. M.): "Nota's over de mbanga-sekte bij de Azande-Abandia." In: *Miscellanea ethnographica.* Tervuren, Musée royal de l'Afrique centrale, 1963, pp. 171–191, pl. (Annales du Musée royal de l'Afrique centrale. Série in-80. Sciences humaines, 46.)

DE ROP (le Père A. J.): "Lilwa-beeldjes bij de Boyela." In: *Zaïre,* 1955, vol. IX, no. 2, pp. 115–120, pl.

EVANS-PRITCHARD (E. E.): "Mani, a Zande Secret Society." In: *Sudan Notes and Records,* 1931, vol. XIV, pp. 105–148.

EVANS-PRITCHARD (E. E.): *Witchcraft, Oracles and Magic Among the Azande.* Oxford, Clarendon Press, 1937, XXVI–559 p., fig., pl.

HULSTAERT (G. E.): "Les cercueils des Eleku." In: *Aequatoria,* 1959, 22e année, no. 1, pp. 11–15.

HULSTAERT (G. E.): "Les cercueils anthropomorphes." In: *Aequatoria,* 1960, 23e année, no. 4, pp. 121–129, fig.

KERELS (H.): "L'art chez les Mangbwetu." In: *Les beaux-arts,* 1936, no. 215, pp. 22–23.

LOTAR (le Père L.): *La grande chronique du Bomu* . . . Bruxelles, Institut royal colonial belge, 1940, 163 p. (Institut royal colonial belge, section des sciences morales et politiques. Mémoires, collection in-80, t. IX.)

LOTAR (le Père L.): *La grande chronique de l'Uele* . . . Bruxelles, Institut royal colonial belge, 1946, 363 p., pl. (Institut royal colonial belge, section des sciences morales et politiques. Mémoires, collection in-80, t. XIV, fasc. 1.)

ROUVROY (V.): "Le 'lilwa' (district de l'Aruwimi, territoire des Bambole)." In: *Congo,* mai 1929, pp. 783–798, fig.

SCHWEINFURTH (G.): "Das Volk der Monbuttu in Central-Afrika." In: *Zeitschrift für Ethnologie,* 1873, Bd. 5, pp. 1–27.

SCHWEINFURTH (G.): *Artes africanae. Abbildungen und Beschreibungen von Erzeugnissen des Kunstfleisses centralafrikanischer Völker.* Leipzig, F. A. Brockhaus; London, Sampson Low Marston, Low and Searle, 1875, 51 p., pl.

SCHWEINFURTH (G.): *Au cœur de l'Afrique, 1868–1871; voyages et découvertes dans les régions inexplorées de l'Afrique centrale . . .* Trad. par H. Loreau. Paris, Hachette et Cie, 1875, 2 vol., IV–508 + 434 pp., fig., pl.

ZANGRIE (L.): "Les institutions, la religion et l'art des Ba Buye (groupes des Ba Sumba du Ma Nyéma, Congo belge)." In: *L'ethnographie,* Paris, 1947–1950, nouvelle série, t. 45, pp. 54–80, fig.

EAST AFRICA

BENNET-CLARK (M. A.): "A Mask from the Makonde Tribe in the British Museum." In: *Man,* 1957, vol. 57, no. 117, pp. 97–98, fig.

BOCCASSINO (R.): "Il contributo delle antiche fonti sulla religione dei Latuca, Obbo, Bari, Beri, Denca, Neer e altre popolazioni . . ." In: *Annali lateranensi,* 1951, vol. 15, pp. 79–144, pl.

BOSCH (le Père F.): *Les Banyamwezi, peuple de l'Afrique orientale.* Münster, Aschendorffsche Verlags, 1930, XI–552 p., pl. (Bibliothèque-Anthropos, t. III, fasc. 2.)

CERULLI (E.): *Etiopia occidentale . . . Note del viaggio 1927–1928.* Roma, Arti grafiche, 1933, 2 vol., 254 + 266 p., fig., pl. (Collezione di opere e monografie a cura del Ministero delle Colonie, 16.)

CLARK (J. D.): "Dancing Masks from Somaliland." In: *Man,* 1953, vol. 53, no. 72, pp. 49–51, fig., pl.

CORY (H.): *Wall-Paintings by Snake Charmers in Tanganyika.* London, Faber and Faber, 1953, 99 p., fig., pl.

CORY (H.): *African Figurines, Their Ceremonial Use in Puberty Rites in Tanganyika.* London, Faber and Faber, 1956, 176 p., fig.

CORY (H.): "Religious Beliefs and Practices of the Sukuma/Nyamwezi Tribal Group." In: *Tanganyika Notes and Records,* 1960, no. 54, pp. 14–26, fig.

DIAS (J.): *Os Macondes de Moçambique.* Lisboa, Junta de investigações do ultramar—Centro de estudos de antropologia cultural, 1964, 2 vol., 180 + 192 p., fig., pl.

DRIBERG (J. H.): *The Lango, a Nilotic Tribe of Uganda.* London, T. Fischer Unwin, 1923, 468 p., fig., pl.

HARRIES (L.): *The Initiation Rites of the Makonde Tribe.* Livingstone, Rhodes-Livingstone Institute, 1944, 41 p. (Communications from the Rhodes-Livingstone Institute, 3.)

JUNKER (W.): *Dr. Wilh. Junkers Reisen in Afrika, 1875–1886* . . . Wien, E. Hölzel, 1889–1891, 3 vol., fig., pl.

KRONENBERG (A. and W.): "Wooden Carvings in the South Western Sudan." In: *Kush,* 1960, vol. 8, pp. 274–281, pl.

MAQUET (J. J.): *Afrique, les civilisations noires.* Paris, Horizons de France, 1962, 288 p., fig., pl. (Hommes et civilisations.)

PAULME (D.): "Carved Figures from the White Nile in the Musée de l'homme." In: *Man,* 1953, vol. 53, no. 172, pp. 113–114, pl.

SEKINTU (C. M.) and WACHSMANN (K. P.): *Wall Patterns in Hima Huts.* Kampala, Uganda Museum, 1956, 10 p., pl. (Uganda Museum. Occasional paper, 1.)

SELIGMAN (Ch. G. and B. Z.): "The Bari." In: *The Journal of the Royal Anthropological Institute of Great Britain and Ireland,* 1928, vol. 58, pp. 409–479, fig., pl.

TROWELL (M.) and WACHSMANN (K. P.): *Tribal Crafts of Uganda.* London, New York, Toronto, Oxford University Press, 1953, XXII–423 p., fig., pl.

SOUTH AFRICA

CATON-THOMPSON (G.): *The Zimbabwe Culture, Ruins and Reactions.* Oxford, Clarendon Press, 1931, XXIV–299 p., fig., pl.

CHRISTOL (F.): *L'art dans l'Afrique australe* . . . Paris-Nancy, Berger-Levrault, 1911, XXII–147 p., fig., pl.

COILLARD (F.): *Sur le Haut-Zambèze. Voyages et travaux* . . . Paris-Nancy, Berger-Levrault et Cie, 1898, XXVIII–590 p., pl.

COOPER (G.): "Village Crafts in Barotseland." In: *Human Problems in British Central Africa,* 1951, vol. XI, pp. 47–60.

DAVIDSON (B.): *L'Afrique avant les Blancs; découverte du passé oublié de l'Afrique.* Trad. de l'anglais par Pierre Vidaud. Paris, Presses universitaires de France, 1962, XII–327 p., fig., pl.

GELFAND (M.): *Shona Religion with Special Reference to the Mako-rekore.* Cape Town [etc.], Juta & Co., 1962, X–184 p., pl.

JUNOD (H. A.): *Mœurs et coutumes des Bantous, la vie d'une tribu sud-africaine.* Paris, Payot, 1936, 2 vol., 515 + 580 p., fig., pl. (Bibliothèque scientifique.)

KIRBY (P. R.): "The Building in Stone of a New Kraal for the Paramount Chief of the Venda in the Nineteen-Thirties." In: *South African Journal of Science,* 1956, vol. 52, no. 7, pp. 167–168.

KRIGE (E. Jensen): *The Social System of the Zulus.* 3rd ed. Pietermaritzburg, Shuter & Shooter, 1957, XIX–420 p.

KUPER (H.), HUGHES (A. J. B.), and VAN VELSEN (J.): *The Shona and Ndebele of Southern Rhodesia.* London, International African Institute, 1954, 131 p. (Ethnographic survey of Africa: Southern Africa, IV.)

REYNOLDS (B.): *Magic, Divination and Witchcraft Among the Barotse of Northern Rhodesia.* London, Chatto & Windus, 1963, XIX–181 p., fig., pl. (Robins series, 3.)

RICHARDS (A. I.): *Chisungu, a Girls' Initiation Ceremony Among the Bemba of Northern Rhodesia.* London, Faber & Faber, 1956, 224 p., fig., pl.

RITTER (E. A.): *Shaka Zulu, the Rise of the Zulu Empire.* London, New York, Toronto, Longmans Green & Co., XVI–383 p., pl.

ROUMEGUERE (P.) et ROUMEGUERE-EBERHARDT (J.): "Poupées de fertilité et figurines d'argile. Leurs lois initiatiques." In: *Journal de la Société des Africanistes,* 1960, t. XXX, pp. 205–223, pl.

SCHOFIELD (J. F.): "Zimbabwe, a Critical Examination of the Building Methods Employed." In: *South African Journal of Science,* 1926, vol. 23, pp. 971–986.

SCHOFIELD (J. F.): *Primitive Pottery* . . . Cape Town, South African Archaeological Society, 1948, 220 p., fig. (Handbook series, 3.)

SICARD (H. von): "The Bird in the Zimbabwe Culture." In: *Ethnos,* 1943, vol. 8, no. 3, pp. 104–114.

SUMMERS (R.): *Zimbabwe, a Rhodesian Mystery.* Johannesburg, Nelson, 1963, VIII–120 p., pl.

WALTON (J.): "South African Peasant Architecture: Nguni Folk Building." In: *African Studies,* Johannesburg, 1949, vol. 8, no. 2, pp. 70–79, fig., pl.

WALTON (J.): "Carved Wooden Doors of the Bavenda." In: *Man,* 1954, vol. 54, no. 58, pp. 43–46, fig.

WALTON (J.): "The Soapstone Birds of Zimbabwe." In: *The South African Archaeological Bulletin,* 1955, vol. 10, no. 39, pp. 78–84, fig.

WALTON (J.): *African Village.* Pretoria, J. L. Van Schaik, 1956, XII–170 p., fig., pl.

WALTON (J.): "Patterned Walling in African Folk Building." In: *The Journal of African History,* 1960, vol. 1, no. 1–2, pp. 19–30, fig., pl.

CONCLUSION

BOAS (F.): *Primitive Art.* New York, Dover, 1955, 378 p., fig., pl.
CHARBONNIER (G.): *Entretiens avec Claude Lévi-Strauss.* Paris, Plon-Julliard, 1960, 167 p., pl. (Les lettres nouvelles, 10.)
DE HEUSCH (L.): *L'Afrique noire in art et les societés primitives à travers le monde.* Paris, Librairie Hachette, 1963, 347 p., pp. 78–79.
DUVIGNAUD (J.): *Introduction à la sociologie.* Paris, Gallimard, 1966, 173 p. (Collection "Idées.")
FAGG (W.): "On the Nature of African Art." In: *Memoirs and Proceedings of the Manchester Literary and Philosophical Society,* 1952–1953, vol. 94, pp. 93–104, pl.
FAGG (W.): *L'art nègre: ivoires afro-portugais . . .* Trad. par Jeanne Reverseau. Prague, Artia, 1959, XXIV p., pl.
GERBRANDS (A. A.): *Art as an Element of Culture Especially in Negro-Africa.* Leiden, E. J. Brill, 1957, X–158 p., fig., pl. (Mededelingen van het Rijksmuseum voor Volkenkunde, 12.)
LEROI-GOURHAN (A.): *Préhistoire de l'art occidental.* Paris, L. Mazenod, 1965, 482 p., fig., pl. (Collection "L'art et les grandes civilisations," 1.)
LÉVI-STRAUSS (C.): *Anthropologie structurale.* Chapitre: "Art." Paris, Plon, 1958, pp. 269–294, fig., pl.
MAUSS (M.): "Rapports réels et pratiques de la psychologie et de la sociologie." In: *Journal de psychologie normale et pathologique,* 1924, no. 10, pp. 892–922.
MAUSS (M.): "Une catégorie de l'esprit humain: la notion de personne, celle de 'moi' . . ." In: *The Journal of the Royal Anthropological Institute of Great Britain and Ireland,* 1938, vol. 68, pp. 263–281.
MAUSS (M.): *Manuel d'ethnographie.* Paris, Payot, 1947, 211 p. (Bibliothèque scientifique.)
MURRAY (K. C.): "The Artist in Nigerian Tribal Society: a Comment." In: *The Artist in Tribal Society . . .* Ed. by Marian W. Smith. London, Routledge and Kegan Paul, 1961, pp. 95–101. (Royal Anthropological Institute. Occasional paper, 15.)
OLBRECHTS (F. M.): "Contribution to the Study of the Chronology of African Plastic Art." In: *Africa,* London, 1943, vol. XIV, pp. 183–193, pl.

Index

345